THE
LIVING FOREST

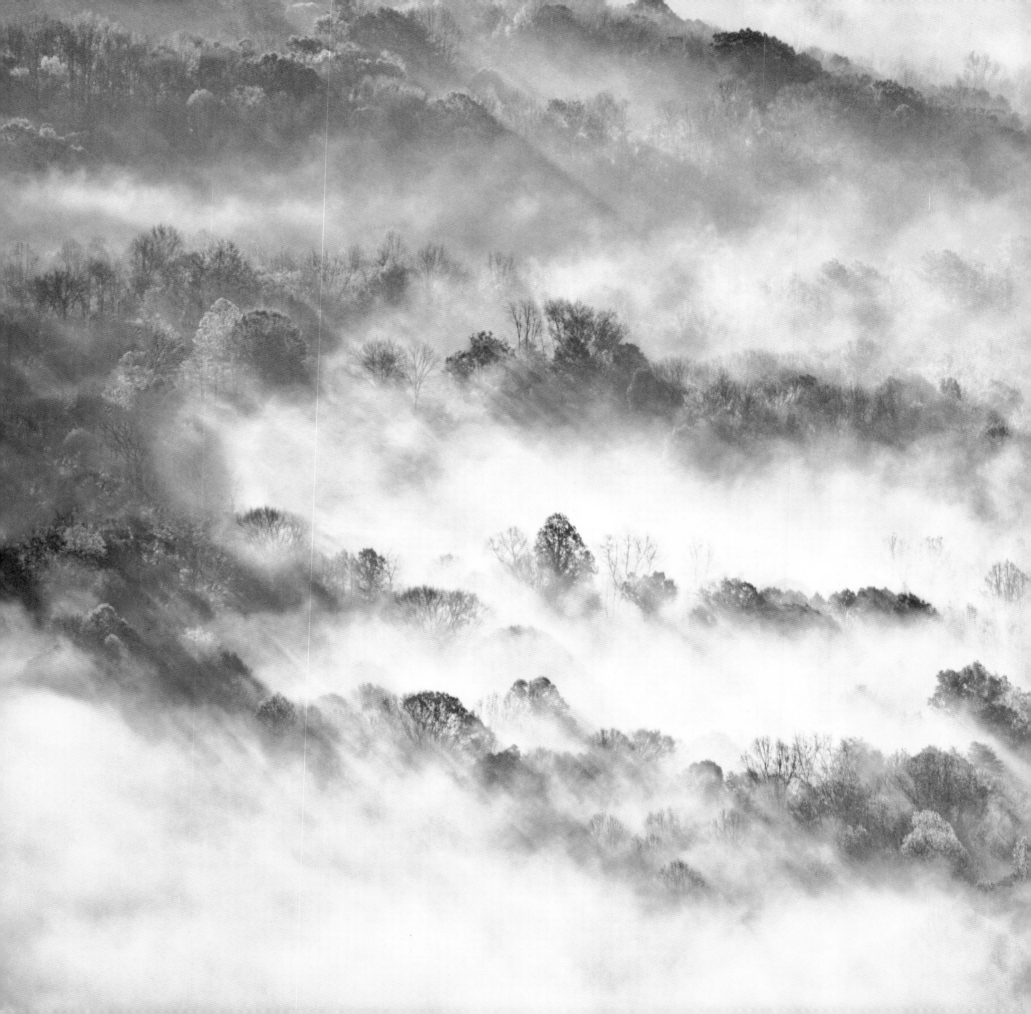

Photography by ROBERT LLEWELLYN / *Written by* JOAN MALOOF

THE LIVING FOREST

A VISUAL JOURNEY INTO THE HEART OF THE WOODS

TIMBER PRESS • PORTLAND, OREGON

Published in 2017 by Timber Press, Inc.
The Haseltine Building
133 S.W. Second Avenue, Suite 450
Portland, Oregon 97204-3527
timberpress.com

Printed in China

Text design and cover design by Adrianna Sutton

Library of Congress Cataloging-in-Publication Data

Names: Maloof, Joan, 1956– author. | Llewellyn, Robert J., photographer.
Title: The living forest: a visual journey into the heart of the woods / photography by Robert
 Llewellyn ; written by Joan Maloof.
Description: Portland, Oregon: Timber Press, 2017. | Includes bibliographical references
 and index.
Identifiers: LCCN 2016057868 | ISBN 9781604697124 (hardcover)
Subjects: LCSH: Forests and forestry—Pictorial works.
Classification: LCC SD385 .M35 2017 | DDC 634.9022/2—dc23 LC record available at
 https://lccn.loc.gov/2016057868

A catalog record for this book is also available from the British Library.

*To Joan Maloof and her dedication
to preserving our forests.* R. L.

·

*To all supporters of the
Old-Growth Forest Network;
they enable me to speak
for the forests.* J. M.

The Old-Growth Forest Network is the first national organization working
specifically to preserve ancient forests for the enjoyment of present and future
generations. In counties capable of supporting forest growth we identify at least
one forest that will be forever protected from logging and open to the public.
Then we help families connect with these forests. The result will be a national
network of treasured forests where all generations can experience native
biodiversity and the beauty of nature. We also speak out for threatened ancient
forests everywhere. To learn more, visit www.oldgrowthforest.net.

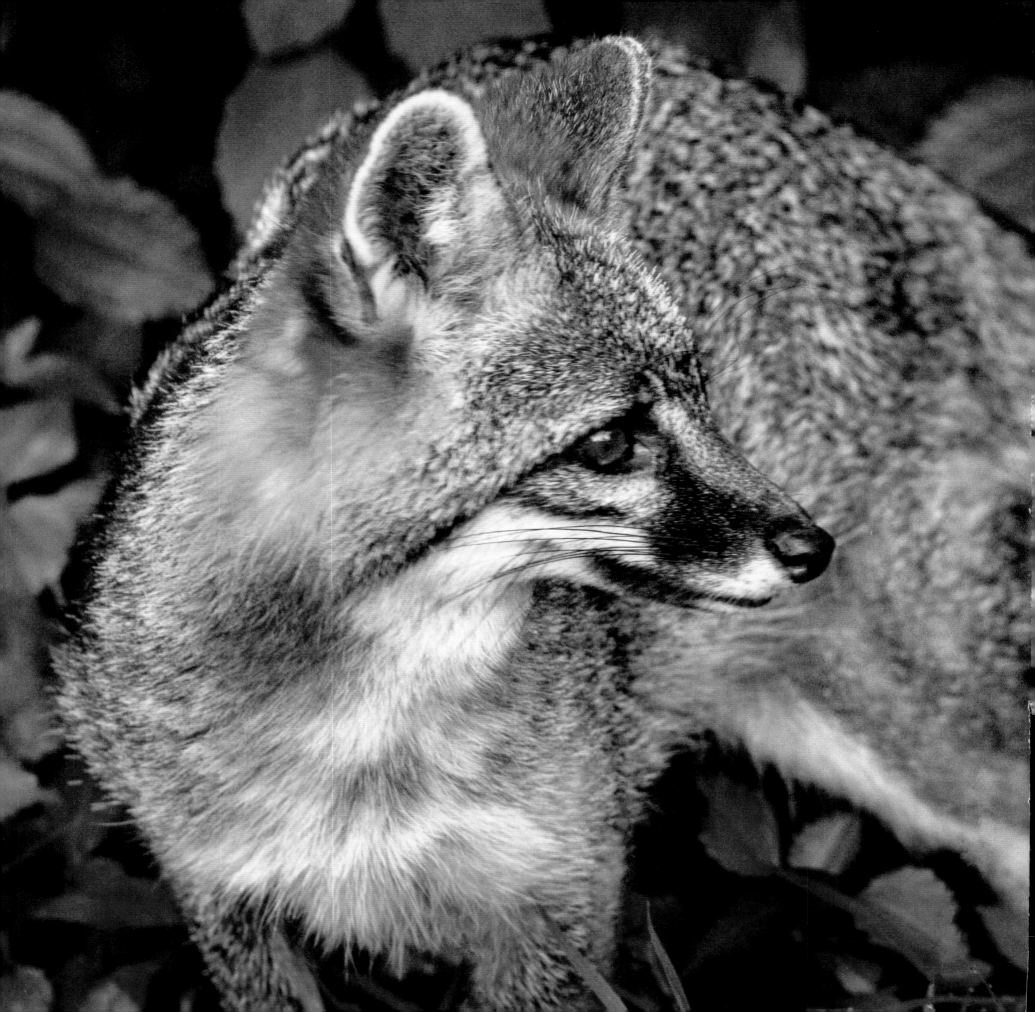

Contents

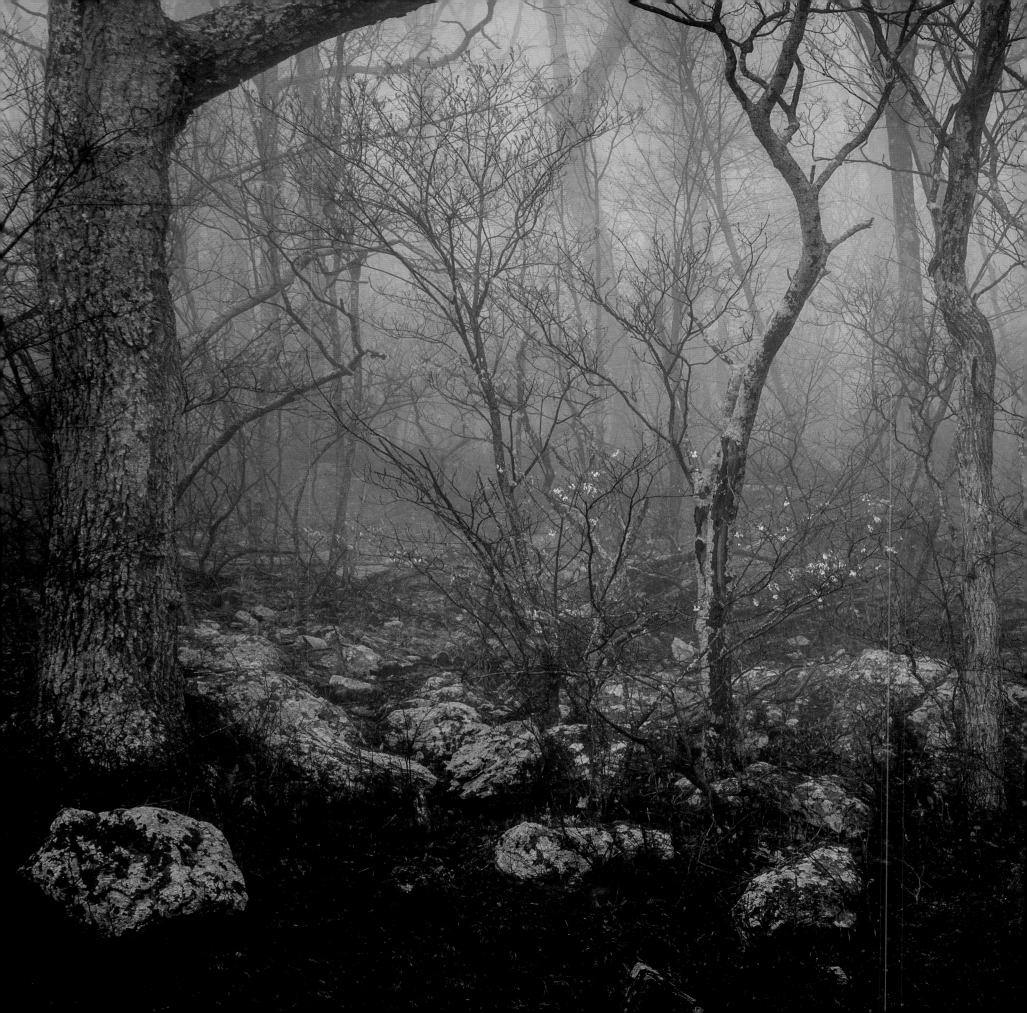

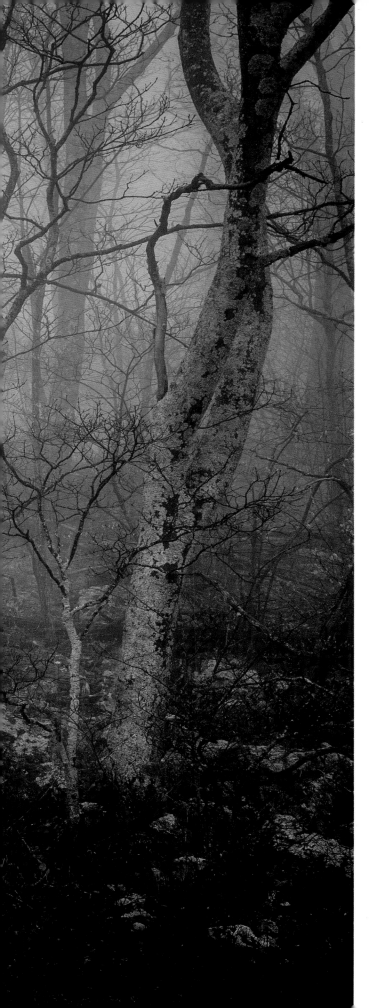

Preface

IT IS OUR INTENTION that this book be a reminder that the living part of our planet, the biosphere, is just a thin and lovely membrane. We have harmed much of this membrane, but because it is alive it has the ability to heal. Here we celebrate the part of the biosphere known as the temperate deciduous forest, and all the life it contains. It is our wish that increased understanding will provide motivation for allowing the forest to continue unimpeded on its wild trajectory.

Although the photographs on these pages are stunningly beautiful and we can witness such views, it's impossible to really see the whole of a forest. A forest is a complex web of energy and matter that reaches far beyond the confines of identified acreages. Much of what a forest does, and is, is invisible and can never be captured by the camera. At other times, the energy and the matter align on the scale of human perception and we *see*: oh, a blossom, a salamander, a mushroom, a bear! All amazing, all wonders to be studied forever and, even then, to be felt more than fully understood. Take any one of these photographic images and spend some time with it, and you will understand what the poet William Blake meant about seeing "the world in a grain of sand." These nodes of matter show us the never-ending flow of energy right here, right this moment. And the shutter clicks.

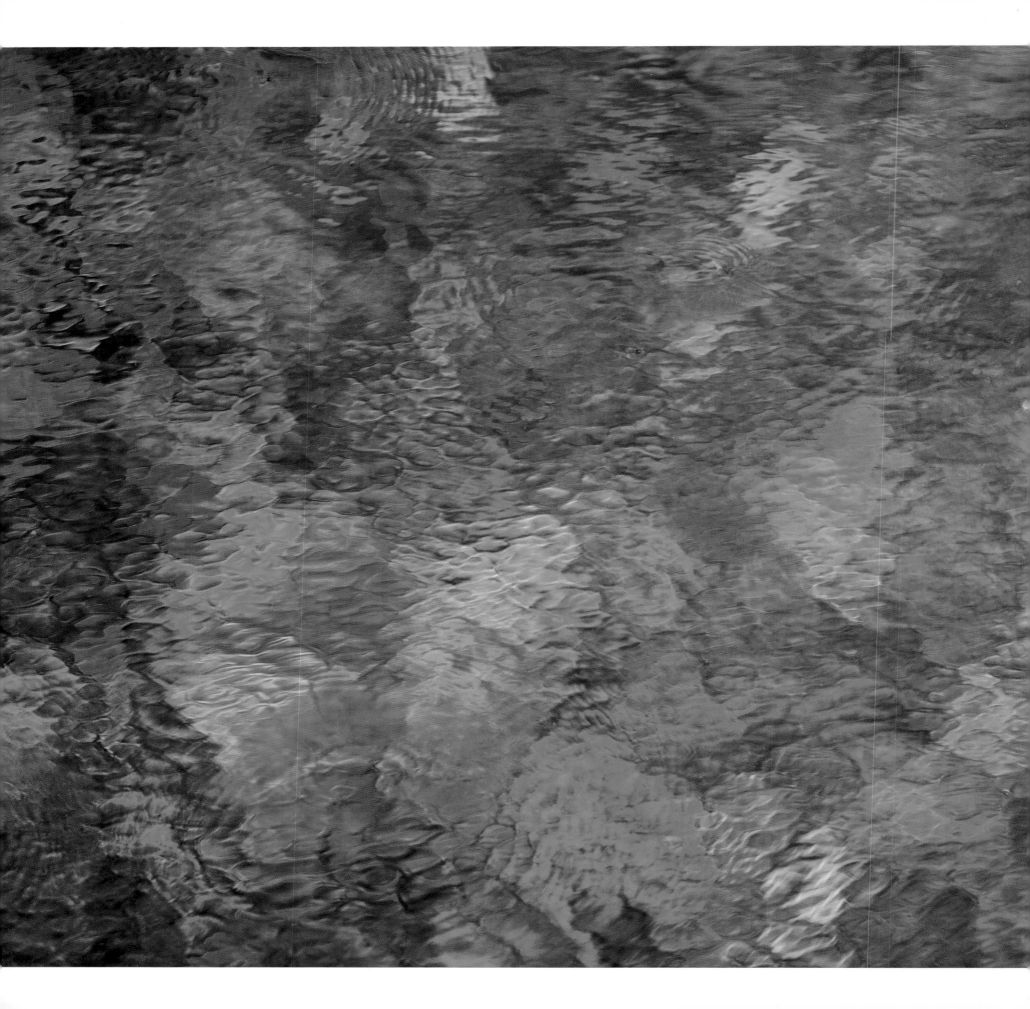

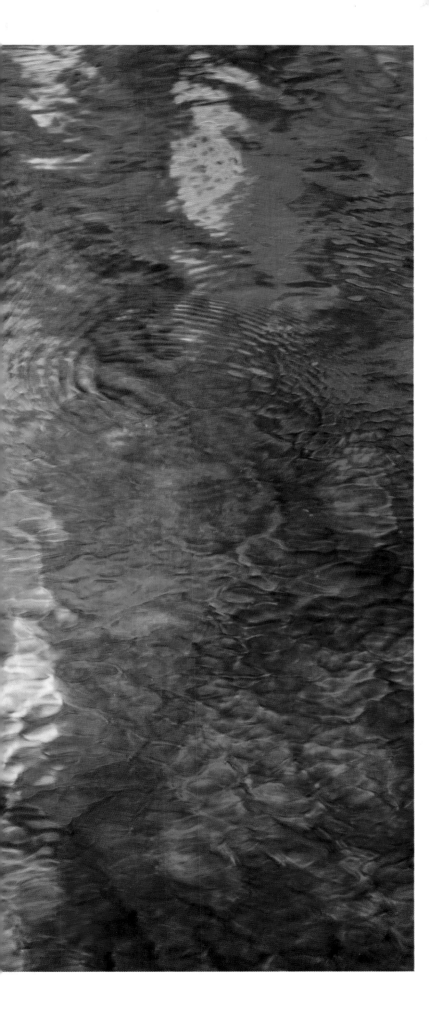

The pen is slower, but it can include a bit more of the intersections. It can tell of strand pulling strand in the web of life. It can hint at the dimension of time.

And then, finally, beyond the camera and the pen is the energy and matter that you, reader, bring to the equation. For after you douse yourself in the images and the words, you must go a step beyond and add the dimension of experience. It is only then that you will truly start seeing the forest. And the forest will see you, too. There are plenty of eyes in these photos and, as you will read here, even the eyeless trees sense your light.

But how do we organize this discussion of a place where everything is happening at once? We chose to start with the largest bones, the trees— the living structures that define a forest—and to move from the canopy to the ground. There is much life in the canopy, but primarily it is a surface for catching light—the source of energy that powers the entire forest.

Trees are creators of rain. And many forest creatures depend on the water held in and released by the forest. So we look closely at that.

As we move through the forest, and through these pages, we witness animals that are wholly dependent on the habitat created by the towering trees even though they will never have the experience of being in the top of one. Other animals use the trunks as highways, and their movements may reach from the ground to the treetops. Given the size and upright posture of humans, the sight of tree trunks is the most common way we experience the forest, too.

We must also consider the invisible fourth dimension of time in order to truly understand a forest. Three chapters capture how a forest changes throughout the year: from fall's spectacle to winter's silence, from spring's emergence to summer's ripeness.

Next, and perhaps most important, we take a peek at the forest parts that are intimately intertwined with the soil. This is the (mostly) underground life of the forest—roots and fungi.

While we're down there, we take a close look at the primitive plants. They will never make buds or flowers or fruit, but they are the green ones we always associate with the forest: moss and fern, playground of the faeries.

And finally, no discussion of the forest is complete without acknowledging how the forest makes us *feel*. Few words do justice to those feelings, so Llewellyn's images stand alone at the end to convey a most precious resource provided by forests.

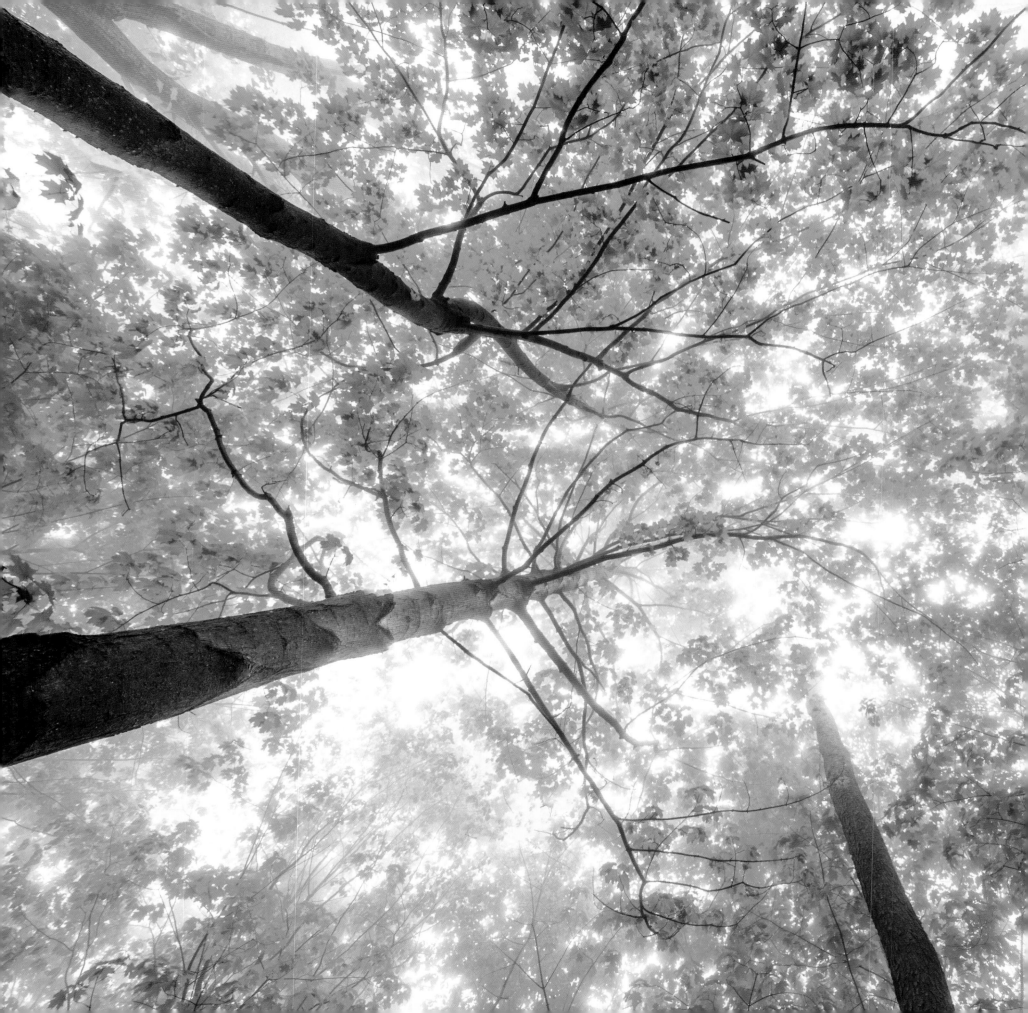

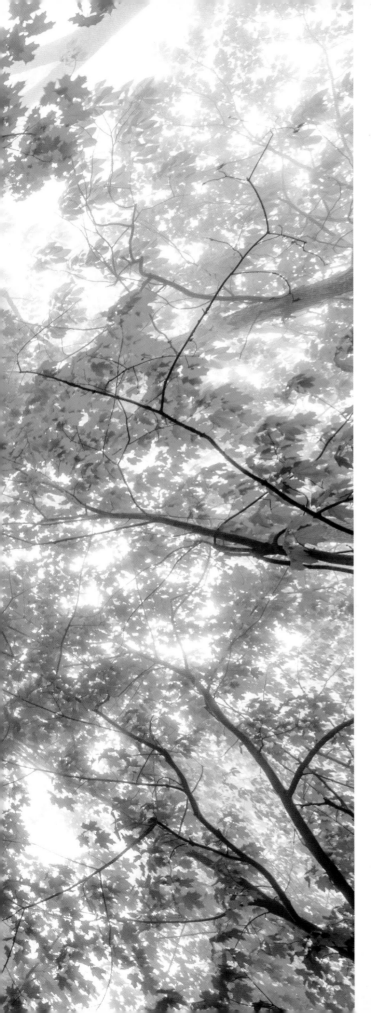

Toward the Sky

The Canopy and Bird Life

WE ARE GOING TO step into the forest now. We are leaving behind the cars and the computers, and maybe even the people. We are going to take this journey to see, to feel, an ecosystem that has been around for a very long time—one that doesn't depend on humans, although we depend on it. This is a real place, and it may not be far from your home. It's a place where both the learning and the mysteries go on forever.

Let's start by looking up into the canopy. To really feel a forest canopy we must use different senses, and often the most useful one is the sense of imagination. You might spread a cloth and lie on your back. Be patient. Just wait. Soon you'll notice the swaying of the tops of the trees. Note that they don't all sway with the same motion. Give it more time. Just watch. Do the taller trees sway more than the shorter ones? But they're not all moving together, right? The movement seems more like a circling, like an eddy. First this part of the forest, and then see how the wave moves through and ends up over there? This forest is very different from the one we walk through that seems solid and still.

Listen to the hushing music the trees make as they move, a most relaxing sound. As the apostle John said in the Bible, "The wind blows where it pleases, and you hear its sound, but you don't know where it comes from or where it is going. So it is with everyone born of the Spirit" (John 3:8). And your spirit moves, too, as you lie there bathed in the susurrations of the green heights.

The Zen monk Shunryu Suzuki put it this way: "When we hear the sound of the pine trees on a windy day, perhaps the wind is just blowing, and the pine tree is just standing in the wind. That is all that they are doing. But the people who listen to the wind in the tree will write a poem, or will feel something unusual. That is, I think, the way everything is."

If you wander across a prairie, most of the life exists between foot and head height, so it's all very accessible, very visible. Wandering through a forest, by contrast, presents you with a scene that seems at times very quiet and empty of creatures. Life is abundant there, but much of it exists in the canopy—that high green layer between earth and sky. Binoculars or climbing ropes, or both, can give us a sense of what's happening up there, but we're still only visitors. Although in our earliest years we may feel an instinct to climb, we're primarily creatures of the ground now.

The easiest lives to imagine, because chances are we'll hear some of their songs along with the tree songs, are the birds. There goes one now. What kind? Too fast to tell, too dark, too hidden. Only those with ears trained for such things can put a name to it.

When you walk through a forest talking or singing, the birds can hear you, too, and may sing back. And they see you, probably before you see them. If it's a forest you walk in often, they may even know you as *you*.

Winging in from the river now comes a huge bird even children know. It's the great blue heron, and its raspy croaking can't really be called a song. We're used to seeing these birds near the water's edge, but now this one is flying toward the treetops where it raises its young on an aerial raft of loosely woven branches. And now our imaginations get turned upside down as we consider the canopy from above instead of from below. From above, the impression is of texture—the highs and lows of various tree species, some rising far above the others. The birds know this landscape as intimately as we know the streets we drive every day. They would miss that tree if it were gone.

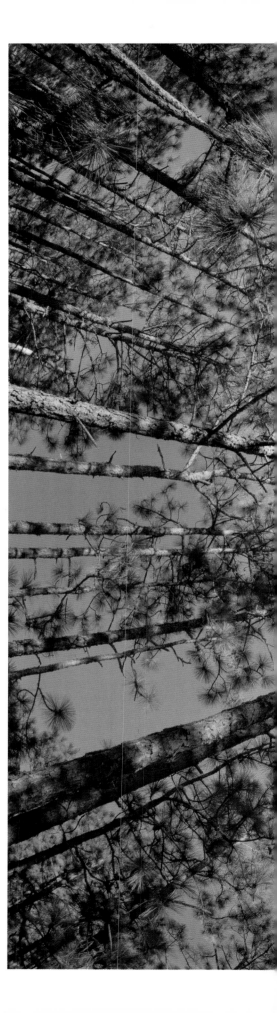

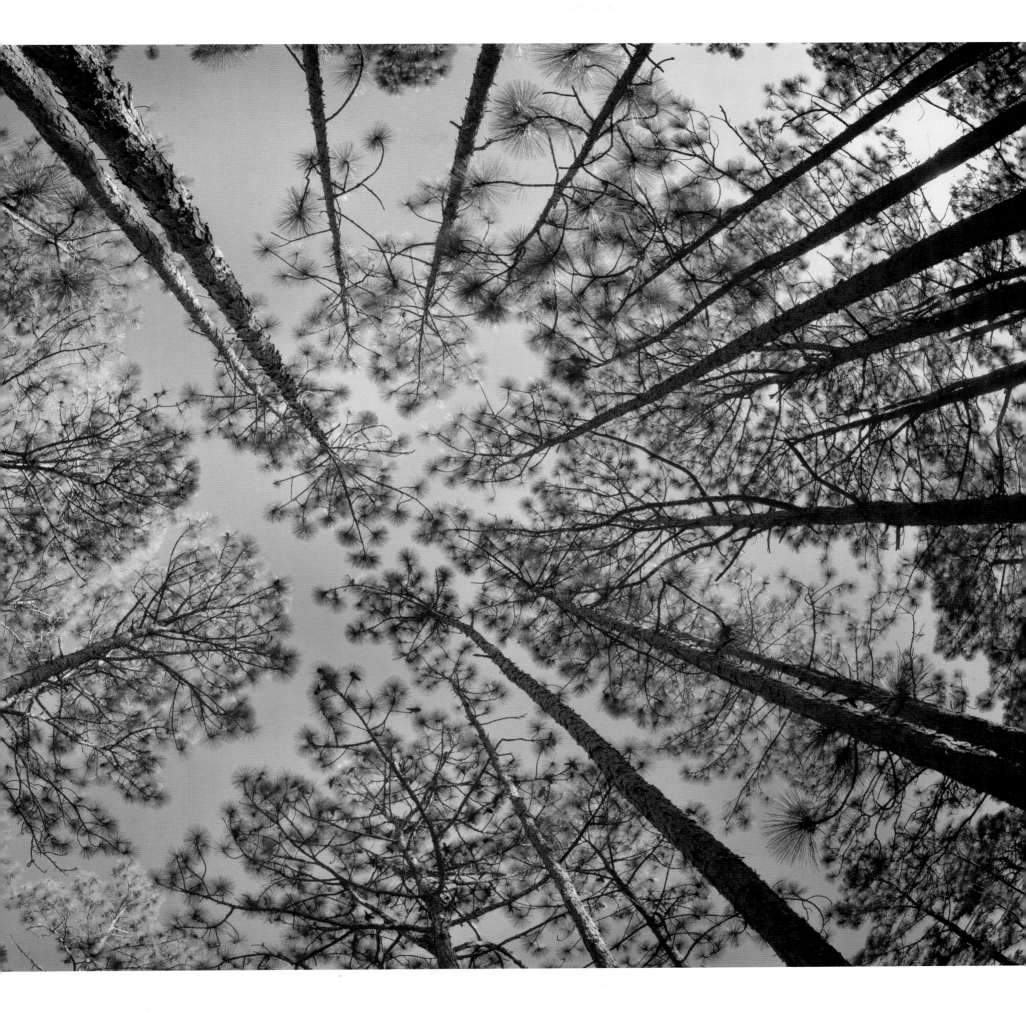

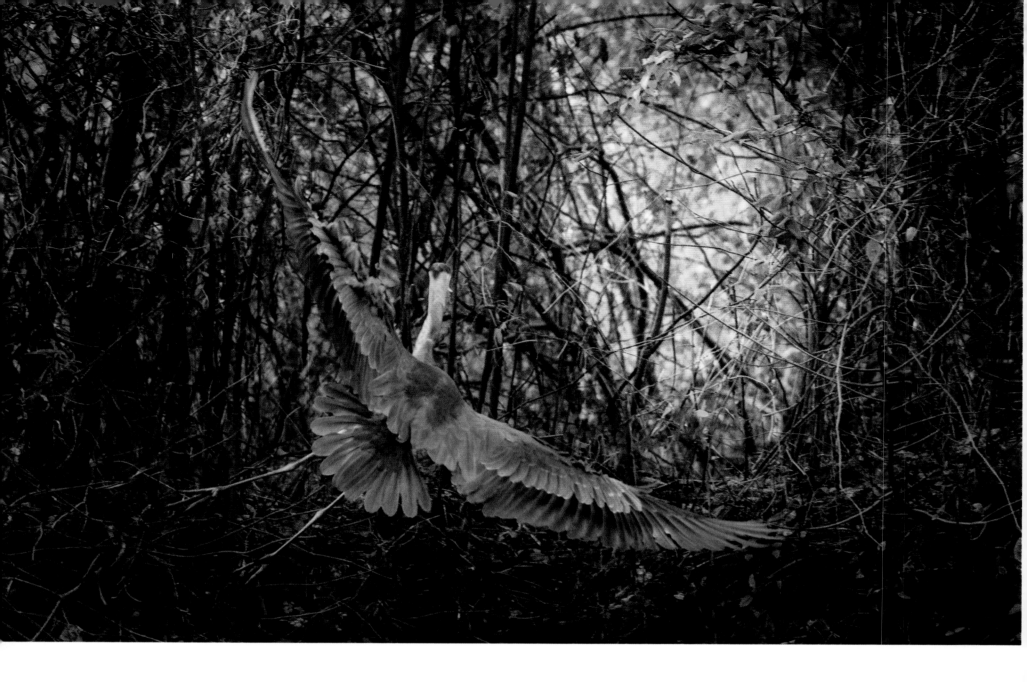

We know, although we can't always see them, that a variety of birds are winging their way from one tree to the next up there. Many of these birds are migrants that have left their tropical winter homes for the abundance of the northern forest during our all-too-brief warm season. They return to the same trees year after year, sometimes for fifteen years or more. Here they rest from their journeys, mate, build a nest, and feed their young ones before returning to their other homes. Other birds are here year-round, and although we see them frequently around our houses, they also need the forest. If we could crawl through the treetops, we would find evidence of these visitors that have the gift of flight.

The great blue heron has a six-foot wingspan yet weighs less than six pounds. Its hollow bones make it light and allow for easy liftoff.

From a bird's-eye view, the forest canopy appears textured with the varying heights of distinct individual trees. (top) ▶

Although we think of herons as wetland birds, they nest in the forest canopy. The male brings twigs to the waiting female, who then weaves them into a secure treetop platform. (bottom) ▶

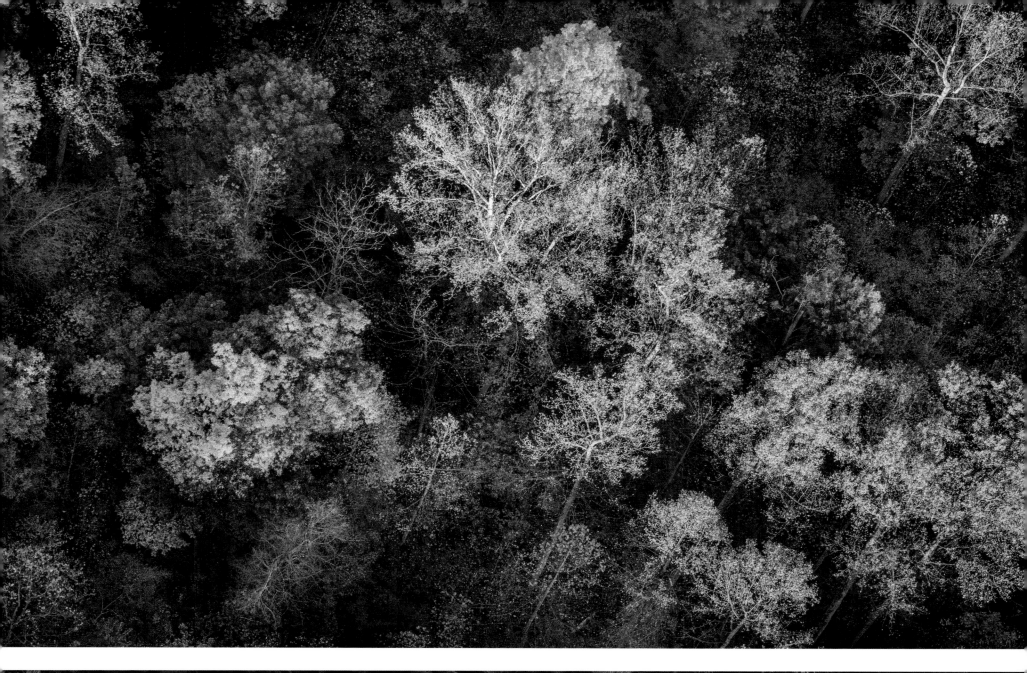
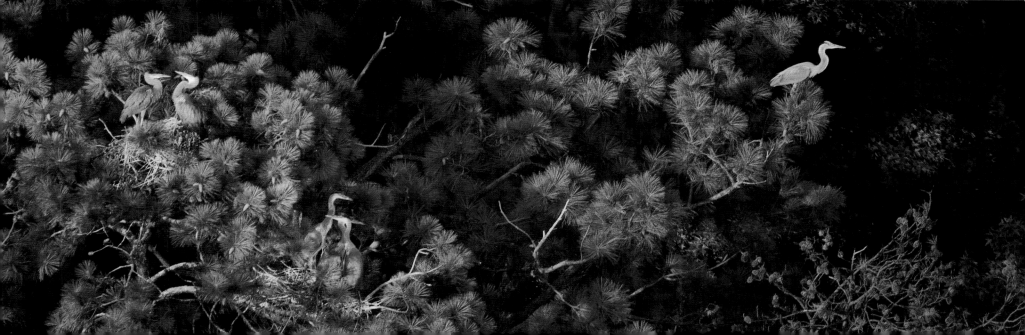

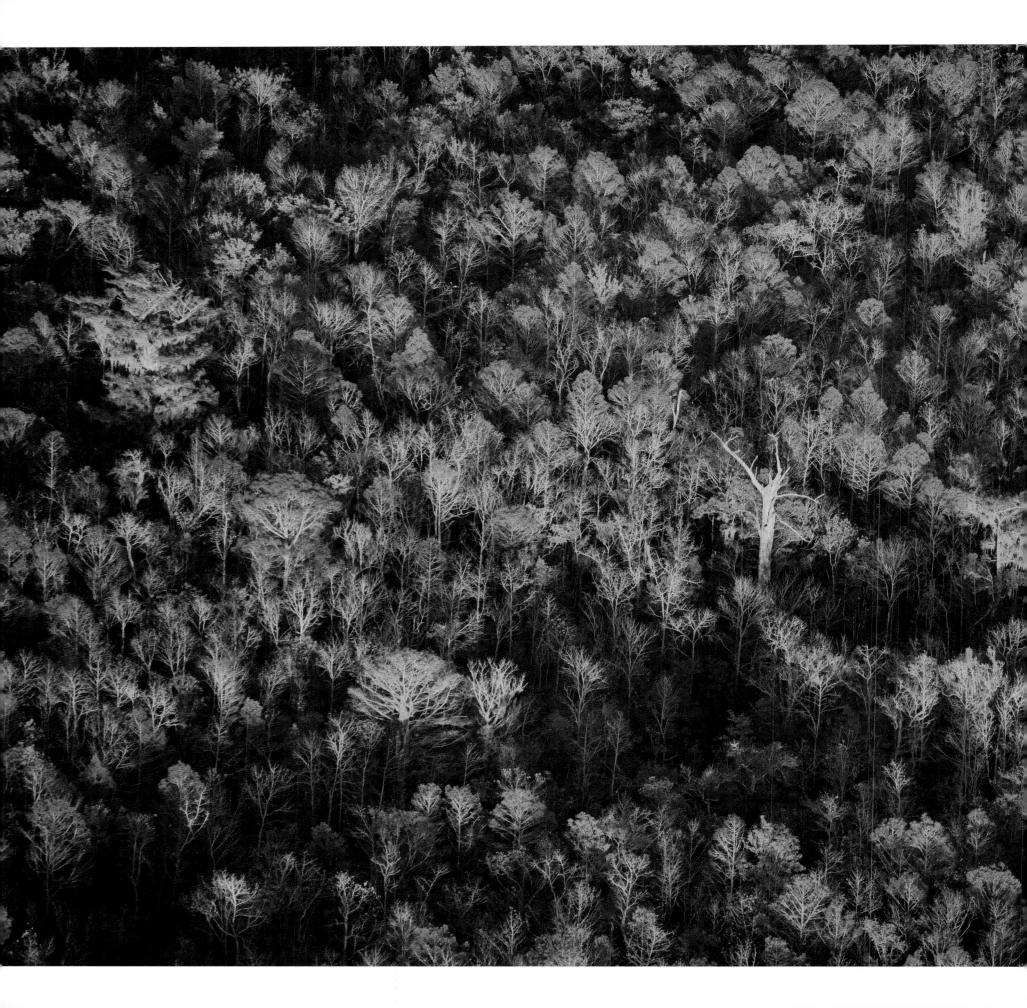

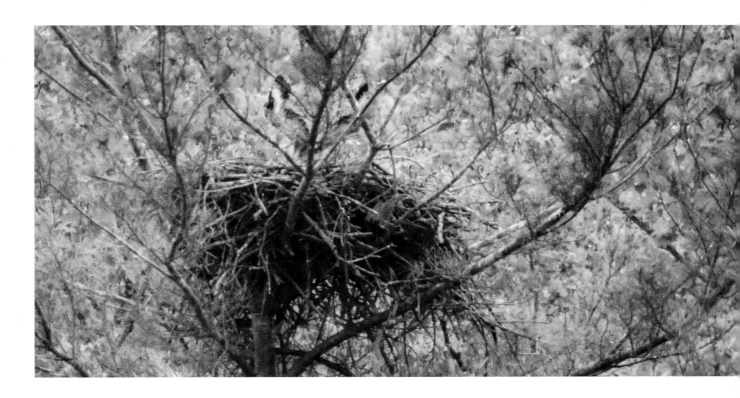

Raptors, like eagles, hawks, and osprey, often pick the tallest tree in an area for their nest. They may add to the same nest year after year.

How do birds know which materials to collect and exactly how to construct a nest? They're born knowing—just another of nature's mysteries. ▼

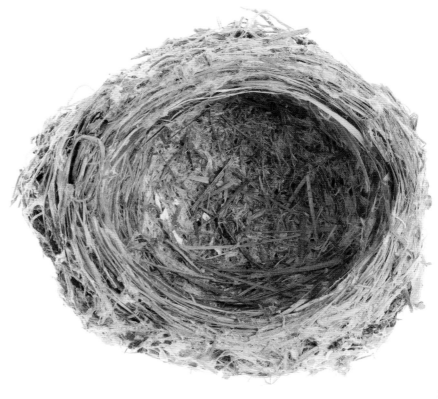

Most migrating birds return to the same area, and often the same tree, year after year. The birds that return to Sandy Island, South Carolina, pictured here, are fortunate that their forest has been preserved. ◄

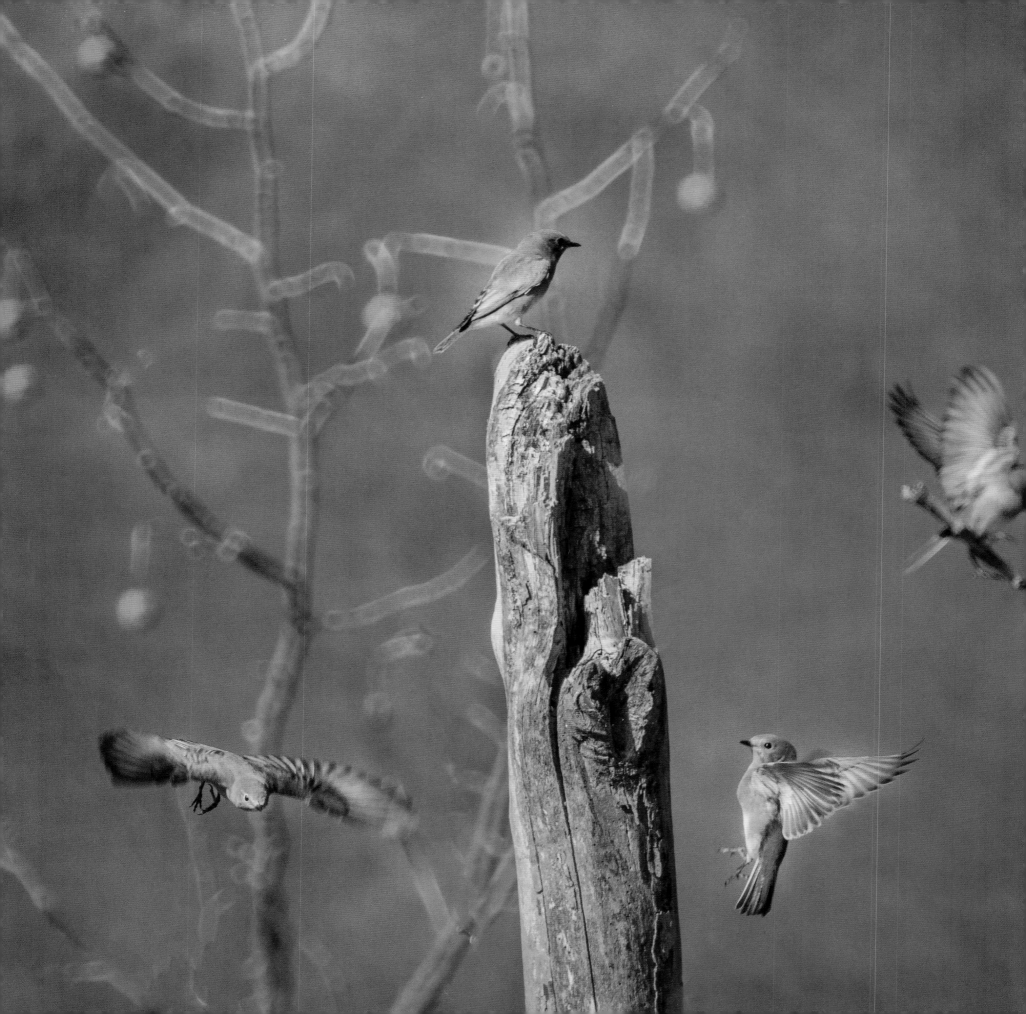

But not every bird builds a nest; some chisel a cavity, or take advantage of a hollow space in a dead or dying tree, or use the space made by a previous chiseler. Bluebirds, who we are used to seeing nest in cylinders or boxes we provide, once commonly found old woodpecker nests or small cavities to call home. That was before vast deforestation, competition from nonnative house sparrows and starlings, and DDT changed life for bluebirds to the point where they rely on our help. Bluebirds are rebounding thanks to this nesting assistance, but unfortunately that is not so for red-headed woodpeckers. Once very common, these woodpeckers are declining in number due to many of the same adversities that have affected bluebirds.

When we see birds way up in the canopy, frequently they are picking insects off the trees. In addition to providing great food for their baby birds, it's a big help to the trees. How else could a tree rid itself of the things trying to eat it? Well, actually, a number of creatures in the canopy, including other insects, help the tree rid itself of the small eaters and suckers. For every plant-eating insect out there, there's another insect looking to eat it.

Eastern bluebirds are very social, except during the breeding season. Individuals may live for more than ten years.

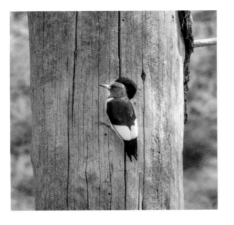 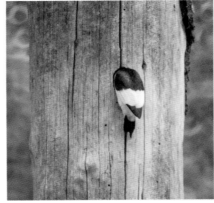

Male and female red-headed woodpeckers look identical, and both of them feed the nestlings. Sometimes a third bird will join in defending the nest and feeding the young.

Northern cardinals have a crest of feathers on their head that they can raise or lower depending on mood: calm and quiet, down; agitated and aggressive, up. ◂

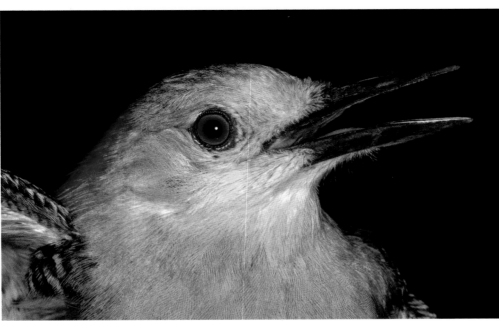

The northern flicker is among the few woodpeckers commonly seen on the forest floor; they're down there eating their favorite food—ants. ◂

Crows are extremely intelligent. They have a language all their own, and they can recognize individual humans. ▸

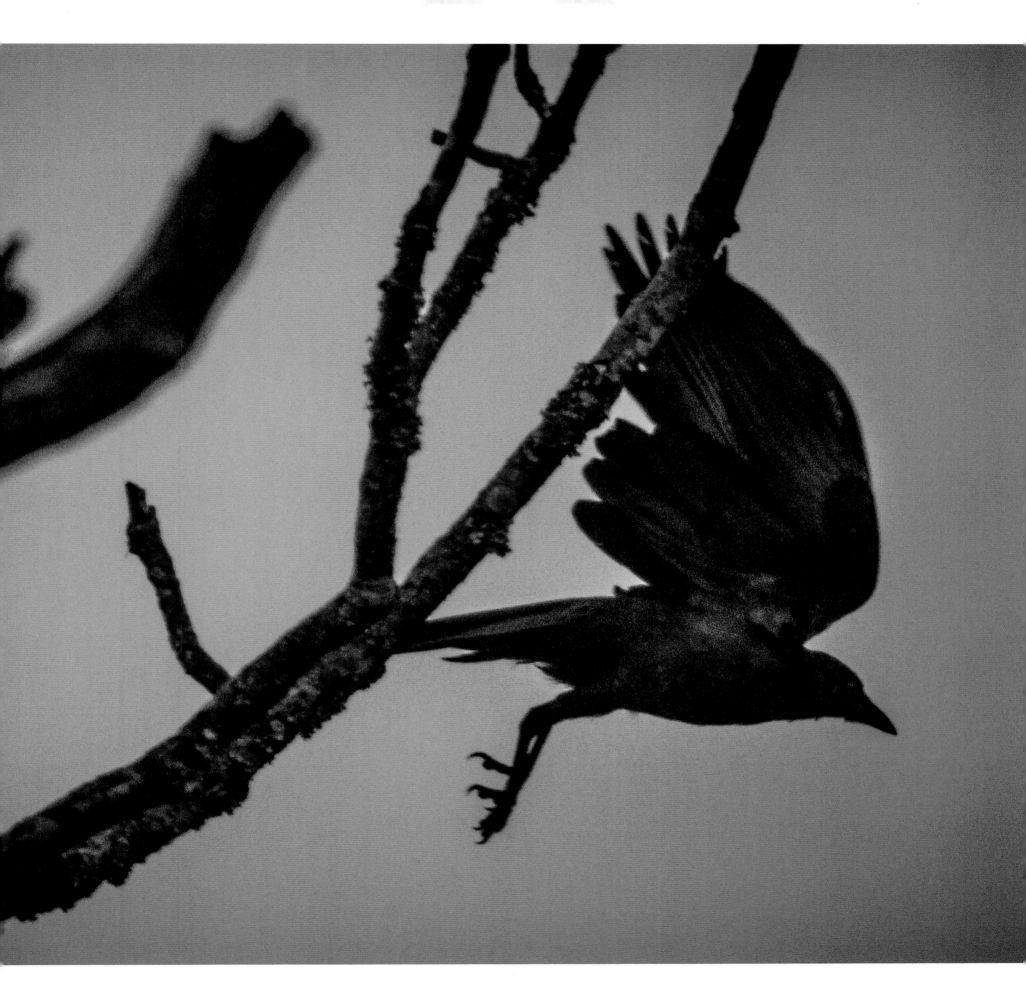

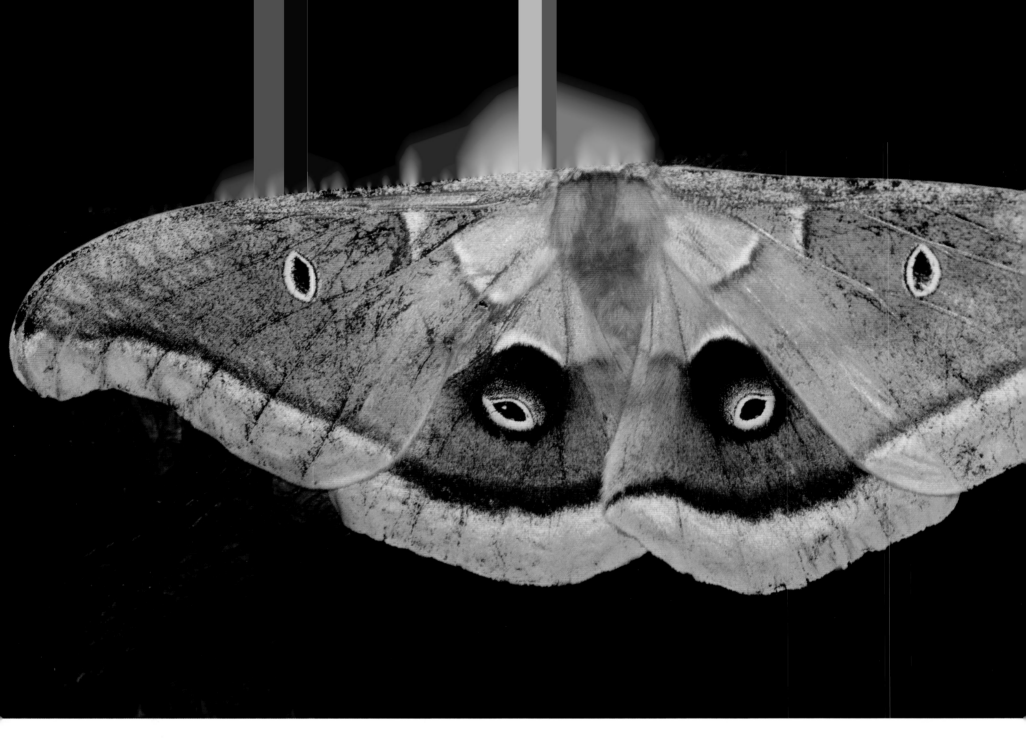

The polyphemus moth has large spots that mimic eyes, one way to deter predators. This male will search for unmated female moths by "smelling" them with his large, bushy antennae.

A large praying mantis will eat a small spider, and a large spider will eat a small praying mantis. Round and round they go, far above the ground. (top) ▶

The spider's eight legs are all put to use in extracting the silk from the spinnerets on its abdomen and creating a web. (bottom) ▶

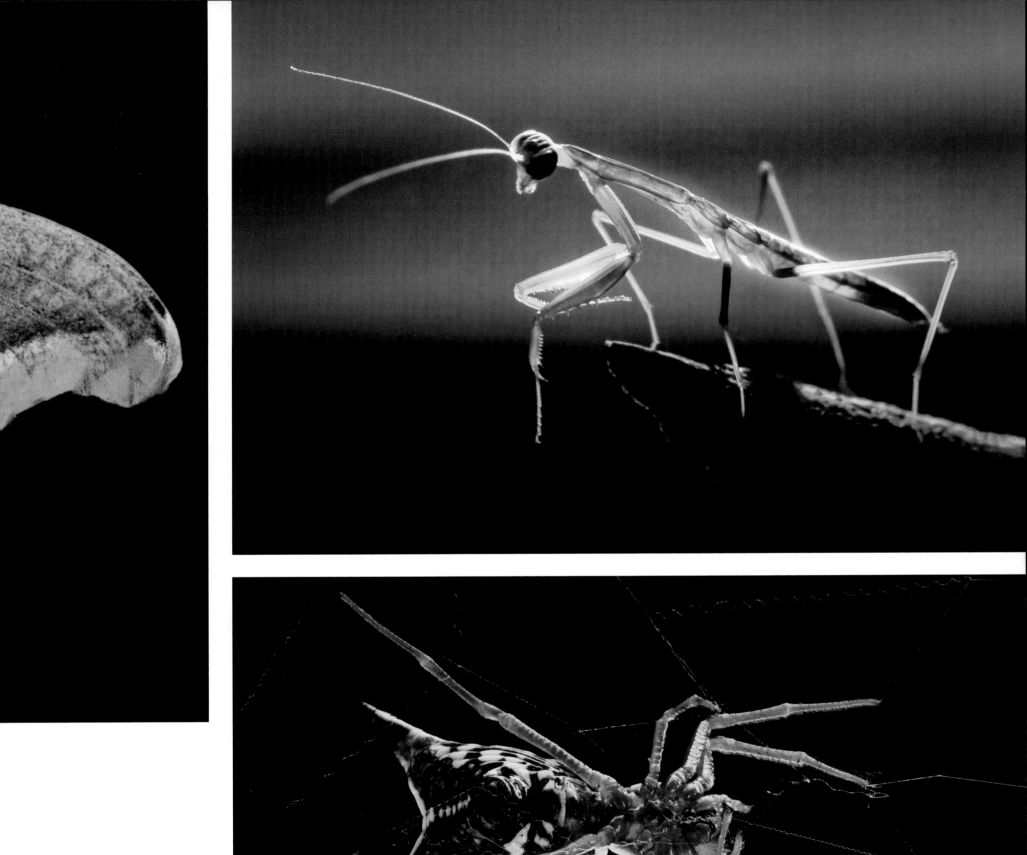

Another friend of trees is the bat. Bats are the only mammals that fly, and they fly fast enough to catch night-flying insects, including moths that are trying to lay eggs on the trees' leaves. These insects fly at night to escape predation by birds, but that just makes them vulnerable to bats.

Although bats can see, their eyes don't do them much good on a pitch-black night. So the bat has evolved another way to find insects—it makes a high-pitched sound that strikes the insect and echoes back. The bat's large ears catch the returning sounds and its brain interprets the echoes so the bat knows where the insect is and how fast it's flying.

But moths are not helpless in this sport of "catch-the-thing-in-the-dark." Although humans can't hear the high-pitched echolocation calls of bats, moths can. When they hear that sound, they can quickly drop or change direction to evade the bat. Some moths even produce their own sounds to try to jam the bat's sonar.

Sometimes bats eat insects on the fly, but more often they catch them in their wings and take them back to the roost for eating. Very often that roost will be in a tree, perhaps in a hollow space or under shaggy bark, so the bat provides a service to the tree and the tree provides a home for the bat.

Besides relying on birds to eat bugs, and other insects to eat bugs, and bats to eat other insects, trees also produce chemicals to deter the things that want to eat them. When a caterpillar or a slug crawls across a leaf, the tree knows it is being touched by an insect, and it reacts by making chemicals that either taste bad to the insect or interfere with the insect's growth and reproduction. Even if there are no insects on our tree but a tree nearby is being eaten, our tree can sense the compounds its neighbor is producing and start producing deterrent compounds of its own. To bring the story full circle, birds have been shown to increase their hunting activity on trees that are giving off caterpillar-deterring chemicals. It's as if the tree has emitted a silent cry for help and the birds respond. We have much more to learn about all of this.

A plant leaf knows what's eating it because it can sense the chemical compounds on the feet of the insect. This forest tent caterpillar may not be welcomed by the tree, but it's an important food item for some birds.

Humans are much more closely related to bats than we are to birds. The bones in a bat's wings are analogous to human finger bones, and bats have sensitive cells on their wing membranes like the sensitive fingertip cells in humans. ▶

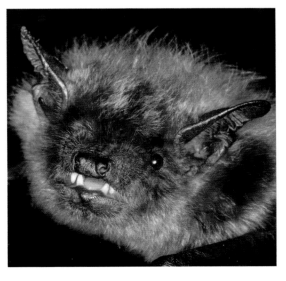
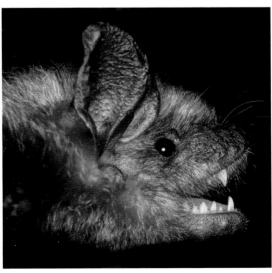

Another layer of avian life in the forest is the birds that don't feed on insects, seeds, or berries, but instead on dead animals—the vultures. These birds clean the forest, lifting the debris away on lovely wings that circle overhead in lazy spirals. Turkey vultures find carrion using their extremely sensitive sense of smell. Just a few molecules of the chemical given off by the bacteria found on rotting meat will cause a vulture to circle and circle until it locates the source of the odor.

Vultures have no feathers on their heads because feathers would just hold the smell and the bacteria from the rotten meat they feed upon. But a vulture's bald head does let us see another sense organ of birds: ears. The vulture's ear looks like a dent in its head. Other birds have ears, too, but we don't notice them because they're covered with feathers.

Owls may look like they have external ears, but those earlike tufts are just display feathers. The real ears are hidden under feathers on the side of the head. External ears would create resistance during flight and the sound they would make cutting through the air (at the very high speeds an owl sometimes flies) would drown out other sounds they need to hear, like the scurrying of rodents through leaves. Owls depend on their ears and large eyes for hunting small animals at night. Owls will sit for hours, listening and watching, while grasping a branch with their fleshy feet. When prey is detected, owls swoop silently down, feet first, and grasp in their talons the meal they will bring back to the nestlings.

Birds of prey that hunt by day, such as hawks and eagles, rely more on sight than on smell or hearing. Their vision is much better than that of humans; they can see twice as clearly and much farther. A third eyelid protects their eyes from curious chicks or from the dust and drying effects of flying more than a hundred miles per hour. This eyelid is somewhat translucent, so they can still see when it's closed.

Raptors depend on trees for a perch high above the forest floor where they can survey the happenings and spot their next meal—which might be a red-headed woodpecker. They also build nests high in the canopy for raising the next generation of their kind. The young birds will travel far in their lifetimes—seeing forests you will never get to see—but if they can, they'll return each year to the forest where they hatched from that delicate egg far up in the canopy.

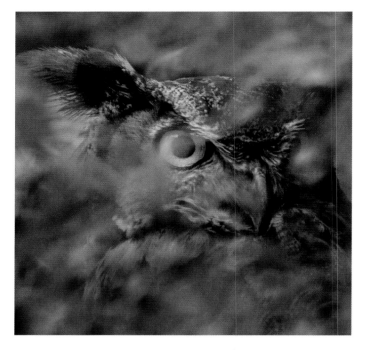

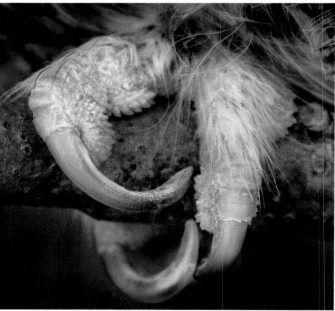

Large eyes help this great horned owl see at night. The earlike tufts are not ears at all but just for display. The presence of scales on an owl's foot shows that it is closely related to reptiles.

Turkey vultures circle until they find the carrion they've been smelling, then carry the debris away on lovely wings ▶

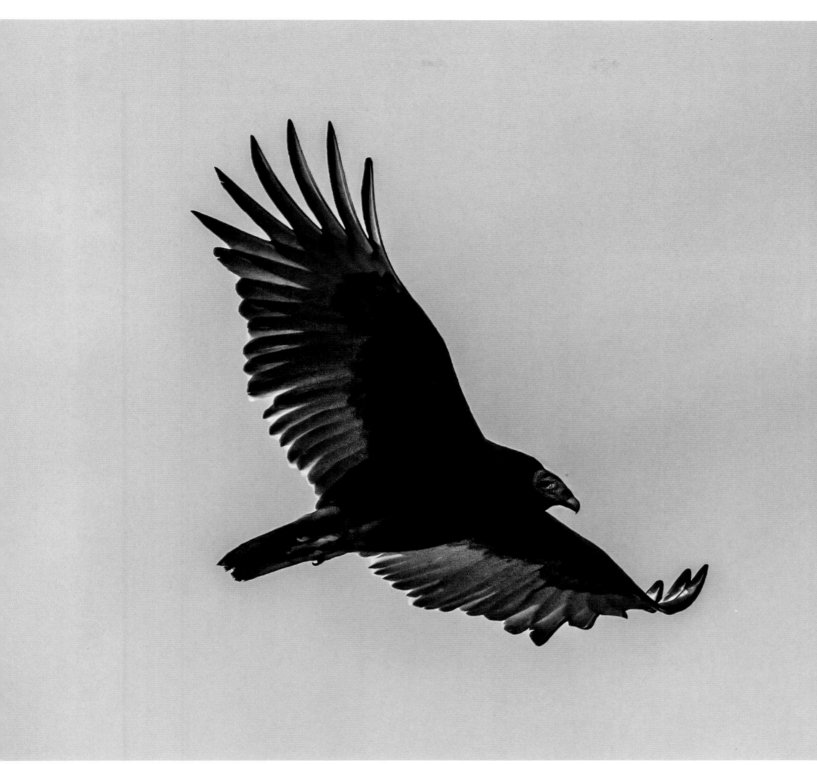

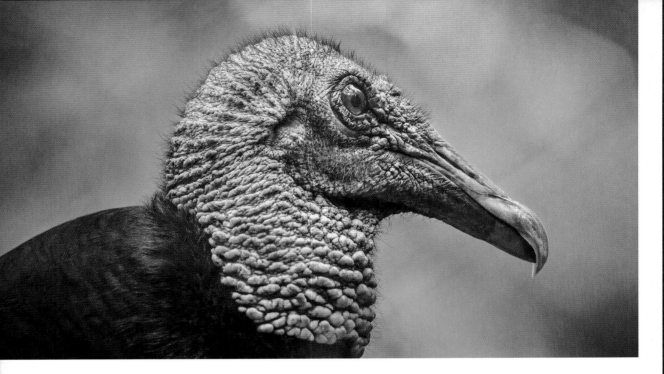

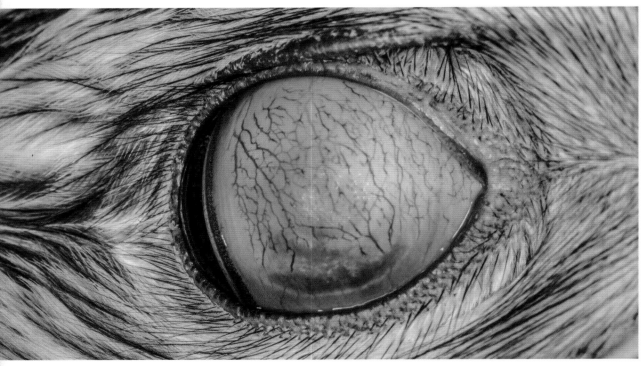

(TOP) Black vultures don't have the keen sense of smell that turkey vultures do. They watch where the turkey vultures go and follow them. Because they have no head feathers, we can easily see the ear.

(BOTTOM) Birds of prey have an extra eyelid they can see through; it protects their eyes from damage or drying during high-speed flights.

Eagles can see clearly for miles, a capacity difficult for us to imagine. ▶

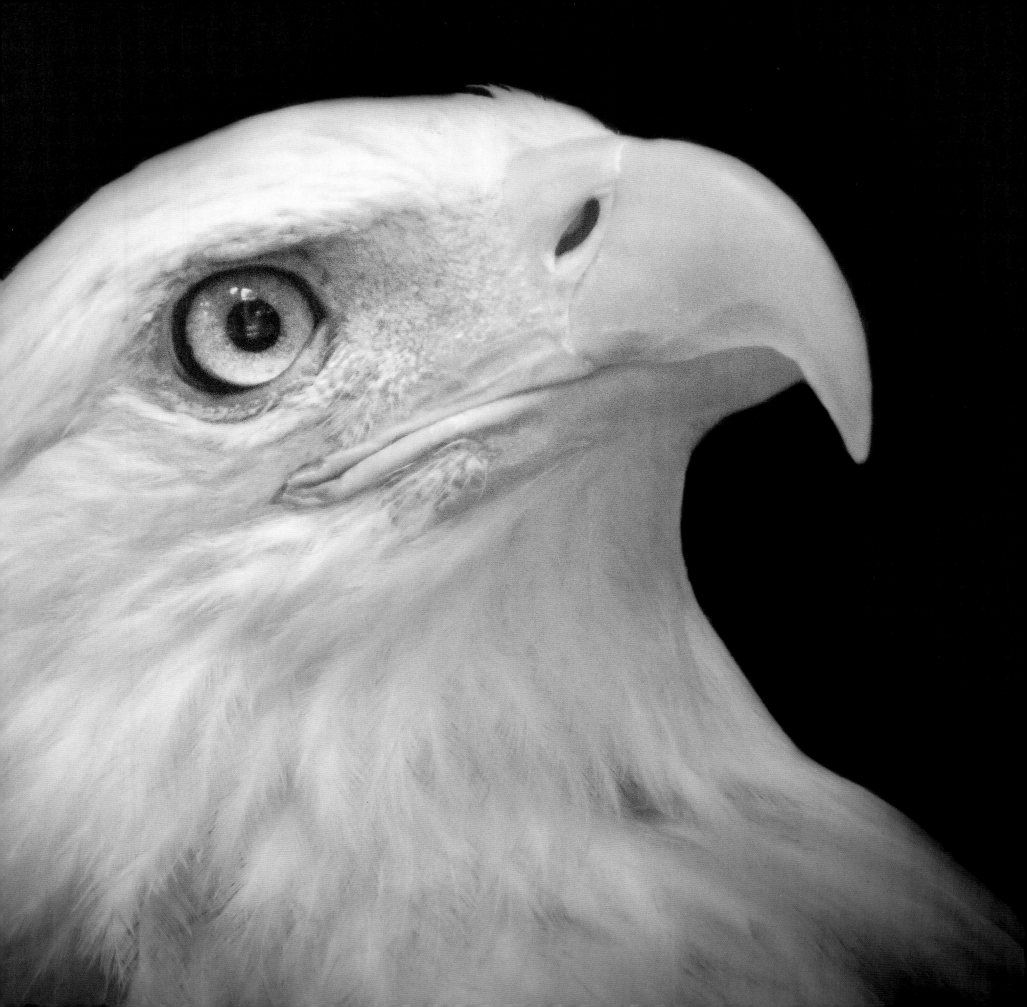

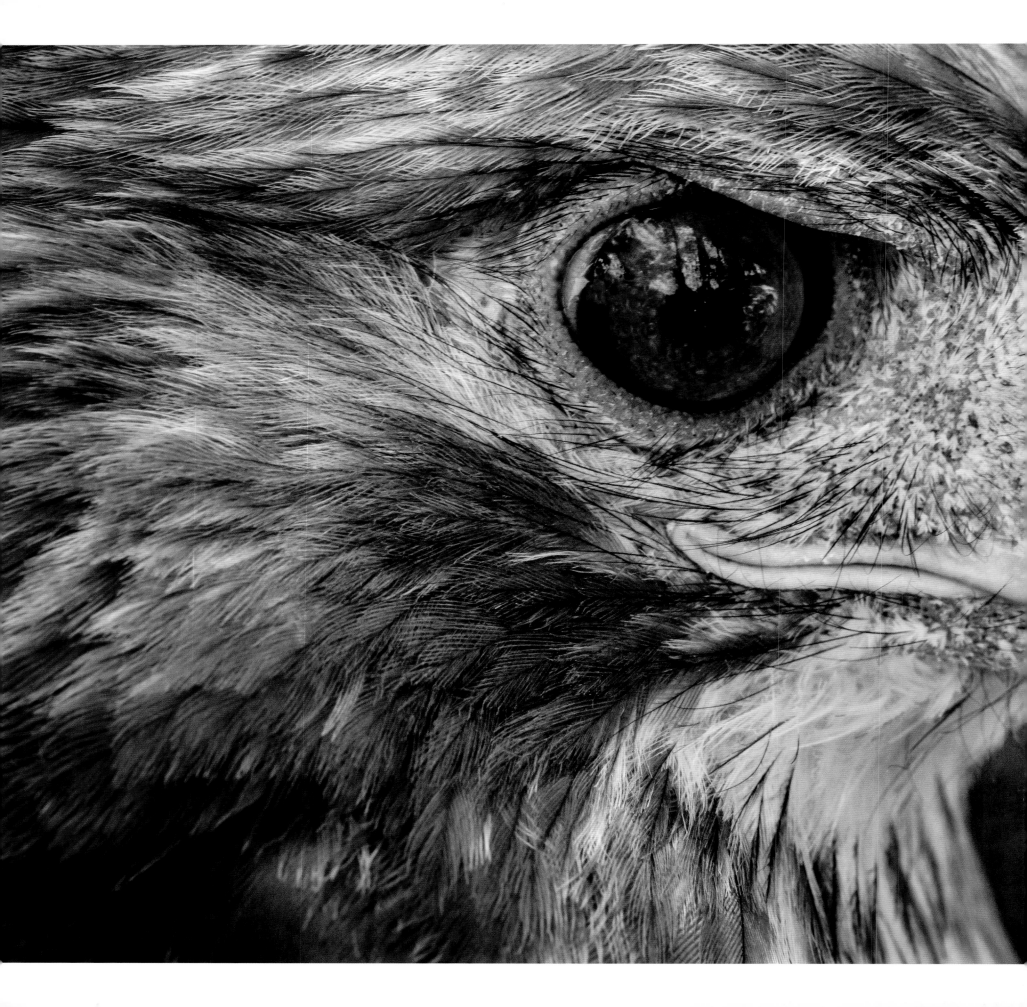

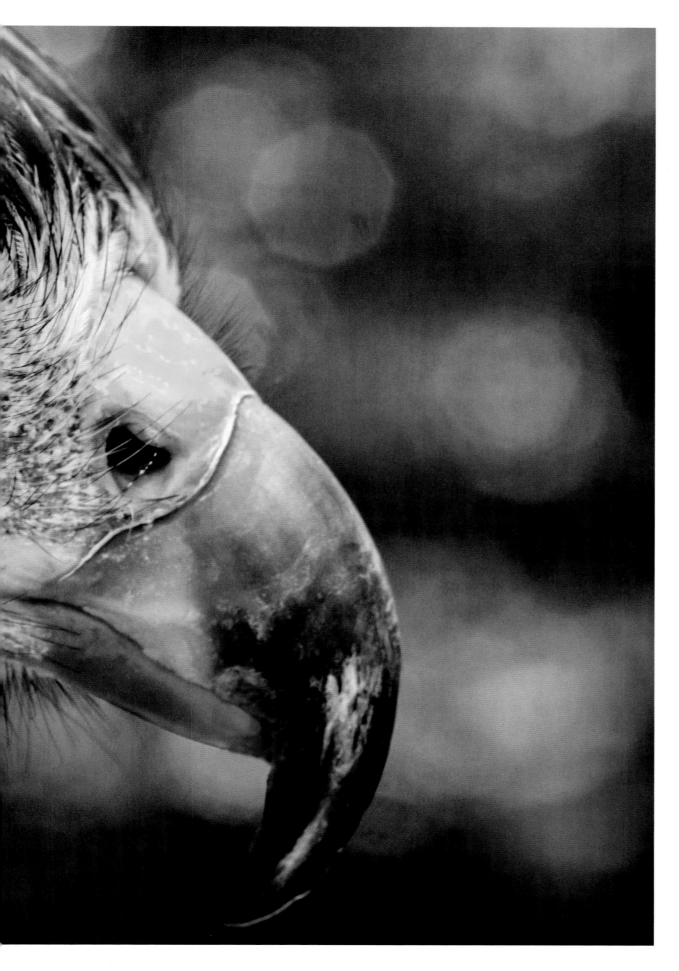

The red-tailed hawk is a creature of the forest. The yellow area on the beak over the nostrils can vary in color, serving to advertise the physical condition and social status of the bird.

Eyes All Over

Leaves

TREES DON'T HAVE TWO eyes like we do, yet they can see. They know how much light is hitting their leaves, and they know the quality of that light, too. They know if it's summer or winter by the length of the day, and they know if it's noon or afternoon by the wavelength of the light. (The noon light is stronger and more direct, while the afternoon light is softened by the additional distance of atmosphere it must travel through when the sun is at a lower angle.) It's as though the whole plant is covered with millions of tiny eyes—with each photosynthetic cell in each leaf acting as a miniature light receptor.

Both animals and plants sense light when specific molecules are triggered by specific light wavelengths. Humans have some of the same receptor molecules that plants have. Red wavelengths? It must be morning or afternoon. Blue wavelengths? It must be midday. Plants respond to these wavelengths and to day lengths, too, by producing various hormones. Days are getting shorter? It's fall, time to drop the leaves. Midday in summer? Ripen the fruit.

Plants have evolved this incredible sensitivity to light because light is everything to them. Without it they die. Light is a key ingredient in every morsel of their food (sugar made from sunlight, water, and carbon dioxide). We are used to the idea that plants need sunlight, but when we think about that concept more deeply we find that it has many implications. For instance, if the leaves in the top of a tree's canopy intercepted all the light, no branches or leaves would be needed lower down and our trees would look like green umbrellas. Instead trees have evolved an architecture that allows them to share the light throughout.

And not only does the light sharing go on along a branch, but the branches themselves are arranged so they won't completely block the light for the branches below. Along a trunk the branches alternate or grow opposite each other, or perhaps even spiral around, but they're never stacked one immediately above the other like a ladder.

Eventually, as a tree grows taller—indeed, as the entire forest gets taller— very little light reaches the leaves on the bottom branches. The tree then gets only a small energetic return from the resources it put into making those leaves. Finally it makes no sense to even have a branch there at all, so the tree stops sending resources to the branch. This process may happen very slowly, but finally the branch dies as a result of the low light, and perhaps in the next windstorm that branch will fall. Many decades of this lead to a tall tree with most branches on the top and very few lower down. We look at trees like these and know they are "forest-grown" trees. They have literally been shaped by light, or the lack of it.

(PREVIOUS) Is this what the world looks like to a tree? We know that trees sense light, but we don't know what it looks like to them. What would the world look like to us if our skin were covered with tiny eyes?

This forest-grown tree shows a typical branching pattern with very few branches lower on the tree. ▶

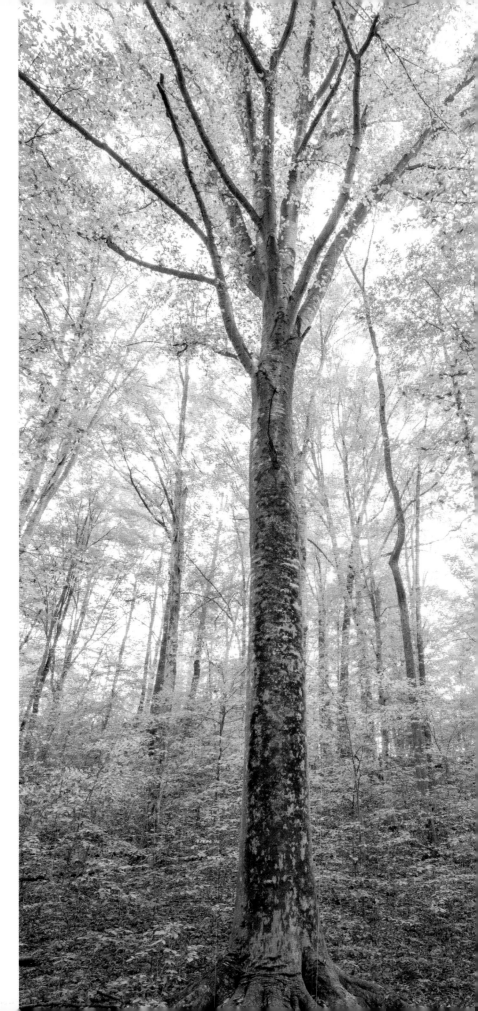

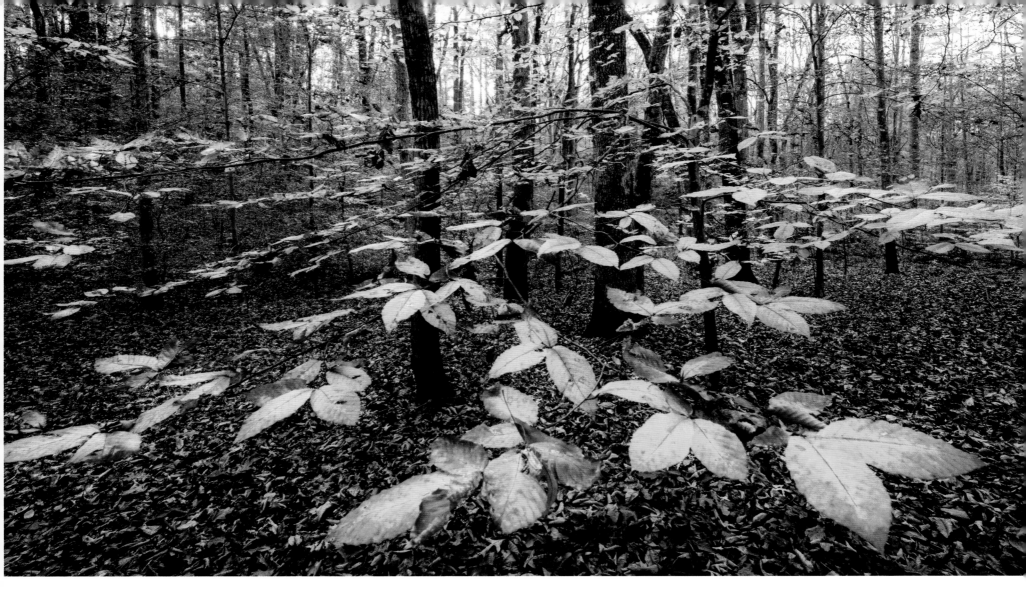

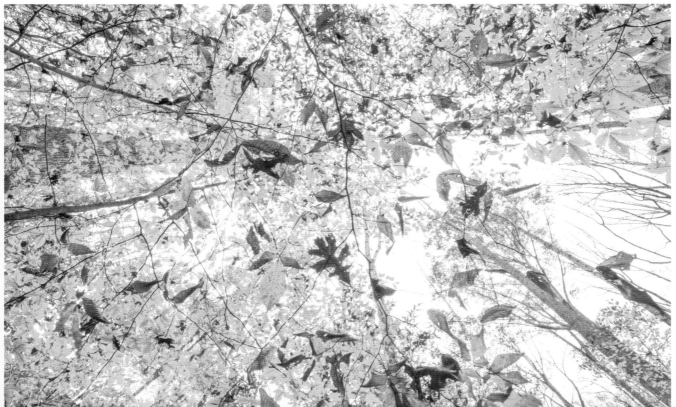

These beech tree leaves
are no longer actively
photosynthesizing—it's fall and
their green chloroplasts have
gone into the tree's recycling
bin in preparation for leaf
drop—but we can clearly see
the way the leaves share the
light space.

If you lie on your back in the
forest, you can experience the
sharing of light space from the
underside. Warning: this reverie
could fill many hours. ◄

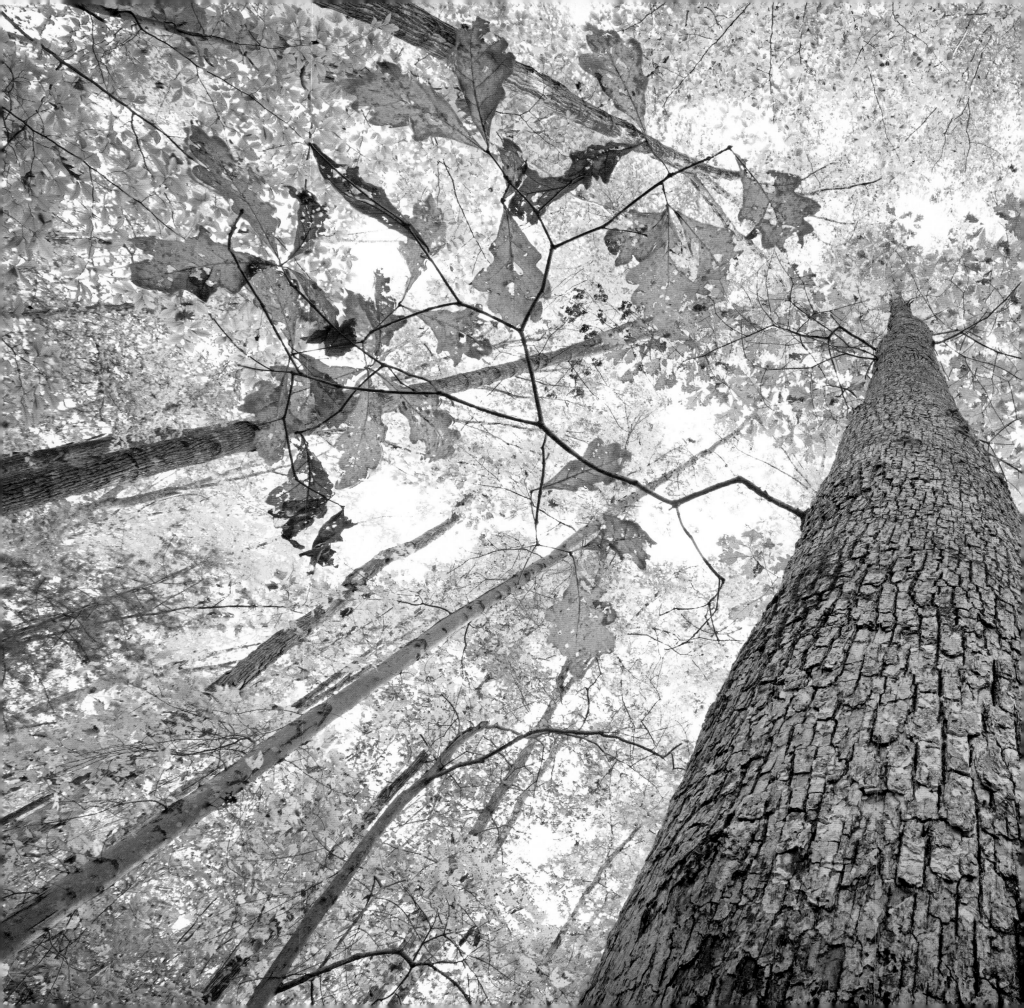

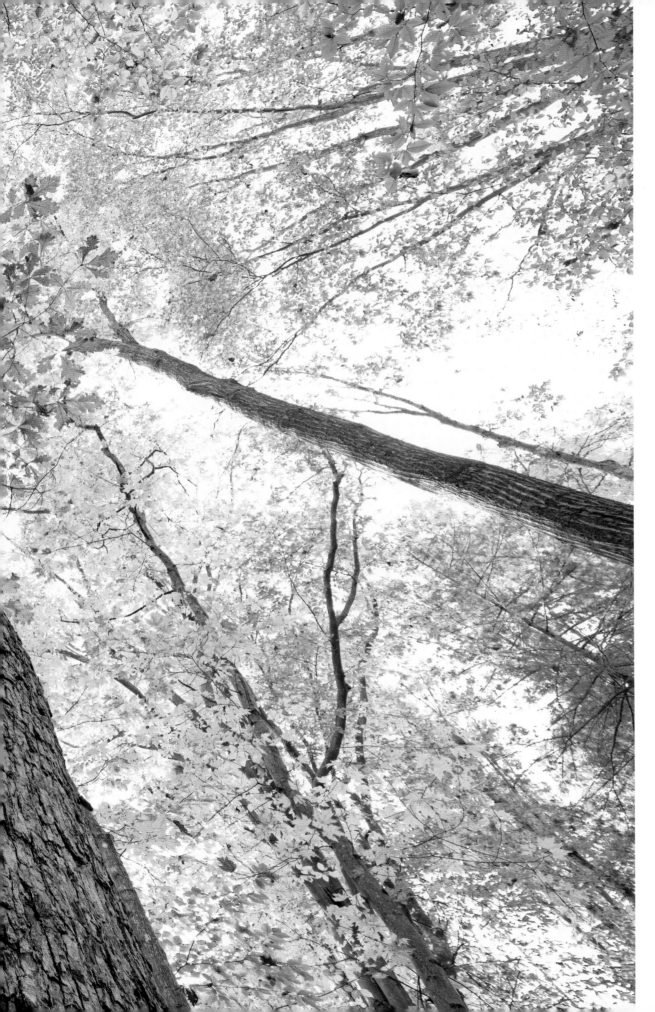

Each season fewer and
fewer leaves are produced
on the lower branches.

If a tree grows in an environment with abundant light and no shading from other trees, it may be able to keep its branches all the way to the ground. Think of a grand live oak.

This phenomenon of trees losing lower branches, or not, depending on light levels, gives us clues to the past. When we see a big tree in the middle of a forest that has large lower branches—living or dead—we can surmise that that tree once grew in the open. Most likely the tree stood in a pasture and shaded field animals, and perhaps field workers, from the harsh sun. In time, for various reasons, the pasture was left ungrazed and unmown and the gentle creep of succession resulted in a forest springing up where none had recently been. After a few decades the grand old pasture tree became a part of the forest, but its lower branches, deprived of light, began their slow decline.

Tree people call these wolf trees. Perhaps this term came from the idea that wolves gobble up all the food around them, and foresters saw these trees as gobbling up lots of space that could have been the domain of the tall, thin trees that their mills were built for. In the past it was thought that these trees, like the animals they were named after, should be eliminated. But the wolf trees were often unmanageable, and so they were left. Many of these ancient ones have been witness to Native American encampments, to the now-extinct passenger pigeon, and to the birth of the United States. Today some of these trees are our largest, oldest, and most beloved. Birds and other animals are found in much greater abundance in these wolf trees than in the ones ready for factory production lines.

Unless you understand the primal urge of trees to grow toward the light, you might be tempted to look at a forest canopy and think that two nearby trees are purposely sharing the space. But when you see as a tree does, you realize that one is avoiding the other tree's branches because the branch is dark, not light. More buds develop on the sunny side of the plant, so that's the direction in which it will grow.

This beech tree, perhaps the same age as the one on page 36, didn't grow in a forest. Although their genetics may be the same, this open-grown beech tree has a very different form from one that grew in a forest. Trees are light, embodied. ▶

(NEXT) Young trees that don't get enough light will never reach the canopy.

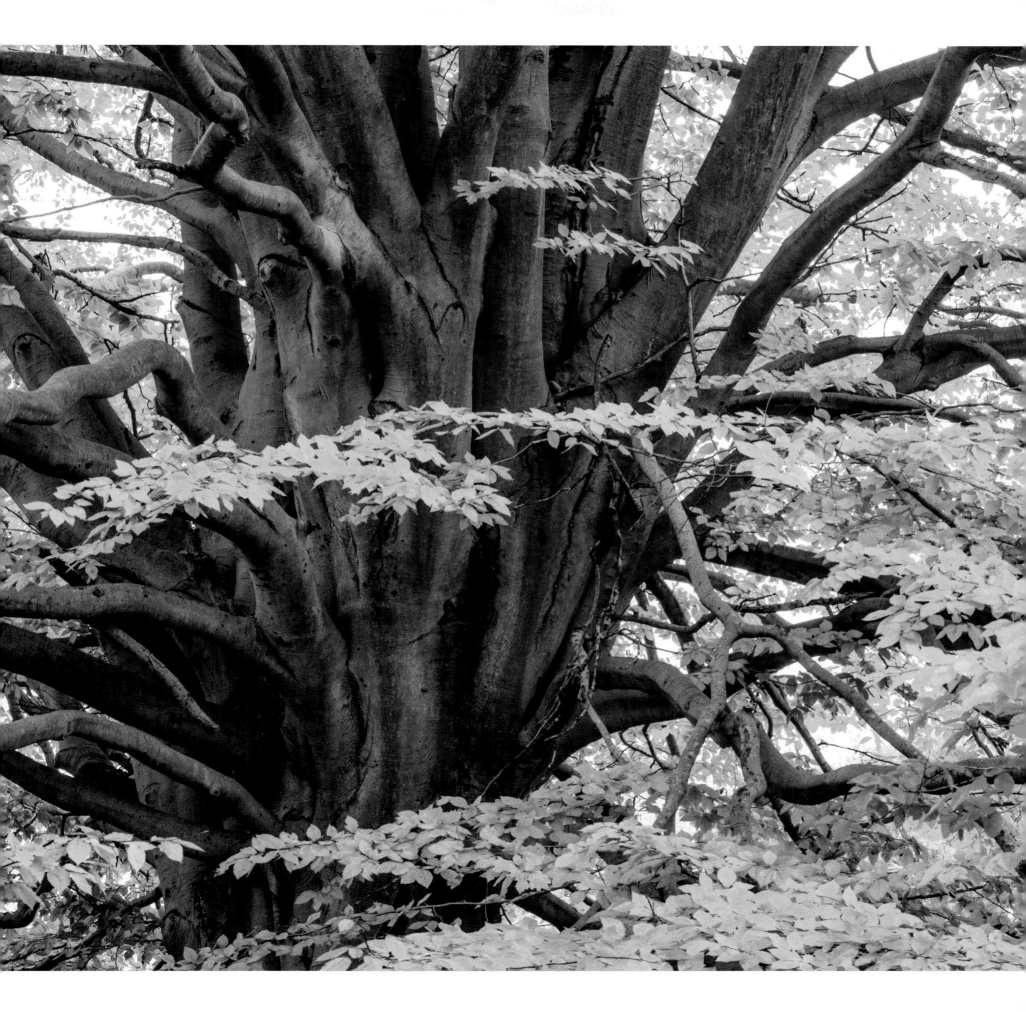

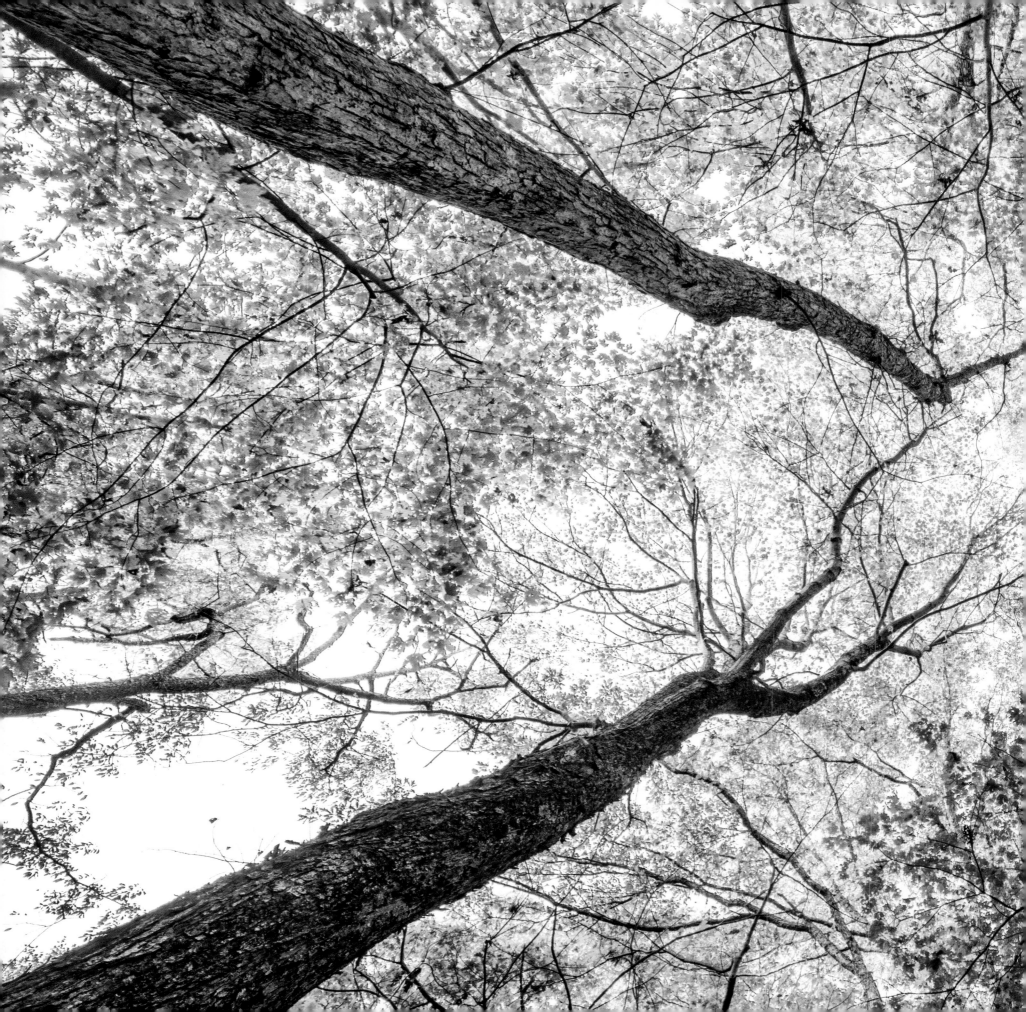

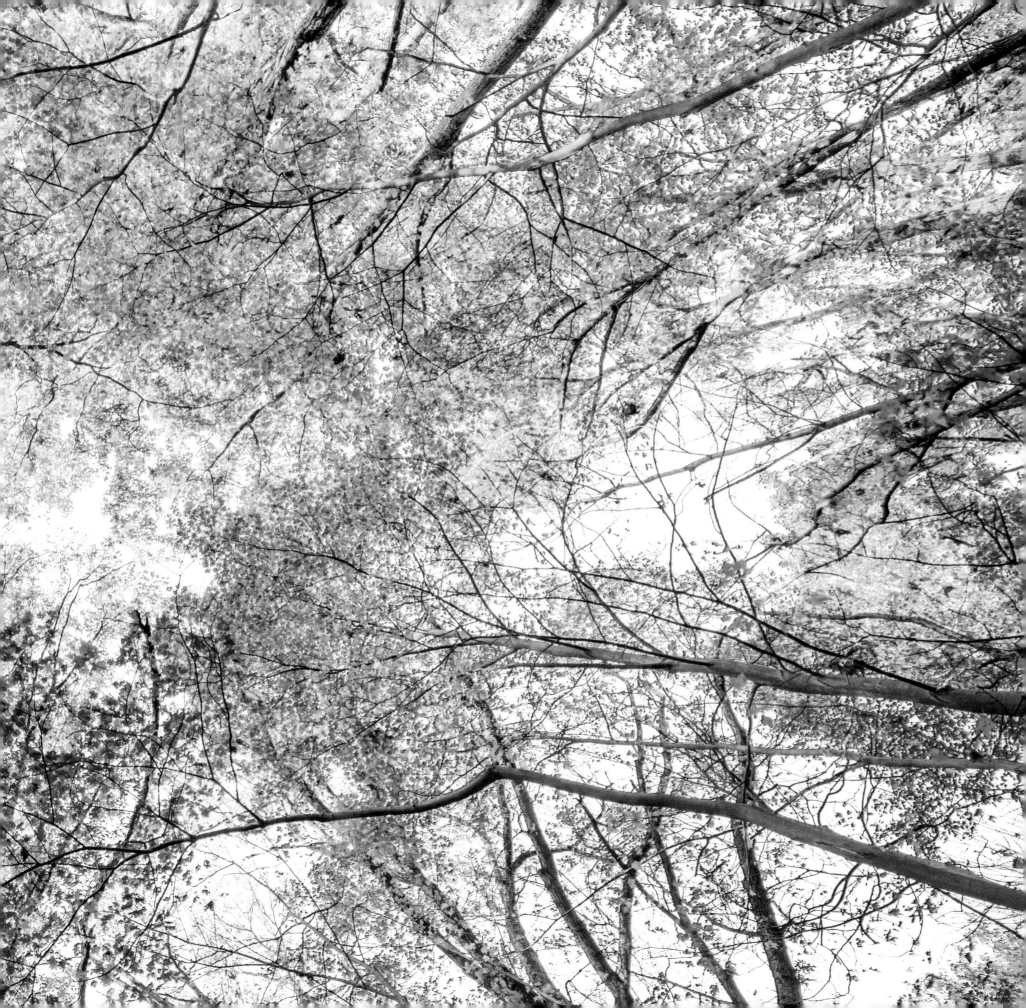

But it's not just black or white, or even shades of these colors. A tree's leaves can sense the specific wavelengths contained in the light. They do this through chemical mediators the same way we do—certain wavelengths activate certain molecules in a living cell. In humans this happens mostly in the retina, and to some extent in our skin, but in plants it happens in all the light-sensitive cells.

Shine daylight through a prism and you'll see all the colors of the rainbow as the light is split into various wavelengths: red, orange, yellow, green, blue, indigo, violet. To plants this rainbow looks different because they can "see" a color we can't: far-red. Their rainbow is: far-red, red, orange, yellow, green, blue, indigo, violet.

The most important wavelengths to a tree are those that result in the colors red and blue. Those are the wavelengths used most in photosynthesis. When sunlight shines down through a forest canopy the red and blue wavelengths are absorbed, and other wavelengths, such as far-red and green, pass through or are reflected. So a leaf knows it's in the shade of a forest when red and blue light are scarce but green and far-red light are abundant. In this way the shade created by living plants differs from the shade cast by a rock or a building. When a plant senses the light wavelengths present in a shady forest, it responds by growing differently from how it would grow in the open.

It's not only branches that wither and die due to lack of light; young trees may meet the same fate. In a leafy green forest we see many trees sharing the space and light, and even low branches still holding some leaves. But if we return decades from now, some of the trees will be much larger, having successfully captured the light, while other trees—losers in the battle for the light—will be dead.

Although it hasn't been studied, humans, too, may have biological responses to forest light. We don't have receptors to sense far-red light, as plants do, but when we walk in the shade of a forest we are being bathed in far-red light. We know that time spent in a forest reduces blood glucose, blood pressure, and stress hormone levels, but the exact reason is elusive. Chemical compounds given off by the leaves? Perhaps. Light wavelengths? Possible.

Every different color represents a different wavelength. Plants respond to specific wavelengths.

Imagine that instead of walking through an environment defined by light and dark, you could only grow through it. Then each decision would be like this: light, light, toward the light. ▶

Trees are sensitive not just to where the light is but also to how long it lasts each day. In spring the trees leaf out in response not only to temperature changes but also to changes in day length. Animals respond to changes in day length in very similar ways: detection and then hormone release. While the plant response to longer days involves leaf expansion, the animal response frequently involves mating behavior.

Sun cycles are the primary driver of plant responses, but what about that bright moon reflecting the sun's rays? Experiments show that plants can detect even the low light levels of moonlight. Full-moon light promotes flowering and root growth in some plants (although very few plants have been studied regarding their response to moonlight). In other plants moonlight may interfere with their timing of day lengths, so they "sleep" by changing the angle of their leaves at night—the leaves close or move away from the moon.

Animal behavior in the forest also changes in response to light. Many forest animals, like bats, ants, and reptiles, are most active just after sunset. On full-moon nights, nocturnal rodents stay put because they're easier targets for owls then. Night-flying pollinators, like moths, are more active on moonlit nights.

No one has studied how forest trees respond to moon cycles. Might nut-bearing trees be more likely to drop their nuts on a night when rodents won't be out to eat them? One thing we do know is that the forest, as an ecosystem, is aware of the moon's cycles.

So we know that plants and animals are sensitive to sunlight and moonlight. What about starlight? Birds are sensitive to starlight and use it to aid their long-distance migrations. Trees? Imagine you have lived for hundreds of years in the same spot with the sky, the focus of your yearnings, constantly over your head. You are exceptionally skilled at sensing and using light. Hour after hour, night after night, year after year, the small far-away suns roll by. Do you think you might have a relationship with the stars? Most likely, but it is a relationship we humans don't yet understand.

Moonlight is the sun's light reflected. Forest plants and animals respond to even these low levels of light.

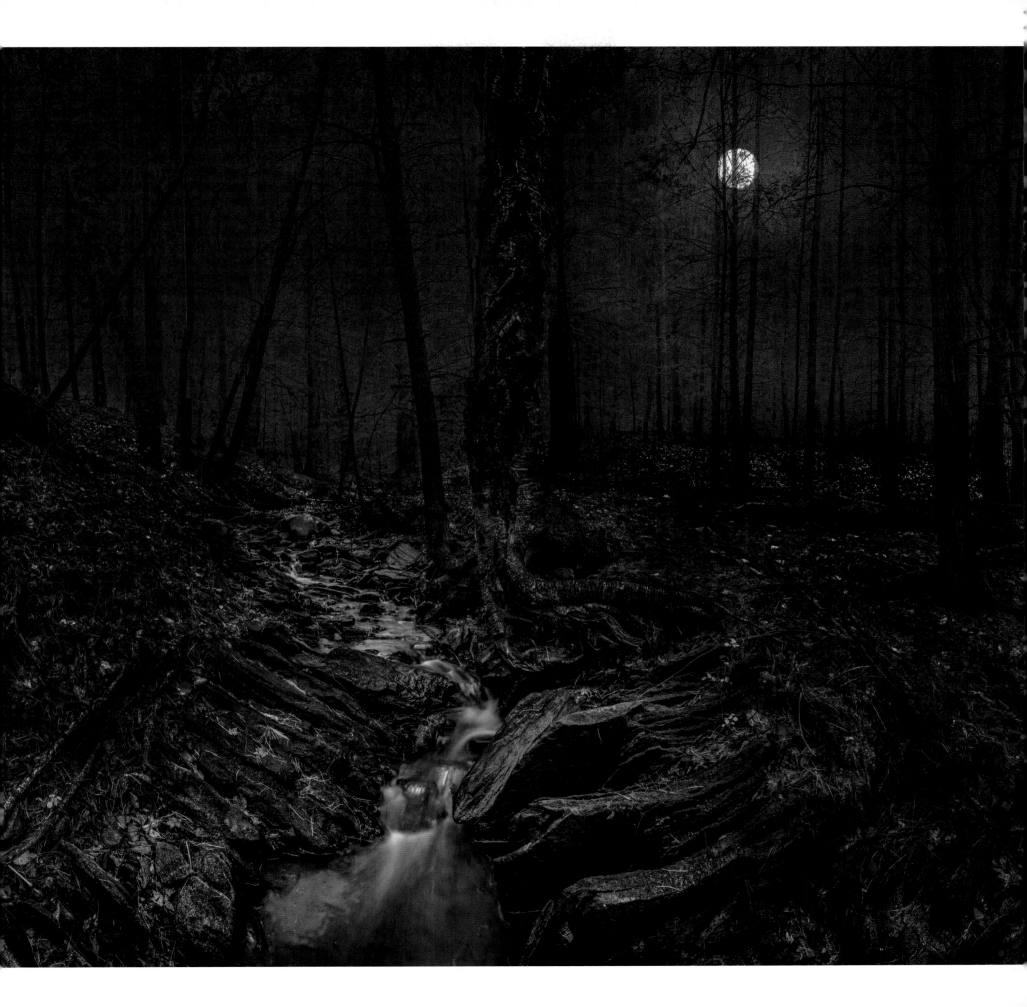

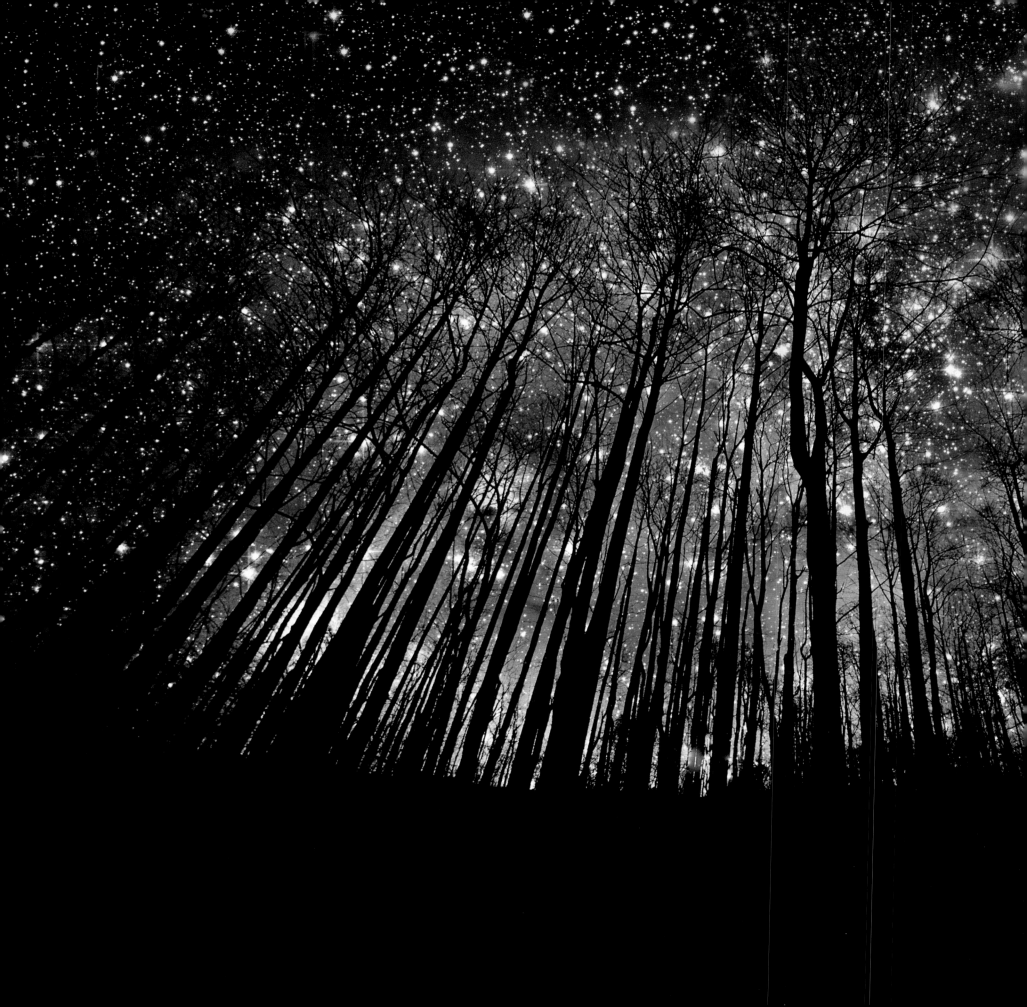

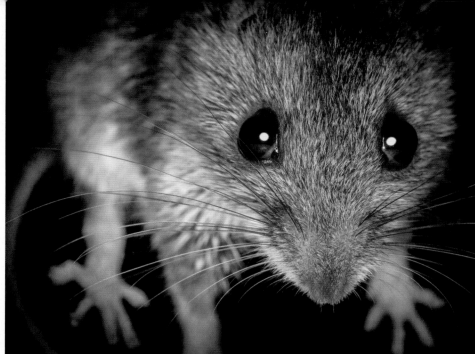

Rodents in the forest behave differently during the full moon.

Are trees sensitive to starlight? We don't have the answer to that yet. ◄

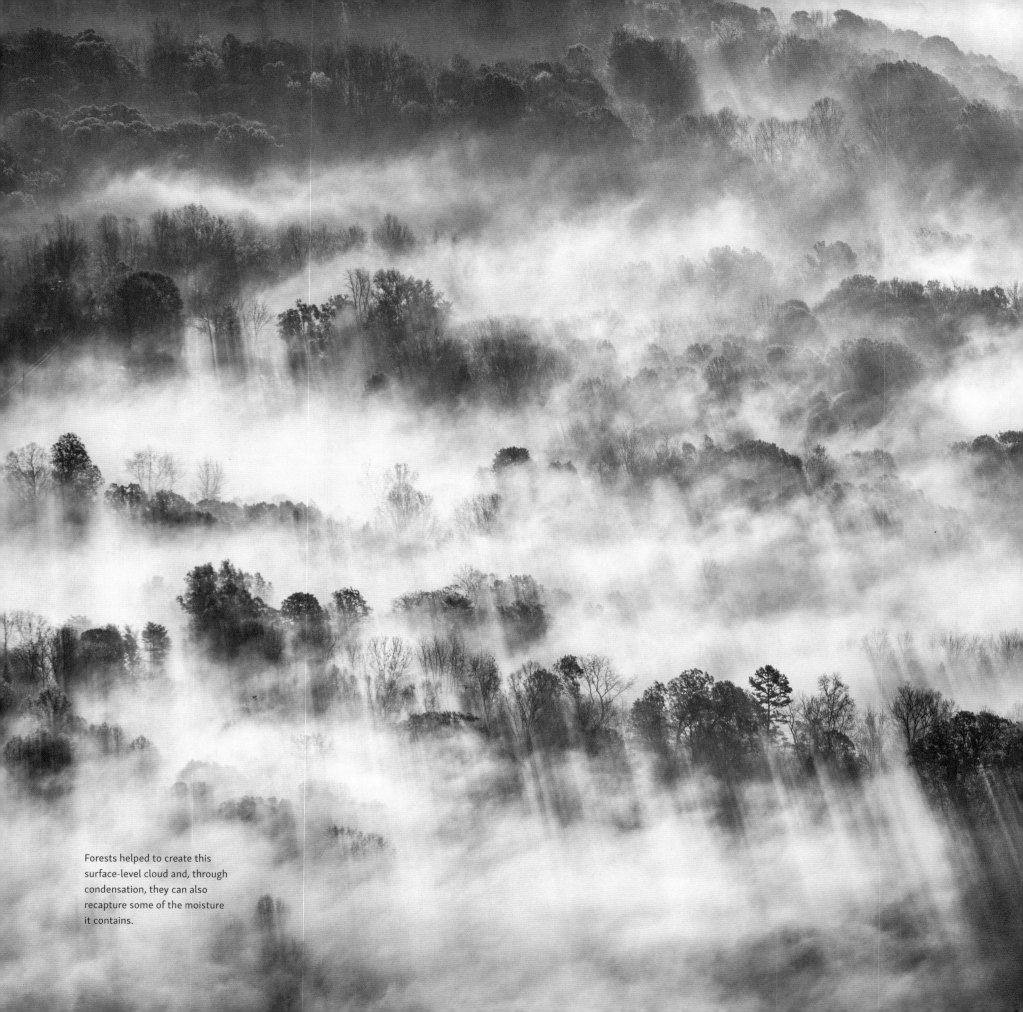

Forests helped to create this surface-level cloud and, through condensation, they can also recapture some of the moisture it contains.

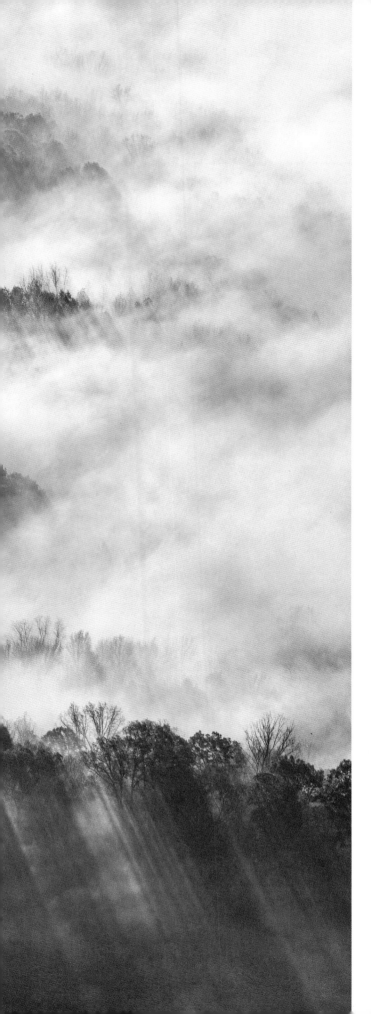

A Deep Breath

Lungs of the Land

WHO HASN'T BREATHED ON a mirror or a window on a chilly day and seen water vapor condense on its surface? Or witnessed their warm breath create steam when it's exhaled on a frigid winter's day? These are visible reminders of a normally invisible phenomenon— water moving from our bodies into the environment.

Trees exhale, too; they passively exhale water vapor through multitudes of tiny pores called stomata that cover each leaf. Indeed, most of the water molecules that enter their roots and journey up that long, dark stem are released from the leaves unchanged through these pores. We are still learning how stomata function.

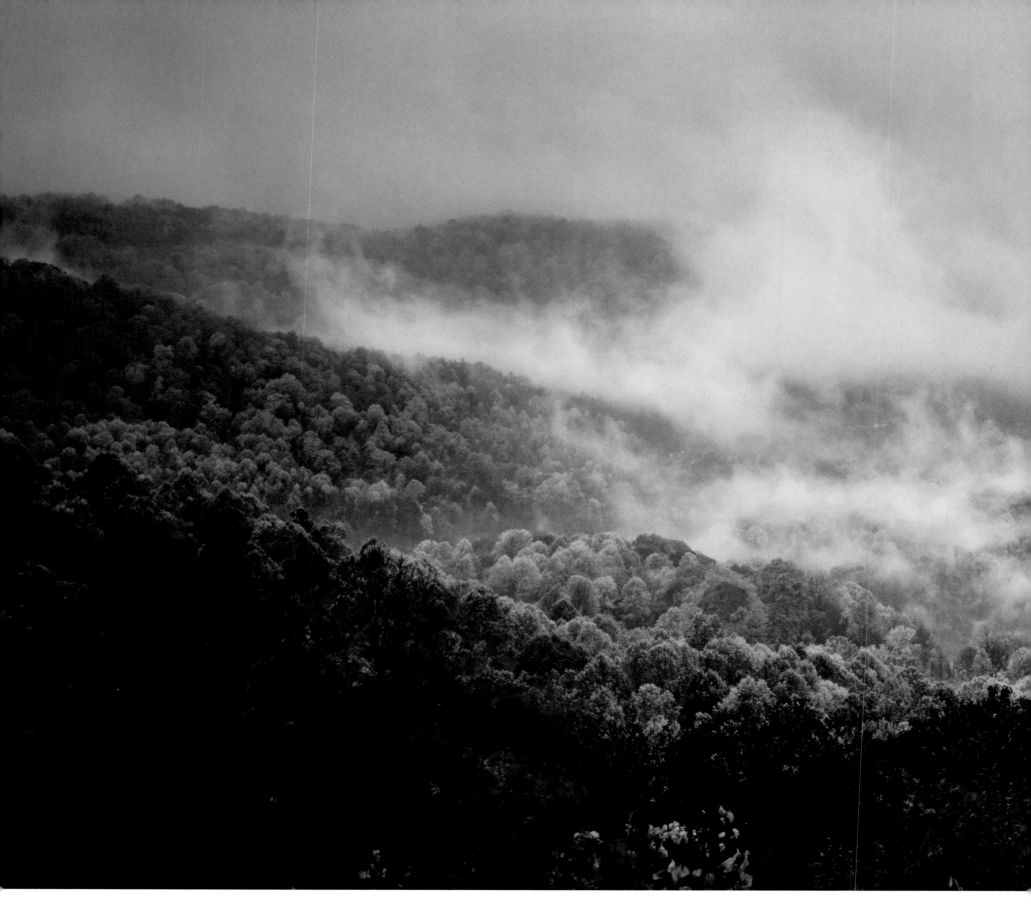

Imagine the forest exhaling water vapor and oxygen, and inhaling carbon dioxide, for that's what it does.

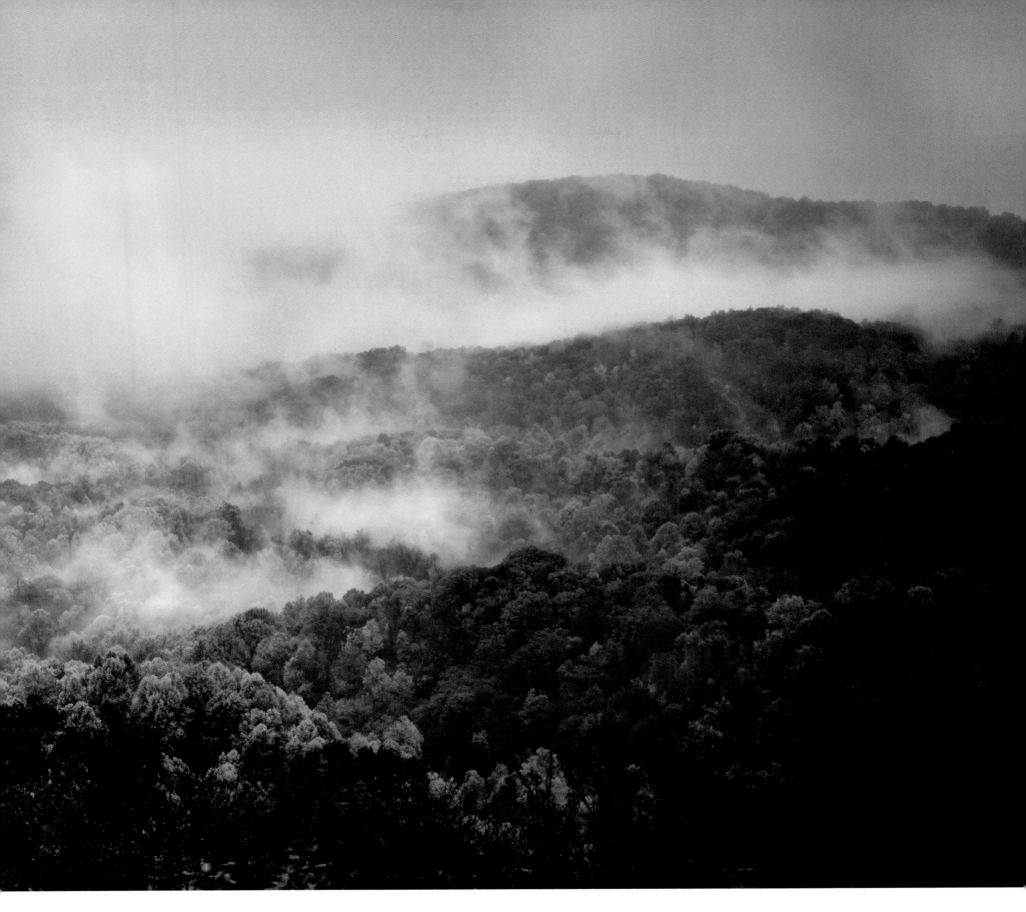

Stomata are visible on some plant fossils, so we know that the size and number on a typical plant have changed over time. Many millions of years ago, the first plants had larger stomata but fewer of them. When carbon levels in the atmosphere dropped, some plants evolved to have smaller but more abundant stomata. In part, it was this change in stomata size and number that allowed more plant species to evolve and inhabit the drier regions of the planet. Now that carbon levels are rising again, the number of stomata per area of leaf is again declining. Plants do respond to the environment, although sometimes that response is very slow.

We are born with one mouth, but the number of tiny pore-mouths that will develop on a leaf is determined by the atmosphere surrounding that plant. How does a just-developing leaf know the number of stomata it will need? The existing leaves tell it, for they have been sensing and responding to that atmosphere.

Stomata don't open and close simultaneously. Instead each one behaves as an individual. It's such a quiet process that we aren't aware of it while walking through the forest, but a giant microscope projecting in real time would fascinate us as it showed the openings and closings of the stomata. It would be like watching fireflies flashing on a hot summer night—you know there's a rhyme and reason in each flash, but the complexity of the combined flashes causes your mind to stop trying to figure it out, and finally you just enjoy the show.

Beyond the show of these pulsing pores, we must also consider the huge global influence they have on regulating atmospheric levels of water, carbon dioxide, and oxygen. For at the same time that the stomata are releasing water vapor, they're also releasing oxygen and sipping in the carbon dioxide the plant needs for photosynthesis. Every year the majority of the water circulating through the atmosphere moves through stomata. The oxygen you're now breathing, the molecule that's keeping you alive, has at some point cycled through a tree. Every year 40 percent of the carbon in the atmosphere moves through stomata. These tiny plant pores can change the climate of the planet and influence the course of evolution. Ponder that as you walk through the forest. The trees are breathing out and you are breathing in. You are breathing out and the trees are breathing in.

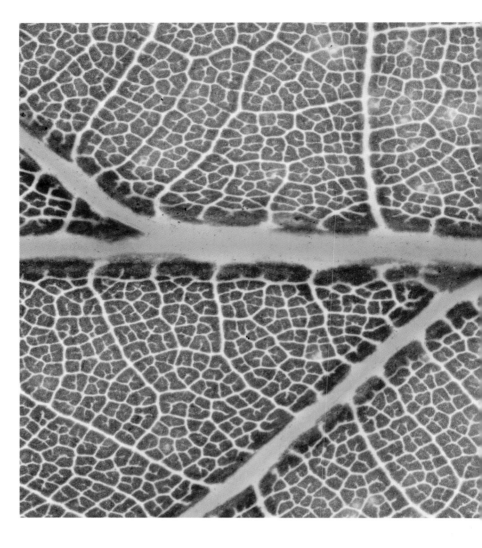

A very close look at a leaf reveals the tiny veins that carry fluids to and from each cell. An even closer look, with a microscope, reveals the pores that allow gases such as water vapor, carbon dioxide, and oxygen to pass into and out of the cells.

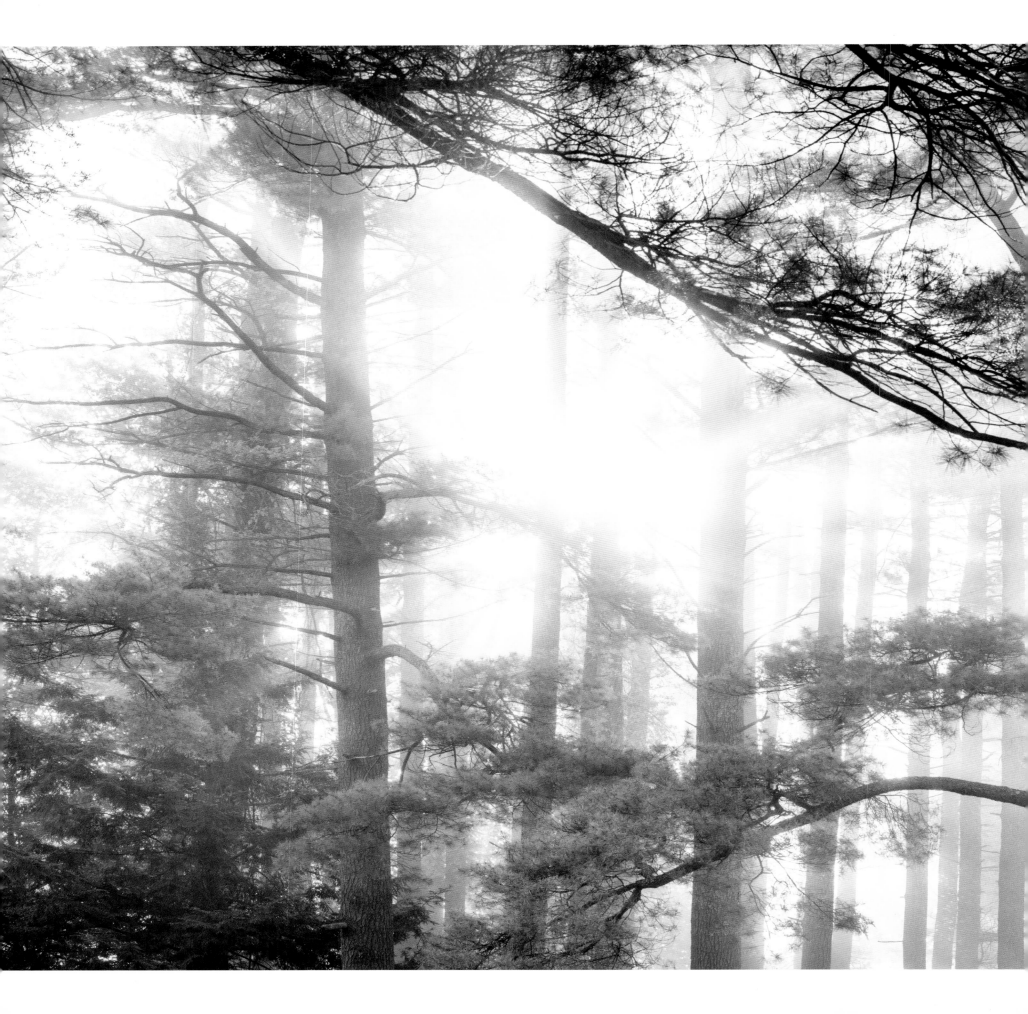

Plants sometimes seem so static, but in many ways they're more responsive to the environment than we are. The cells controlling the pore openings are constantly adjusting to changes in light, humidity, and carbon dioxide. They're even aware of what's happening in the root zone.

Whereas we have muscles to help us pump oxygen in and carbon dioxide and water vapor out, trees must depend on a much larger and more remote pump—the sun. It's the sun's radiant energy striking the pigment molecules on a leaf's surface that puts the whole green breath in motion. Though each pore operates as an individual, there's also a larger daily rhythm. Think of humans in a city rising in the morning, accomplishing their daily tasks, and then retiring at day's end—a larger pattern to all the many individual variations on this theme.

Imagine this pattern from a forest's perspective. As the planet slowly rotates eastward, the life-powering orb appears. Only the tallest of the trees catch her first light. As the light brushes the treetops, long shadows are cast—not on the ground, but on the very air. The forest's giant exhale of water vapor has become the canvas for her shadows. Cool morning temperatures condense the vapor until it's visible, a treetop cloud. Water drops that were recently in the dark earth have become transformed. They've moved into the roots, squeezed through the trunk's passage, escaped through the leaf pores, and are now floating in air.

Each of these trees will shepherd tens of thousands of gallons of water into the atmosphere this year. Every day of the growing season, a tree moves and releases enough water to fill a bathtub. And that water never disappears: it may be caught again by the trees, when vapor condenses on the leaves or the trunk and rolls down into the soil once again; or the wind may carry the vapor to a distant forest that will be quenched by the rain from its unknown partner; or the water may find its way through runoff and rivers to the glass by your bedside.

Later in the day the air will warm and the droplets will disperse—our white canvas will fade away. The warm air column will rise like an invisible balloon. As the warm air rises, it creates a suction that pulls in air from other places. This very large pattern is like the earth taking a deep breath. Air that's pulled in from across the ocean contains moisture that will fall on the land as rain or snow. This atmospheric movement is critical to the existence of forests on the planet: the precipitation that falls on the forest and enters the atmosphere after traveling up through the trees is carried aloft and off to water another forest. In a way, the forests are watering each other and themselves.

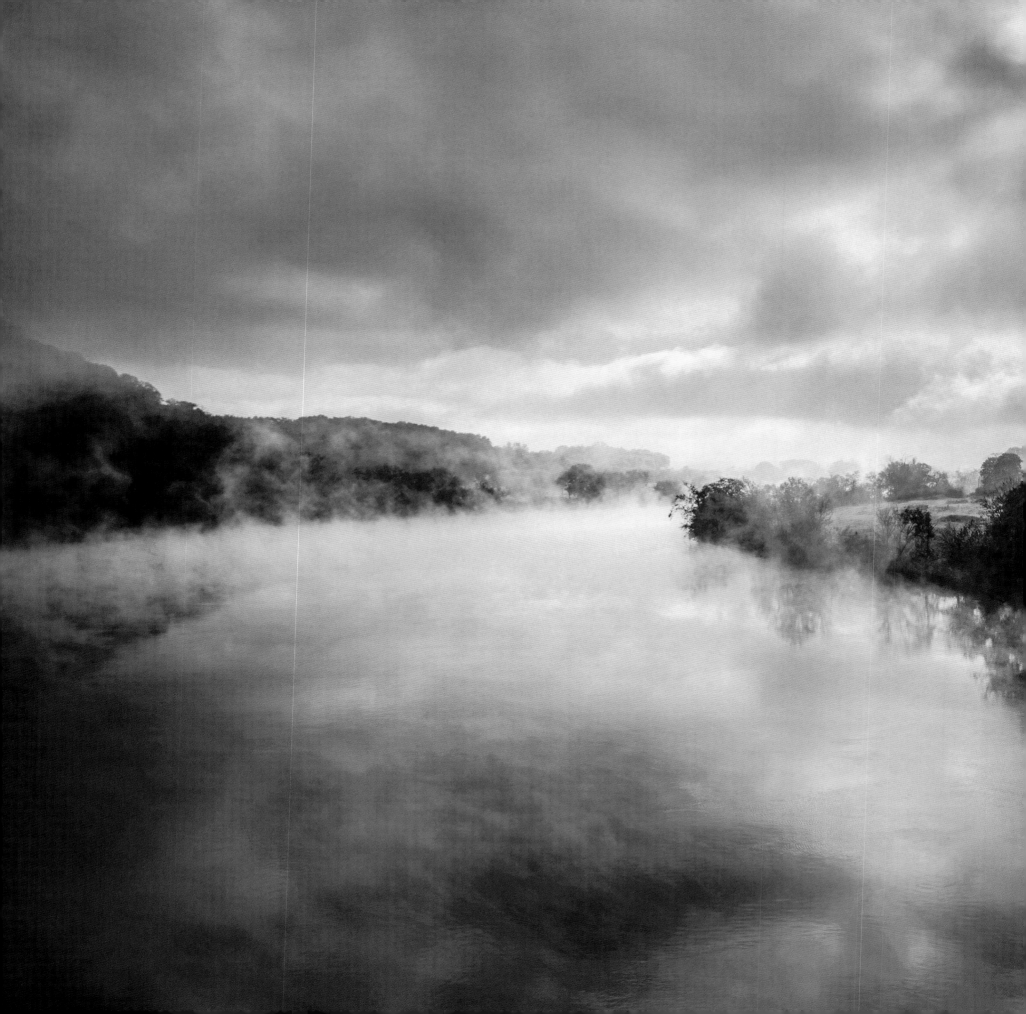

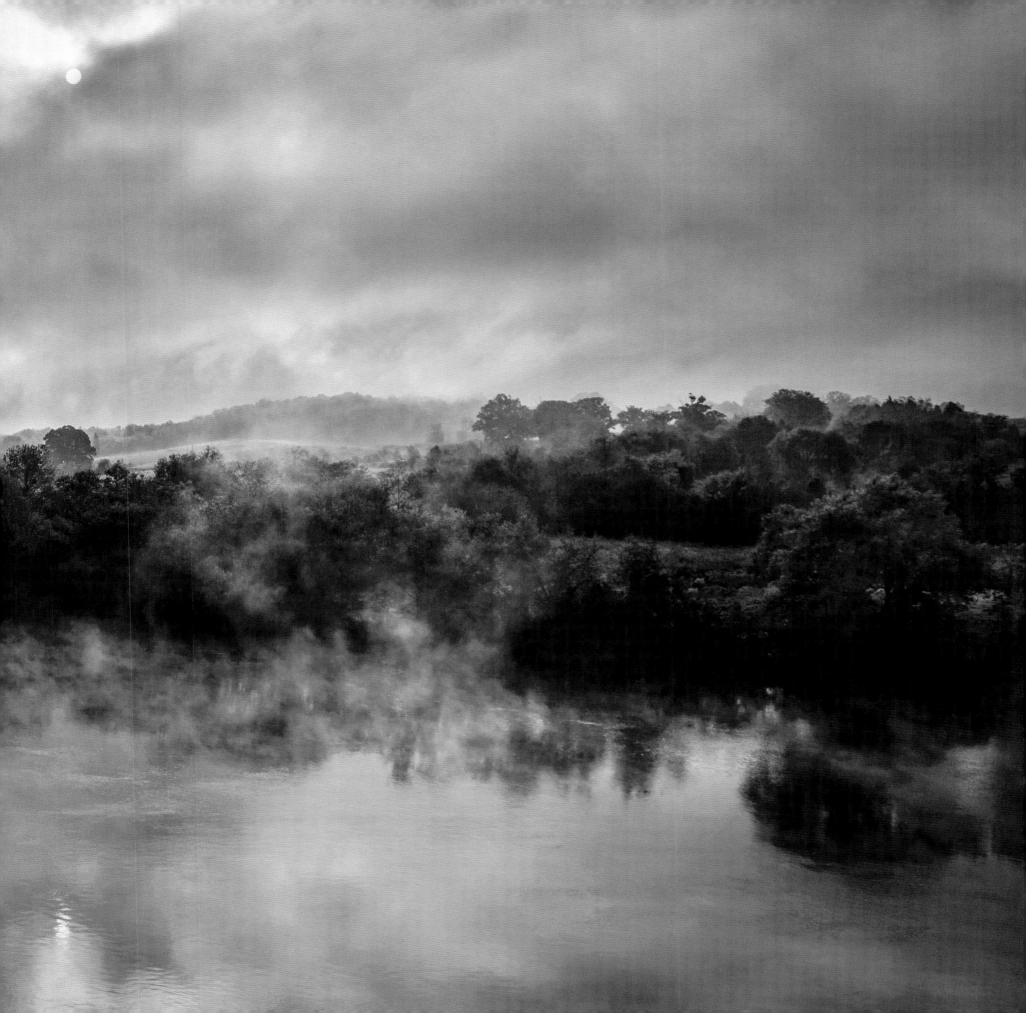

The sun, now high overhead, casts shadows on the ground and provides the energy for our forest to continue its vital role of water mover. The leaves, like millions of little factories, will make sugars to power the tree. Water, one of the raw ingredients, must be imported from the ground. Carbon dioxide, the other raw ingredient, must be imported from the air. Oxygen is merely a by-product of the process, but one that we are vastly grateful for.

Another way forests breathe is by plants drawing in carbon dioxide in the daytime while photosynthesizing and then releasing carbon dioxide at night as the cells continue to function and respire. This is a long, slow breath that takes twenty-four hours.

(PREVIOUS) Water vapor released from a leaf may fall to earth as rain and then flow into a river, where it becomes our drinking water.

Water, carbon, and oxygen cycle through the forest in a long, slow breath. ▶

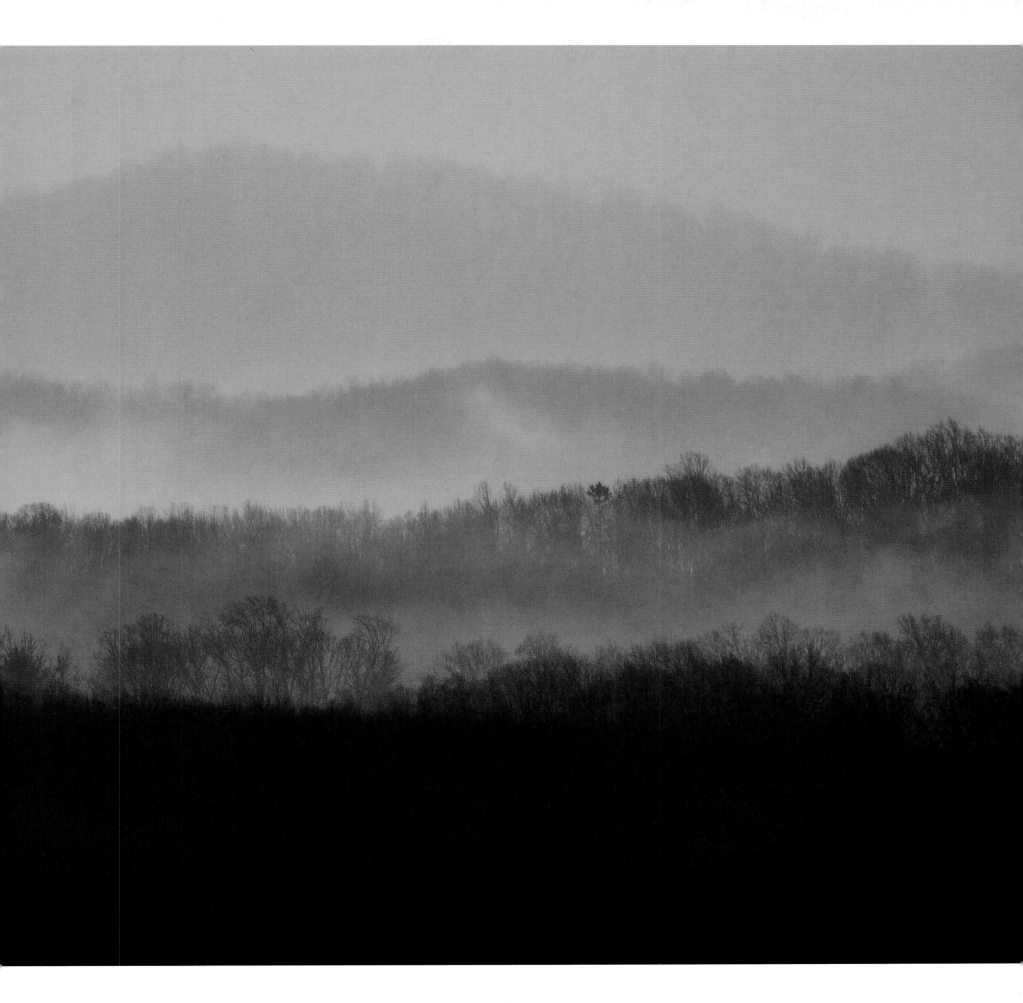

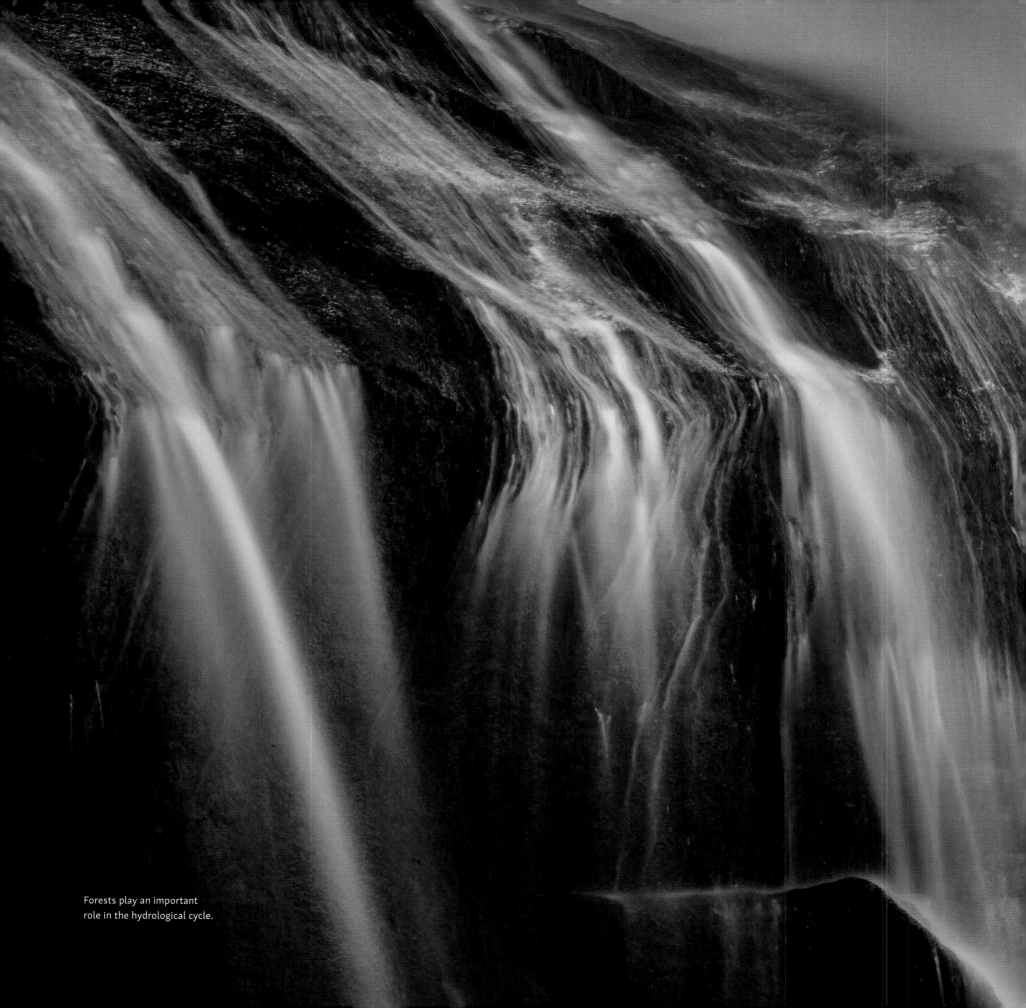

Forests play an important
role in the hydrological cycle.

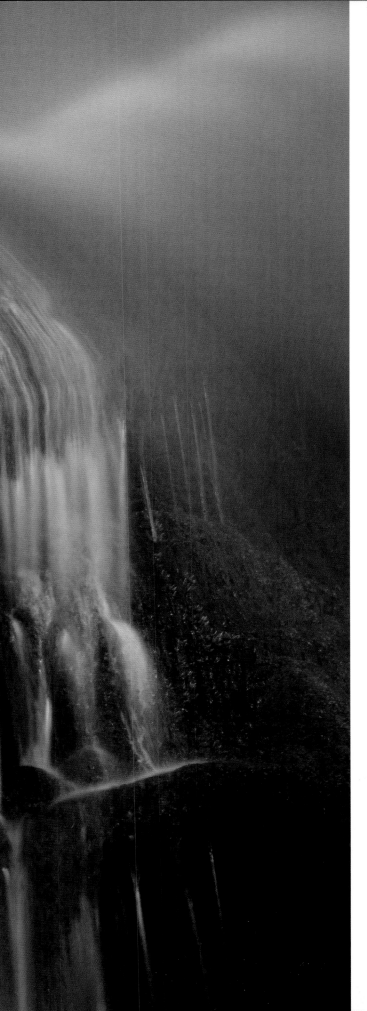

World of Water

Cycles and Creatures

FORESTS AND WATER GO together. Forests help make rain by pulling water from the soil and releasing it into the air where it rises, cools, and comes back to earth. But that's not the end of the story. To truly know a forest, you must understand how it manages the water it receives from the atmosphere.

Some of the water that reaches a forest is still in vapor form. Fog and mist drift through the forest, and the vapor condenses on leaves and needles. Snow falls gently and collects on twigs and needles before it reaches the ground. Tiny raindrops fall slowly, and these, too, may gather on leaves and twigs before sliding slowly toward earth along the trunk. The moss on the trunk eagerly awaits this moisture and holds on to as much of it as it can. The bark, too, soaks up some of the water.

During a short, gentle rain, the canopy catches and directs virtually all of the precipitation to the trunks, and then the trunks and the things growing on them absorb everything that reaches them, leaving none for the ground. Perhaps you've experienced being in a forest during a rain when you barely felt a drop, although you could hear it. It's not difficult to imagine the forest as a living, breathing sponge, holding on to the life-giving dampness that comes from the sky.

But sometimes the rain falls in buckets, the large drops coming down hard and fast. In open places, such forceful rain causes soil erosion and compaction. Runoff from such a rain carries soil particles that cloud waterways with sediment. Forests prevent that. When a hard rain falls on a forest, the drops are slowed before they reach the ground. In the summer they hit leaf after leaf after leaf, rolling and splashing from one to the other until they plop gently to earth. Even in winter months, when the leaves are down, the fine twigs break the rain's fall.

And when the slow drops reach the ground, they land on a cushion of decomposing wood and leaves. This spongy layer holds on to most of the moisture from a short rain. Only a long rain can saturate the organic layer and soak into the mineral soil below. This all happens so gently and slowly that no soil particles are carried away. Most of the rainwater stays right in the forest. In the summer it may be taken into the tree roots, carried up, and released through the leaves. In the winter the excess water may trickle slowly into the groundwater or into a nearby stream. Or it may form pools in the forest. This water has been washed by the forest. The forest slowly gives back clean, clear water.

Sometimes it seems like water springs right from the forest soil, and it does, as the spongy soil releases it drop by drop from many surrounding acres. There are few pleasures greater than entering a shady forest on an otherwise hot, dry day and finding a rushing stream of cool, clean water. And since so many of our remaining ancient forests are in rocky places where it was difficult to bring machines, the streams are often found rushing over rocky outcrops. Your first emotional response may be exhilaration, then joy, and if you remain still long enough, despite the sound of rushing water a silence will descend on you. This is a gift of the forest, too.

Needles and leaves can catch moisture or small raindrops from the air and transfer the liquid gently to the ground.

Rain soaks into the soft soil,
and the forest slowly releases
the clean rainwater it has
captured. ▶

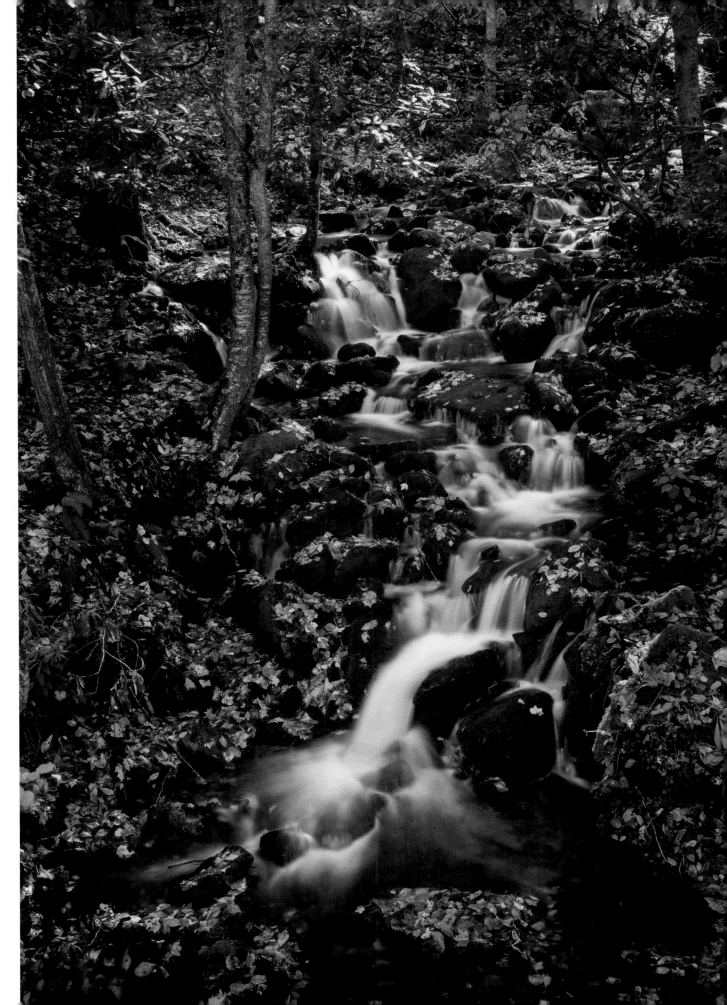

Cool, flowing water in a dark
forest is a treat for the senses.

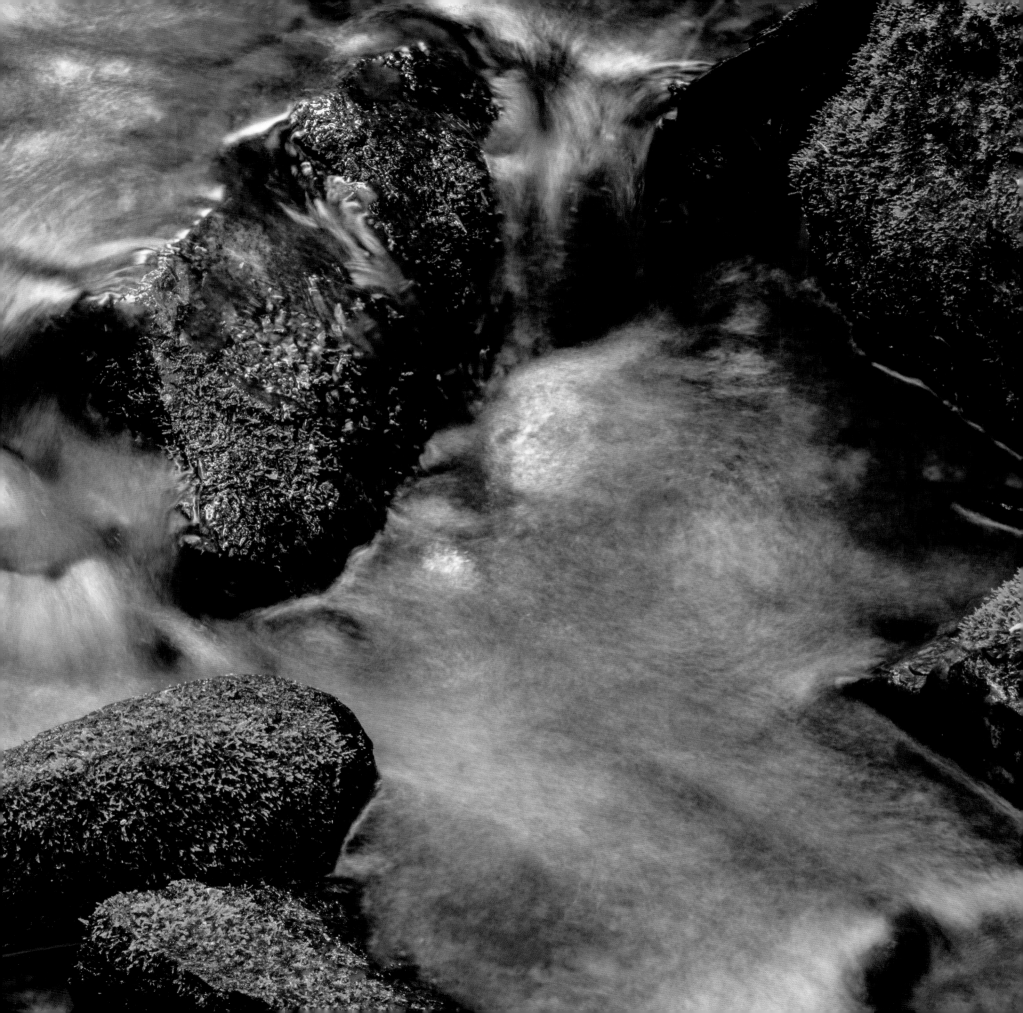

And this clean water will flow from the forest out to the closest river, and the river eventually to a lake or an ocean, all cleaner for having started in the forest world. Each of these bodies of water, from small to large, is home to plants and animals. All of them, and all of us, have the forest to thank for helping to keep the water clean.

A crayfish could not live in its tiny rivulet unless the forest canopy kept the land cool and shaded, and prevented mud from entering the stream. A muddy stream would interfere with finding prey—and even with getting oxygen. The damp, spongy forest soil releases its water drop by drop so the shallow stream flows even in dry weather. No forest, no clean water, no crayfish. Although it might look like a lobster, a crayfish will never get more than a few inches long. It will eat just about anything it can find, including frogs, salamanders, dragonfly nymphs, and even small fish when it can catch them.

As the streams get deeper, fish can live in them. Fish species vary widely in their tolerance to temperatures, oxygen levels, and water clarity. Some species, like carp, can live in warm water and come to the surface to gulp air if oxygen levels are low, but other species, such as brook trout, need cold and highly oxygenated waters. Streamside forests keep the water clean and cold. "Trout grow on trees" is a trademarked slogan of the Stroud Water Research Center, a clear reminder of the close relationship between the two. Trout disappear from a stream after as little as 4 percent of a forested watershed surface gets covered with paving or buildings.

When searching for life on other planets we search first for water, because water equals life. As mammals we have evolved to carry our water within us. A woman may walk to a stream, take a drink, and then walk miles from any standing water, carrying her unborn baby in the watery environment of her womb. Reptiles have evolved a similar trick, but they store the embryo with water outside their body, in an egg.

To tell reptile from amphibian, look closely: if it has scales, it's a reptile. A skink may look much like a salamander, but besides being four-legged animals in the forest they're only distantly related. A skink, being a reptile, lays eggs that don't need standing water, and the animal that hatches from those eggs is already fully formed. The more primitive amphibians, like salamanders, depend on the water in a forest to be their nursery.

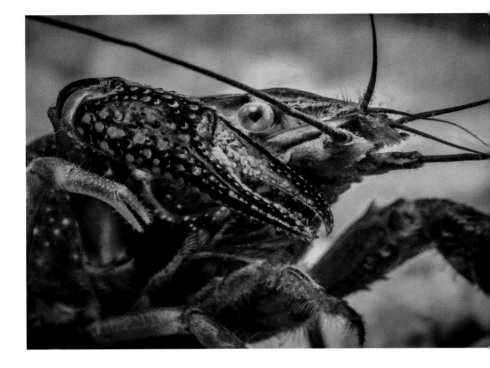

Crayfish have multiple sets of antennae and legs. They can voluntarily release an appendage to a predator; a valve then seals off the missing section so body fluids don't escape. The appendage will grow back.

A brook trout hides near the rocks. The surrounding forest keeps this stream clear and cold, conditions that are vital for the trout. ▶

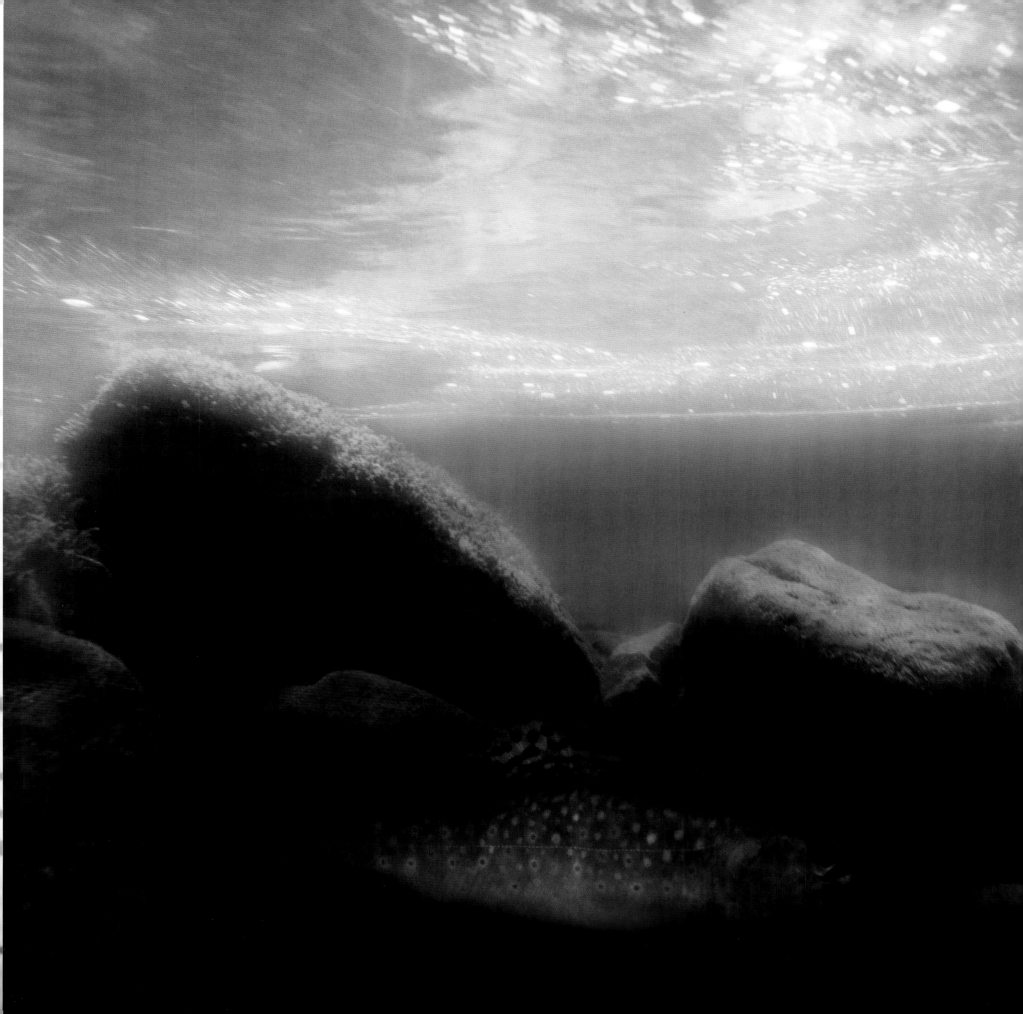

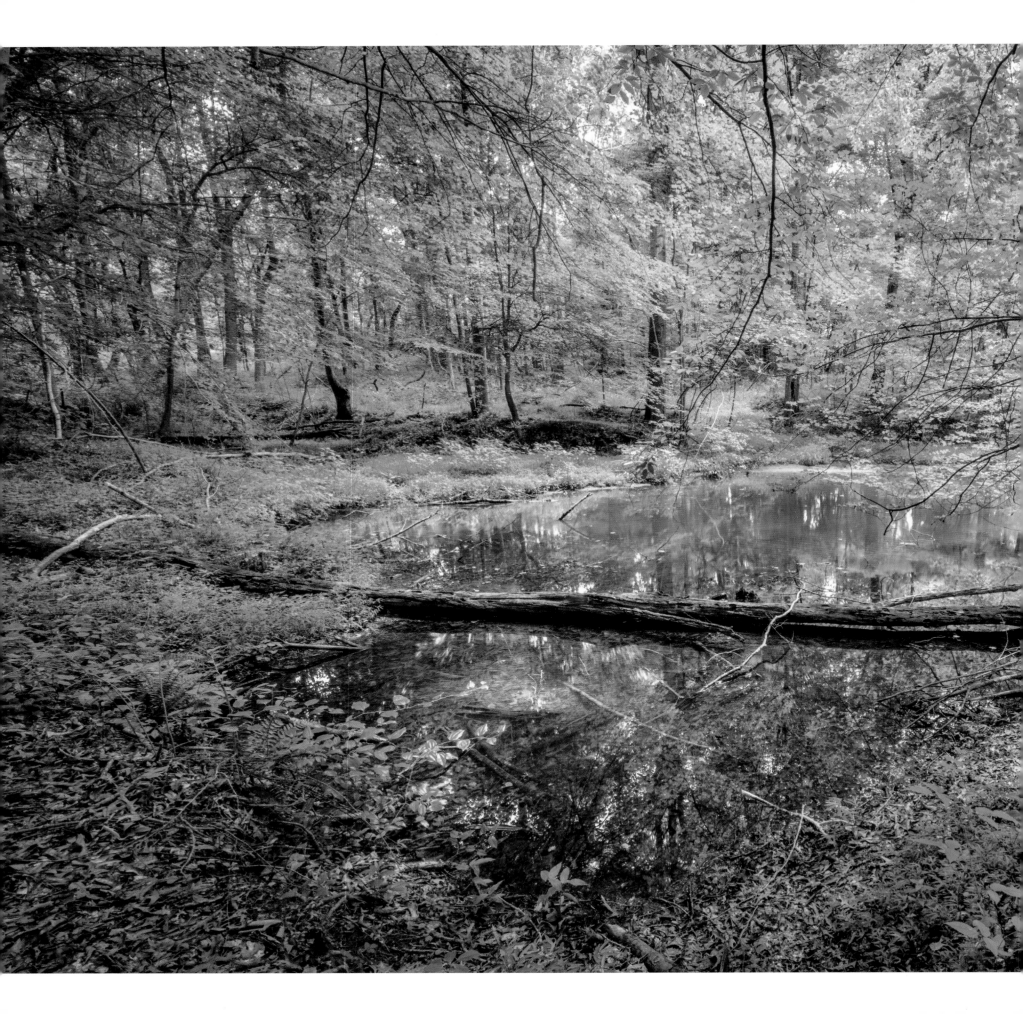

Not all the water that enters a forest leaves it by streams and rivers. Sometimes the water is just held there in large puddles we call by poetic names such as Carolina bays or ephemeral ponds. These shallow forest pools are also called vernal pools because they contain standing water in the spring. All fall and winter the rain and snow have been falling, and the forest soil is saturated. Spring walks reveal wide puddles in the heart of the forest. Many amphibians release their reproductive cells into this kind of watery environment, and the fertilized eggs eventually hatch into free-swimming larvae.

Besides calling you out from your house, the warming temperatures call spotted salamanders out from their underground burrows. On a rainy spring evening, thousands of them may congregate at a single pool. There they socialize, and when a male finds a female he begins an ancient choreography. First he swims up underneath her, wiggles his tail, and swims her to the shallow edge. If she shows interest by rubbing her nose on him, he will begin depositing his sperm packets on the shallow underwater vegetation. The sperm are in an oval cap on a tiny tower of gelatin that he produces. The female then positions herself over one of these towers and settles down onto it. When she leaves, the oval cap with the sperm is inside her, but the gelatinous tower is still there. She then lays her fertile eggs in the pool. Finally the adults crawl back to their separate burrows in the soil, deep under the fallen leaves.

They only come out to feed on damp nights, and they won't return to the pool until next year. Meanwhile their embryos, covered in green jellylike balls, are on their way to becoming larvae. The egg balls are green because they contain algae. Is the algae attracted to the nitrogen released by the embryo? Does the embryo need the oxygen given off by the photosynthetic algae? No one is sure, but we do know that the salamander embryos don't do well without the algae and the algae don't do well without the salamanders. They, like so many other things in the forest, need each other. A close microscopic examination reveals that the tiny embryos actually have the algae throughout their body tissues. It's not a far stretch to imagine that these salamander embryos are photosynthesizing.

A shallow pool in the forest is important reproductive habitat for many frogs, salamanders, and insects with aquatic life stages.

After the embryos hatch from their green eggs, the little larvae swim through the pool. Now they can feed on their own and no longer need the algae. They have what appear to be feathery wings springing from their necks just behind the head. These are external gills that pick up oxygen from the water. In a few months the larva will develop little legs, its external gills will shrink, and it will be ready to crawl out of its natal puddle.

Salamanders have a variety of lifestyles. They are in-between characters enjoying life in the water and on the land. Red-backed salamanders spend no part of their lives in standing water and yet without moisture in their environment they can't breathe, for they have no lungs and must depend on oxygen diffusing through their damp, permeable skin. Others, like the just-discussed spotted salamander, mate and lay eggs in the water, and the young larvae breathe through gills, later developing lungs as they move to the land.

The marbled salamander feels the urge to mate not in the spring but in the fall, and mating happens on land. He displays himself to the female and then deposits a sperm packet on the ground. If the female is responsive, she accepts the packet and draws it into her body. She then makes her way to a pool. If it's dry, as it is likely to be in early autumn, she buries herself under the detritus, lays her eggs, and waits. The fall leaves drift down upon her. She will stay underground with her eggs for weeks. She won't eat at all during her vigil; her mere presence deters egg predators. At last the rains begin and the leafless trees no longer suck water from the ground. The pool fills, and the eggs hatch. Her work is now done and she can return to drier land while the larvae swim in their new ocean and search for one-celled organisms to eat.

Even the small larvae are responsive to their environment. When night falls after a clear, sunny day, the larvae all drift up to the surface of the dark pool to feed. When the morning sun comes out, they sink back down among the submerged leaves. On full moon nights they stay low, because the moonlight allows predators to spot them. But during an eclipse of the moon they rise back up and resume feeding for a brief time under cover of darkness.

After a few months they're larger and hungrier, and suddenly a miraculous abundance appears. The spring peepers gather at their pool and lay masses of delicious gelatinous eggs that are like manna from heaven.

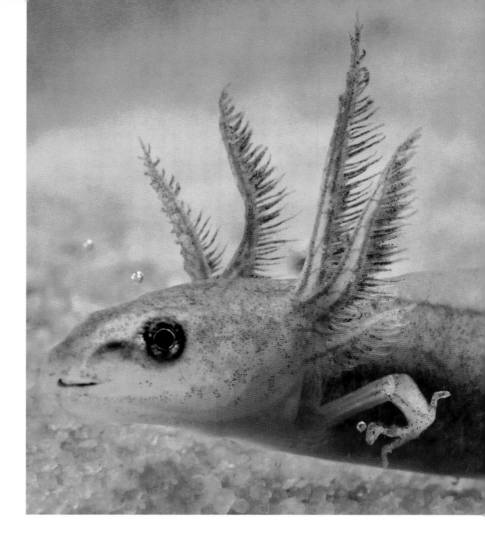

A larval salamander has external gills that collect oxygen from the water. A few species retain these gills into adulthood, but in most species the gills disappear.

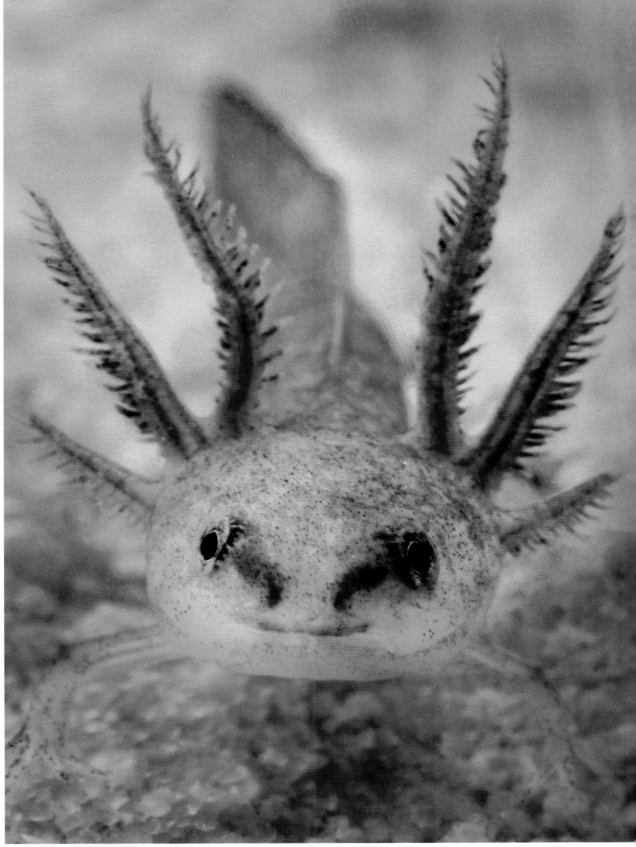

The face of a larval salamander has dark areas between the eyes and the mouth that can detect chemical scents in the water. Salamanders have highly developed senses of sight, smell, and touch.

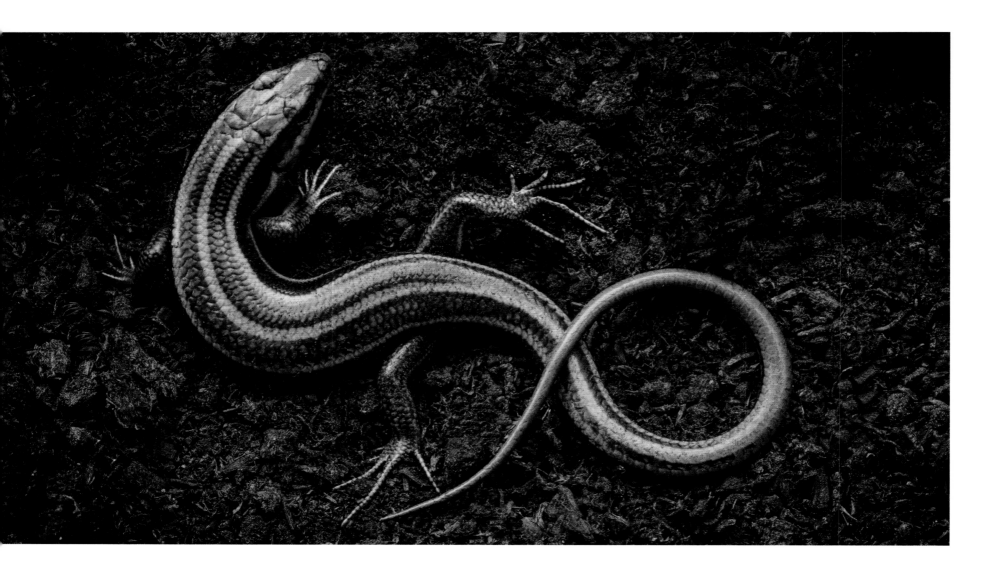

Soon the uneaten frog eggs hatch and legions of tadpoles swim in the pool—and not just peeper tadpoles but many kinds of frogs and toads. A few frightening things appear in the pool, too, like dragonfly larvae. These strange-looking things just sit on the bottom of the pool hiding and then grab any tiny tadpole or salamander larvae that swim by.

Yellow-spotted salamanders come to lay eggs, too, and tiger salamanders. The tiger salamanders are a little larger than the others and mate a little differently, but like the others, they always return to their home pond to breed. Salamanders have tiny home ranges—measured in feet. Other than breeding time, they may spend their whole lives around the same rotted log or pile of rocks. To get to their breeding pond, they navigate by the sun as well as using their very acute senses of sight and smell. When they arrive at the pond, the male tiger salamander bumps into the female, and this is his cue to her that she should follow. She may lay a thousand fertile eggs.

Although it looks similar to a salamander, the five-lined skink has scales that identify it as a reptile. Females lay eggs in moist decaying logs and remain to protect them until they hatch.

The forests of the southern Appalachian Mountains are the global center of salamander biodiversity and density. These species were all found in one day in one location in Virginia. ▶

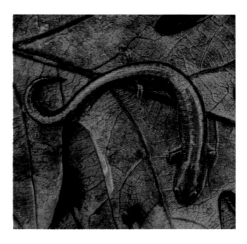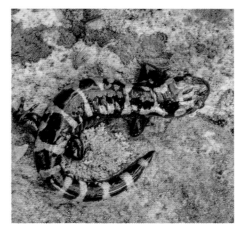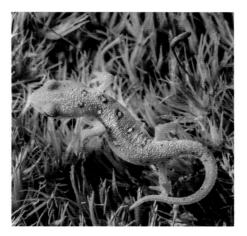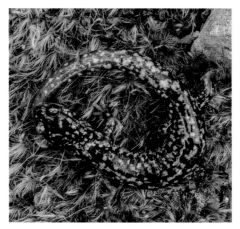

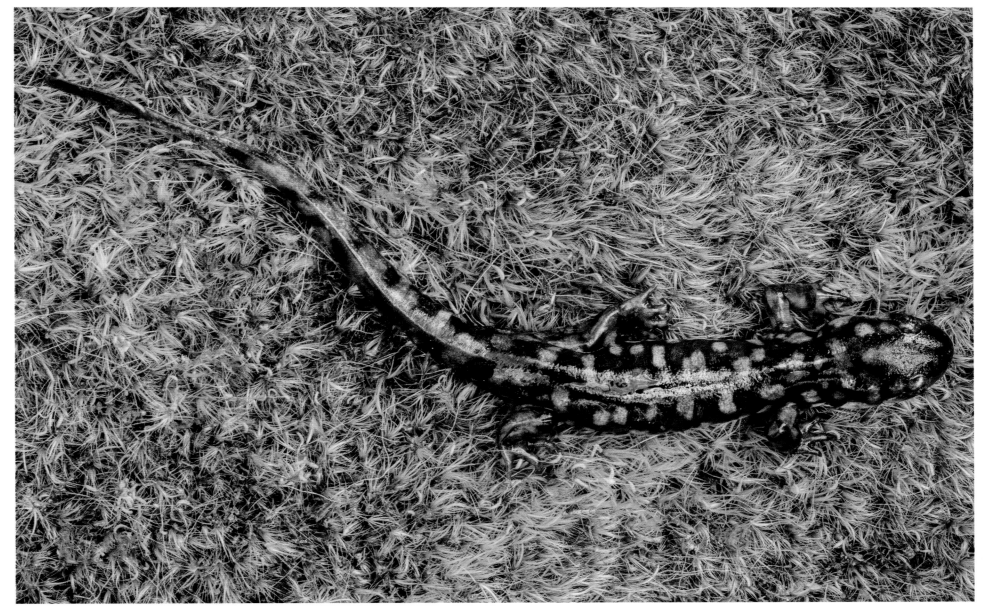

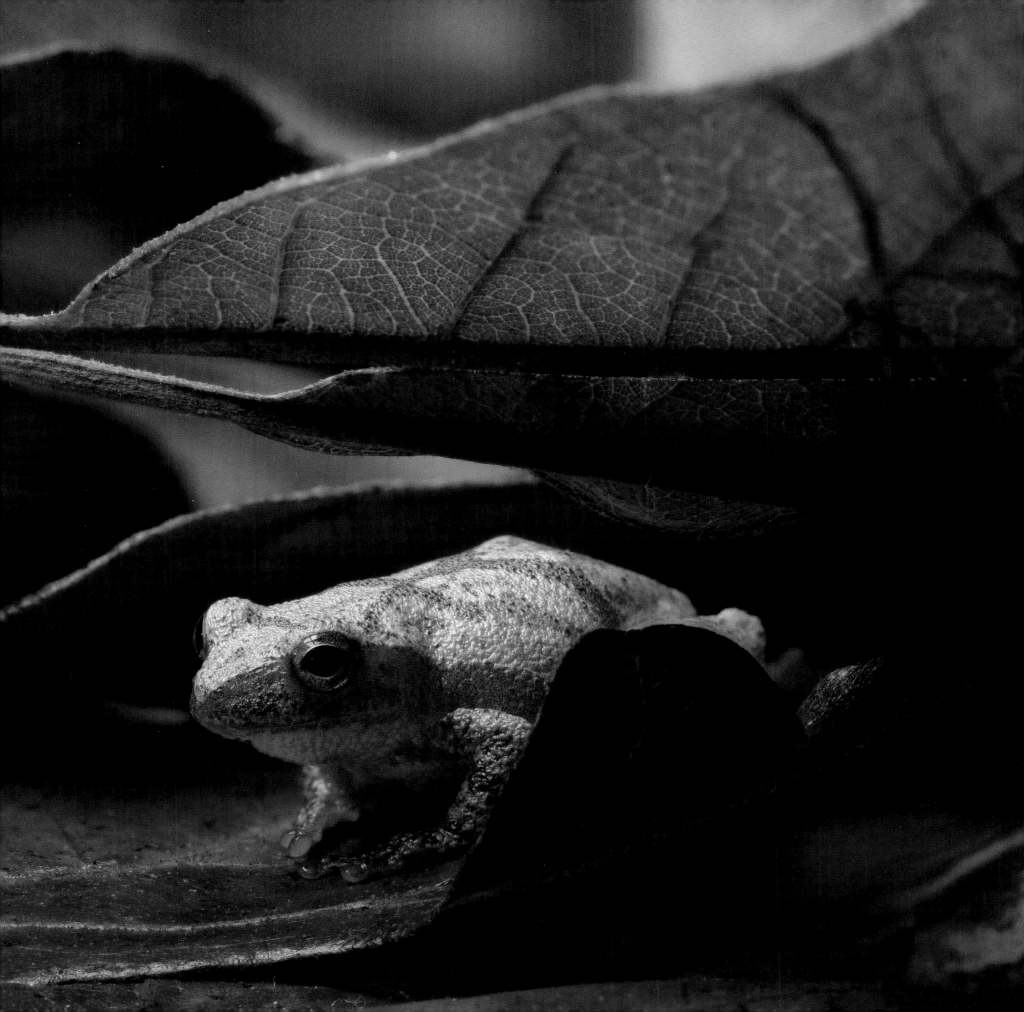

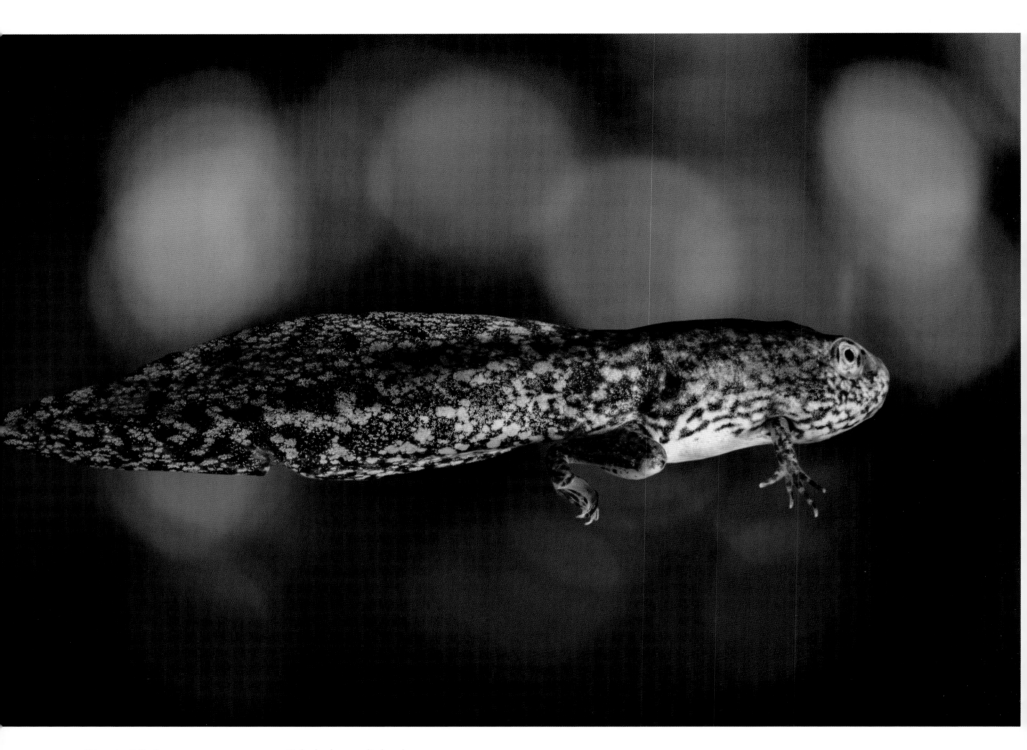

(PREVIOUS) Spring peepers are the first frogs to start calling in the very early spring. A single frog sounds like a loud chick peeping, but a whole chorus of them sounds like a symphony of sleigh bells.

Tadpoles have no limbs when they hatch; over a number of weeks first the back legs form, then the front legs appear. A few days from now this little froglet will exchange gills for lungs and crawl up onto the land.

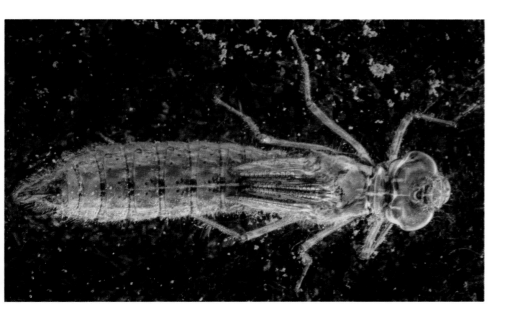

Most of a dragonfly's life is spent underwater. This nymph is ready to crawl out of the water, break out of its old skin, and become a creature of the air. ◄

The adult blue dasher dragonfly will defend its perch. ▼

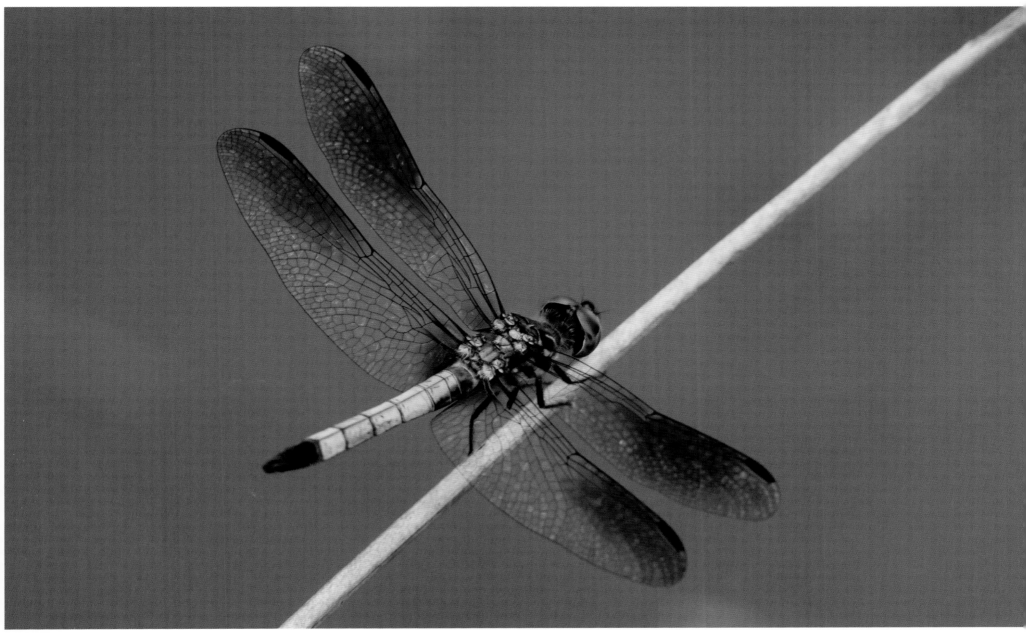

As the weeks roll by and the air gets warmer, the tree leaves emerge from their buds. Like straws, the thirsty tree roots are sucking the vernal pool dry. This is a mixed blessing: if the pool dries up too quickly the larvae may not make it to adulthood, but the very ephemeral nature of the pool is why it contains no fish that would happily eat eggs and larvae. Meanwhile the salamander larvae are growing longer legs, and their feathery gills are disappearing. The tadpoles are growing legs, too, and their tails are shrinking. Soon all the creatures of the pool climb out, just before the pool dries up completely.

Our salamanders have become creatures of the land. They will burrow a foot or two down and live a primarily subterranean life. We walk by overhead with no clue of what's under our feet. But the trees are helped by the presence of the salamanders. The burrows provide channels for oxygen and rainwater to reach the roots, and the water that flows over salamander excrement is like a dose of fertilizer for the trees.

In its second autumn the young marbled salamander will make its way back to the pond where it hatched, and it will return for many years. The spotted one may return to the same pond for twenty or thirty springs. While salamanders are on their way to and from the pools where they hatched, they find insects or worms or tiny frogs to eat.

A turtle's pattern is opposite that of frogs and salamanders. When most salamanders are heading toward water to lay eggs in spring, female turtles are leaving the water and heading toward land to lay eggs. Although turtles live in larger streams, rivers, and ponds that don't dry out in the summer, they need healthy wild land nearby for nests. Smaller species, like the painted turtle, lay eggs two or three times a year, but a big old snapping turtle will only haul herself around to dig a nest once a year. Other animals, such as raccoons and snakes, depend on these nutritious eggs as an important source of food. As a result, only a small percentage of turtle eggs last until hatching time.

How many salamanders are in this photo? We don't normally see them because they spend most of their time underground where their skin can stay cool and damp.

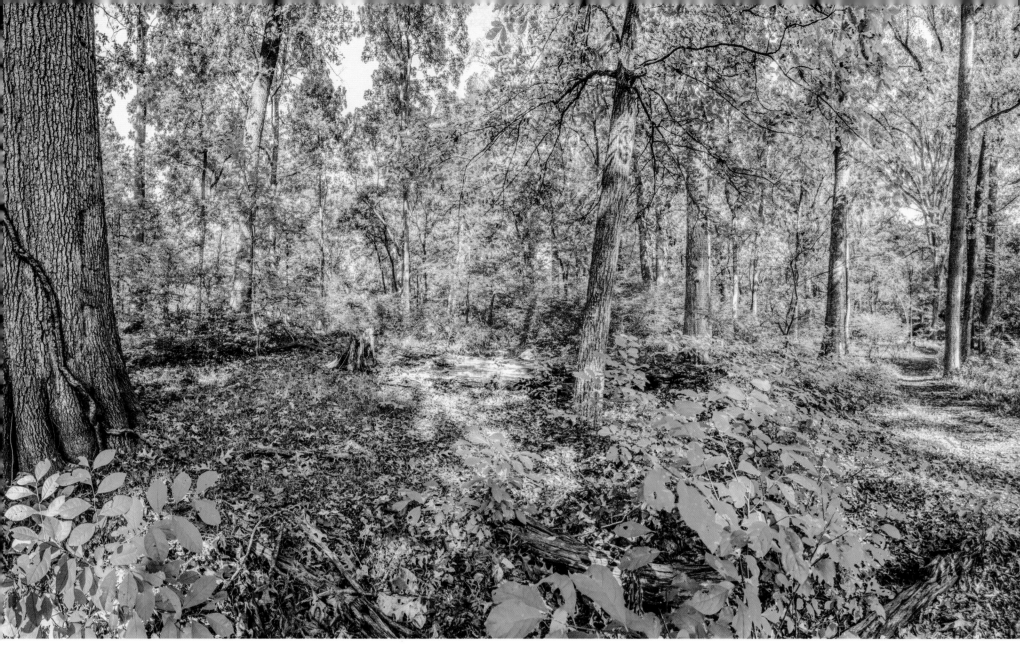

One way tiger salamanders
protect themselves is by
releasing toxic secretions from
glands beneath the skin. ▶

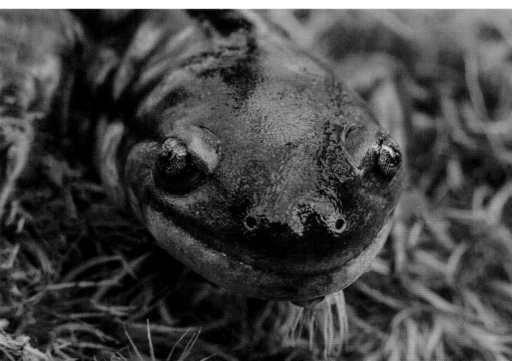

Like salamanders, turtles of different species share commonalities but also have variations in their lifestyles. One thing they all share is their basic structure. For one thing, turtles have no teeth; instead their jawbones are sharp and not covered with flesh as ours are. And imagine having your backbone on the outside of your body—that's what life is like for a turtle. Its shell is actually a modification of spine and rib bones, so despite the cartoons that show turtles crawling from their shells, that could never happen in reality. And this bony shell needs care. Algae grow on turtle shells as easily as on rocks. One reason you see turtles basking in the sun at the edge of the water is to dry off the shell so algae won't grow on it. The basking also warms the turtle up so its muscles are ready to swim and hunt. It can't produce its own body heat, so it's totally dependent on the help of the sunshine and a place to crawl up out of the water. Most often the ideal basking place is a shoreline tree that has fallen into the water. Forests and turtles are connected.

When a painted turtle is warmed up, it will swim along the shallow water poking its head into the vegetation and stirring up things to eat, like tadpoles, insect larvae, small mussels, and crayfish. Its webbed feet are ideal swimming paddles, and its long claws help it dig in the mud and tear apart its food. Once its meal has been consumed, the turtle will crawl back out into the sunshine, and the warmth will help move its digestive muscles.

A snapping turtle's basking behavior is a bit different. Imagine trying to haul that hulk of a body up onto a log. Instead it floats on the surface of the water and lets the sun warm it there. Its snout sticks up above the surface because, like all reptiles, it needs air to breathe; but when it's ready to go to the bottom, cover itself with mud, and wait for something delicious to happen by, it can hold its breath for almost an hour.

Although snapping turtles have a lifespan like that of humans, and it takes them as long as humans to reach sexual maturity, their species has been around for much, much, much longer—four hundred times longer—than the human species. Turtles were around during the time of dinosaurs and lived through the extinction episode that killed them. Look again at a turtle's face and think about that.

Painted turtles will walk miles overland to find mates, making them vulnerable while crossing roads. Some volunteer groups put up temporary fencing along roadways and carry the turtles across. ▶

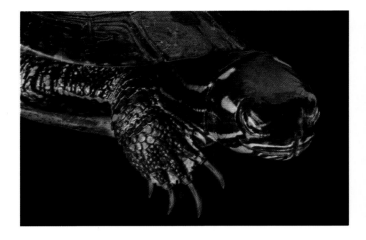

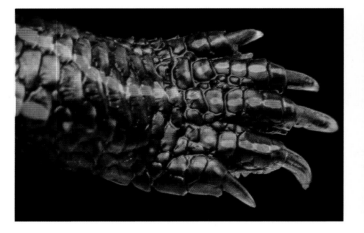

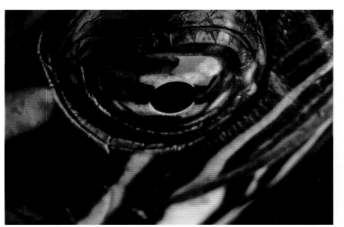

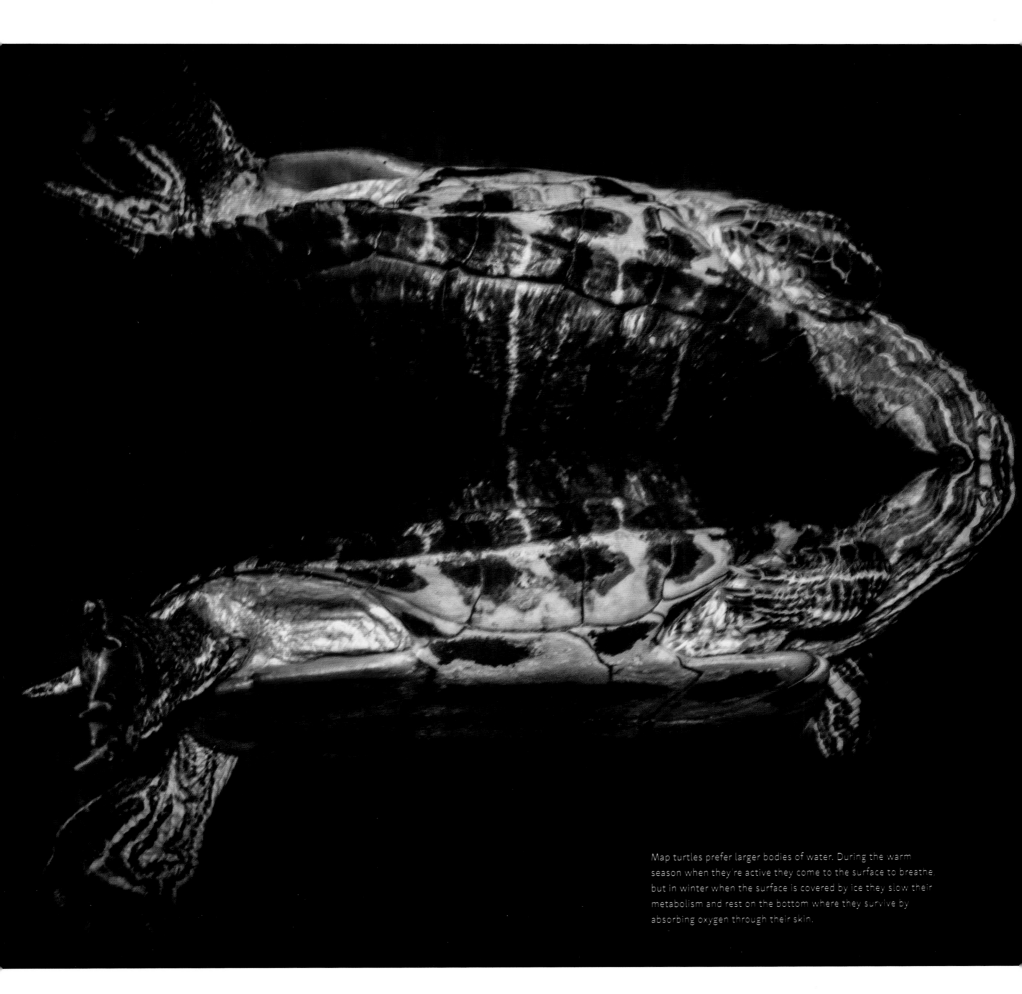

Map turtles prefer larger bodies of water. During the warm season when they're active they come to the surface to breathe, but in winter when the surface is covered by ice they slow their metabolism and rest on the bottom where they survive by absorbing oxygen through their skin.

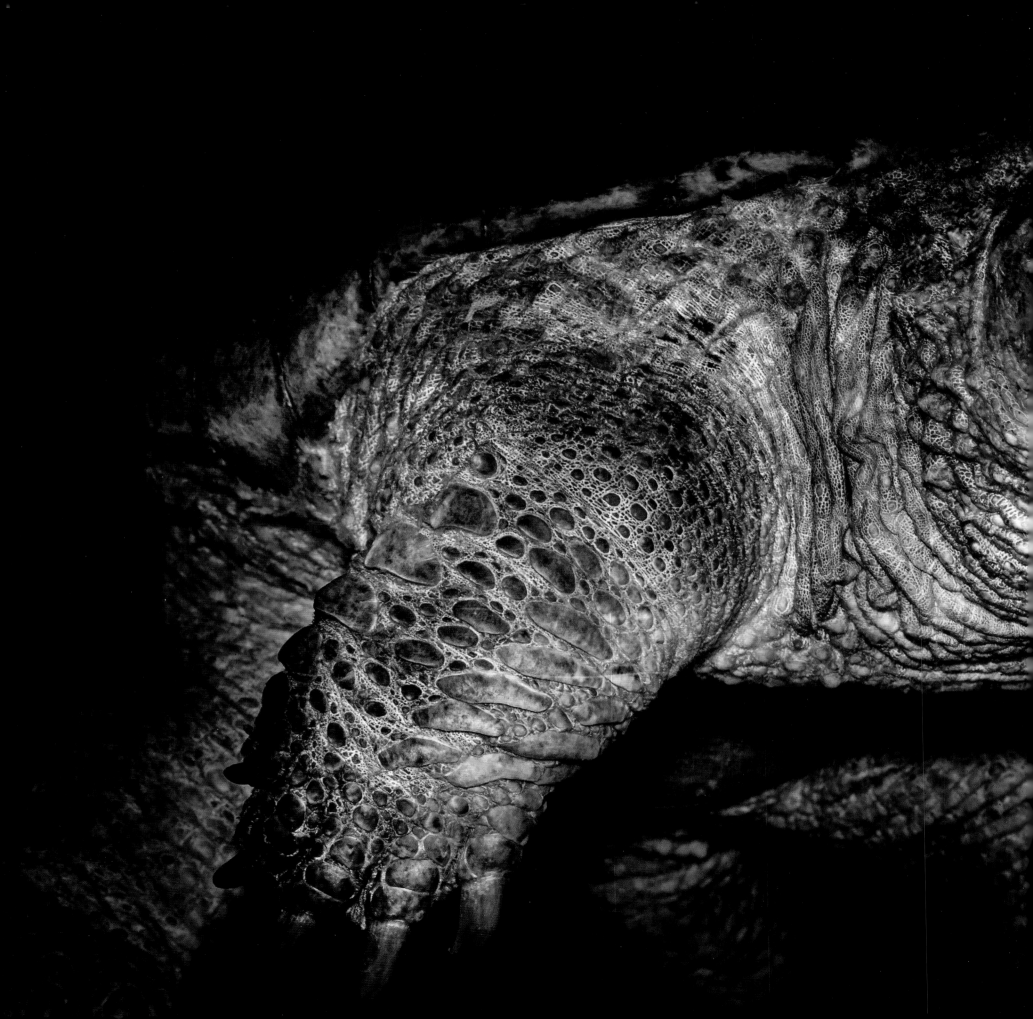

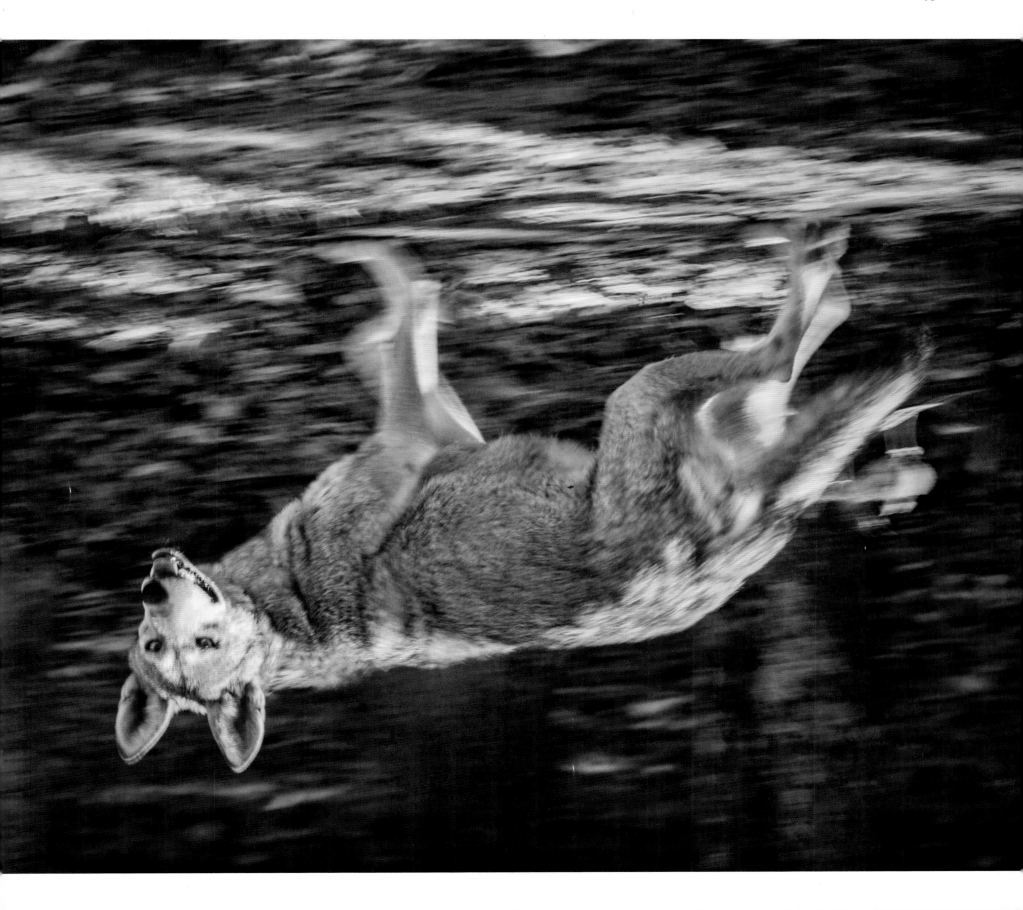

Mice are highly sensitive to their environment. Their long whiskers contribute to their keen sense of touch, and they also have well-developed senses of sight, smell, and hearing. Although many mice inhabit the forest, you're unlikely to see them because they hide when they feel and hear your approach.

Scent is the primary way that white-tailed deer communicate with one another. Their sense of smell is hundreds of times better than that of humans, and even better than a dog's. ◄

At one time wolves and cougars roamed the eastern forests. These days, with those top predators almost gone, nearly every animal in the forest—including gray fox and bobcat—is afraid of coyotes. Coyotes will kill and eat them. In places with many coyotes, very few gray foxes exist. Climbing trees is an important means of escape for both foxes and bobcats.

Any of these larger animals would happily eat mice. A mouse may escape by hiding in a small hole at the base of a tree or between rocks. But it must choose carefully, because a snake might be hiding in any of those places. The timber rattlesnake looks the most frightening, but the copperhead or the friendly looking black rat snake would eat a mouse, too. In this situation the coyote is a friend to the mouse, because the coyote also eats snakes—even rattlesnakes.

The only common animals left that are not afraid of coyotes are adult bears. Bears like to eat berries and seeds and insect grubs—and peanut butter when some human is careless.

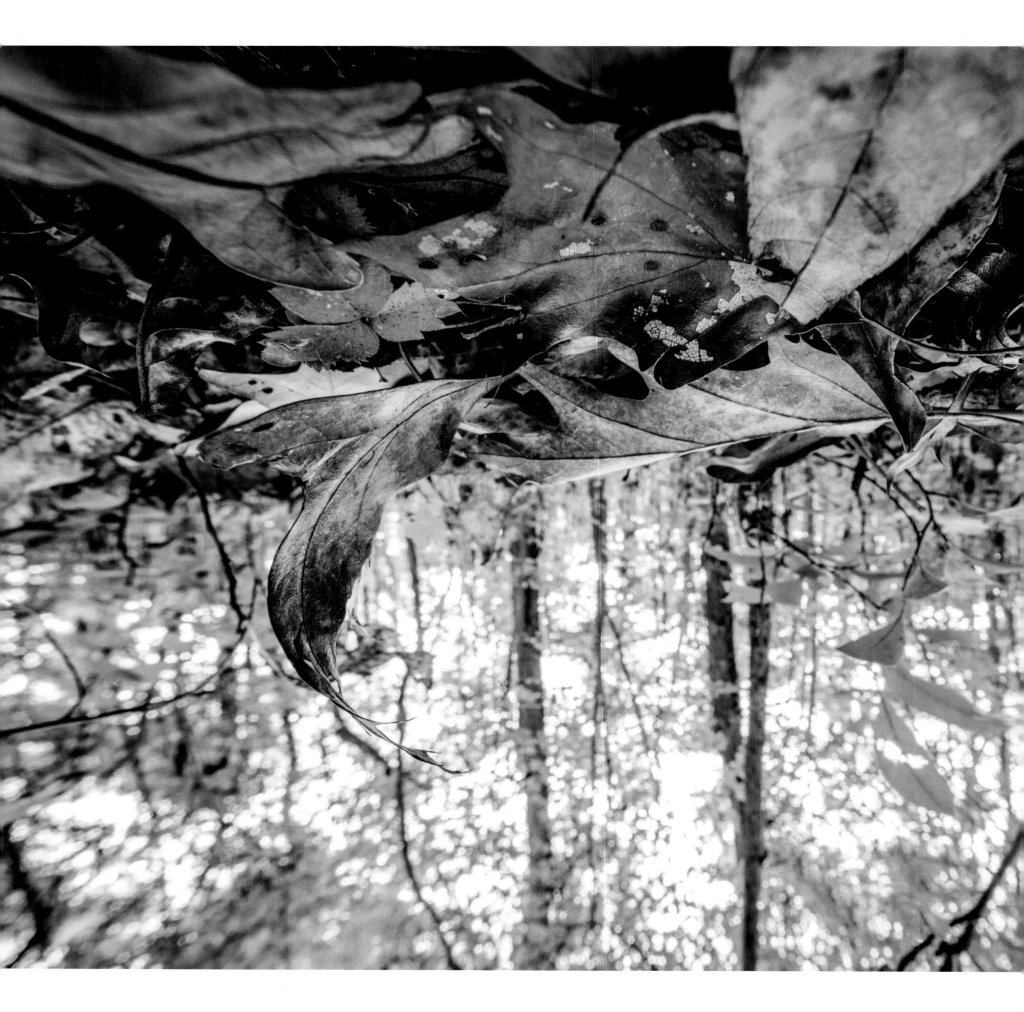

The leaves rustle as the turtle takes step after step. It might be time to pause and nibble on a small blackgum fruit that has fallen to the ground, or a worm, or a slug that looks back. Or perhaps it's time for a rest. Have you ever stood still in the forest and appreciated the beauty of the sunlight streaming through the leaves? Can a turtle appreciate a similar sight?

Another animal you're likely to see in the forest, because it's so large and abundant, is the white-tailed deer. All animal populations go in cycles, and right now deer are very abundant, so abundant that it's hard to believe that a hundred years ago they were rare and endangered. They were completely gone from Indiana, and only tiny populations remained in most eastern states. Extreme hunting pressure is the most likely explanation for their former rarity. Along with hunting deer, humans were also hunting, trapping, and poisoning wolves and cougars—predators of the deer. After many years of this, not much large wildlife remained. In many states, including Indiana, Illinois, Maryland, Pennsylvania, and Tennessee, deer were eventually reintroduced or restocked. But the predators were not.

Now there are so many deer and they're eating so much that we worry about the long-term effects on the forest. If the deer have eaten all the seedlings, what will happen years from now when the big old trees die their natural deaths and no young ones are growing to replace them? The chain of effects is never-ending. Even the turtle may be affected when the blackgum, sassafras, persimmon, and dogwood fruits no longer rain down to where he can get them.

It's getting dark; the turtle sees a mouse nibbling on something. Humans may spot a mouse in their home, but they rarely spot one in the forest. Mice usually come out after dusk, and with their excellent vision and hearing they manage to stay hidden when humans are about. The turtle and the mouse share the bounty on the forest floor but worry that coyotes or wolves could show up at any moment. Coyotes eat fruit, too, but they prefer eating animals. Once box turtles get old enough, their shells harden and they can close themselves inside for protection; but before the age of two their hinges don't work, and before the age of seven their shells are still soft enough for a coyote to bite through.

If a turtle lives beyond seven years and stays in the forest—away from the roads and the mowing machinery—it has a good chance of living fifty more years, and possibly a hundred. What those eyes will see!

The forest floor is a very familiar place for a box turtle. Most box turtles stay in a specific eight-acre home range. In the winter the turtle will burrow a few inches underground.

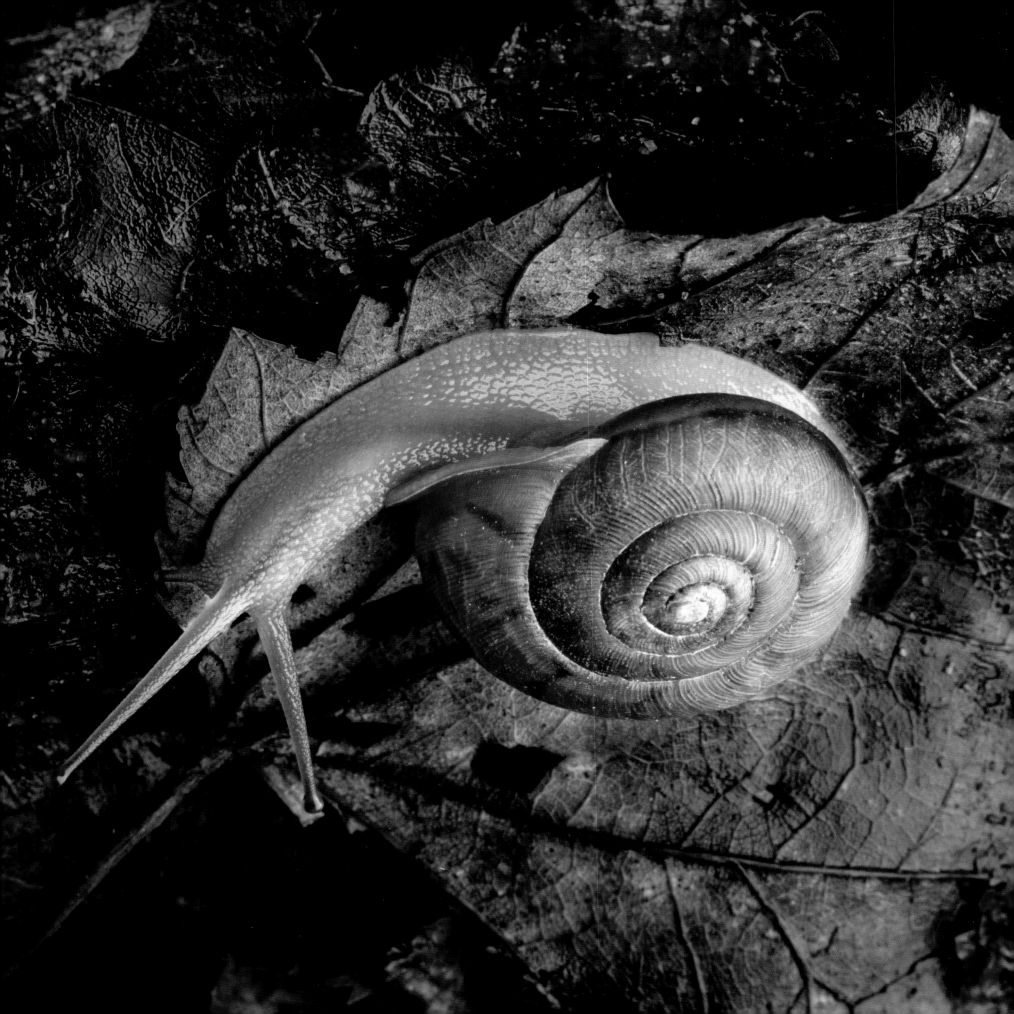

Snails are an important part of the forest ecosystem because they can collect calcium from dead leaves, store it in their shells, and pass it along to other animals that need calcium to produce eggs. ◄

Turtles frequently eat wild mushrooms and thus help distribute the microscopic spores. ►

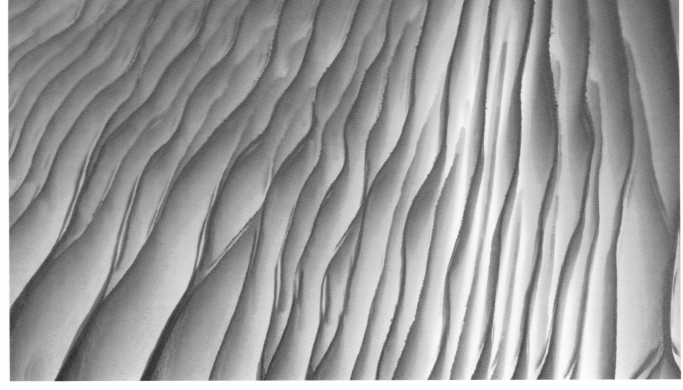

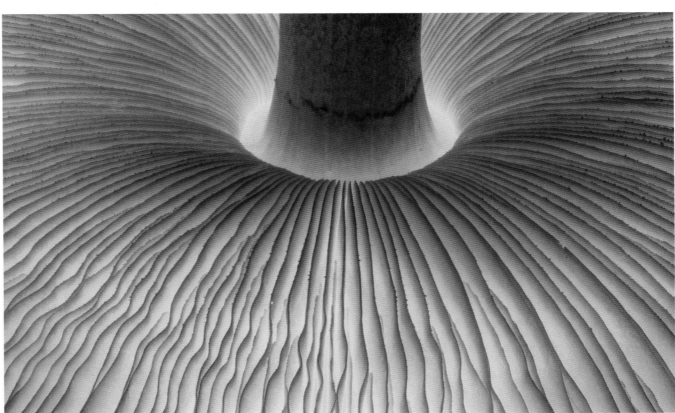

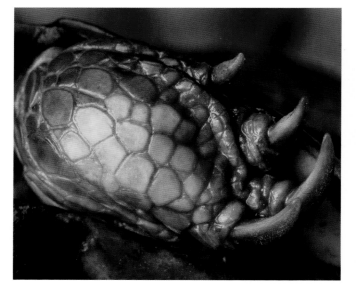

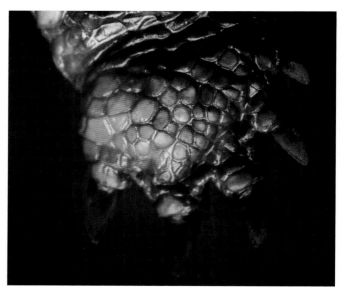

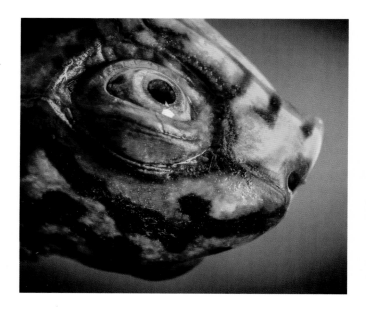

Maybe this turtle's eye is caught by a cicada nymph; just crawling to the surface after years underground, it would make a fine meal. Or perhaps he is watching the mushroom grow that will be tomorrow's breakfast. Are his eyes sharp enough to see the tiny spores that will pass through his body and be deposited along with digested organic matter that makes the perfect compost? A snail is feasting on one of the mushrooms. Turtles like to eat both snails and mushrooms. Which one will he choose?

Snails are a very important part of the ecosystem because in addition to eating mushrooms they eat dead leaves, a food few other mobile organisms are interested in. The dead leaves contain small amounts of calcium, and the snails store this calcium in their shells. Other animals that need calcium in their diets—like turtles and turkeys—eat snails to supply this need. Turkeys need the calcium to produce strong eggshells, and research shows that they seek out and eat more snails during the egg-laying season. Turtles need calcium to ensure strong shells.

Possibly the box turtle is looking for the patterned shell of a female. Each turtle's shell is unique, and maybe he will recognize the shell of a she-turtle he encountered last spring. His five-toed front foot reaches forward an inch while his four-toed back foot pushes off. The female he's looking for will have longer, narrower front nails and yellowish-brown eyes. Perhaps she's looking for him, too, but since box turtles can't call out in the manner of birds and wolves, their meeting may be strictly a matter of chance.

(TOP ROW) A colony of mayapple plants offers food at just the right height for a turtle. Although the fruits are toxic when green, box turtles readily eat the ripe yellow fruits and spread the seeds through the forest.

(PREVIOUS) Unlike other eastern turtles, box turtles are creatures of the land.

What does the world look like through the eye of a male box turtle? Females have yellowish-brown eyes.

Many box turtles live for more than a hundred years. Each one has distinctive markings on its skin and shell. ▶

On the Ground

Animals of the Forest Floor

WE KNOW THAT THE forest is home to many animals, but it's rare for us to see them. Humans tend to be loud and clumsy creatures, giving the animals time to hide before we approach. Those we are most likely to see are the slow ones, like box turtles. Although they're quiet, harmless, and not uncommon, we still feel delight when we find these wild creatures crawling across the ground.

Our domestic pets depend on us for their food, but the wild things in the forest must find their own. What does the slow turtle find to eat? Box turtles eat just about everything. This turtle might be looking for his favorite fruit, the mayapple. Dangling beneath the low leaves, this snack is at just the right height for a turtle. He will crawl away with seeds in his belly and deposit them in another part of the forest where perhaps they will start a new colony. On the way he might also nibble on fallen dogwood berries or sycamore seeds.

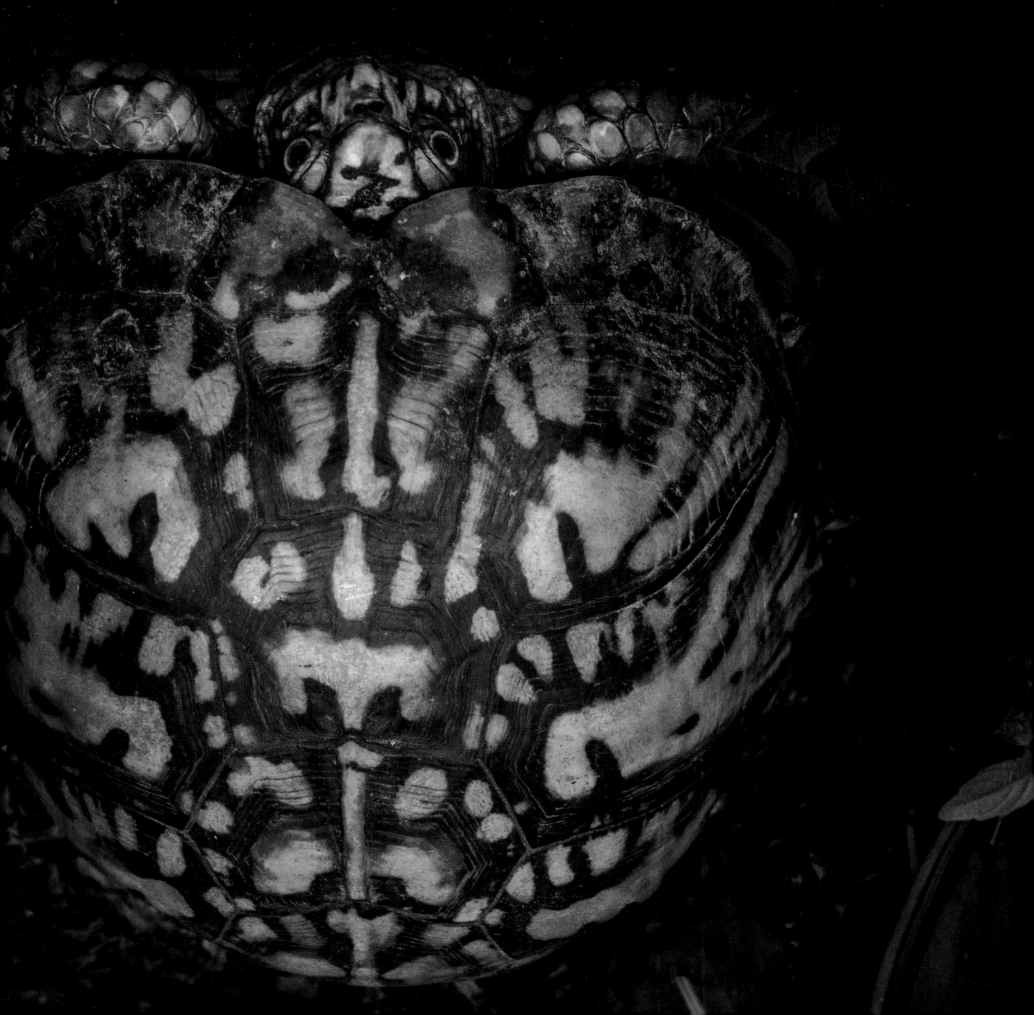

This large old snapping turtle, like all turtles, is more closely related to birds and dinosaurs than to lizards and snakes, something we've learned in the past few years with the development of sophisticated genetics techniques.

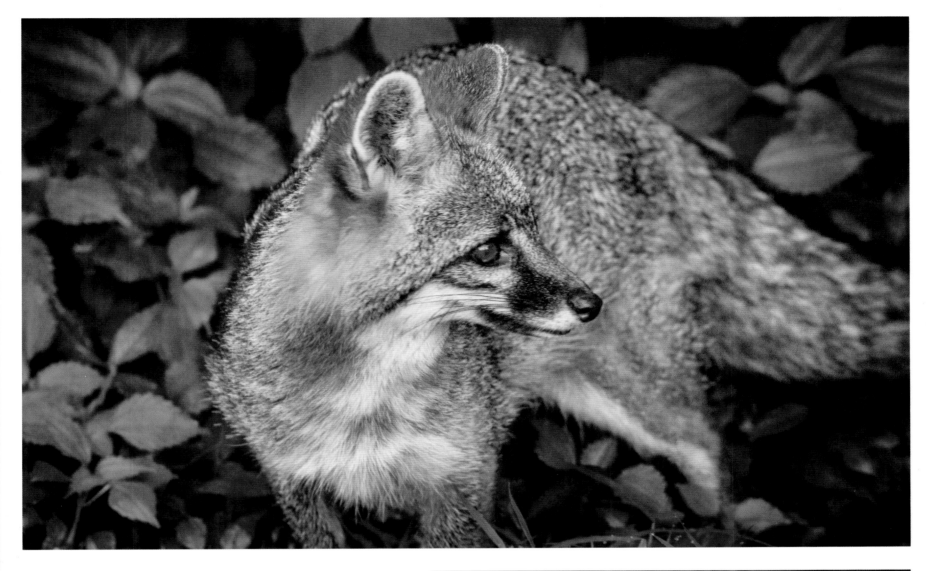

Historically, red wolves were found in the bottomland forests and swamps of the southeastern United States. They were almost driven to extinction but are now being reintroduced through captive breeding programs. ◄

Gray foxes have hooked claws that enable them to climb trees. This helps them reach tree fruits, escape predators, and get to denning hollows high up in trees.

The female bobcat has a home range of about four square miles. She marks her territory with scents and scratches, and raises her young alone. ►

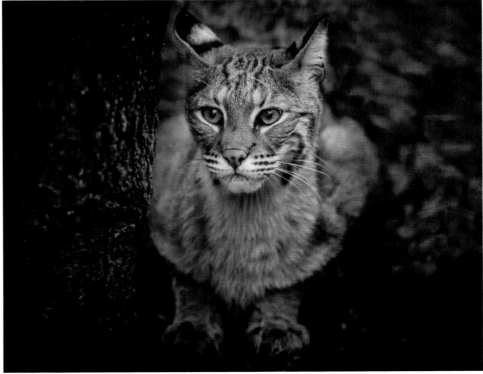

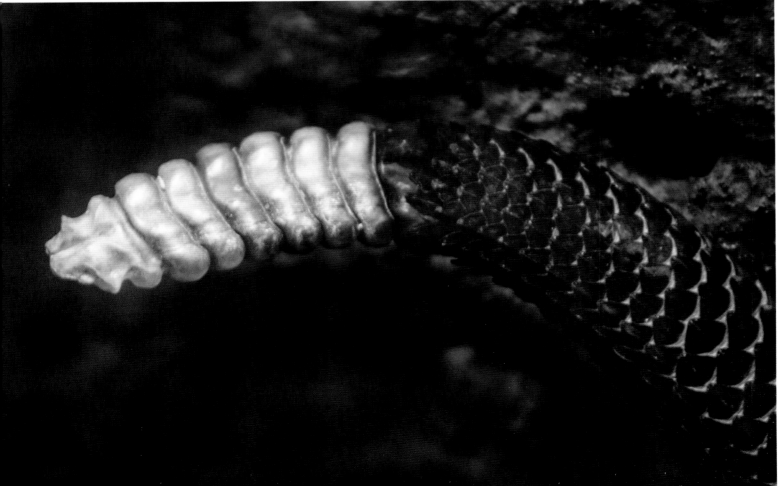

The rattlesnake is a deadly predator of mice, but at least it warns of its presence.

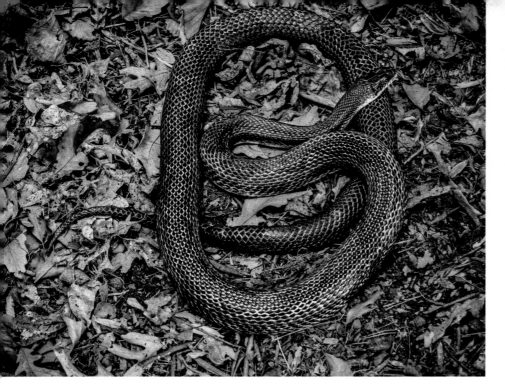

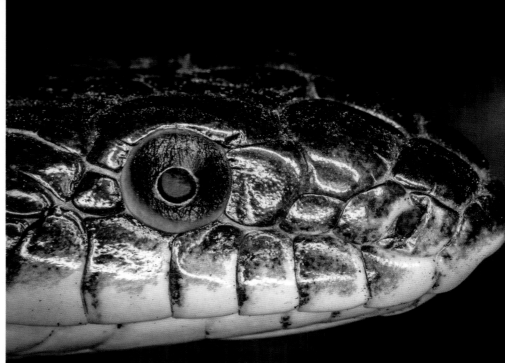

Black rat snakes are harmless to humans, but they would happily eat a mouse. In winter they may hibernate in the same den with rattlesnakes.

All of this eating! And we have barely touched on a few strands of the food web. The interactions are incredibly complex and vary by location, time of day, and time of year. But at the base of every one of these strands of the food web you'll find the forest plants, because they are the ones able to pull energy from the sky. And even when a life has ended, the matter and energy previously held in that form continues to be passed down the line—to the bacteria and the fungi, the insects and the soil, until all that's left are the invisible atoms and molecules, and finally those return to the trees themselves. The cycle continues, but the story ends differently every time.

Trees are capturing energy and turning it into matter. And the matter— leaves, fruits, branches, whole trunks—continuously rains down upon the ground. Imagine if thousands of years' worth of this organic matter stayed where it landed. No seeds could reach the soil to germinate, it would be nearly impossible for animals to move across the land, and fires would burn so hot that nothing could survive them. Fortunately, we have a different sort of food web that processes the dead. It starts with the bacteria. Bacteria are everywhere all the time; they cover our skin, they cover the leaves, they cover the ground, they exist in unimaginable diversity, and they are changing all the time. Whether you're animal or plant, there are bacteria that harm and bacteria that help.

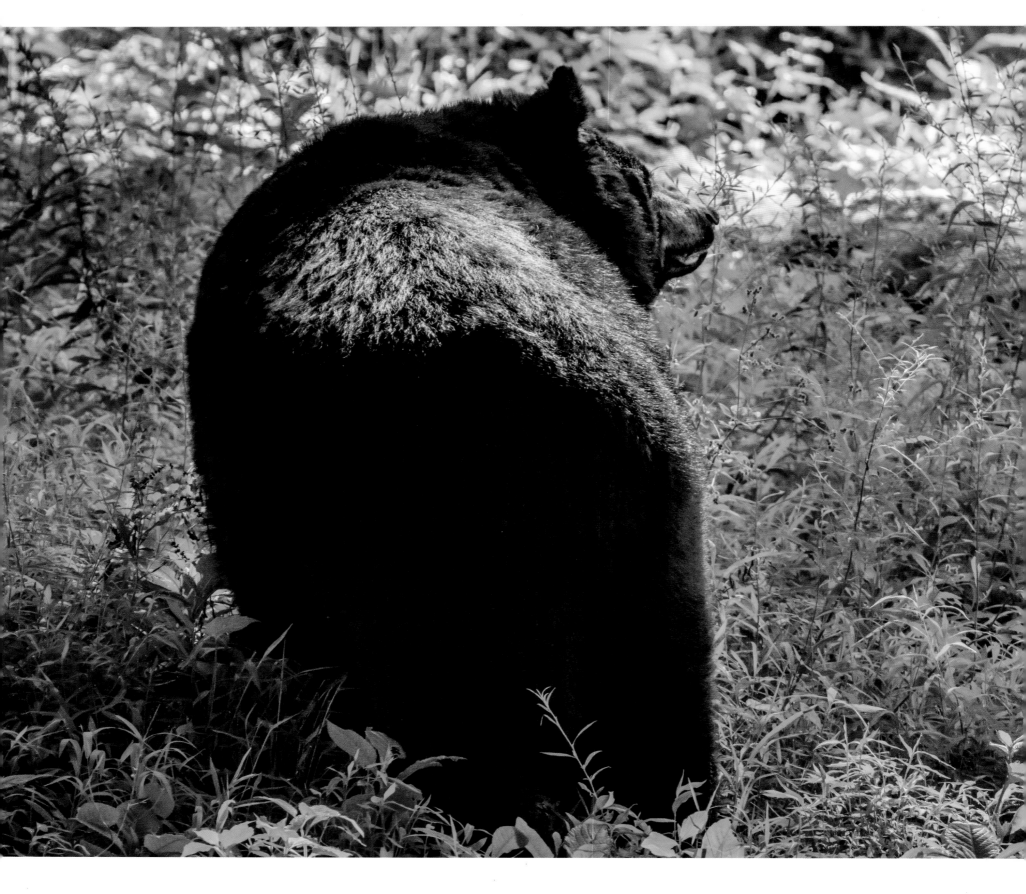

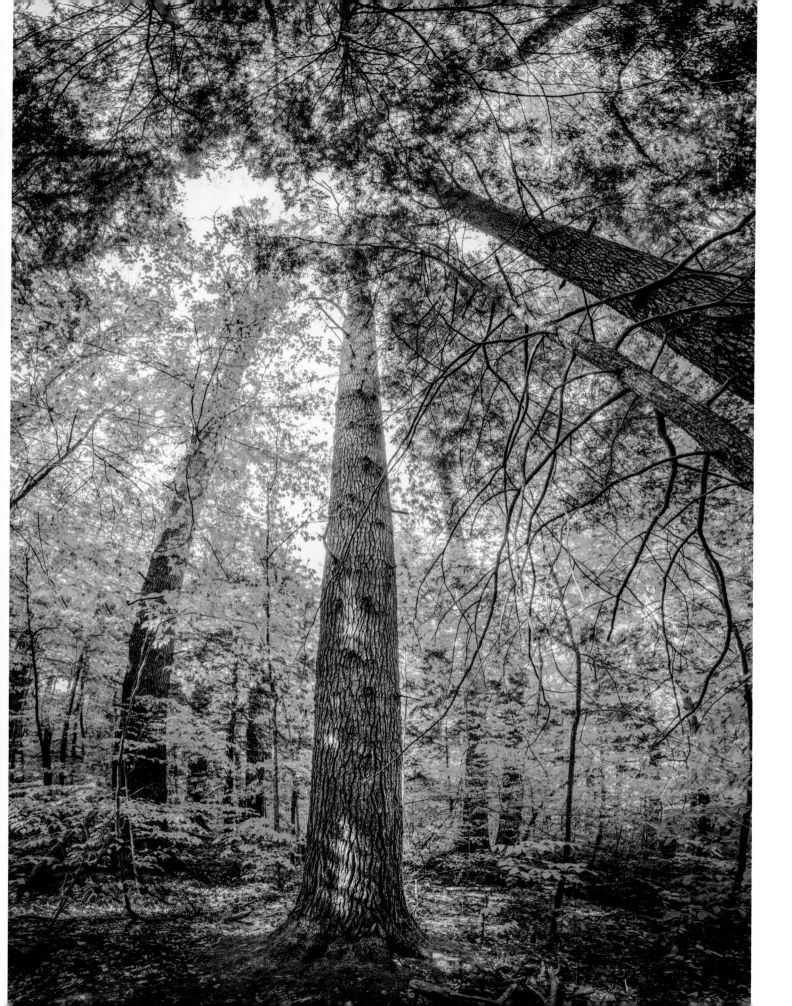

All strands of the food web start with photosynthetic organisms. Plants are the green fuse that lights the fire of life and hands energy down the line. ◄

(OPPOSITE) Prime habitat for black bears consists of a forest with mature hardwoods such as beech, maple, birch, and evergreen species. Bears can both climb trees and swim.

Bacterial coverings shift throughout the day and year. When something (or part of something) dies, the bacterial community covering it starts shifting in response. The processes that previously kept certain bacteria in check are no longer functioning. Along with the bacteria, microscopic fungal threads also start growing on the detritus. The dead matter becomes a matrix for the small living cells. And other, slightly larger but still tiny things feed on the bacteria and the fungi—like those amoebas and ciliates you may have seen under the microscope at school. And bacteria can feed on fungi, and fungi on bacteria, and fungi on fungi, and so on. It's a tiny complex world down there that we hardly know anything about. All these little things begin to break down the dead matter and make it more nutritious at the same time.

Then along comes something that eats them all up at once. A millipede is monstrous in dimension compared to the microbes we're discussing. A millipede crawls across the ground munching entire leaves that contain complete tiny ecosystems. And if anything tries to stop it, the millipede sprays it with poisonous cyanide. Its bright coloration is common to creatures, like bees, that are bold enough to warn of their venom. If you pick up a millipede and shake it loosely between your hands, you'll smell its defensive scent. The odor is rather pleasant, but it might be a good idea to wash anyway.

Millipedes were the first land animals, and one of the early species was more than six feet long. Like the turtles, they have seen even the dinosaurs come and go. Today, only animals like toads are interested in eating millipedes.

The millipede's job of chewing up fallen leaves helps speed decomposition along. And although it gains some nutrients and calories from this ingestion (mostly from the microbes on the leaves), the millipede's re-ingestion of its own excrement is more important. You see, after the millipede eats the leaves, it eliminates them in pellet form. The pellets are moister and higher in nutrients than the originally ingested leaves, so they're an even better place for bacteria and microbes to live and multiply. By the time a millipede gets around to re-ingesting the pellets, the meal has become even more nutritious. It may sound gross until you consider that we have bacteria helping us with digestion and nutrient release, too—it just happens inside our large intestine. Many other animals, from ruminants to birds, use multistage digestion; it just doesn't include an external stage.

Dead plants are also a part of the food web. The slow decomposition of tree trunks provides important habitat for many species. Eventually the wood becomes soil.

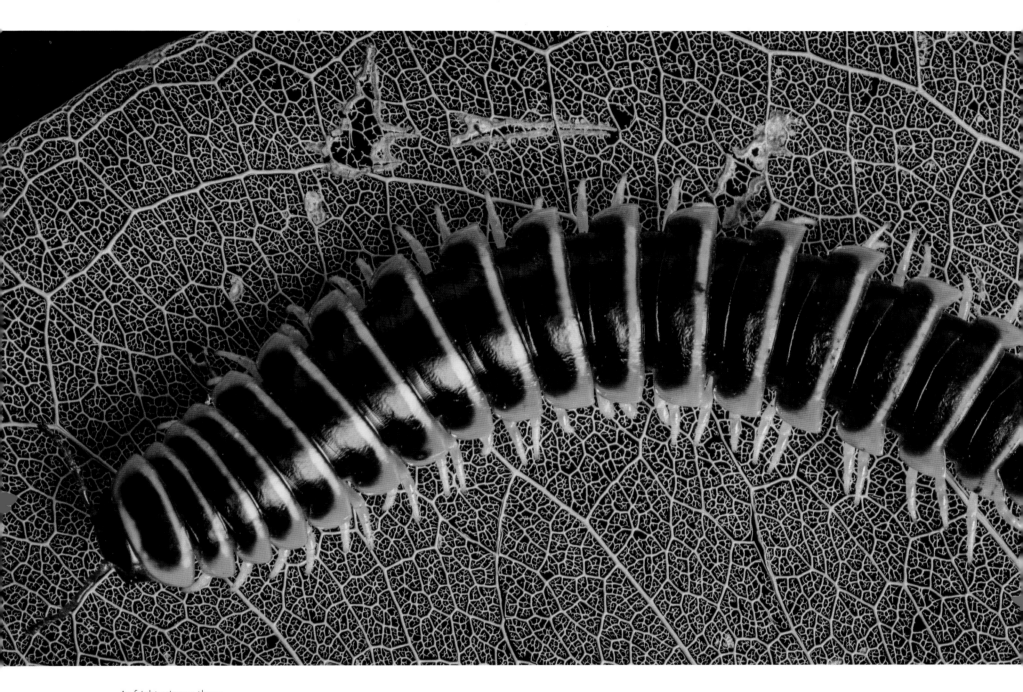

As frightening as these creatures may appear, the millipedes in our forests are harmless to humans.

Another tiny creature moving across the forest floor that is important in breaking down all those fallen branches and trunks is the termite. Unlike in our homes, where termites are an unwelcome pest, in the forest termites play a key role in releasing nutrients from wood back into the soil. But it takes a village to accomplish this important task. A termite can be thought of as the vessel and vehicle for the hundreds of tiny microbes in its gut that do the real work of wood digestion. Termites are so dependent on these microscopic bacteria and protozoans that they would starve without them. Within the gut these tiny beings have their own division of labor, and they, too, would not survive without each other.

Ants are the enemy of both millipedes and termites, so both those organisms have evolved strategies to defend against them. One study found that the millipede's defensive chemical makes ants act crazy, cross their antennae above their heads, and then pass out. Termites, on the other hand, have a whole social class whose main job is to crush ants. They're so specialized for this task that they're not even capable of feeding themselves. Despite this soldier caste, ants are still the number one cause of termite mortality. Salamanders can be of some help here, since they frequently eat ants.

(TOP) The Fowler's toad eats the many insects that live in decaying vegetation.

Ants in a colony tend eggs that have entered the pupal stage. In E. O. Wilson's book *The Ants*, he notes that the estimated ten thousand trillion individual ants alive at any one time weigh about as much as all human beings combined. Their tightly woven social system is the key to their success. ▶

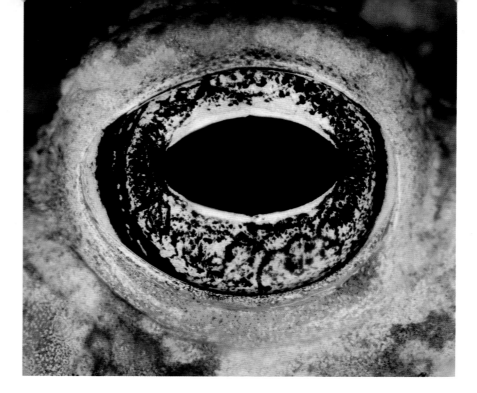
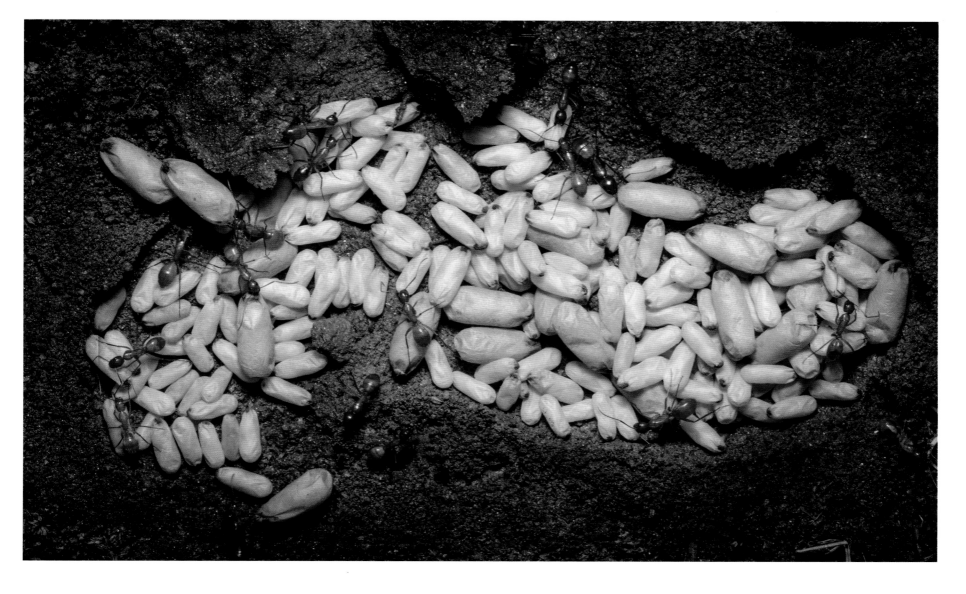

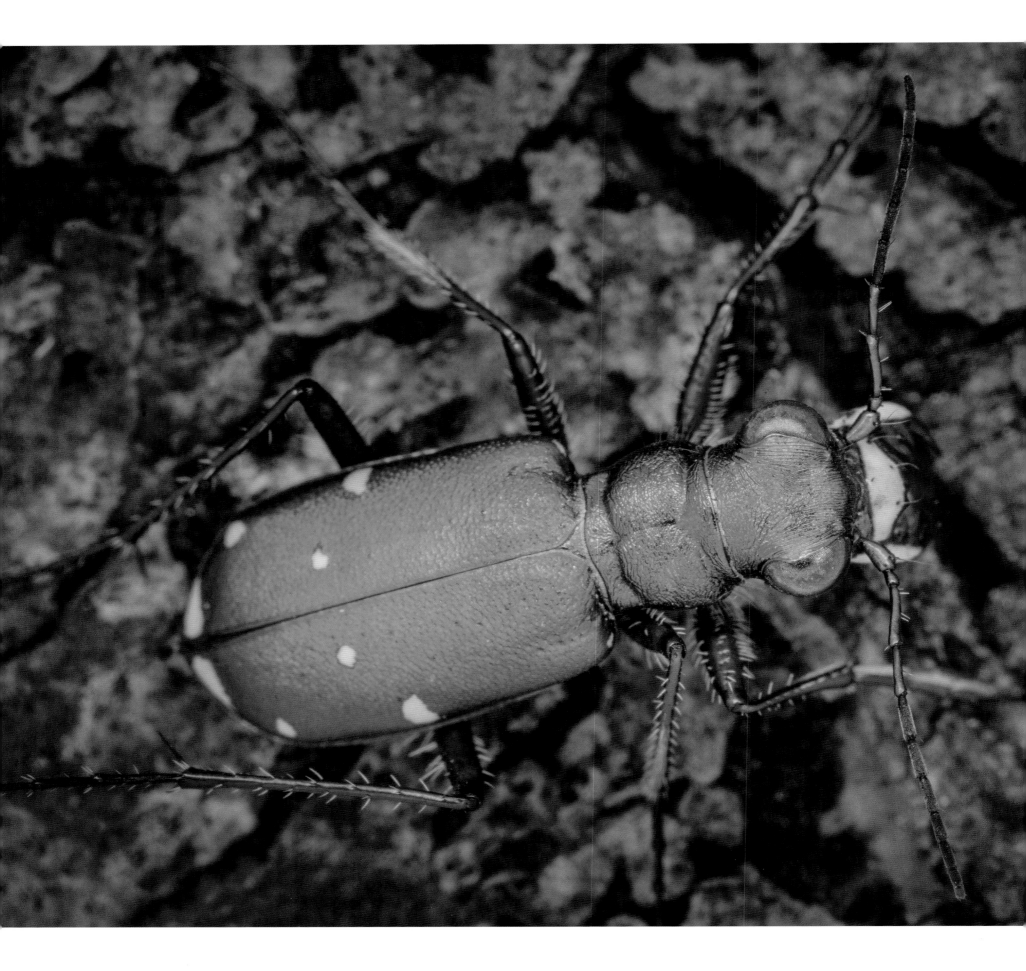

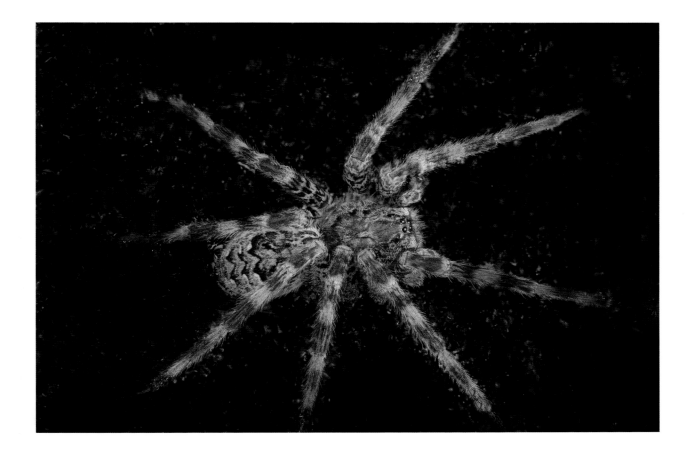

Wolf spiders have eight eyes arranged in three rows. If you shine a flashlight in the forest at night, you can see glowing reflections from all the spider eyes.

A six-spotted tiger beetle roams the forest floor by day, and at night it returns to the same hole where its mother laid the egg it hatched from. ◄

The larval phase of the iridescent green tiger beetle is another ally in the war on ants. The fast and graceful adult beetle runs across the forest floor. A fertile female makes individual holes in the soil and deposits one egg in each. When an egg hatches, it becomes an unattractive white grub with a frightening dark head. The grub stays put in its natal hole and waits for ants to crawl by; then, springing its head from the hole, it catches them in its jaws. After a year of this lifestyle the grub pupates and then hatches into an adult. Imagine waking up to be a fast, lovely, iridescent green creature after a year as an ugly stay-at-home troll! But the adult beetle doesn't forget its roots; every night, after a day of foraging, it returns to the same hole where it was born. It will spend the entire winter there, too. It can live for up to four years if a toad or a wolf spider doesn't eat it before then.

All of this is happening on the forest floor, and we walk by it almost as if we live in another dimension. All of these interactions, these lives in the forest, are dependent on the presence of the trees and the structure, matter, and energy they provide.

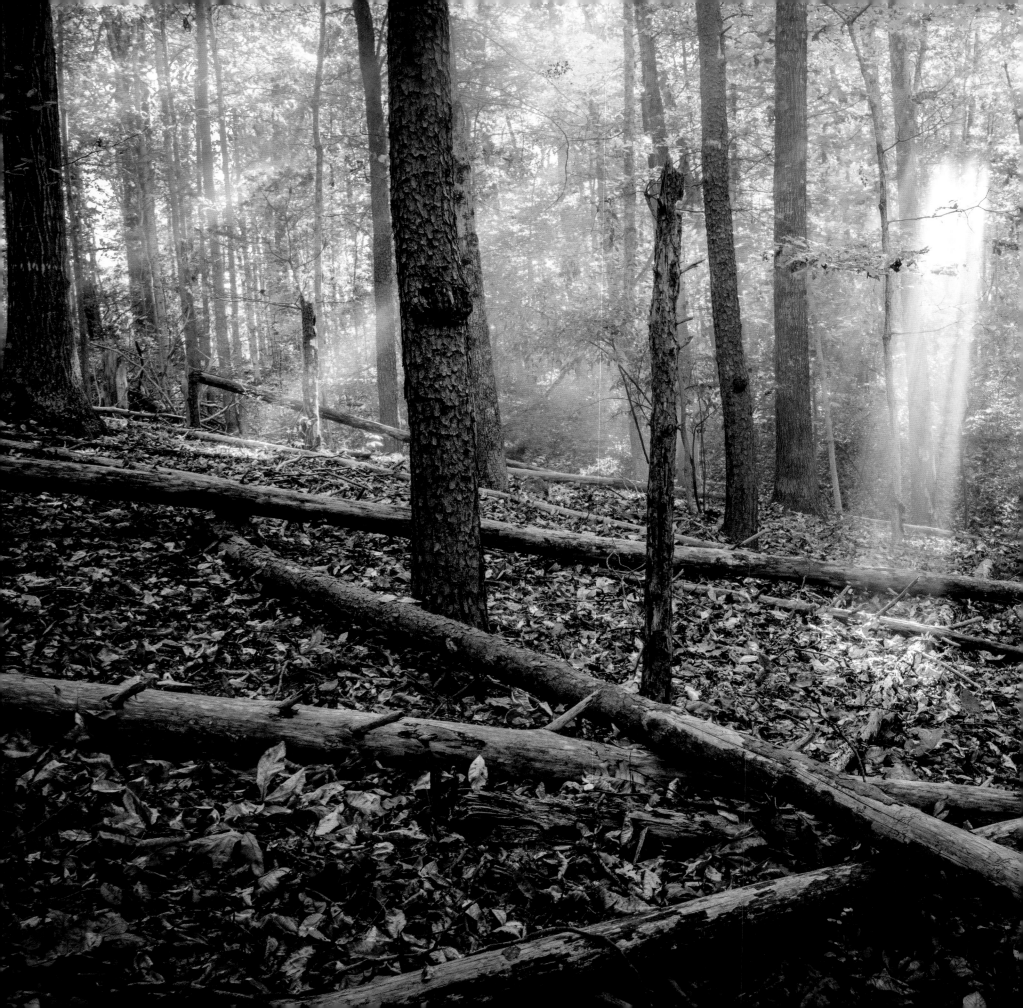

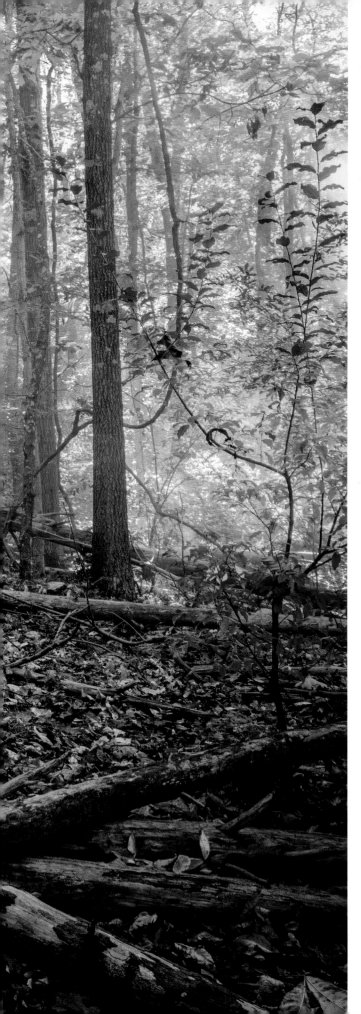

The Middle Realm

Trunks

WHILE WALKING THROUGH A forest you might focus on the ground looking for animals and wildflowers; or you might focus on the spreading branches in the canopy and the birds that move amongst them; but most often a forest experience is one of trunks, for that is the forest at human eye level.

You might first register the trunk size: large, medium, small; and after that the patterns of the bark: smooth, striped, shaggy. Take enough forest walks and you may start wondering which species is associated with each pattern. Many botanical guidebooks use leaf shape for identification—but those leaves are so far away from where you stand that you can barely tell if they're pointed or lobed. The bark, however, is right where you can touch it and smell it.

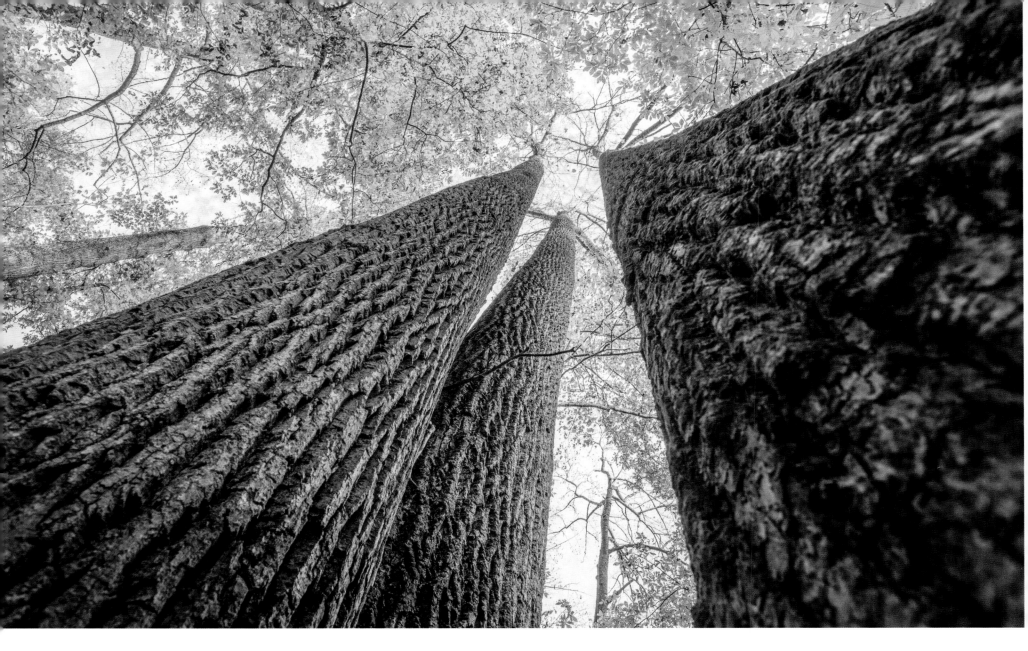

To some, the study of bark patterns might sound like a boring hobby, but once you get into it you discover a maze of great complexity. One avenue of this maze is that the bark patterns on a tree change over time. The young ones look very different from the old ones. And the older they get, the more individual they become, just like your aging relatives. Two trees of the same species and the same age side by side may look very different.

And beyond the study of bark as a means of identification is the pleasure to be gained in the sheer aesthetics of bark. It has a single function—protecting the growing layer beneath it—but so many different ways of accomplishing that task.

(PREVIOUS) In between the canopy and the ground is the middle realm—the tree trunks and the creatures that use them either as highway or home, or both.

A three-trunked tulip poplar rises from the ground to the sky.

A close look at bark reveals the wondrous diversity of patterns. ▶

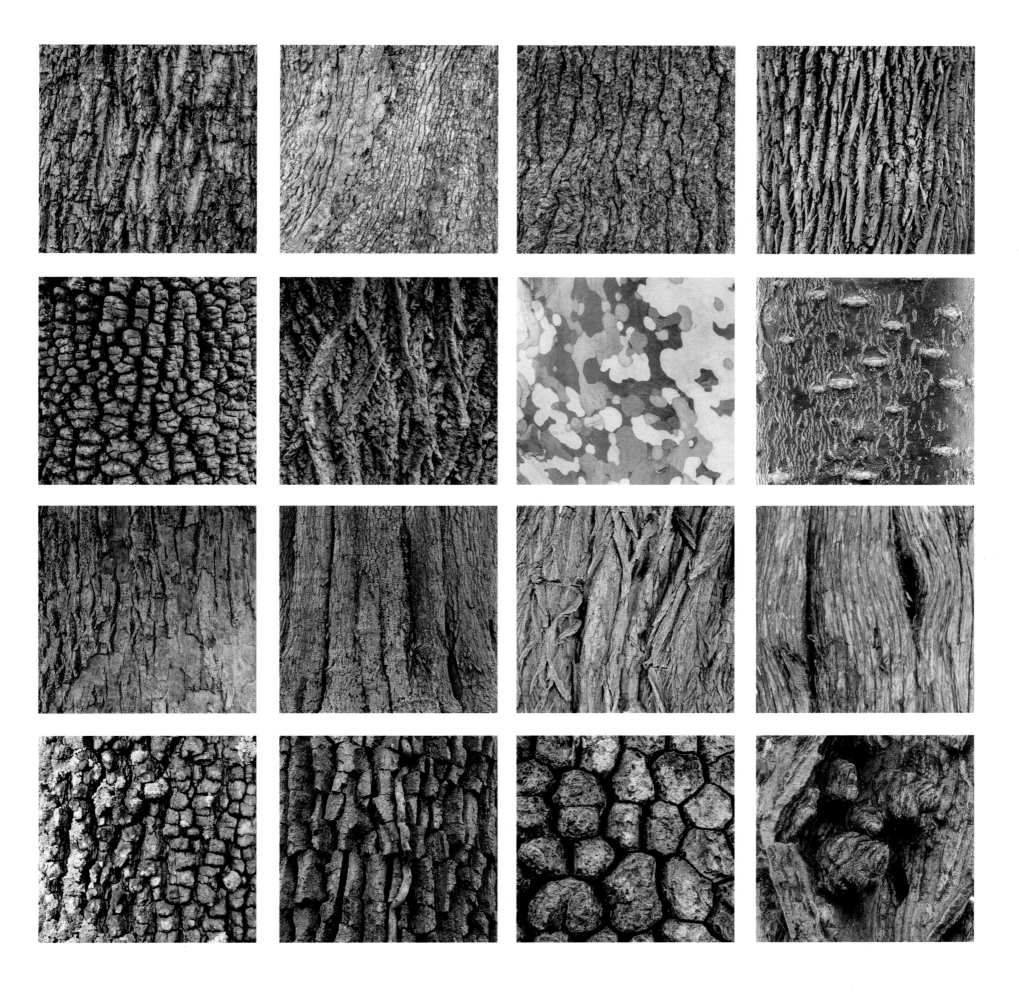

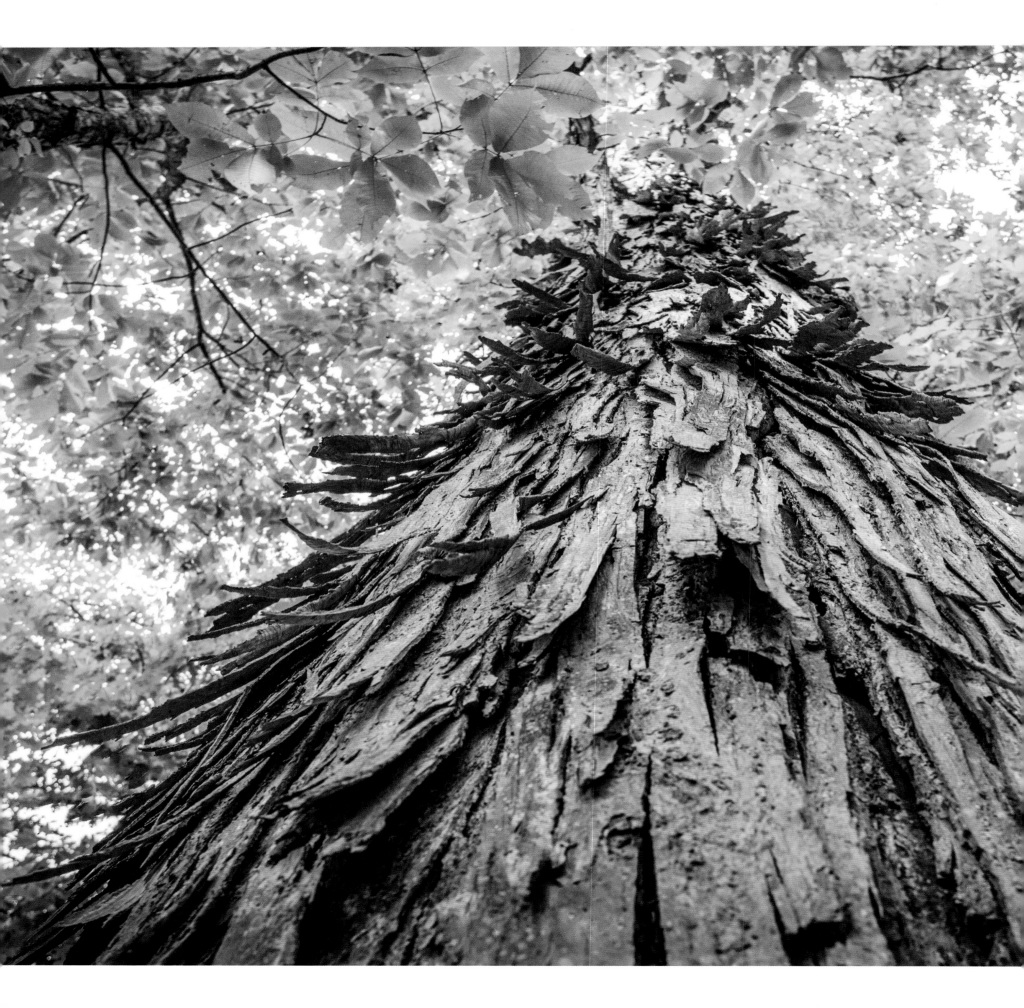

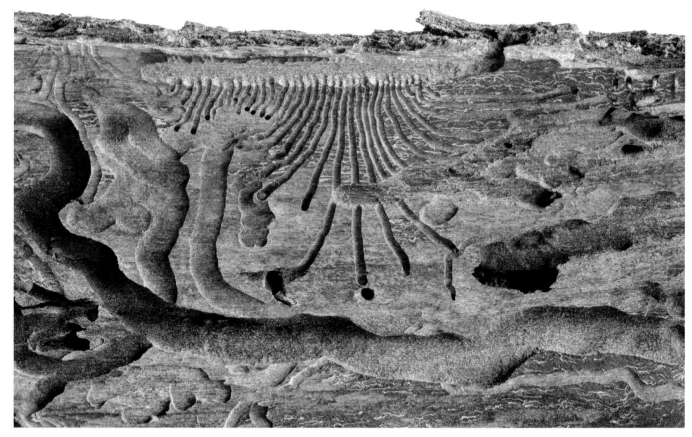

A whole world of interactions may occur beneath a tree's bark. The beetle larvae who made these tunnels are long gone, but their work remains. ▲

Some trees, like this shagbark hickory, get shaggier as they get older. These bark flaps are good places for small bats to sleep away the daylight hours. ◄

Under this interesting brown covering you'll sometimes find another world—a lovely, complex world created by insects that live by eating the tender wood beneath the bark. The insects may be long gone, but the signs they leave behind indicate that an intelligent society once occupied this territory, much like the abandoned cliff dwellings of the Anasazi Indians.

The tiny creatures at work here are bark beetle larvae. There are many different kinds of these beetles. An examination of the patterns, along with knowing the tree species they're found on, help determine which particular species made the designs.

In some species, the male beetle will gnaw his way through the bark and a short distance into the wood to create a space for his "lady friends." Guided by his scent, between one and five females will find their way through the passage he made and into his bachelor pad. After they mate with the male beetle, the females go their separate ways and begin chewing their elongated nurseries. In other species of bark beetles, it's the mated females who tunnel through the bark and into the tender sapwood. No matter how the first part of the story goes, the second part is always the same: the female chews a small separate space for each of her eggs and then lays them, at which point her work is done.

The eggs eventually hatch into pale wormlike larvae. These larvae know the world only as a dark place that smells of fresh wood. They don't have to think about what to do next, for they're genetically programmed to start chewing in a particular pattern. Some species chew in wandering S-shaped patterns, and some head in a right angle away from the main nursery chamber. As the larva slowly eats its way away from home, it grows larger and larger. Just as pencil marks on a farmhouse wall indicate the growth of its young residents, the size of an individual tunnel reveals the growth history of the larva.

Then one day the larva doesn't feel like chewing wood in a line anymore, as it has been doing all year; instead it chews a small cavity and just lies there. Its skin begins to get dry and tight. It turns brown. If a larva thinks, it might think it's dying. But then spring arrives, the brown shell bursts, and it has become a winged insect. It starts chewing at a right angle once again—but this time the turn takes it toward the outer bark. After a final mouthful of bark our creature sees sunlight for the first time—and its wings are used for the first time, too. In the tree trunk is a small hole where the beetle emerged, and somewhere in the forest is a little beetle looking for a mate.

The trees aren't harmed much by the small in-and-out holes; most of the damage is done by the larvae-created tunnels that cut across the vessels used to transport fluids. This can kill a tree, although that's not the larvae's objective. The emerald ash borer and the southern pine bark beetle are two notorious killers. Sometimes the adult beetles carry in fungus spores, and the fungus may do more harm than the larvae.

In the end, bark beetles are bad news for individual trees, but they're part of the greater forest ecosystem. By bringing stressed trees to the ground, the beetles create homes and meals for a myriad of other organisms, including fungi, birds, reptiles, amphibians, and mammals. And they bring light to those small plants on the forest floor awaiting their turn in the sun.

With all this talk of tree trunks, let's not ignore the animals who use these trunks as vertical highways. A whole suite of forest organisms don't live just on the ground, or just in the canopy, but instead move between these two worlds—between heaven and earth. Squirrel is the first one who comes to mind.

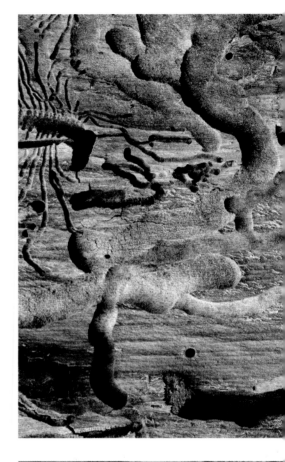

Viewing these lines and shapes made by beetle larvae at a much larger scale, you might wonder about the intelligent beings who made them.

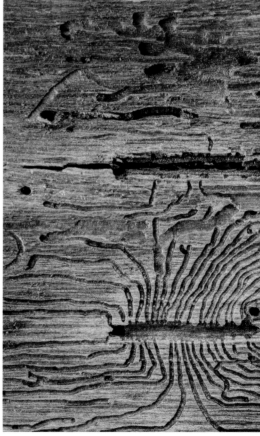

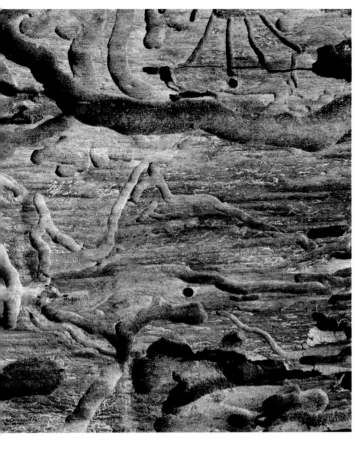
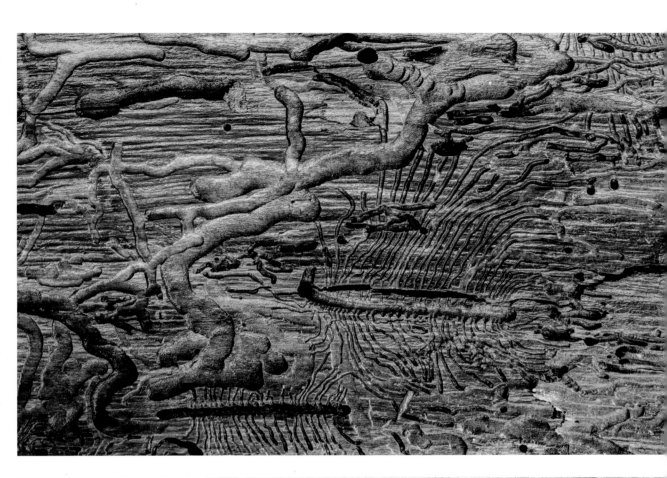
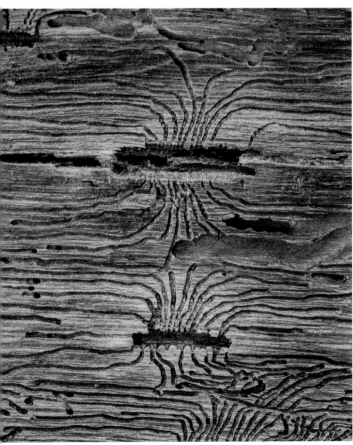
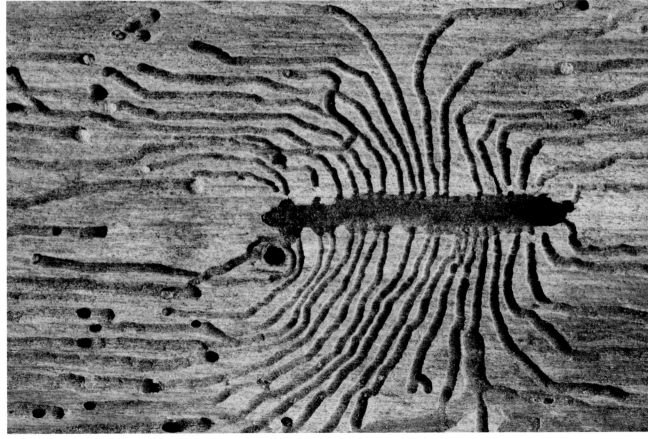

Squirrels nest up in the canopy in small groups of related females, or just single males on their own, but to find and store food a squirrel must move up and down the trunk. Squirrels eat just about anything, including buds and bark, but seeds that can be stored in the ground, such as acorns, beechnuts, and hickory nuts—all gifts from the trees—are their most important food. On a harvesting mission, a squirrel will collect a small number of seeds and hide them together under leaves or in the ground. Then it will go to collect more seeds and hide them somewhere else, and so on. It may create thousands of these small caches. A squirrel remembers where it hid all of the seeds, and within two days it will be back to eat the seeds or move them to longer-term storage. If they're seeds that might germinate soon, like the white oak acorn, the squirrel will nip out the embryo.

In the course of this foraging, squirrels find other things to eat that won't keep underground. These treats, such as dogwood berries or cicadas, they will eat right away while perched in the canopy. A squirrel has big pads on the sides of its thumbs, and it holds its food between these pads while it eats. This gives the impression that it's praying.

Thinking like a tree, it may at first seem that the squirrel is a predator—eating the tree's offspring. But if something were to happen to the squirrel (coyote!), then it has done the tree a favor by tucking seeds into the ground out from under the canopy. So a squirrel is neither all good nor all bad for a tree.

While all of this collecting and burying is going on, another drama is unfolding, for squirrels live in a world with a dominance hierarchy. The older males are the most dominant, and when a younger male approaches without the proper attitude of submission the dominant squirrel gets aggressive. This is all communicated with the tail. The tail can be controlled to bend just at the tip, to bend near the middle, or to be held straight (either up by the back or out flat). A tail folded over in the middle or lower indicates subordination, and this squirrel is unlikely to be chased; but if our squirrel holds his tail straight up, the dominant male will chase him.

Female squirrels, on the other hand, have their own social hierarchies. And in both sexes, friendliness expressed as grooming or playing is just as important as aggression. A female is fertile only twice a year, for less than a day each time, and dozens of males may approach her on that day. Mating usually occurs high in the canopy. A dominant male will aggressively defend his access to her, but she often runs from him; as a result one of the young males waiting lower in the canopy may get an unexpected opportunity to mate with her instead.

Dog-day cicadas do not eat at all as adults, but they may be eaten by squirrels. The nymph of this species spends only a year underground, not thirteen or seventeen years like the red-eyed periodical cicadas.

Gray squirrels can communicate with the position and action of their tails. ▶

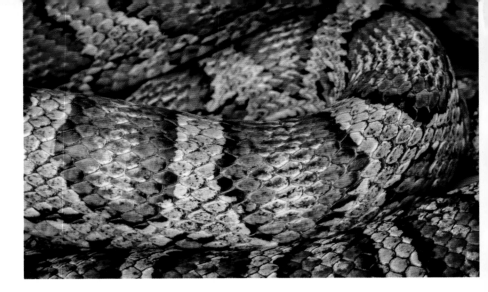

A squirrel also uses its tail in response to threats from predators. An approaching cat will elicit a wild waving of the tail. Interestingly, an aerial predator, like a hawk, will not cause tail waving but will instead cause our squirrel to call out "quaa," and all the other squirrels will stop eating or burying food and look up. Considering how closely squirrels live with humans, it's surprising that scientists learned these things about squirrels just a few decades ago.

It has been observed that when squirrel populations get superabundant, generally in the early fall, the squirrels may swarm—large groups move long distances across the landscape together and even swim across bodies of water. These swarming events were more common in the past than they are now.

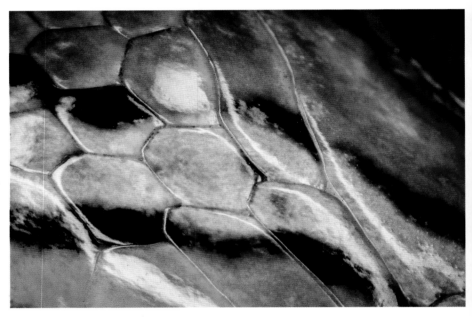

A number of other animals share this highway of bark with squirrels. One is a predator that approaches slowly and silently: the red corn snake. The snake might make dinner of a nest of baby squirrels. This may seem unfair until you consider that adult squirrels sometimes eat baby birds, and a king snake will eat a corn snake. Round and round goes life in the forest. And we step back and see that some always survive—some squirrels, some birds, some trees, some snakes, some turtles.

Besides the bark borers, multitudes of other insects call the trunk home and don't kill the trees. Many of these insects are eaten by tree frogs, who spend most of their time in the canopy and then move down the trunk when it's time to breed. Tree frogs are primarily canopy dwellers, but they need a pool of water for their eggs. Mating and egg laying are done in the same pools where the salamanders breed. Since tree frogs can't fly, or even leap that far, they must make their way down the trunk and back up. They're vulnerable to predators during this time, but some protection is offered by the fact that their skin can change colors to take on the hue and pattern of the surface they sit upon.

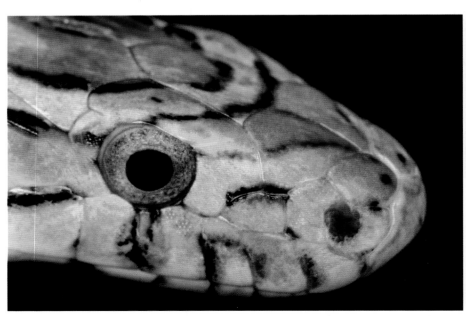

How animals change colors to match the surrounding environment is still being researched. It primarily happens through the action of specialized star-shaped cells in the skin that contain small bubbles of pigment. When the bubbles all move to the same spot in the center of the cell, the skin appears one color; when the bubbles spread throughout the cell, the skin changes to a different color. In frogs, these cells are triggered to move the bubbles by hormonal chemicals circulating through the bloodstream. But what cues the frog to make these hormones? Light reflectance received through the eyes? There are still many mysteries in the forest.

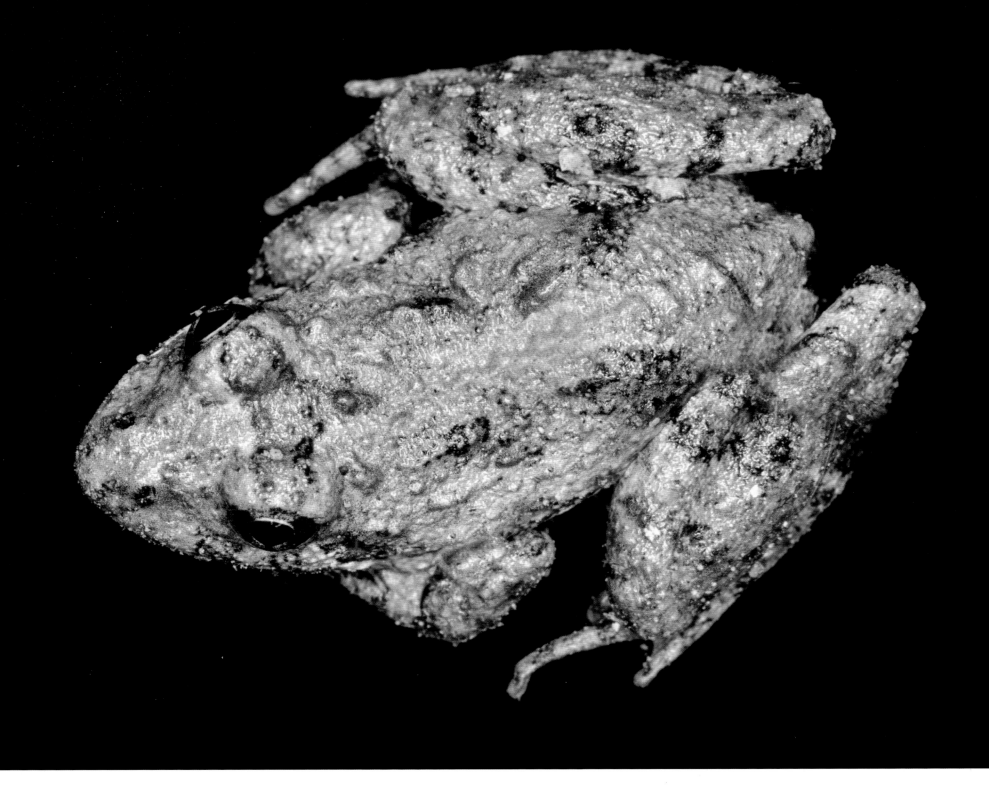

Although many humans have a fear of snakes, the red corn snake is a very gentle creature. ◄

The gray tree frog can change color to match its surroundings.

Shedding and Resting

Autumn and Winter

ALTHOUGH WE TEND TO think of individual trees as unchanging over time, consider that the leaf-dropping species get a new covering every year. It would be like all your hair and skin dropping off each year and then growing back months later. Sounds extreme, doesn't it? Why would trees do that? There are a number of reasons; one is that it can be a way of shedding insects and diseases and making a fresh start. Some nagging problems are better to just rid oneself of instead of trying to fix. Imagine you had a contagious skin disease and an insect infestation before your "big drop." You might be free of these problems after the growing back—at least until you were exposed again.

This shedding could benefit evergreen trees, too, so why don't they shed their leaves? Actually they do shed, just not all at once in such a dramatic way. Pines keep their needles for a number of years before they shed, so something green is always left on the tree when the old needles are dropping. We tend to notice the green on the tree more than the brown needles on the ground. The number of years pines hold their needles before dropping them varies by species: white pines for two or three years, some western bristlecone pines for more than thirty years.

Another reason broad-leaved trees shed is that the leaves are the most delicate part of the tree, and they're susceptible to being destroyed by a hard freeze. Leaf cells could swell and burst, or dry out, especially if the ground is frozen and the roots are unable to take in water. And when it snows, leaves on a tree collect the snow, and the combined weight of so many snow-laden leaves could cause major branches to crack and fall. Better to drop your leaves than your branches! If leaves held on through the cold months, they would act like little sails when winter winds whipped through. Bare trees let the winds slip right by. Wind and hail might also tatter the leaves. When the spring sunshine returned, the leaves would be almost useless. No, better to shed them before winter and start fresh next year.

Pines and many other evergreen species have developed leaves specialized for dealing with those winter challenges. High winds, hail, and snow? Very narrow leaves, like needles, allow the wind to slip right by and the snow to slide right off. Frozen ground? A waxy layer over the leaf keeps it from drying out. Munching insects and animals? Sharp, tough leaves deter them. But there are always compromises, and these small, protected needles can't collect as much sunlight as the broad leaves during the warm growing season. They make up for that lack by being able to capture sunlight year-round. A look across the globe tells us that the evergreen technique works better where winter is longer (think boreal forest) and the broadleaf technique where winter is warmer (think tropical forest). Our temperate forest lies between these two extremes, and trees successfully exhibit both lifestyles.

And so the leaves fall. The reasons sound utilitarian, but the result is so very beautiful. We could imagine that the creation of beauty is the real reason for leaves turning and dropping—because the leaves don't just die and drop but instead are part of a carefully controlled process, an active process. The tree looks at the sun's clock, feels a chill in the air, and senses it's time to kiss the leaf goodbye. It's a long goodbye, lasting an average of twenty days from the first signs of color until the leaf falls.

The tree accomplishes this with chemical messages that direct the leaf cells to stop making the green pigment chlorophyll, and to shred and recycle any old molecules of this substance. As a result, leaves go from green to yellow. Eventually these leaves go from yellow to brown, since they're no longer photosynthesizing and making the energy they need to repair aging cells. Some tree species, like sycamore, beech, redbud, and tulip poplar, never have reddish fall color. They turn yellow, and that's it. This might seem like an unfortunately limited palette until the day you see those golden trees absolutely glowing in the afternoon light. It's as if the sun were shining back up from the ground.

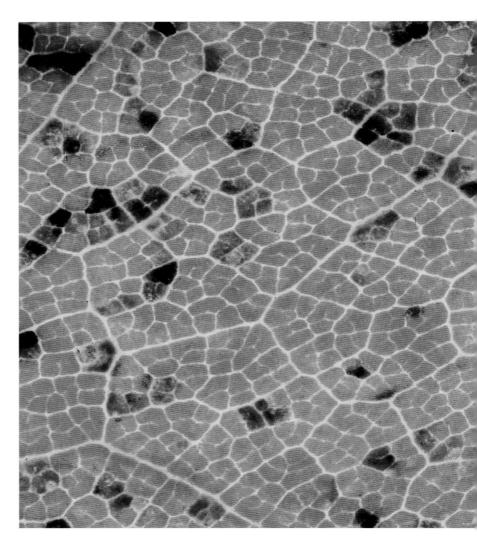

Aged humans get blotchy, and so do aged leaves. In some tree species, red pigment is produced in the fall by healthy cells. The black and green cells here are diseased. This leaf will soon be shed. ▲

(PREVIOUS PAGES) American beech is one of the few deciduous species that hold some leaves until spring, as illustrated by this beech forest in winter. This feature may deter deer from browsing the twigs.

(ABOVE, RIGHT) We can wonder which insects or bacteria or fungus got to this leaf, or we can just admire the artistic results they have created.

An oak leaf has just fallen from the tree. Some people consider it good luck if you can catch a leaf on its way to the ground. ▶

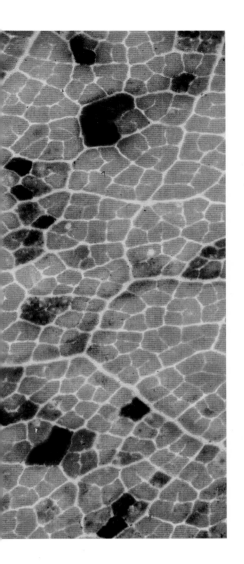

125

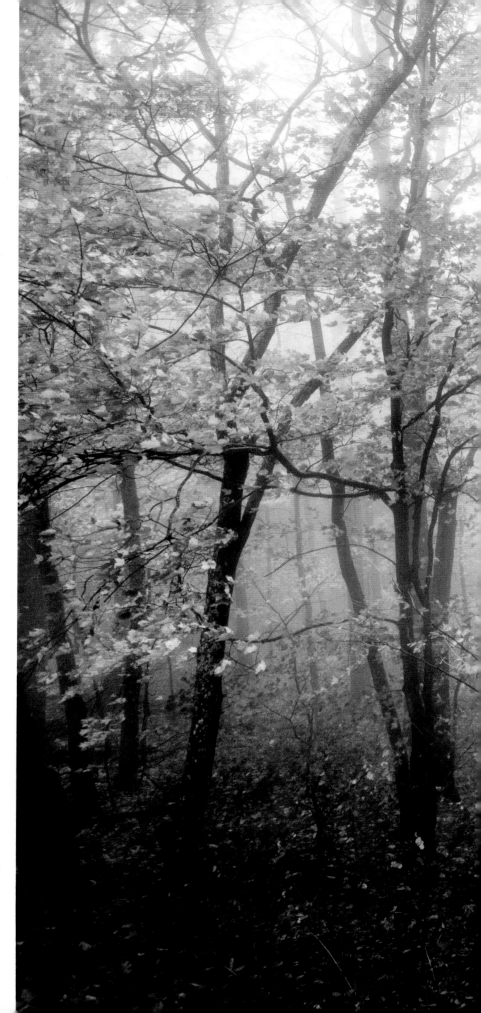

Then there are other species, like blackgum, that never have yellow leaves. They go from green to a deep burgundy red, and leaves drop from the tree while still red. The red coloration in fall leaves is not something that was there all along and just covered up by the green pigments, like the yellow; no, the red pigments are actively produced by leaves during the cold, crisp days of autumn. The pigments are a kind of self-manufactured sunshade. Trees need the sunshade because on cold, bright days their leaves are still producing oxygen through photosynthesis, but the cell's normal process for dealing with the very reactive oxygen molecule is slowed down due to the chilly temperatures. The red sunshade prevents too much oxygen from being produced—like a beach umbrella protecting from sunburn.

Our favorites, of course, are those trees whose leaves show every imaginable shade of green, yellow, orange, and red. Like snowflakes, no two are alike and each one seems more remarkable than the one before. The maples and the sweetgums are the very best at this sort of show. The more sun a leaf gets, the more it will need the red pigments. So trees grown in full sun have leaves with the most remarkable hues.

Different tree species turn different colors in the fall. Some species turn only yellow while other species turn only red. Others, like red maple and sweetgum, turn a multitude of colors. ▶

Each individual cell in this colorful oak leaf makes its own decisions about whether the green chlorophyll goes or stays and whether the red pigments should be produced. ◀

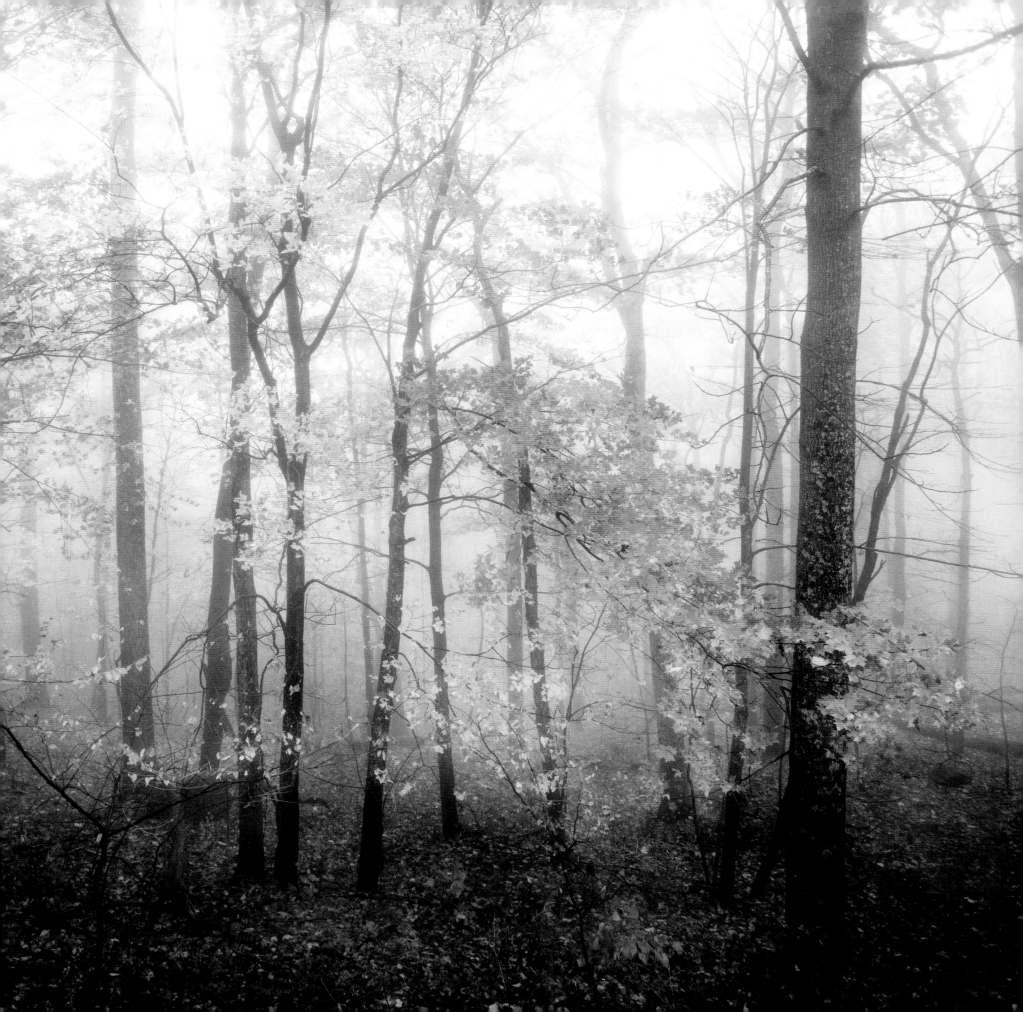

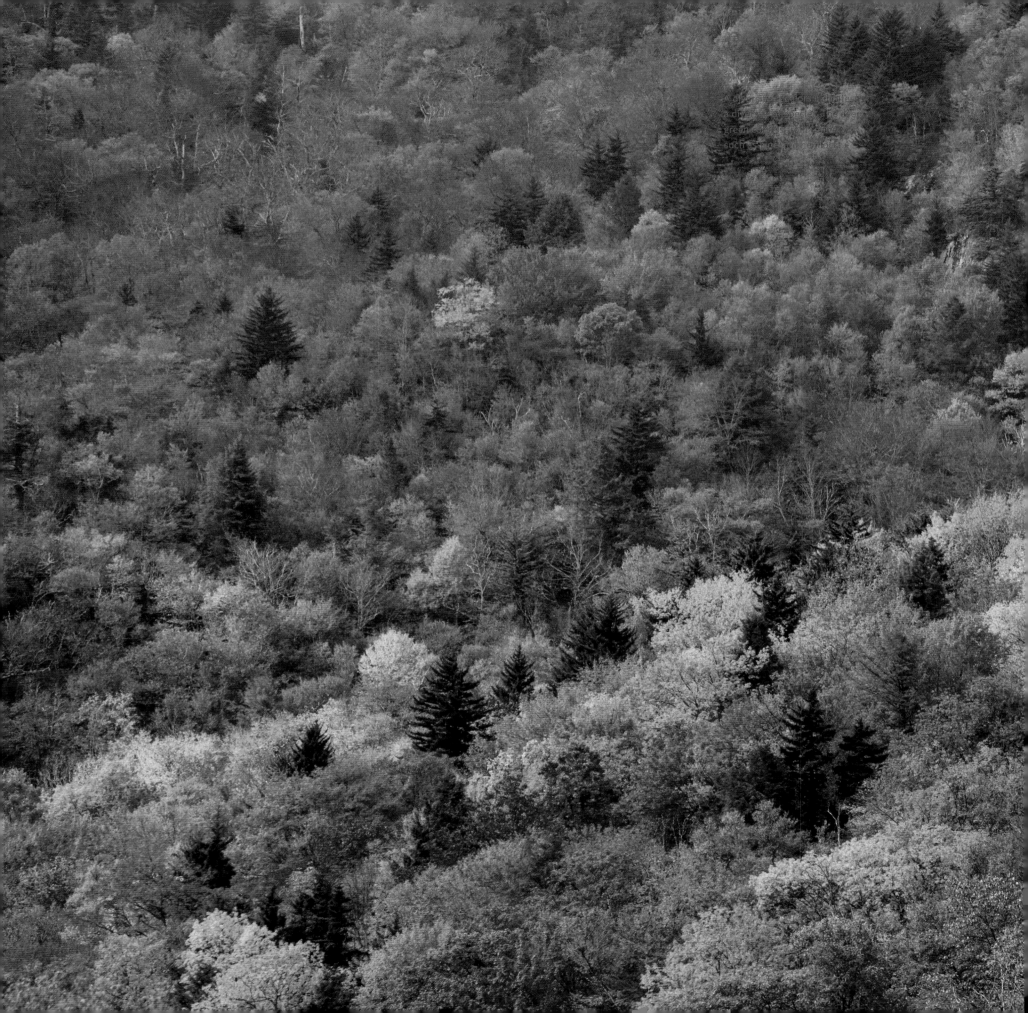

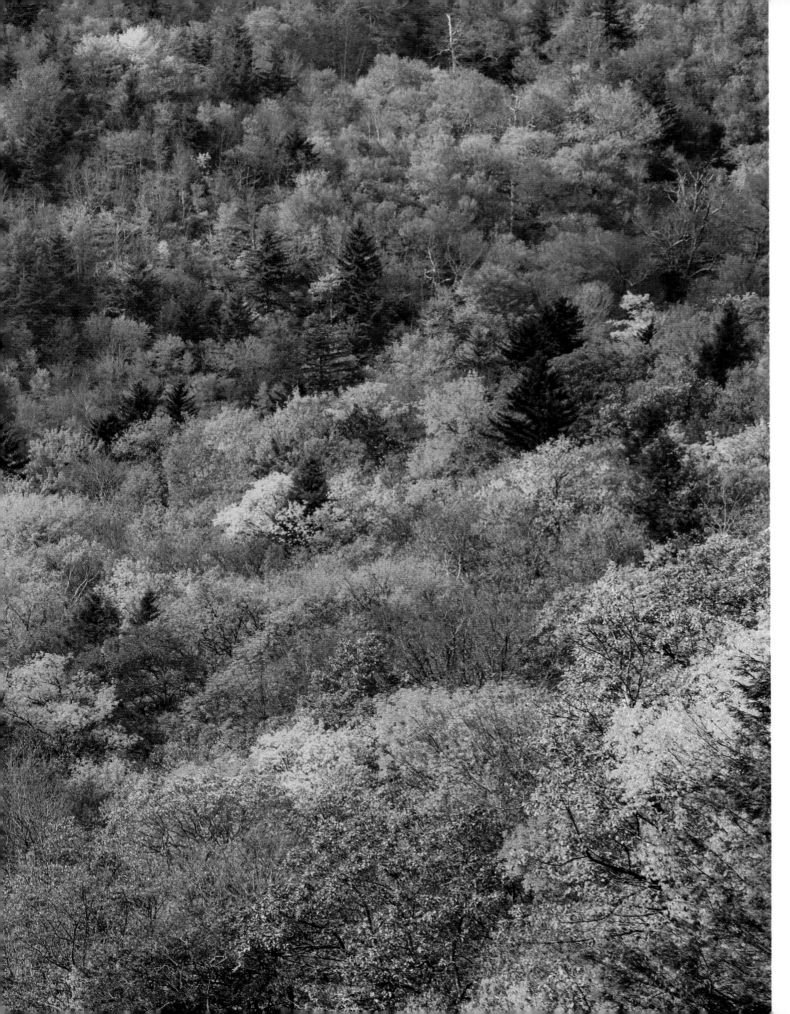

A diversity of colors indicates a diversity of species. The deep green color is from conifers such as pine and hemlock.

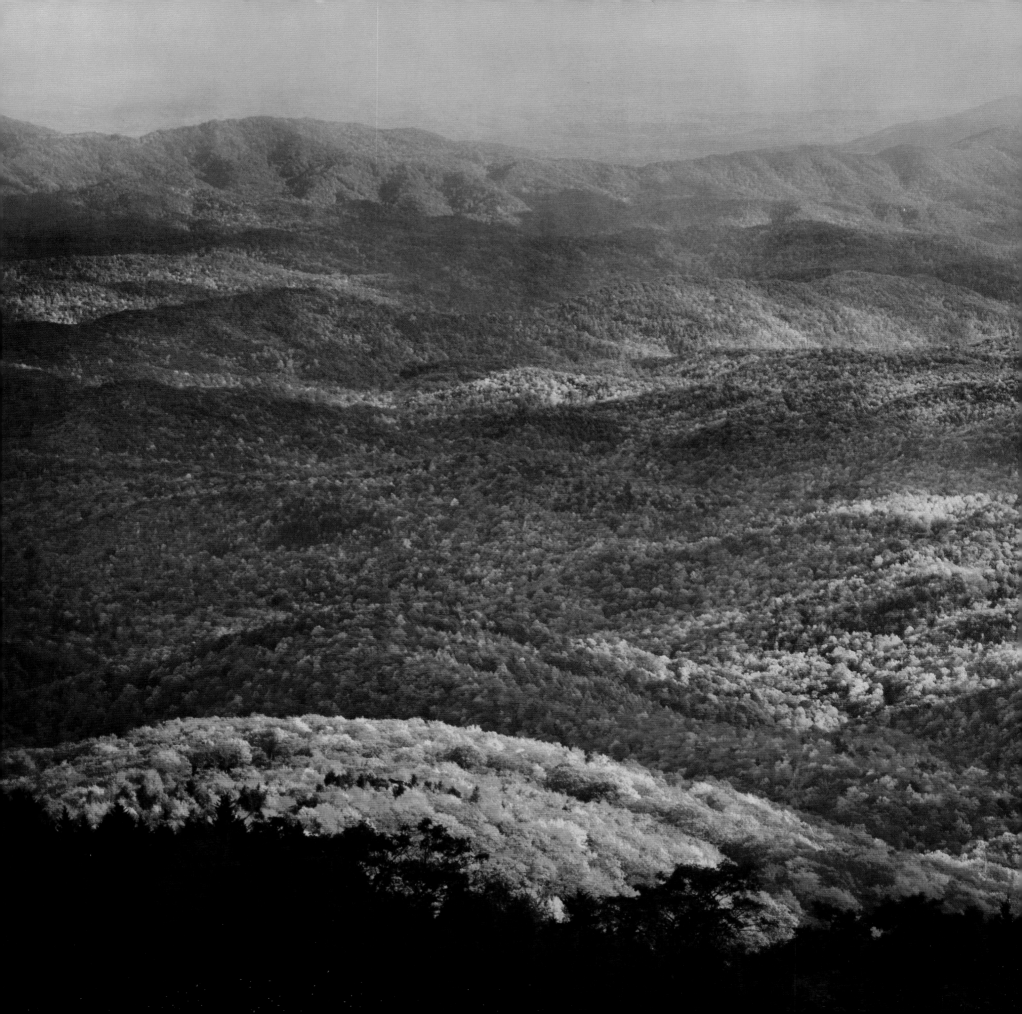

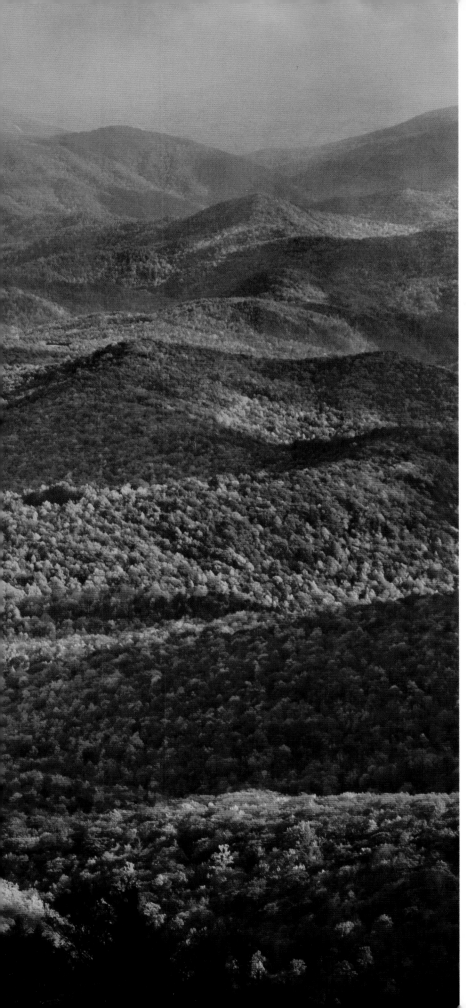

Because of these differences in fall coloration from species to species, it is possible to tell from a distance the general composition of a forest—even while driving by or viewing from an overlook. As soil types change across the landscape, so do species, and so do the colors. One hue graces the north side and another the south side of the slope. Different species, different colors, at the bottom of the drainage compared to the top—an amazing ever-changing art piece offered for free.

Only forests containing broad-leaved trees in places with cold winters and hot summers will produce a spectacular autumn show. These are the temperate deciduous forests, and they occur only in eastern North America, parts of Europe, and parts of eastern Asia. Of these three places, the show in the eastern United States is considered the best on the planet. Consider yourself lucky if you're in the right place at the right time to witness it. Pause to admire nature's beauty and how it resonates deeply within you. And do not make the mistake of just witnessing from afar. Enter this world of tangible rainbows and feel the colors around, above, and beneath you. Breathe the rainbow air. Smell the fungi feasting on the fresh leaves.

The biological processes that cause leaf color changes are different from the process that causes leaves to fall. To initiate the actual falling, a special layer of cells at the base of the leaf's stem makes a layer of scar tissue on the twig side and dissolves the cells on the leaf side. A bit of wind may make the difference in when an individual leaf falls, but even on completely windless days in autumn one can sit and enjoy the rain of leaves that may seem completely random but contains its own impulse.

People from other regions travel to the eastern United States just to see this show of autumn color. It might be listed as one of the wonders of the world were it not so ephemeral.

Albert Einstein said, "What I see in Nature is a magnificent structure that we can comprehend only very imperfectly, and that must fill a thinking person with a feeling of humility. This is a genuinely religious feeling that has nothing to do with mysticism." Leaf-drop religion? Why not. When the air has a chill, and the sunny sky is a perfect blue, and the color of the leaves against it makes your heart beat a little differently, you may readily convert.

Fallen leaves mean life, not death, to a myriad of organisms. The lives of tiny soil insects, and bacteria beyond count, depend on this annual bounty. Even the larger creatures that don't feed on the leaves depend on this moist foliar blanket to protect their delicate skin and hide them from predators. If all this were not enough of a treasure, in a few years the leaves will become soil—the substance that is our truest wealth.

When you pay attention to these seasonal changes in trees, you'll notice that some of the leaves don't fall in fall. Instead, some brown and hang on through the winter, dropping only when the buds of spring swell and push them aside. In some species, such as beech, oak, and hornbeam, this is a normal occurrence, but we really don't know why. A few scientists have speculated that browsing animals don't like eating dead leaves so they'll nibble bare branches instead, giving the fitness advantage to branches that hold their leaves, but there's very little data to support this. Although evolution created all forms and processes, not all forms and processes have an evolutionary reason. Some things are just by-products of evolutionary history. We can appreciate their beauty even without knowing the reason for it.

On occasion, leaves that normally drop off in the fall may wither and die before they have built the special layer of cells that will separate them from the twig. A temporary problem such as an early hard frost may cause this, or it may be a sign that the entire tree is dying. It's interesting how we feel the "not rightness" of leaves whose normal process has been interrupted when compared to leaves that have been through their normal seasonal process.

(ABOVE, LEFT) This leaf, in midfall, is on its way to becoming soil.

The smell of damp fall leaves comes from decay that's already beginning. For many of us, that smell evokes pleasant memories. ◄

Red maple leaves create a beautiful but ephemeral carpet on the forest floor. For many small organisms, they are both a layer of protection and a source of food. ▲

In the mountains in winter, the ground is covered with a layer of snow, and the bare trees emerge from it like fur.

All that color! But that doesn't tell the full story, because for a good portion of the year the forest isn't green and brown but white and brown. The tree flowers have come and gone, the seeds have come and gone, the leaves have come and gone, next year's buds have been made, and now it's time to wait. Life goes on in the forest, but it's tucked away, slowed down, suspended. The tender plants on the forest floor have died back to their roots. Trees stand waiting for the triggers that tell their buds to open. Turtles and frogs are buried down in the mud. Bats and bears and skunks are sleeping. The delicate insects have been killed by the cold, but eggs for the next generation are waiting.

No one has researched the physical and psychological effects of having our world blaze with color for a short time each year, or go all white with snow overnight in the winter, but we celebrate these events anyway. And wait for spring to arrive again.

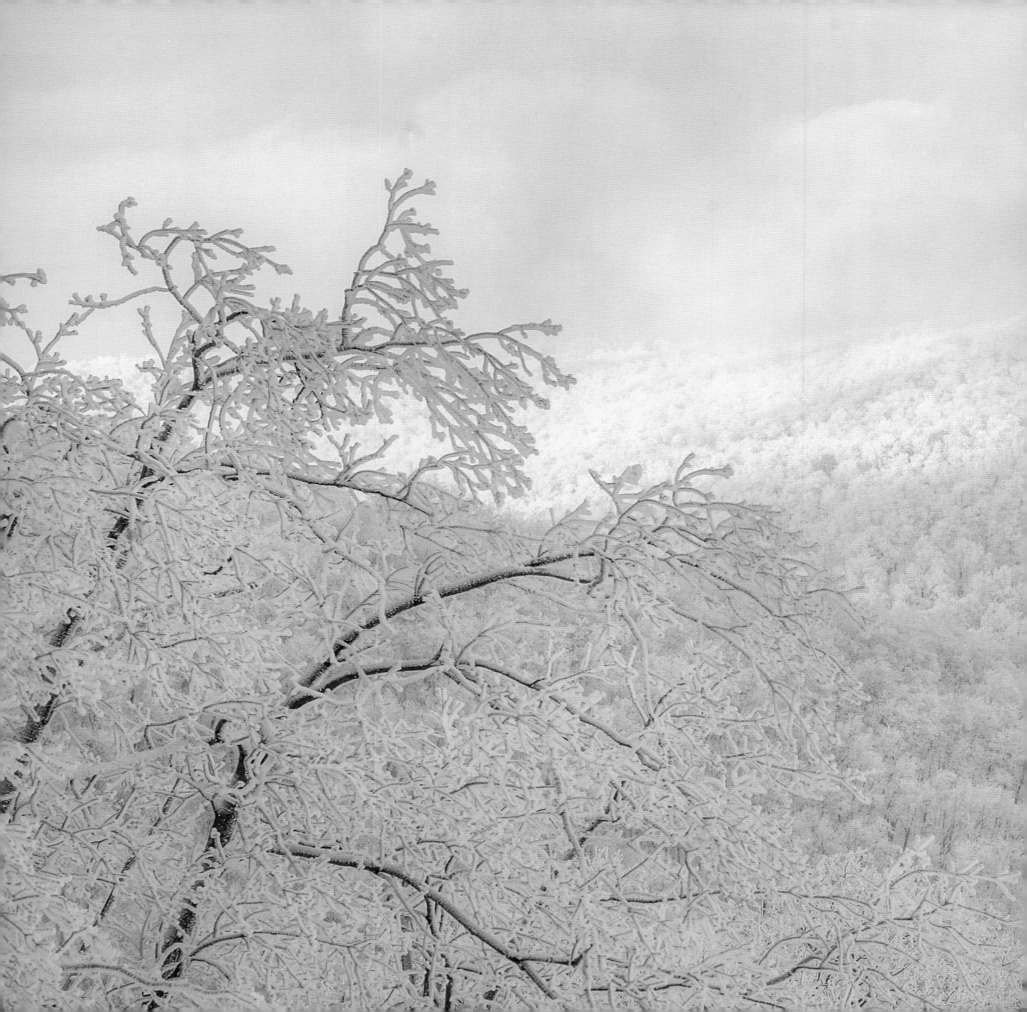

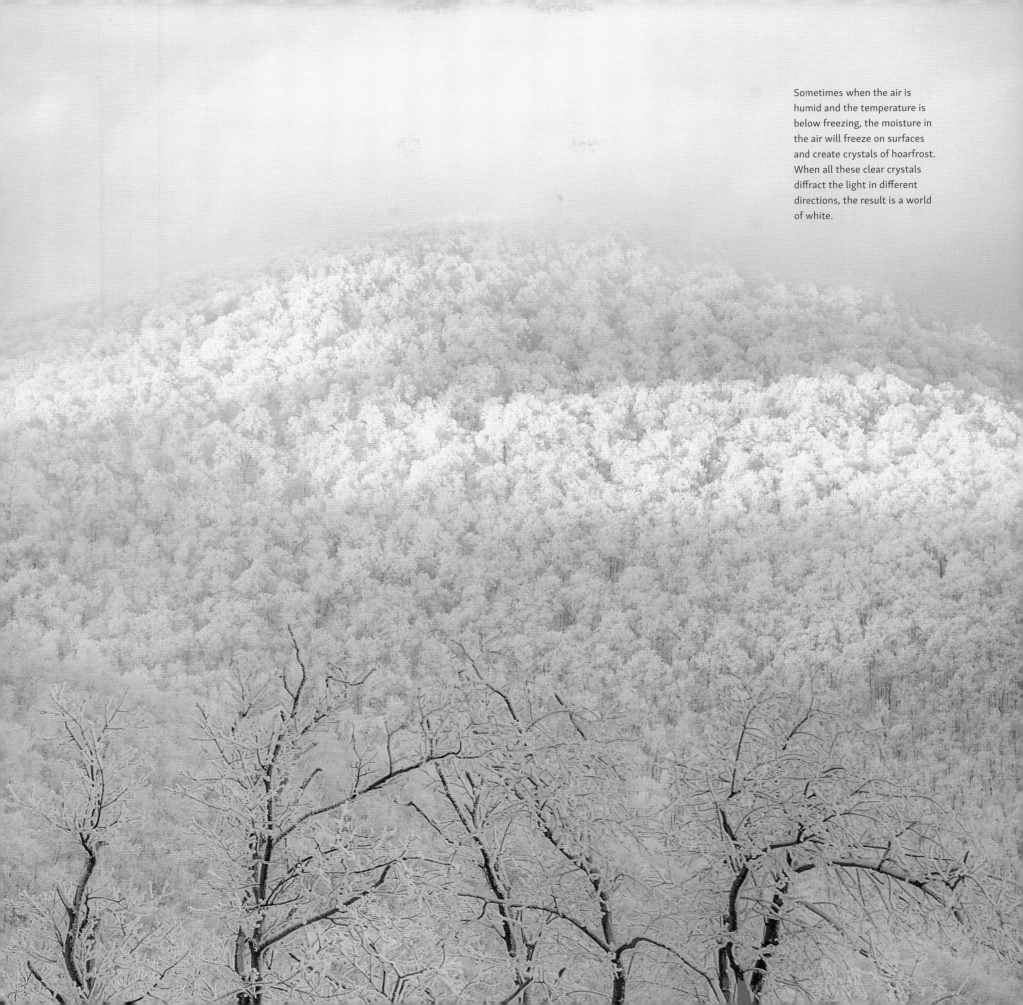

Sometimes when the air is humid and the temperature is below freezing, the moisture in the air will freeze on surfaces and create crystals of hoarfrost. When all these clear crystals diffract the light in different directions, the result is a world of white.

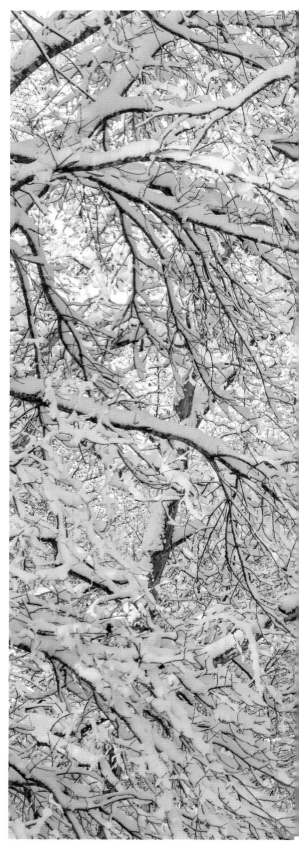

A special quietness inhabits the forest now. Not only have the trees suspended their normal activities, plants and animals of all kinds have also paused. Most of the birds have left. ▲

When the sun comes out after a snowfall, the world feels transformed. As it melts, the snow will seep into the forest soil and provide water for trees, streams, and vernal pools. ▶

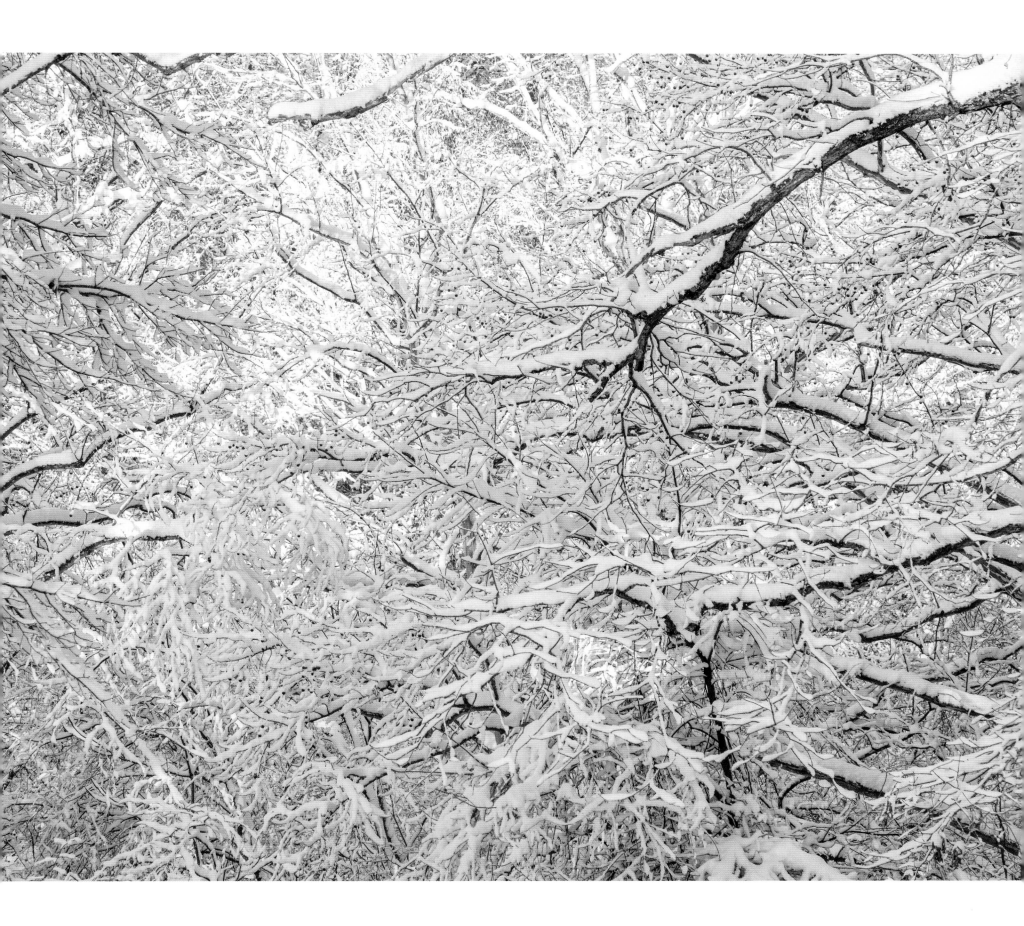

Budding

Winter into Spring

IN MANY PARTS OF the world, the forest seasons are measured by moisture: wet or dry. In the temperate forest, however, seasons are measured by temperature: warm or cold. During the warm season, the leaves are out and actively photosynthesizing; the sugars produced in this process power active cell division and growth. The trees and shrubs take advantage of this warm-season growth spurt by preparing for next year's flowers and leaves, even as this year's leaves are still growing.

If you look carefully at the base of a leaf, you'll see a bump just above it on the twig where it's attached; that's the bud for next year. While the leaves are out these buds are not very noticeable, but in the winter after the leaves fall they become more obvious.

Imagine that you're in an airport watching the luggage go around on the baggage claim carousel. Although the pieces of luggage differ in size and color, they also have similarities. Many of the pieces of luggage are roughly rectangular suitcases, while others are cylinder-shaped duffel bags. You have no way of knowing for

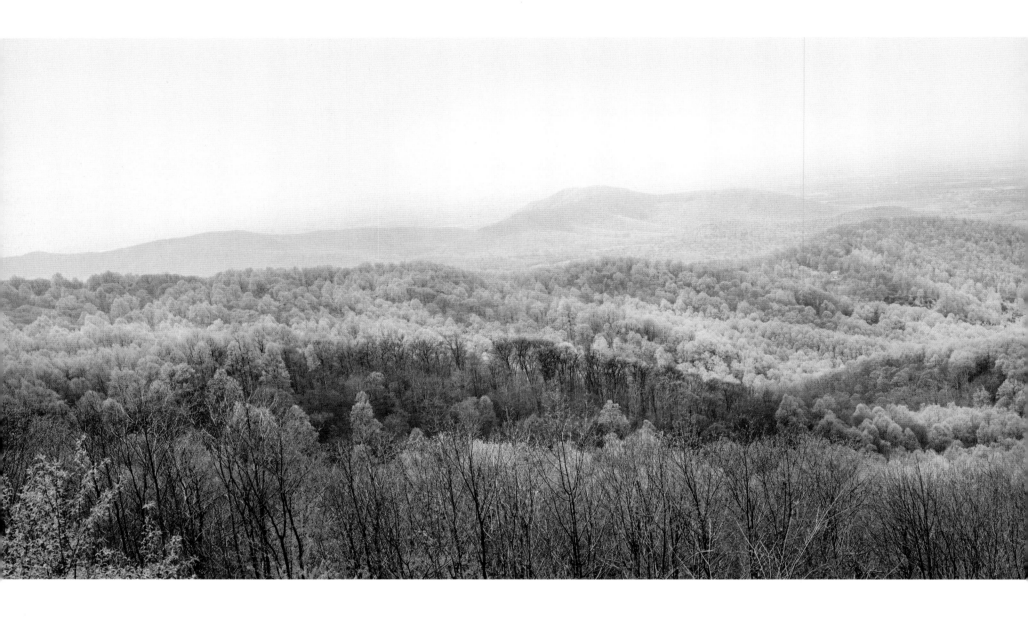

sure what's in each bag, but you can guess that most of them contain clothes and toiletries. It's the same way with tree buds: similarities and differences. The size and shape and hairiness of these buds can help you identify the tree species even without leaves.

Just as there are two common kinds of luggage, suitcases and duffel bags, so are there two common types of buds: those covered in bud scales arranged like shingles on a roof and those with bud scales arranged in pairs clasping each other. Cherry, oak, maple, and sweetgum all have the shingle type of buds. If you cut one of those buds open in the fall or winter and had a good microscope to examine it, you would see that

(PREVIOUS) Red maples produce two types of flowers: male and female. The female flowers stay on the tree and produce the winged seeds we are all familiar with; the male flowers drop to the ground after their job of pollen release is done.

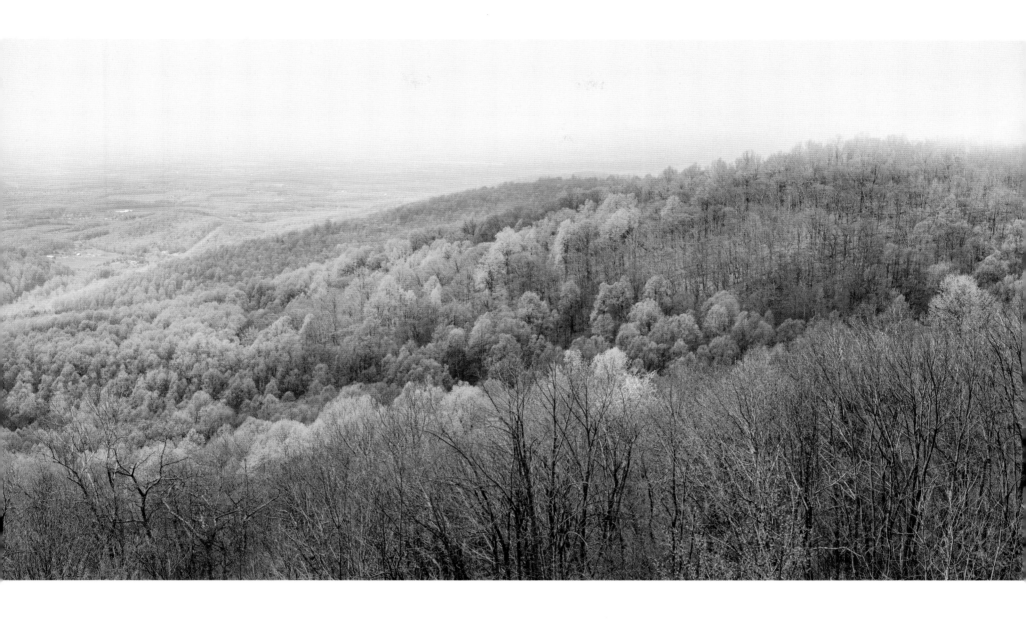

Waves of pastel colors spread across the landscape in early spring. The colors are from tree flowers and new leaves just emerging from buds. Each species will add a distinctive hue. ▲

next year's leaves, and sometimes flowers, are already there waiting for the season to change.

In springtime, the longer days and warmer temperatures initiate bud break. The bud scales are pushed open by the tiny leaves contained within. From a distance, a barely discernible difference in color comes over the forest canopy. The gray-brown turns to something else, something whitish or pinkish, something that definitively says spring to those who eagerly await such signs. And when you go walking, although the air is still cool, you see tiny leaves unfurled and ready for their turn in the sun.

Buds are visible at the base of
each leaf. They are like suitcases
packed for a journey.

If you look carefully at this sweetgum twig, you can see the oval scar where last year's leaf was attached. Inside the oval scar are three smaller round bumps where the vessels carrying food and water went from the twig to the leaf. The shape of the leaf scars can help identify the tree species.

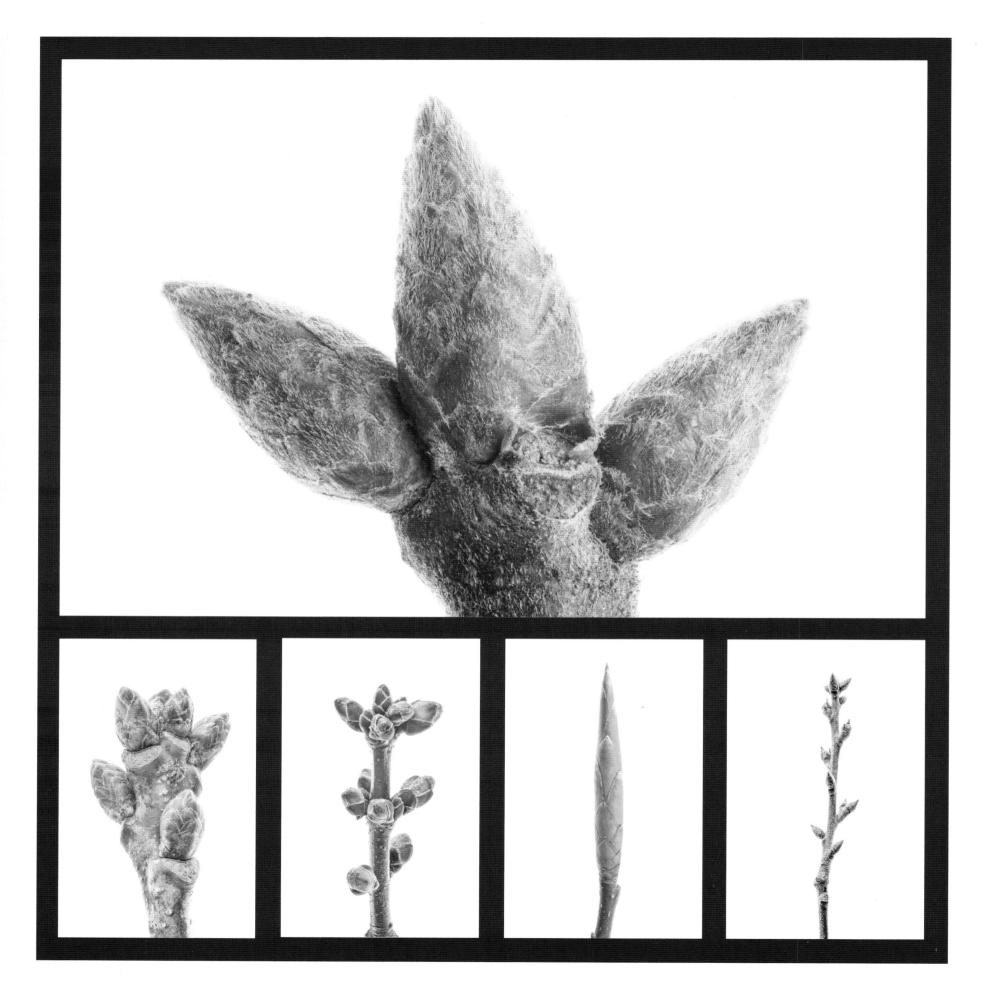

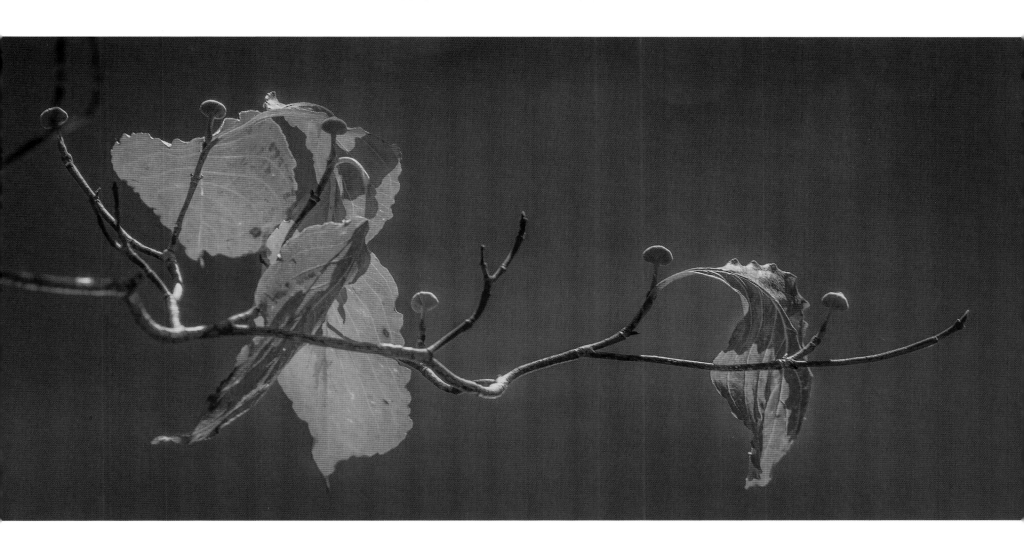

The buds for dogwood's spring flowers are already noticeable in the fall. ▲

The buds are apparent on a tree after the leaves have fallen— some pointy, some rounded, some hairy, some not. Packed tightly inside each bud are leaves for next season. ◄

The buds that contain next year's flowers often look different from those containing leaves. The dogwood is a striking example of this. The fat, round buds at the end of a twig are going to open to reveal next year's flowers. The leaf buds are much smaller. If you're a betting person, you might bet someone in midwinter that you know how many flowers are going to be on that dogwood tree over there come spring. Counting the fat buds is relatively easy, and each fat bud corresponds to one flower, right? Well, maybe not.

When spring finally comes the clasping bud scales break apart, but instead of dropping to the ground, as they do in most other species, the dogwood bud scales open and enlarge and turn pink or white (depending on the variety). Inside these expanded bud scales is a cluster of tiny flowers—about thirty per bud. So if you bet that one branch with three fat buds was going to produce three flowers, you would lose. There would actually be ninety flowers. And each of these flowers might be pollinated and become the red berries we associate with dogwood trees. Squirrels consider them a delicacy.

White oak leaves unfurl after being packed in the bud all winter. The hairiness of the young leaves can make the trees look silvery white at some angles. ▶

From bud to fruit, the dogwood makes its annual journey through the growing season. The fruits are eaten by squirrels and reportedly taste bad to humans. ▶

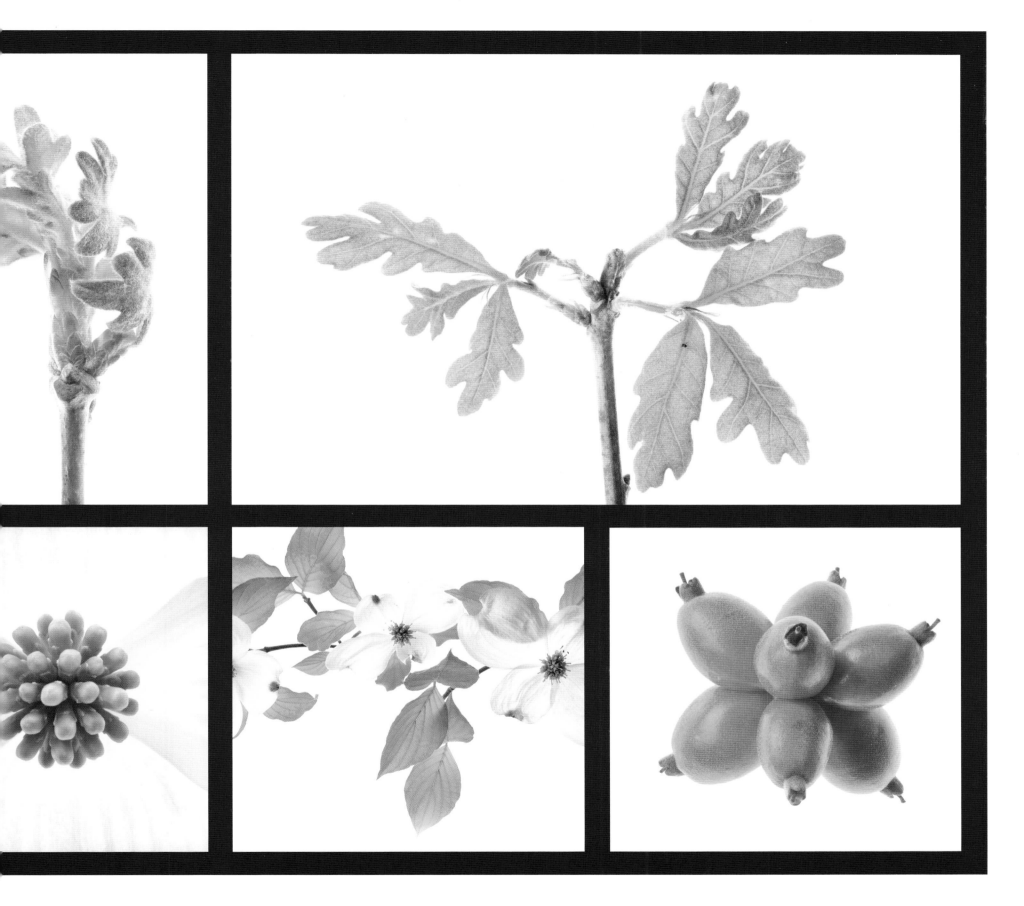

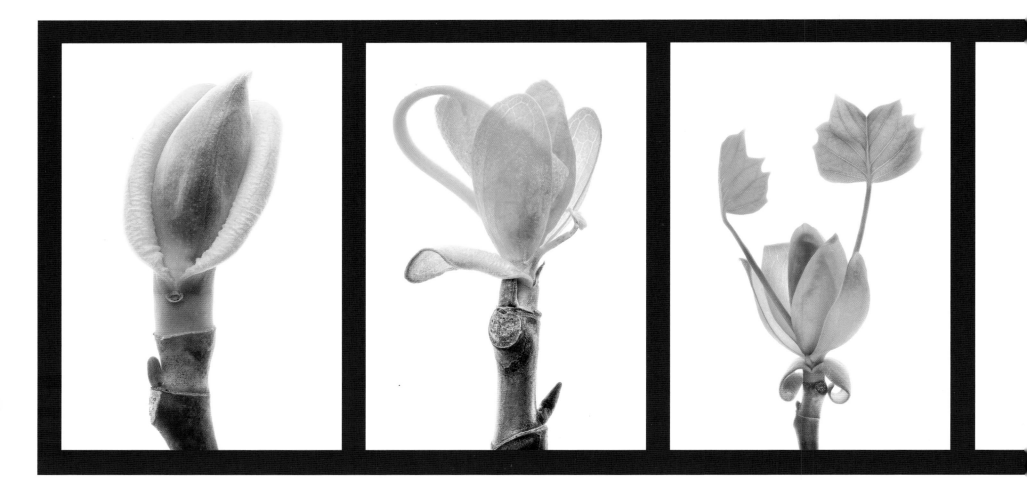

Tulip poplars are among our most ancient tree species, and they have retained a lovely yet unusual way of exposing their new leaves in the spring. The clasping bud scales peel away to reveal two tender leaflike structures at the base of each new leaf. These mini-leaves, called stipules, open and fold back as the delicate true leaf emerges. First one leaf, then two, then four, and the stipules fan out and finally expose a flower bud in the center. And as soon as these leaves are fully expanded and feeding the tree, they start building buds at their base for next year's show.

Anyone who has spent much time looking at forests knows that this progression follows a certain order. Bud break is primarily triggered by an accumulation of days over a certain temperature, but not all trees open their buds at the same time. In the eastern United States, the maples are the first, flowering in February or March. From a distance you may notice that the tops of the trees are suddenly tinged pink, even if you don't know that the reason is the flowers of the red maple. Or perhaps where you live the glow is more of a chartreuse color—that would be the sugar maples or tulip poplars. It doesn't matter what the calendar says, biologists call that spring.

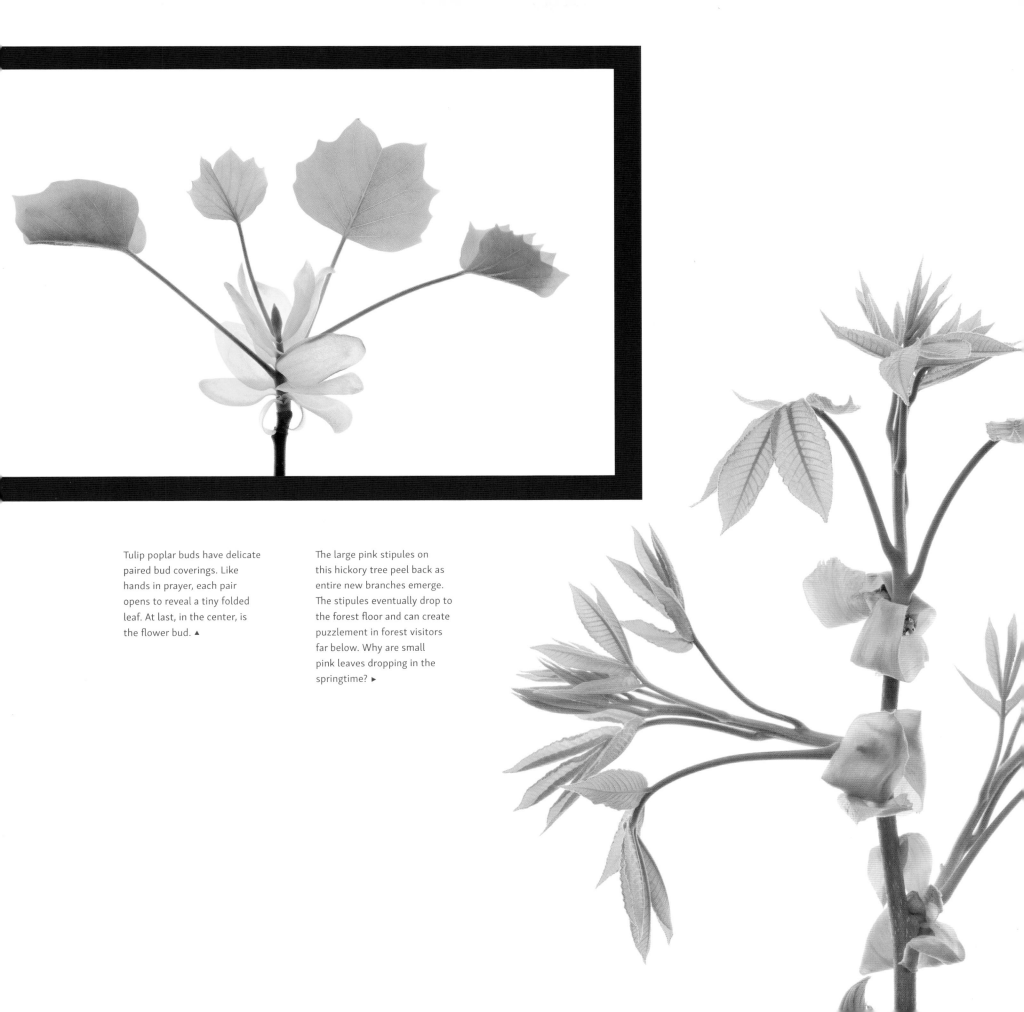

Tulip poplar buds have delicate paired bud coverings. Like hands in prayer, each pair opens to reveal a tiny folded leaf. At last, in the center, is the flower bud. ▲

The large pink stipules on this hickory tree peel back as entire new branches emerge. The stipules eventually drop to the forest floor and can create puzzlement in forest visitors far below. Why are small pink leaves dropping in the springtime? ▶

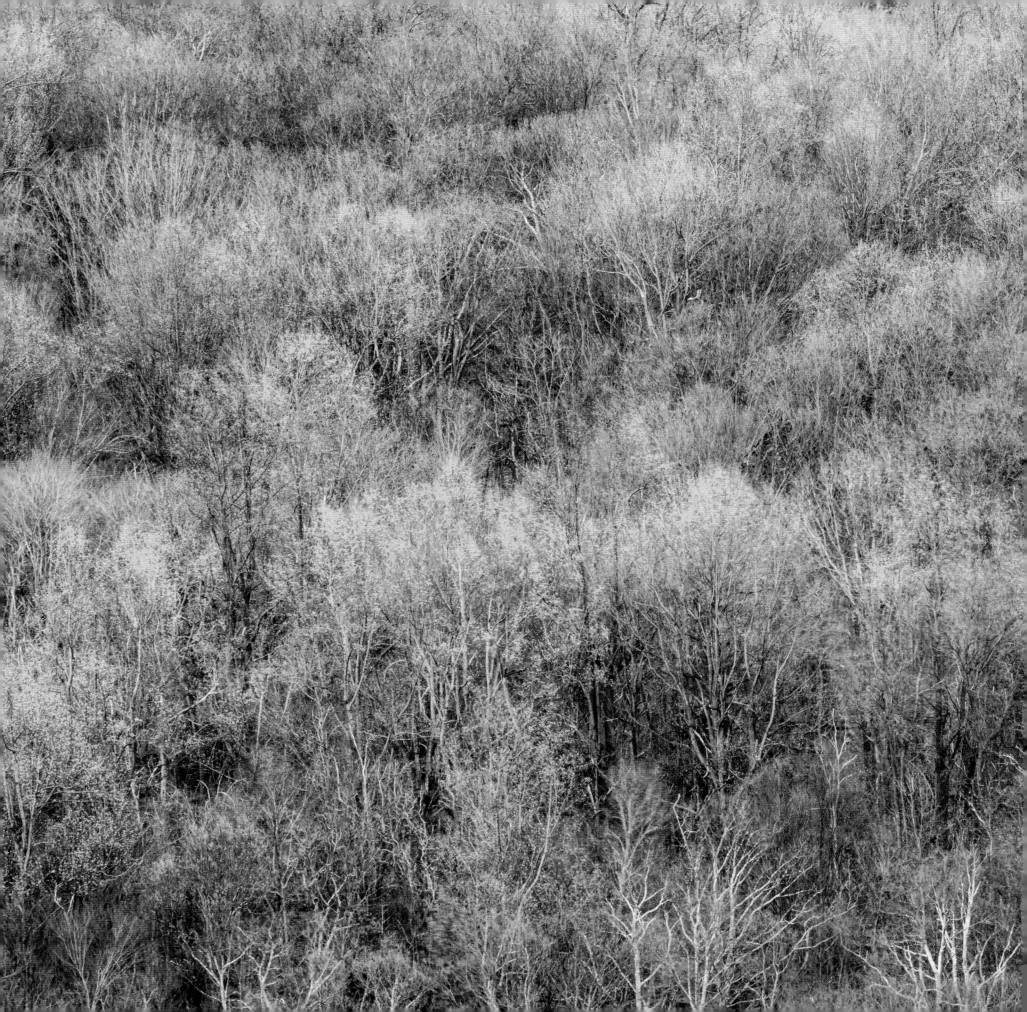

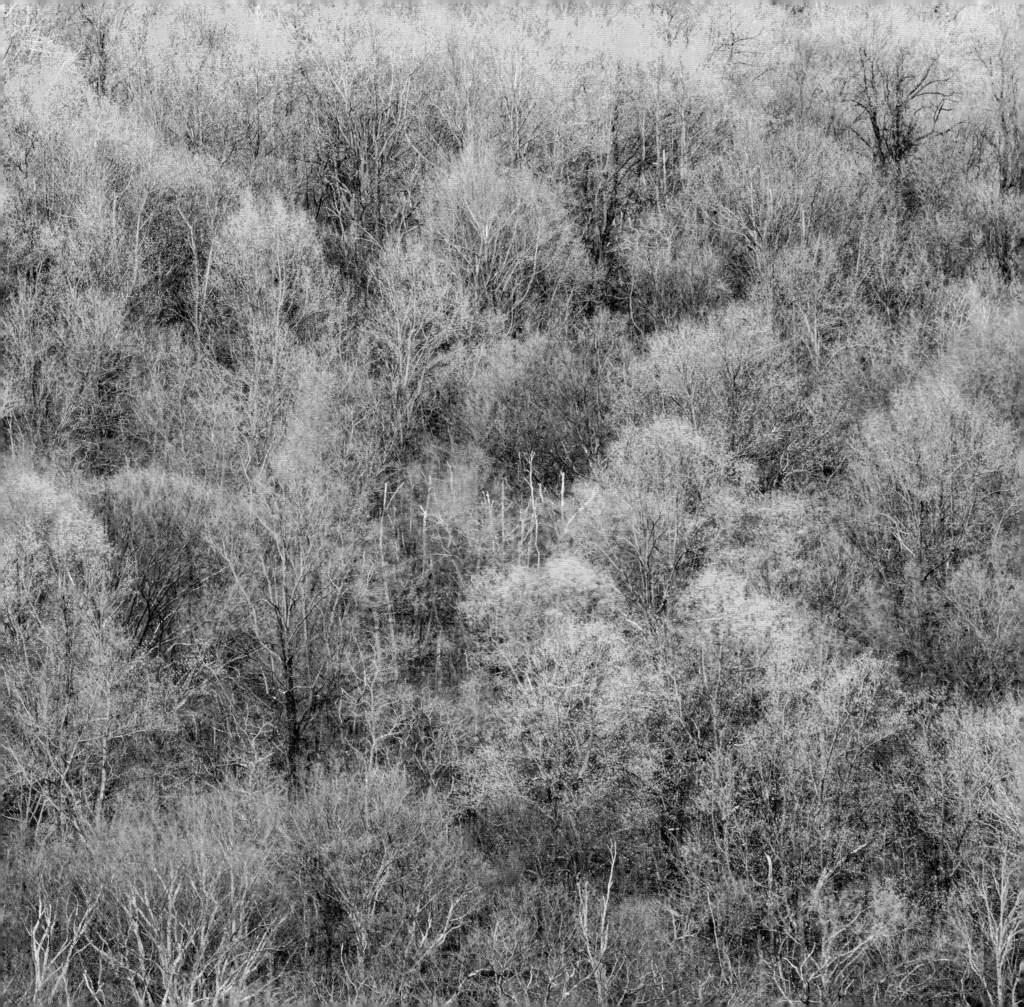

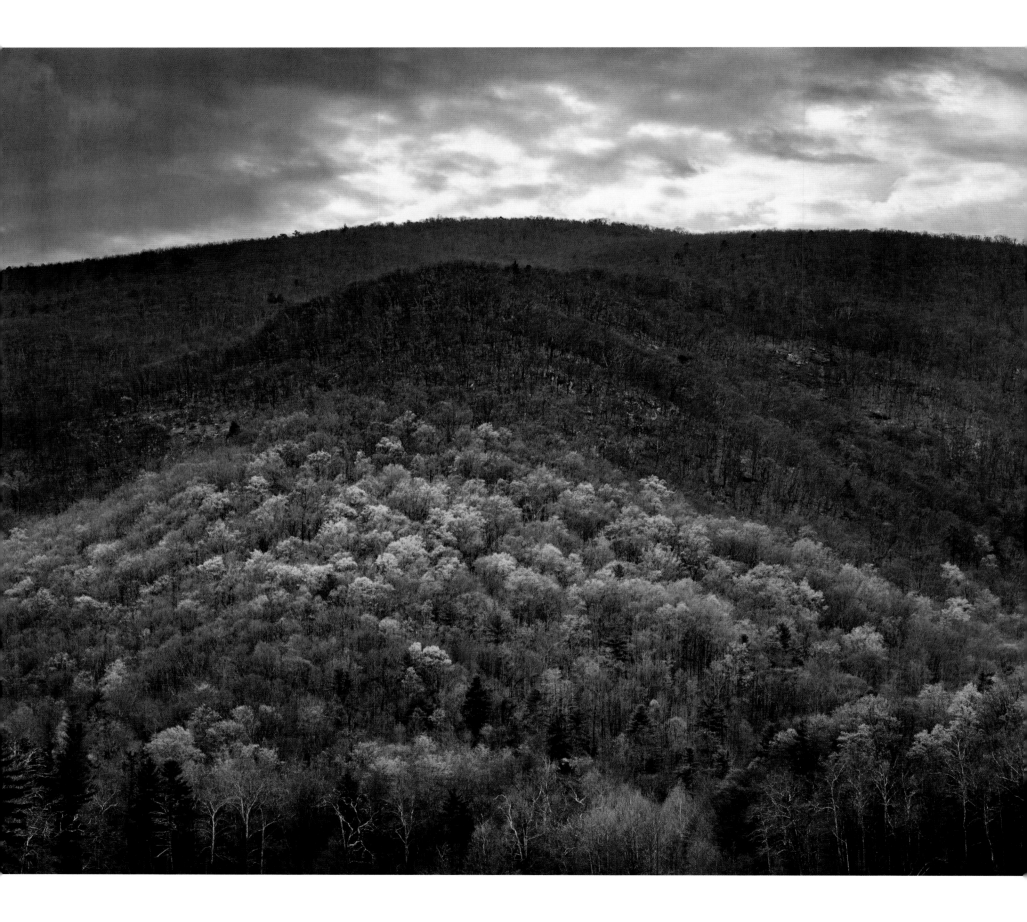

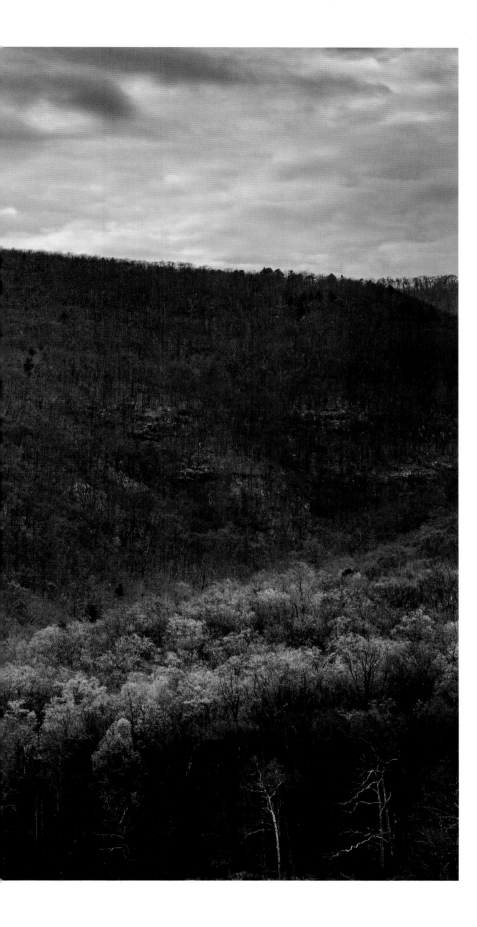

The farther south you are the earlier this happens, but the timing also depends upon altitude. Low-elevation trees leaf out earlier. Spring is delayed three days for every 330-foot increase in elevation. In fall the process is reversed: high-elevation trees show color and lose their leaves first. So if you live in mountainous terrain, you can watch the seasons sweep up and down the hillsides in waves. And within the waves are the smaller ripples created by the next species to break bud, or the next species to color.

Summer is longer in the low elevations. But summer is getting longer everywhere. In the eastern United States, spring now comes one week earlier than it did in 1976. You don't have to ask why; you already know. Bud break is advancing by one or two days a decade, which doesn't sound like much until you count your own personal decades and multiply.

So spring is getting a little earlier every year, as the research shows, and fall is happening a little later. Summer is getting longer, and the trees are growing faster. This is not speculation. This is happening.

(PREVIOUS) Bud break is the first blush of spring. Red maple flowers give the treetops a pink hue while other species add yellows and greens. The oak leaves won't emerge until later.

Spring comes later to the high altitudes. ◄

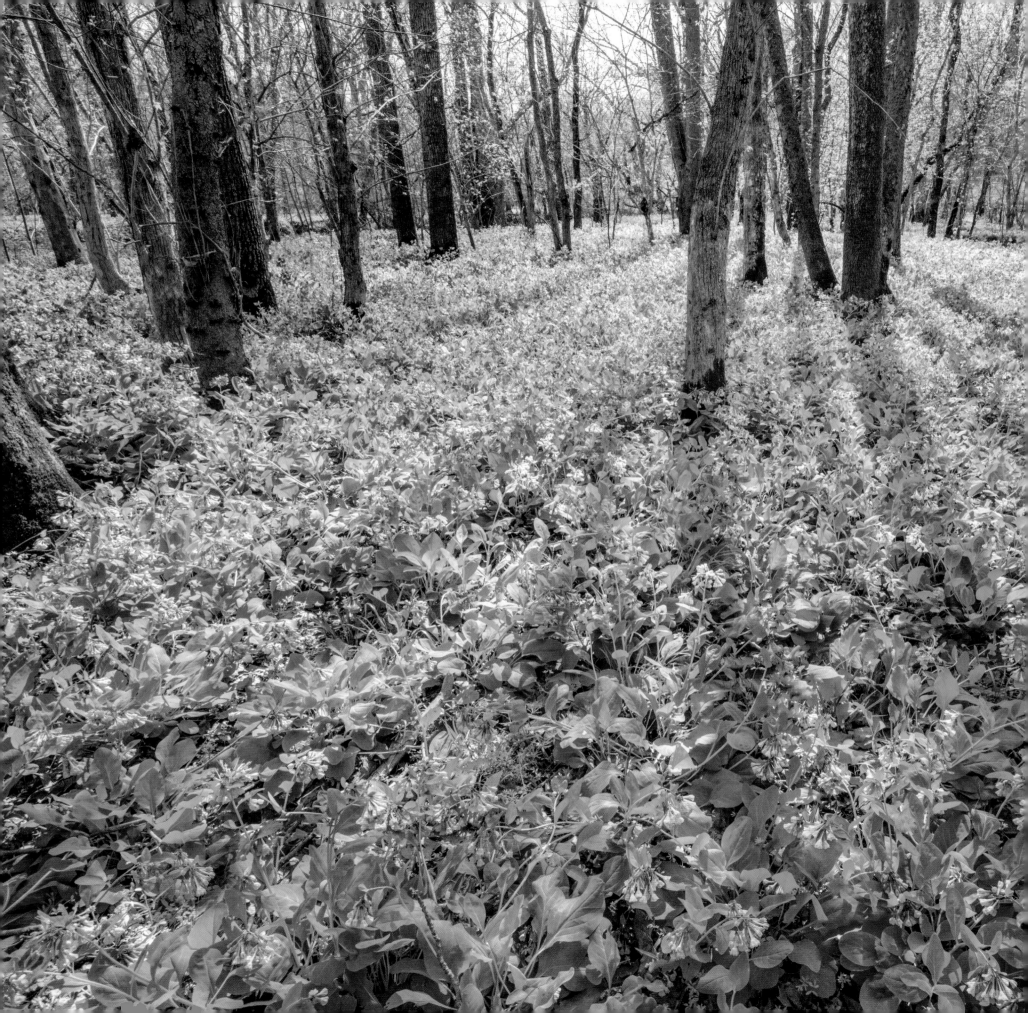

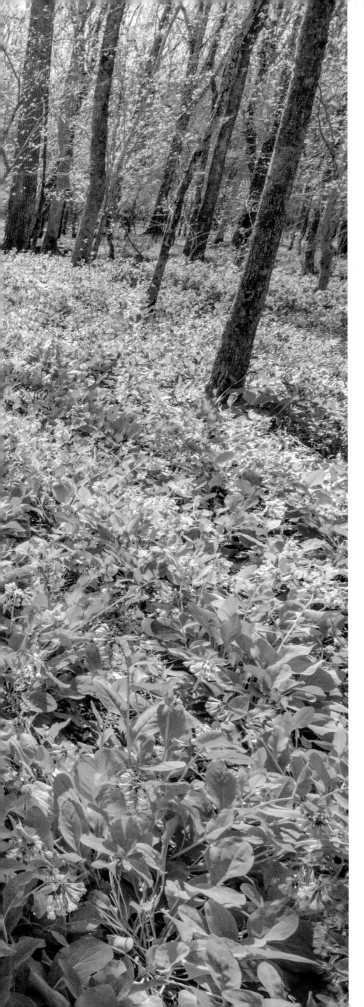

Flowers and Fruits

Spring into Summer

SOIL ITSELF MAY NOT appear beautiful to us, but springing from the soil and wholly dependent on it are many things we label as beautiful. The most obvious are the wildflowers. These small plants have never evolved the stiff trunks that enable trees to grow tall and compete for sunlight. The humble wildflowers must stay close to the ground and hope for the best. And the best does come, when temperatures warm in the early spring but the tree leaves haven't expanded to their full size. It is then that life-giving sunlight reaches all the way to the forest floor, and the smallest plants get their share.

The flowers associated with spring come and go just as quickly as the season, so we call them ephemerals. Some individual flowers last only one day, and an entire plant may complete its reproductive chores in just a month or two—though the memory of seeing those ephemeral beauties may stay with us forever.

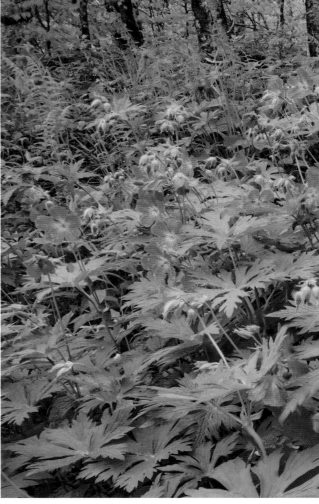

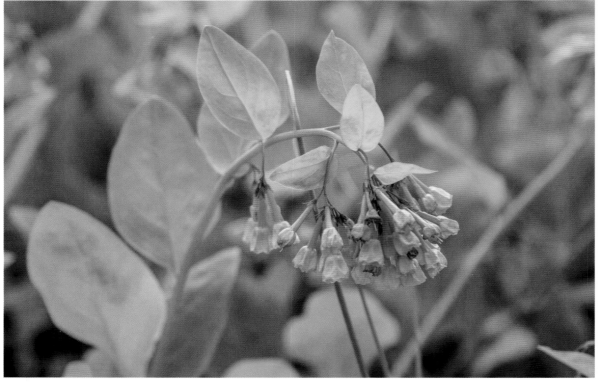

Virginia bluebell flowers change color as they age, sending a signal to their butterfly pollinators about how much nectar they might contain. ◄

(PREVIOUS) In this wild bluebell meadow in Virginia, tree leaves are just emerging; when the leaves finish expanding and shade the forest floor, the bluebell plants will disappear until next spring.

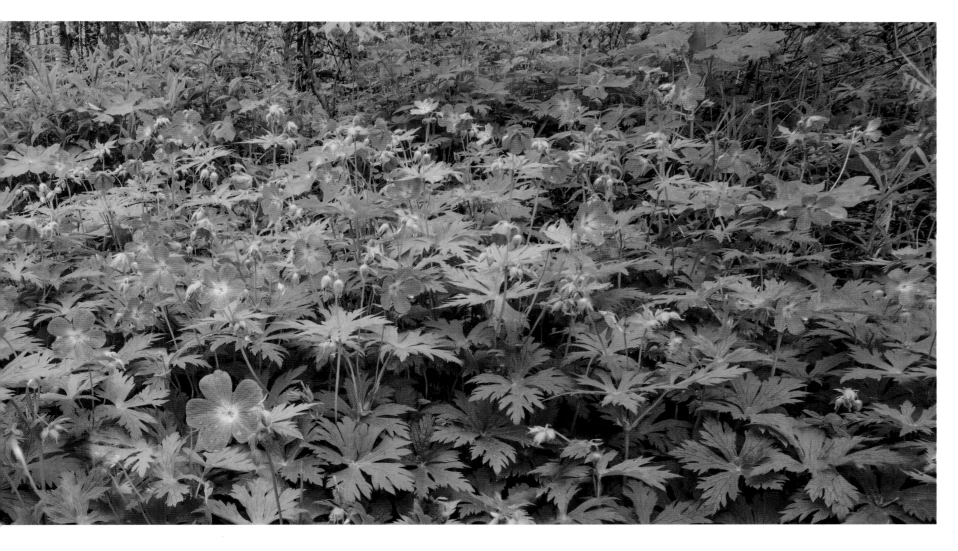

Wild geranium, a perennial
wildflower, spreads by
underground rhizomes. Each
flower can produce a maximum
of only five seeds. ▲

 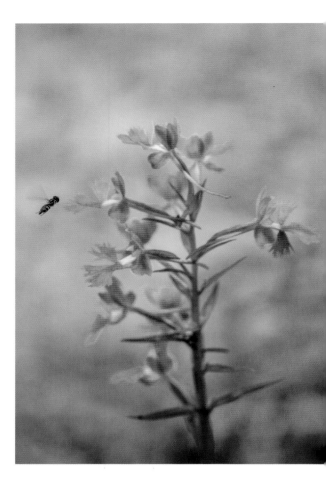

Out of the dark ground, which seemed frozen and lifeless just a few weeks ago, green shoots and flower buds appear. The roots and rhizomes of perennial plants were waiting, alive, underground, for just the right combination of cues from the environment to signal sprouting. All individuals of the same species respond to the same cues, so seemingly all at once their flowers appear in numerous places across the landscape. No one planted or tended these wildflowers that may have underground parts as old as the trees nearby.

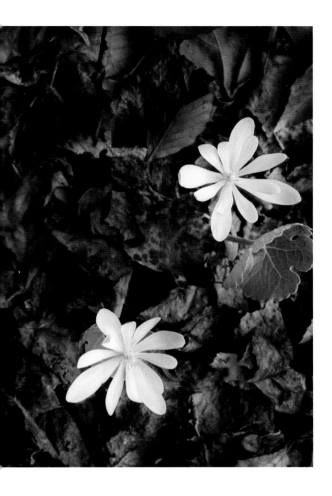
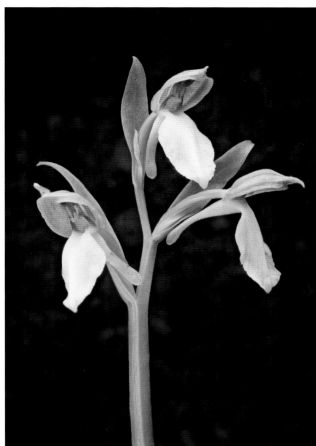
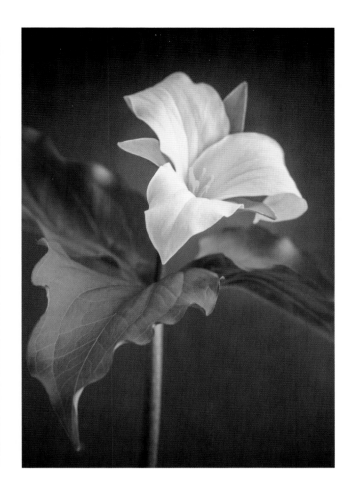

Spring walks in the forest
can delight visitors with
splashes of color from perennial
wildflowers, planted and
tended by no one.

(LEFT TO RIGHT) Bluets, lady's
slipper, purple fringed orchid,
bloodroot, showy orchid,
trillium

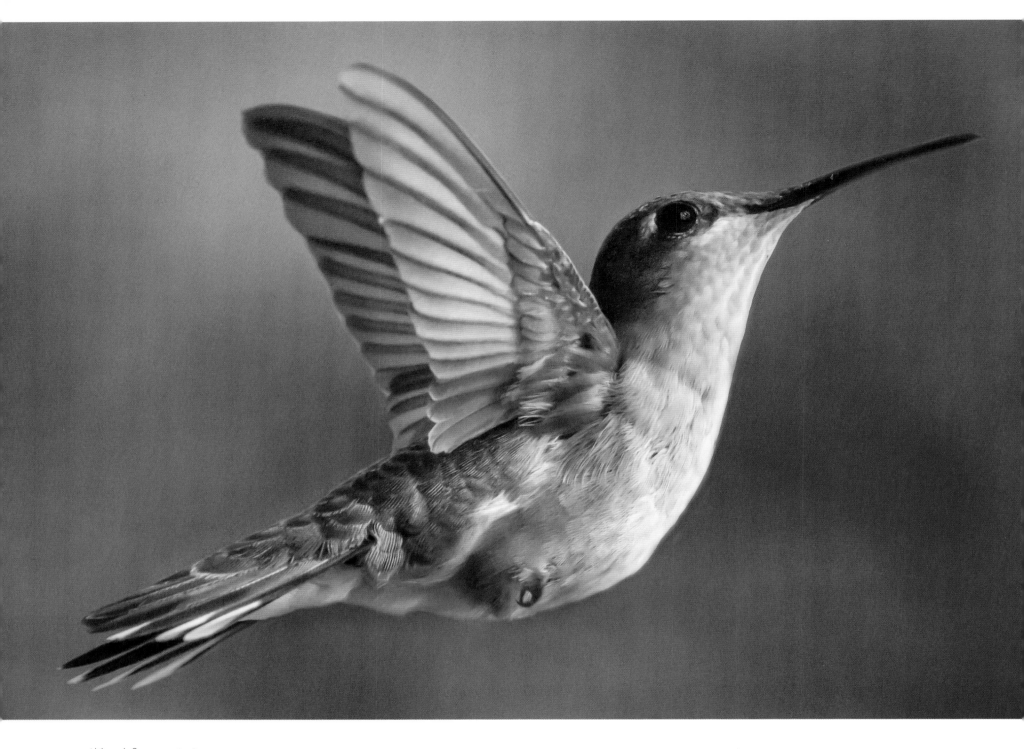

Although flower nectar is an important food source for hummingbirds, the majority of their nutrition comes from eating insects, such as tiny spiders. Pollen is carried from plant to plant on beak and head feathers.

An exception to all of this color and sweet scent is the interesting jack-in-the-pulpit flower. Small flies are its pollinators, and they are attracted to the not-so-pleasant odor of the tiny flowers embedded in the central spathe. The roots of an individual plant may live for more than twenty-five years.

Flower hues are beyond anything the leaves are capable of. These are not the colors of degeneration or protection that we see in fall leaves; these are the colors of attraction, for if flowers want to mate with each other in the heady spring warmth they must enlist a pollinator. And pollinators love color and scent and sweetness, so the flowers offer all of that. We love flowers for the same reasons pollinators do.

After the spring wildflowers, the flowering shrubs take their turn. They want the pollinators to be able to find them easily, too. Azalea, rhododendron, and mountain laurel all add color to the forest. And their eyelashlike pollen wands are just waiting for the right visitor. Sometimes the right one is a hummingbird, sometimes the right one is a bumblebee, and sometimes the right one is a butterfly whose wings brush delicately and carry the pollen aloft.

The small eastern redbud tree also joins in this celebration of spring and pollination. Hundreds of science experiments, and a color that contrasts with green, tells us that a flower must be seen for it to attract a pollinator. In the dark understory of a forest, where redbud lives, it's difficult for flowers to be seen in midsummer. So redbud blooms very early, the same time as the spring wildflowers, and takes advantage of the solar spotlight for a brief time. The nectar in redbud flowers is very important for early-emerging native bees. Although we often appreciate redbud flowers from a distance, they deserve a close-up look for the full effect of the contrast between the delicate flowers and the woody limb they emerge from.

Tiny flowers embedded in the central spathe of the jack-in-the-pulpit have an odor that attracts small flies to pollinate them.

Pawpaw leaves produce a chemical that induces the zebra swallowtail to lay eggs. Zebra swallowtail larvae can retain the chemical into their adult phase, when the chemical makes the butterflies toxic to bird predators. Bright colors warn the birds. ◄

The zebra swallowtail butterfly feeds only on flower nectar and lays its eggs only on pawpaw leaves. Because the caterpillar larvae would eat each other, the female lays only one egg per leaf. ▲

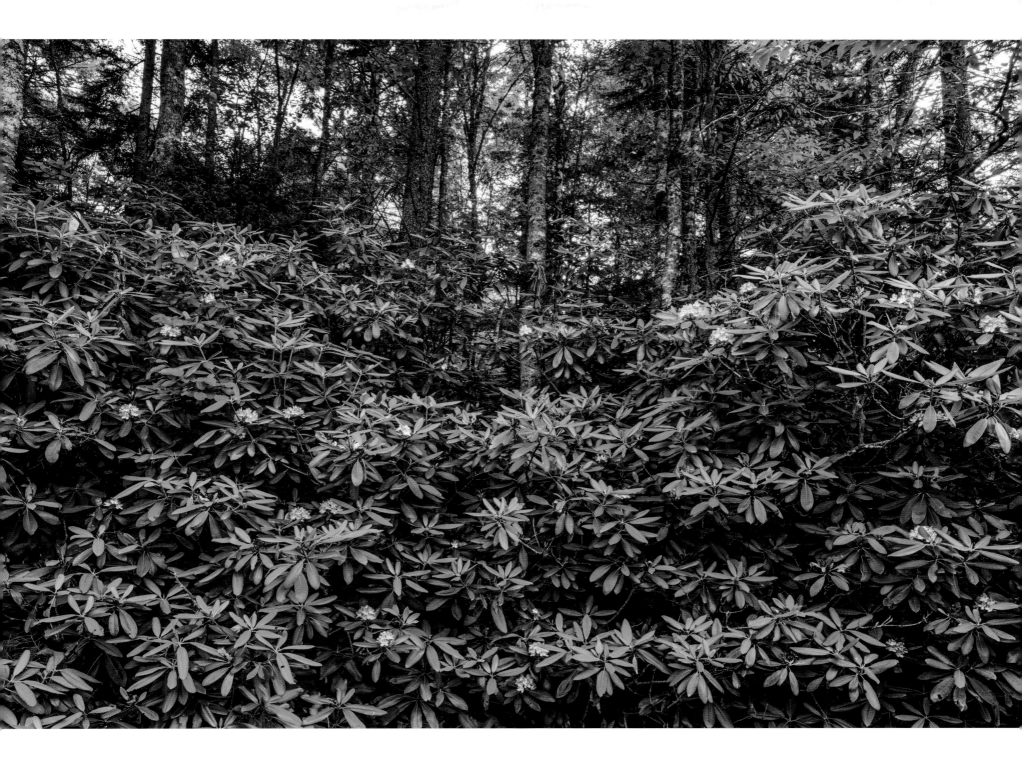

Wild rhododendrons cover thousands of acres in the southern Appalachian Mountains. These evergreen shrubs provide habitat for ten different liverwort species. Rhododendrons require deep, moist, organic soils, and their shed leaves contribute to maintaining this rich soil layer. An individual leaf stays on the plant for six years before it falls. ▲

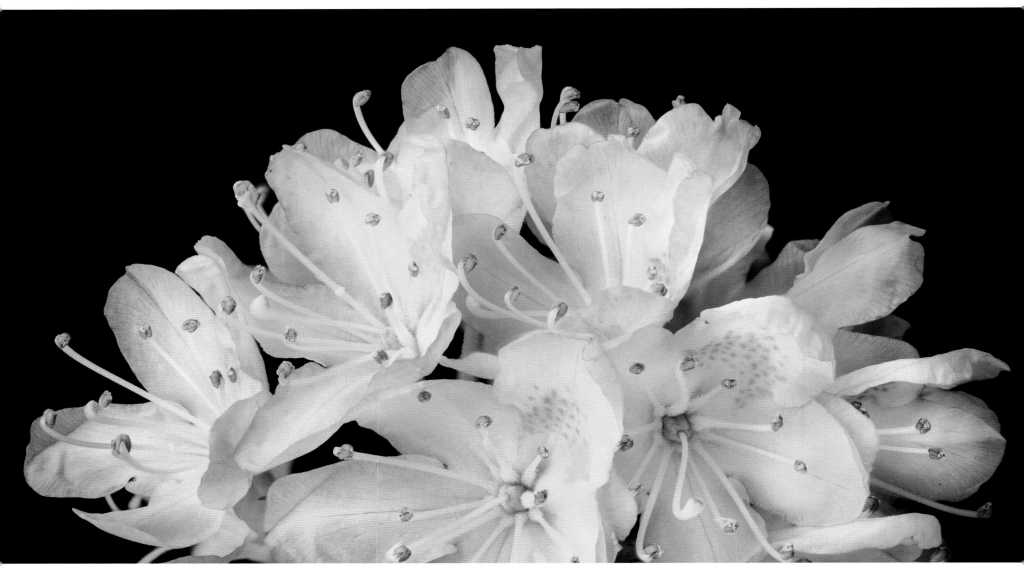

The yellow marks on wild rhododendron flowers are nectar guides that attract pollinators. The flowers look very different to hummingbirds and butterflies, who see colors we cannot. ▲

The flowers of mountain laurel have an interesting pollen dispersal strategy. Just before the bud opens, the elongating stamens push the pollen-containing anthers upward into tiny pockets in the sides of the flower. As the flower opens and expands, the stamens bend backward under tension. When something touches the bent stamen, the anther springs out of the pocket and flings its pollen. ◄

The redbud tree adds a splash of color and a delicate beauty to the spring forest. ▲

Native Americans ate both the flowers and the roasted seeds of the redbud tree. The flowers contain beneficial antioxidants and are also an important source of pollen and nectar for native bees. ►

By the time the redbud finishes blooming, the tips of the taller trees are dusted with hues of green and red. On many plants the male and female parts exist together, within the same flower; but on maple, and a number of others, flowers are either one or the other—male or female. A close look at the spring ground reveals the male red maple flowers that have dropped from far above, perhaps bouncing off a few branches on their way down. These flowers will become soil, but today they add bright sparks to last year's fallen brown leaves and the dark, muddy places. If you can find a low branch, or perhaps one on the ground that a squirrel has nipped off, you can see the perfect details of the male flowers before they make their long journey to the ground.

The female flowers that were pollinated remain affixed to the tree. Inside these flowers, ovaries are swelling and growing into the winged seeds we associate with maples. When ripe, these, too, will fall to the ground, but in a slower spinning motion, open to the wind's suggestion. Some of these seeds might germinate and root in the soil and go on to live for hundreds of years. The others will become soil—and so become home for future generations of seeds.

The spring wave of leaf-out and the autumn wave of leaf-turning each occur in less than a month's time, but the wave of tree flowering is longer and less easy for humans to sense. In tropical climates the pattern is complex, with some tree species flowering many times a year and others going many years between flowerings. Think of the patterns created when waves hit a beach and then head back out to sea while other waves are yet rolling in.

The reddish tint is from the flowers of red maple trees. They may bloom as early as February.

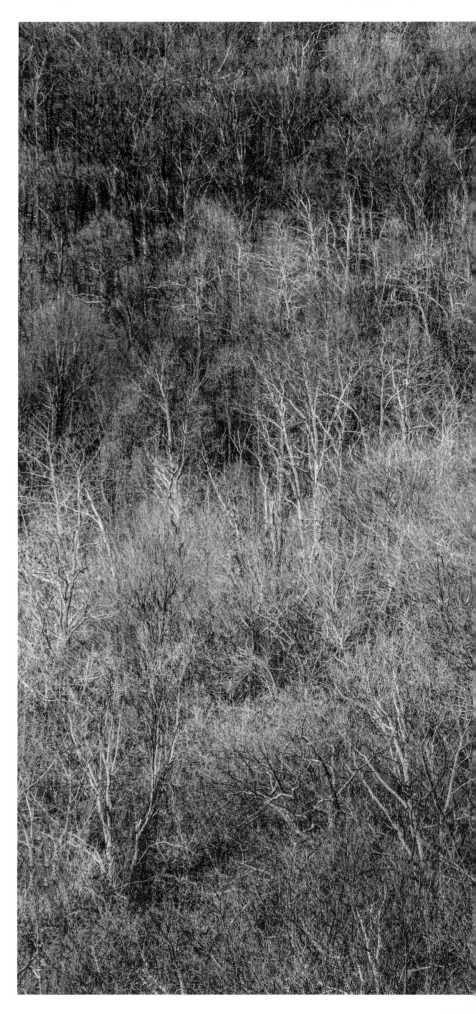

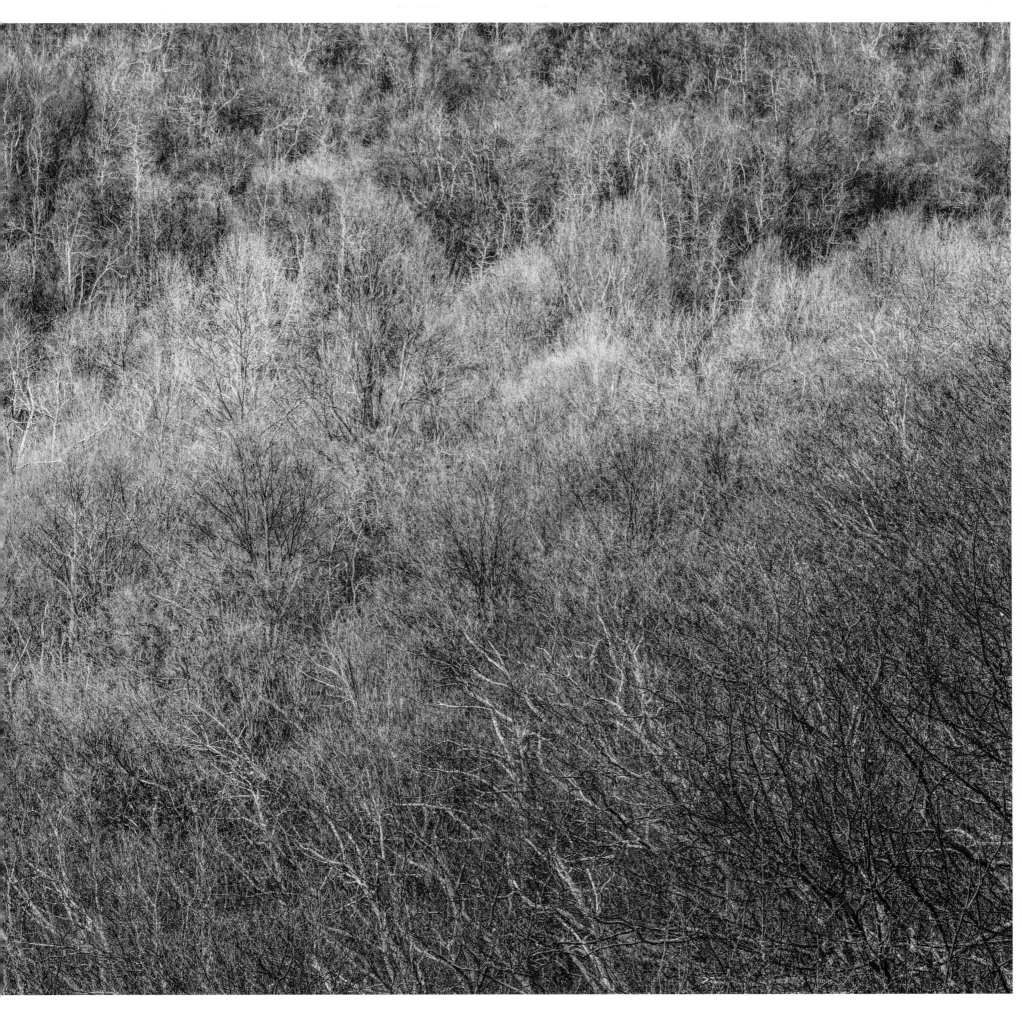

The two antennae-like things are the sticky pollen-capturing structures of the female maple flower. They will intercept windblown pollen, and the fertilized ovules will form the seeds we're familiar with. ▲

These are the immature pollen-producing structures (anthers) of a male red maple flower. They will split open once they ripen, and the wind will carry their pollen to the female flowers. ◄

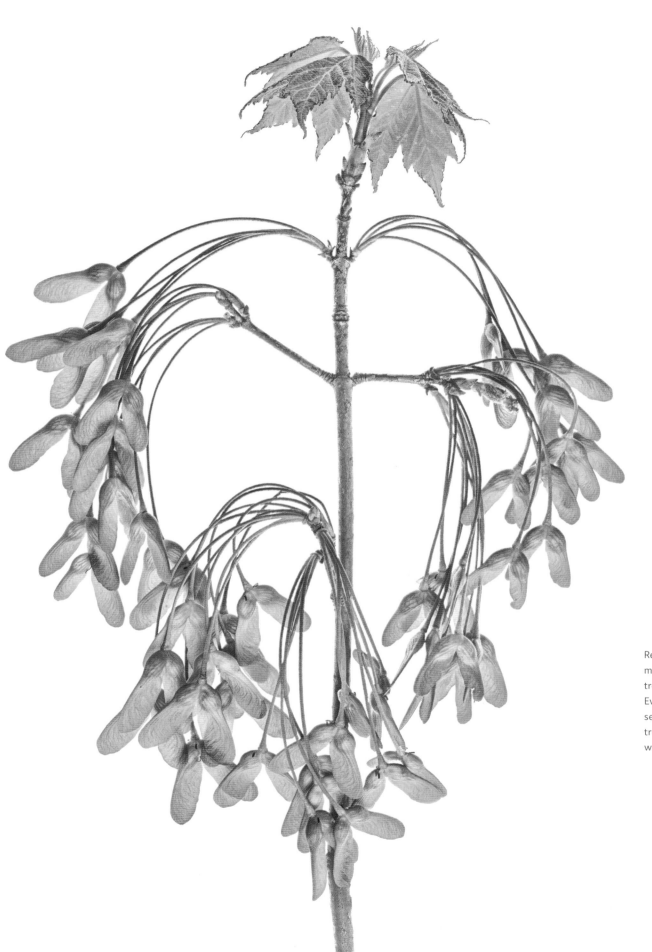

Red maple trees are among the most common and widespread trees in eastern U.S. forests. Even very young trees produce seeds. A one-foot-diameter tree can produce a million windblown seeds. ◄

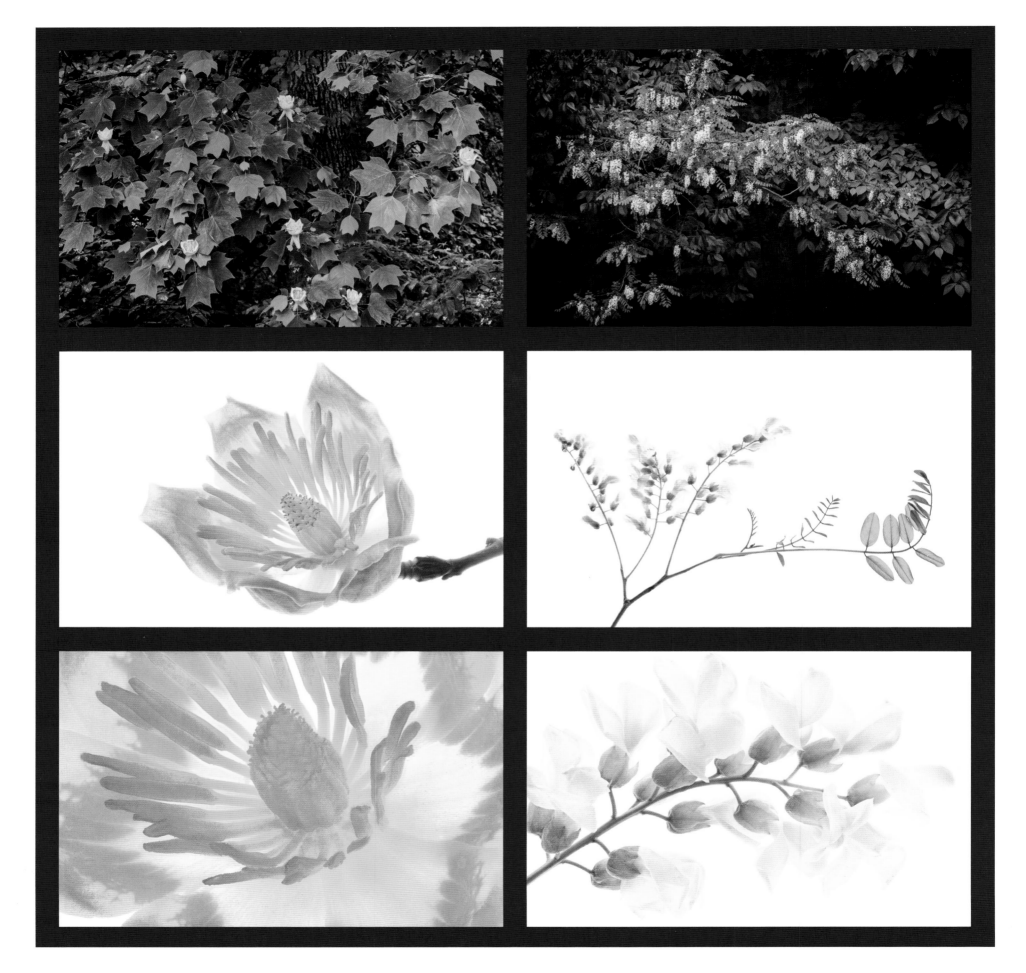

In a temperate forest, however, flowering is on a predicable annual schedule: early bloomers, midseason bloomers, and late bloomers. Redbud, early. Maple, early. Tulip poplar, midseason. Blackgum, late. The early ones bloom before their leaves are out. The midseason bloomers have young leaves just fully expanded when they get flowers, and the late bloomers have fully formed leaves when their flowers finally appear.

The more years you watch, the more you get used to the pattern. Just as bird-watchers have a sense of when to expect the first warblers to return from their migration, tree-watchers know when to expect the black locust flowers and their accompanying sweet breezes and buzzing sounds.

Speaking of the birds and the bees, the sight of certain native flowers has been shown to cue migratory birds to pause and refuel. Where there are flowers there are insects, and insects are an important food for birds that are flying long distances. Insects are a high-quality food—much higher in fat and protein than berries are. Even pollinating bees are occasionally eaten by birds.

Differences between species in tree-flowering times have to do with trees wanting the bees all to themselves. If you need a helper to mate, it's better to have your helper go directly from you to one of your kind (or from one of your kind to you). If all trees bloomed at once, bees might be stopping to sample all types of delicious nectar, and your pollen might get lost along the way. Or the bees could bring you pollen that did you no good. For mating purposes, it's better to be the only thing blooming. So find your niche and stick with that.

But many trees don't need pollinators; they're fertilized by the wind carrying pollen from male flowers to female flowers of the same species. These flowers have all the sexual organs, but they don't need the showy, colorful petals or the sweet-tasting nectar. Those things are only needed for attracting pollinators. What the wind-pollinated plants need instead is lots and lots of pollen. That's where they put their energy. They need to release enough pollen into the wind that a tiny dull female flower is almost guaranteed to be fertilized just by chance. The pollen you see in yellow layers on puddles, on your car, and on the patio furniture is almost all from wind-pollinated trees.

(LEFT, TOP TO BOTTOM) Many people who are familiar with magnolia trees don't realize that the tulip poplar is a magnolia, too. A close look at the central cone and the abundant pollen-producing anthers will bring the recognition that this, too, belongs to the family of plants that were the first on the earth to be insect pollinated. ◄

(RIGHT, TOP TO BOTTOM) Black locust flowers provide abundant spring nectar for native bees. The tree prefers full sun, so it is most likely to grow as a pioneer species in recovering forests and is not normally found in ancient forests. ◄

Many kinds of pollen are drifting in the air, but for a white pine tree only white pine pollen will do. The female flower structures are covered in pink scales that protect ovules just waiting for a windblown grain of white pine pollen. It takes a year and a half for the cones to produce seed ready for dispersal. During wet weather the scales stay closed and hold the mature seeds within, but during dry weather the scales open, allowing the seeds with their papery wings to catch the wind. Most cones are produced high in the tree to assure the farthest journey possible.

Notice that the showy, sweet-smelling, pollinator-needing flowers tend to have both male and female parts in the same flower. But the small, plain, wind-pollinated flowers are often segregated into male or female.

If a male flower releases its pollen too early and no mature female flowers are open yet, that's the end of that genetic line. The reverse is also true: if a female flower opens too early or too late, it will receive no pollen and its ovaries will wither. This is how nature narrows the flowering window until it's open just a crack.

After the male flowers have released all their pollen, they will drop to the forest floor on top of the red maple flowers, which by now are hardly recognizable. Some of the most abundant male flowers found on the forest floor in late spring are from oak and pine. High above are the tiny female flower nubbins that will become acorns or pinecones. A long drop awaits them, too, but not just yet, as it could take them two years to complete their journey to maturity.

The point of all this energy collected and then spent by tree flowers is to produce a vessel that will carry the genes of the organism forward in time—not just so the genes can survive, but ideally so they will multiply and spread across the globe.

All living things die—whether we are talking about weeds or warblers—and all species share a common impulse to reproduce. We can say this with certainty because if a species didn't carry this impulse, it would not still be here for us to celebrate or curse. In mammals the genes are carried deep within the reproductive cells, but in trees they are dangled off the branches waiting for a puff of wind or a wandering creature to carry them away. They are in pollen; they are in seed.

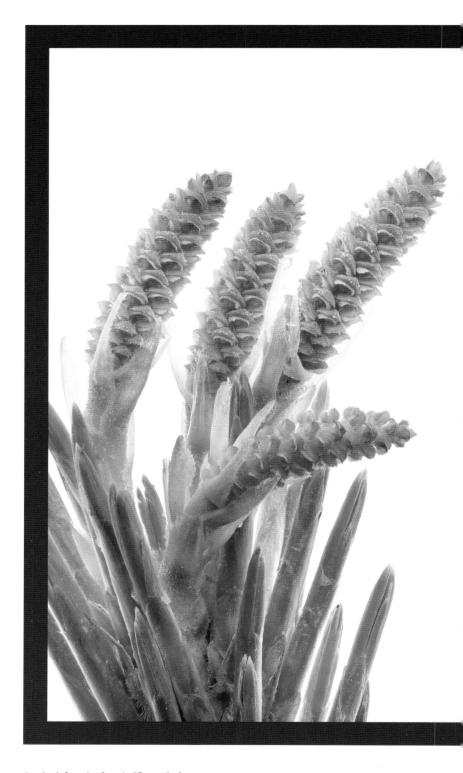

On the left is the female "flower" of a white pine tree. Under these pink scales are ovules waiting for a windblown grain of white pine pollen. The mature seeds are scattered by the wind when the cones open in dry weather. ▲

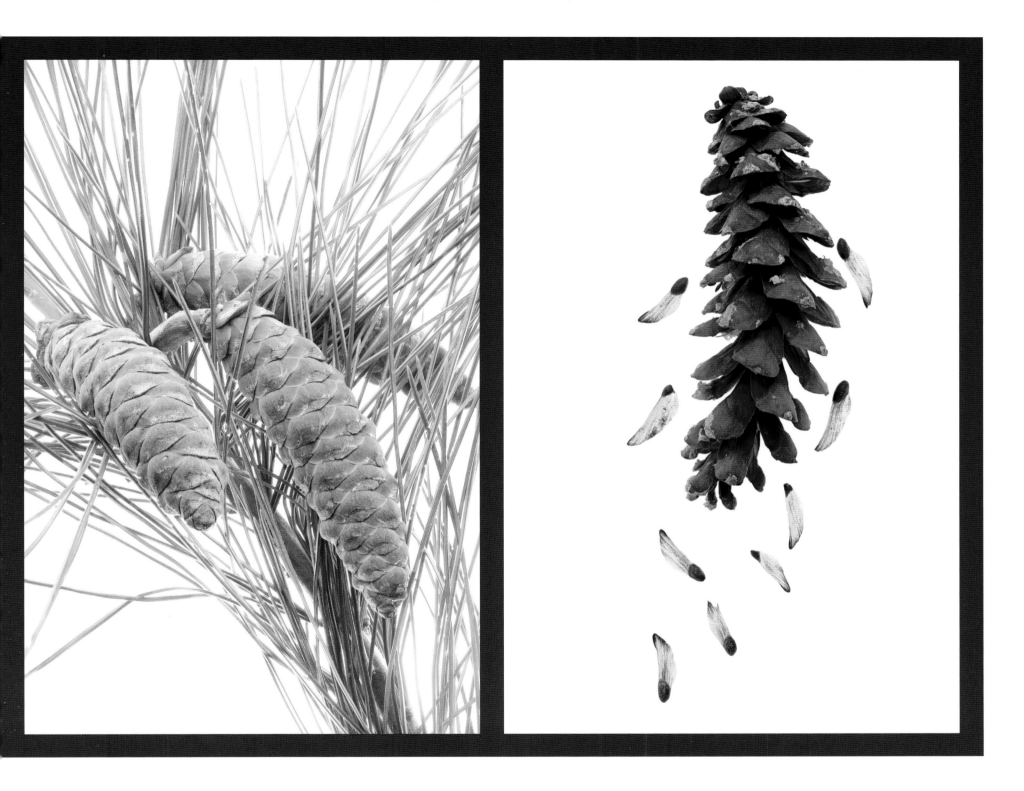

A male eastern red cedar develops a slight orange color in the early spring from thousands of tiny pollen-producing cones like the ones shown here. A female produces bluish "berries." ◄

Much larger than life, these are the tiny flowers of the white oak tree that will catch the windblown pollen and develop into acorns. The tree that sprouts from one of these acorns may live for hundreds of years. ◄

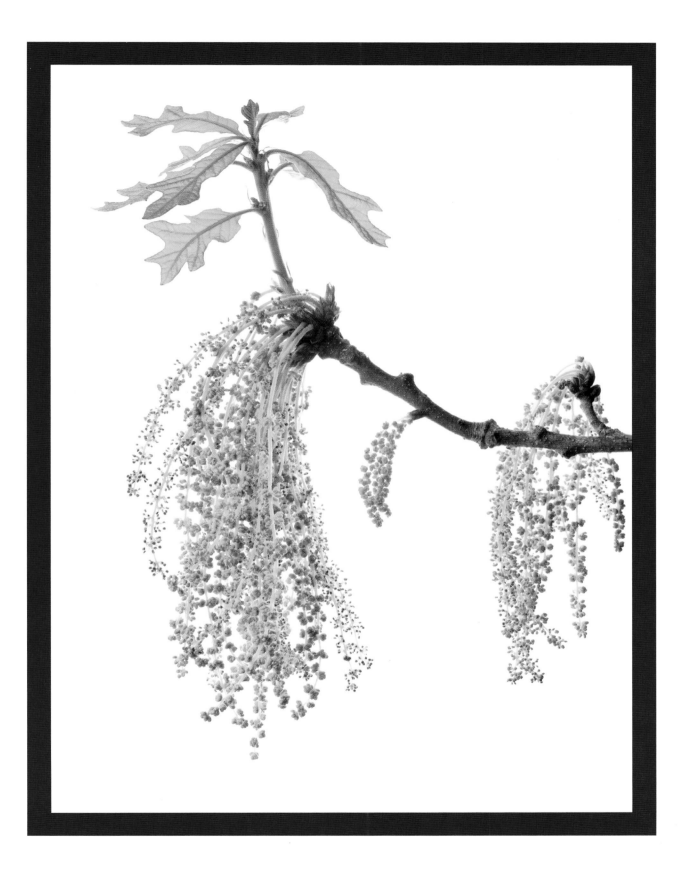

When a red oak tree is in full bloom, the male, pollen-producing, flowers dangle down to catch the wind while the early spring leaves are expanding. ▶

The seeds need help getting around, and they might also need a little protection. Many seeds are delicious and nutritious, but if they get eaten instead of planted, there go the genes for the next generation. Nature's solution to this is to create another structure, a fruit, to fulfill the common assignments of dispersal and protection. Just as human babies are prepared for life in a womb that grows as they do, plant seeds are prepared for life inside a fruit that grows as they do. The difference is that when a baby is delivered to the world, the womb stays with the mother. In plants the protective womblike structure that we call the fruit is released along with the "baby."

In common usage we think of fruits as something sweet and fleshy: blueberries, apples, oranges. We are less used to thinking of dogwood berries, or the papery covers of redbud and elm seeds, or the spiny balls of the sweetgum, as fruits. But all these structures are indeed fruits, with the seeds containing the genes tucked deep inside.

The sweet, bright fruits say, "Please come eat me." And seeds get spread. The papery fruits say, "Wind, come carry me." And seeds get spread. Seeds with thick husks roll down the hill and get spread. In a natural forest, no one needs to plant anything. Seeds will be produced and will spread generation after generation after generation. Some seeds will not live one day, and other seeds will produce a plant that will live for centuries.

When the redbud trees have finished blooming, their fertilized flowers produce brown seedpods that rattle in the wind. The pods will eventually fall from the tree and be blown to other parts of the forest. If the pods remind you of peas, it's because they're in the same plant family.

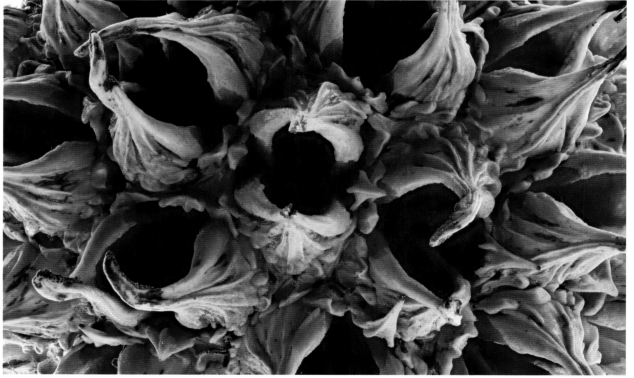

Sweetgum trees also have separate male and female flowers; the female flowers produce these spiny balls. Sweetgums are among our most colorful fall trees, and they provide food for many creatures, from butterfly caterpillars to songbirds. ◄

Sycamore trees naturally grow along river valleys, where they may reach astounding size. Each of the little bumps on the seed ball is an individual seed surrounded by little hairs at its base. The seed balls hang on to the tree all winter, breaking apart gradually in the spring. The seeds may take to the air or float along with the spring floods, and ideally will reach a distant fine place to germinate. ►

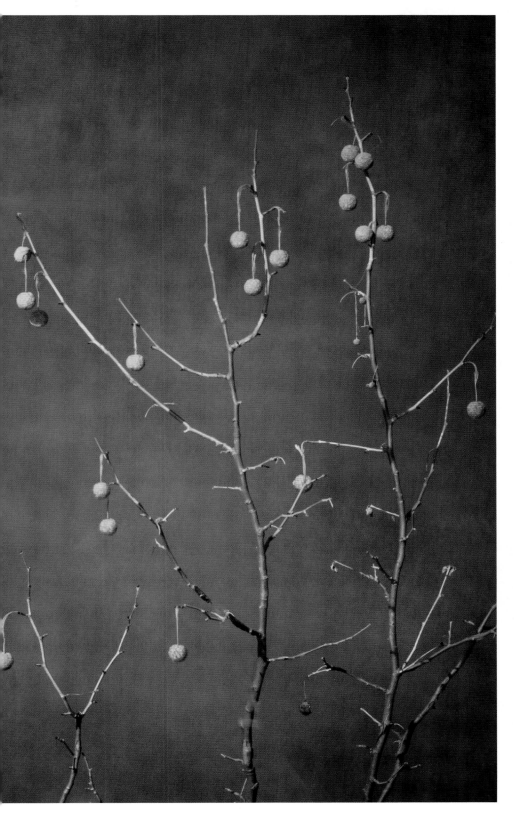
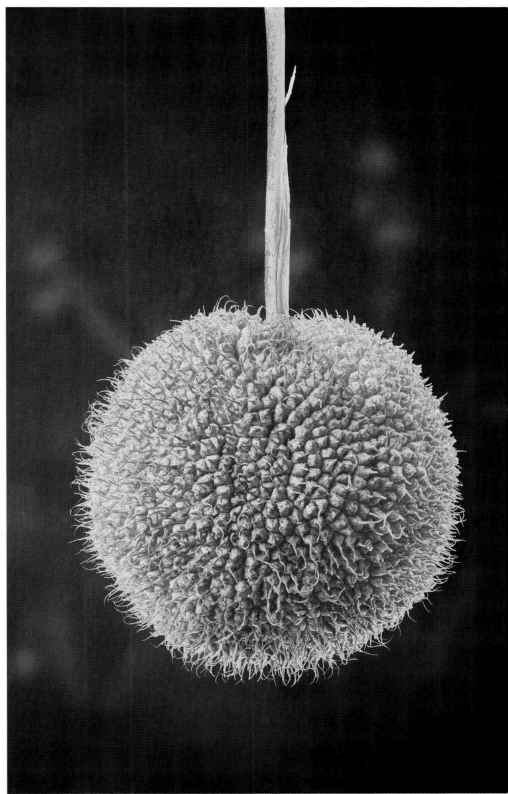

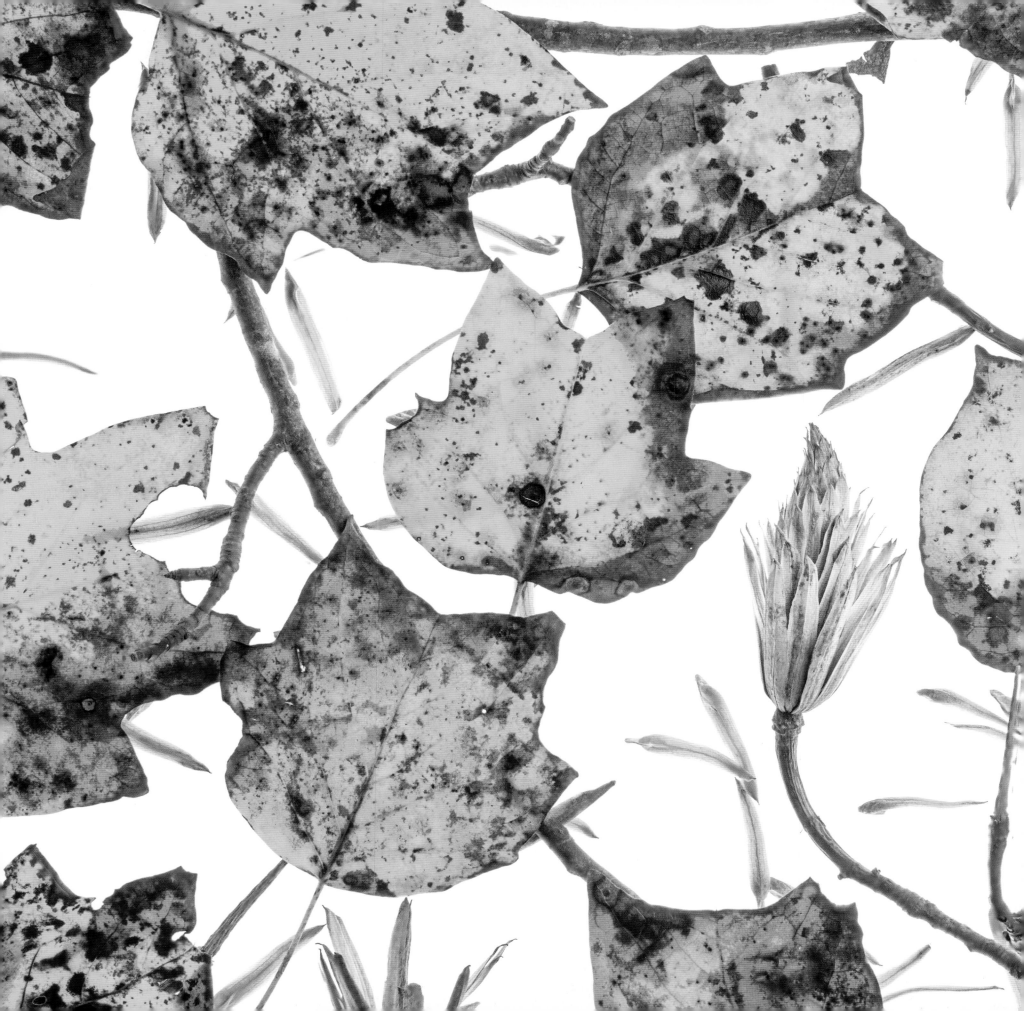

Windblown tulip poplar seeds
may travel a distance more than
four times the height of the tree
and remain viable for more than
four years.

183

The whirligig downward-spinning flight of a red maple seed is a delight for all ages to watch. ◄

Looking at these seeds, of pecan, beech, hickory, and oak, one might wonder what type of dispersal mechanism they use. Rolling down a hill, perhaps? Actually, squirrels, blue jays, and mice are the predominant dispersers. All these seeds contain a large starchy meal that's often hoarded for later consumption. Unconsumed seeds may sprout where they've been buried. ▲

The randomness and complexity of nature are among her greatest beauties. We don't know enough about forests to know how to accomplish that. Forests are communities that take generations to develop. They are certainly more than just planted trees. Trying to recreate a forest after it has been destroyed is like someone from another planet trying to recreate New York City. They may rebuild the major buildings and even populate the city with humans, but it will never be the same city that developed naturally over a period of five hundred years. As the poet W. S. Merwin says, "Only a forest can grow a forest."

At first it might seem that the best place for a seed to land would be down in the softest, deepest place. But that is not ideal for a seed. Down there a seed might land on such a thick layer of leaves that its roots would never reach the soil, and even if it germinated it would dry and die during the summer drought. A seed in such a place could also get covered by so many leaves that its shoot would never make it up to the light. A seed in a deep, rich place is also more likely to be eaten by the creatures of the forest floor who are always scouting for food. Surprisingly, the best place for a seed to land may be up on a rotted log or a mossy boulder.

Starting life in one of these places creates challenges for a root system that must eventually find its way into the soil and stabilize a potentially huge tree. These challenges, and the way they are solved, create beautiful forest art.

Seeds that fall down into the deep leaf litter have difficulty germinating and surviving. The top of a rotting log is a much better place to land. Many of our forest trees started life on a nurse log such as this.

The top of a mossy rock is a good place to germinate because it provides an escape from the nibbling mouths of hungry deer; however, a young tree will soon outgrow this shallow layer of soil, and its roots must find a way down to the true forest floor.

189

Connections

Roots and Fungi

THE FIRST SIGN OF life from a seed is the emergence of a tiny white root. The seed coat cracks and there it comes, grasping for connection with a soft fuzziness. It already knows up from down. This delicate white organ has capabilities we are just becoming aware of. An elephant's trunk has been described by nature writer Carl Safina as a combination of eyes, nose, hands, and machinery. One might imagine a tree root in much the same way.

If the seed is from a species with a taproot, like oak or pine, that first root will dive deeply into the soil and so become a critical anchor for the tree for as long as that tree shall live. The depth of the root is limited by the availability of oxygen. Too deep and there is not enough air for the root to live. Other, lateral roots grow closer to the surface, spreading out in all directions (unless they encounter a physical obstacle). Between four and eleven of these major lateral roots emerge near the soil line. It is this interface of trunk, roots, and soil that Joyce Kilmer was referring to in the second stanza of his famous poem "Trees."

A tree whose hungry mouth is prest
Against the earth's sweet flowing breast

(PREVIOUS) The pattern of swellings at the base of a tree like this old-growth white pine gives an indication of how many major lateral (horizontal) roots the tree possesses.

The root tip is not a passive structure pushing blindly into the earth. Root tips move through the soil sniffing, feeling, seeking, and reacting to the rich underground world. ▲

A germinating maple seed shows the newly developing root system. ▲

These horizontal roots will make their way around other trees and grow far beyond them. They will cross over each other, each root on its own individual mission. The roots don't stop where the tree's branches stop but may continue on for seven times that distance—farther than the distance equaling the height of the tree. When they encounter an obstacle, they know if they're running into a rock or another root. And they react differently if it's their own root or a root from another species.

But the real work of water and nutrient absorption is not done by these big woody roots; the real work is done by the thin white roots that fan off of them. We often think of tree roots as deep down, but the vast majority of them are close to the surface—99 percent are in the upper three feet of soil. These roots stay close to where both oxygen and nutrients are abundant. When they find a nutrient-rich patch, more roots will grow in that location. And roots can sense and grow toward moisture.

The soft feeder roots are a delicacy to many small soil organisms, so a tree must continually grow new ones to replace those that have been eaten. Just as leaves come and go on a tree, so also do roots come and go. When you look at the aboveground parts of a tree and imagine the belowground parts, keep in mind that the surface area of the root system is much greater than the surface area of all the aboveground parts, including the leaves. A typical tree has hundreds of thousands of root tips, each connected by vessels to the top of the tree. And most of these delicate roots are accompanied by a fungus that wraps around them and increases their surface area even more. Imagine wrapping yourself in a large fleece blanket that continually delivers food and water to you in exchange for a little of your body heat. A strange analogy, perhaps, but it does work something like that: in exchange for a little sugar (made from sunlight energy) from the tree, the fungus supplies water and nutrients to the feeder roots.

Mycelia (the mass of filaments that forms most of a fungus) collect nutrients from all over the forest and deliver them to the tree roots, and the tree roots are tied to each other with this underground web. Many plants would die without their fungal helpers, but all we see of the fungi are the reproductive organs that occasionally poke from soil or stem to release spores. It's a beautiful, complex system we're just learning about.

And the fungi connected to those roots that extend so far from the tree, extend even farther. Each tree can thus be aware of what's happening to many, many acres of forest. And roots of individual trees of the same species can form grafts with each other, sharing resources and spreading their reach even farther. The fungal network can even connect individuals of different species. No tree is an island, indeed.

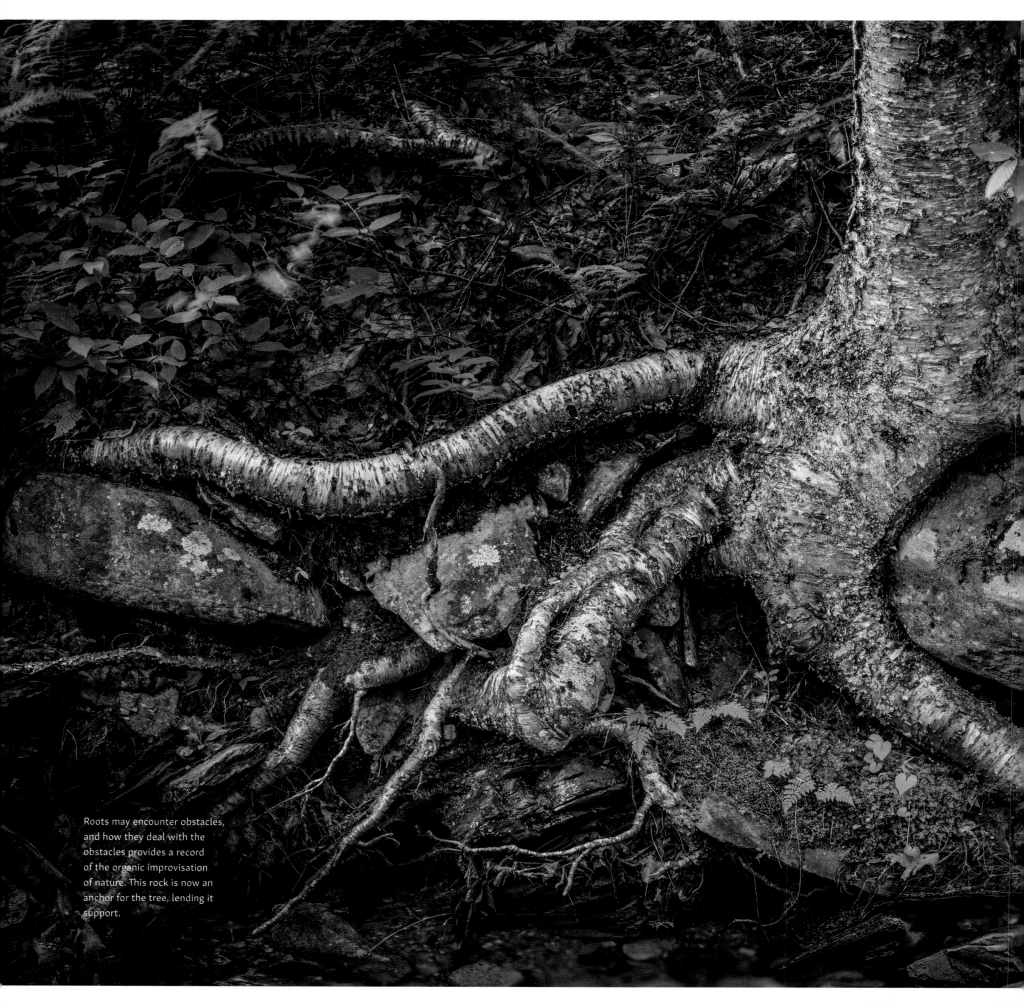

Roots may encounter obstacles, and how they deal with the obstacles provides a record of the organic improvisation of nature. This rock is now an anchor for the tree, lending it support.

Tree roots range in size from the delicate feeder roots to roots almost as large and hard as the trunk. These large old roots even form rings as they grow larger every year. One of the delights of walking through a forest is appreciating the roots that we are able to see—their shapes are even more interesting and unexpected than those of the branches. A large root may snake across a rock seeking the next pocket of soil, or reach for an anchor to balance the top growth that gets heavier each year.

Sometimes the roots cannot hold a tree upright: perhaps the winds were too strong during that last storm. Then we see the tree lying down with the larger roots ripped from the ground but still attached to the trunk. At first soil is still held by these roots, but eventually the soil gets washed away by repeated rainstorms. It is then that we witness nature's abstract root art, free for all to enjoy.

And what becomes of the downed trees? Entirely different types of fungi work to decompose them. Fungi are master recyclers, turning dead plants and animals and even stones into nutrients for the living green layer. Some fungi specialize in living plants, whether parasitizing or helping them; other fungi specialize in dead and dying plant parts, recycling them back into soil and nutrients. And within those two specialties are fungi that specialize in particular species of plants—whether dead or alive or somewhere in between.

The mushrooms that poke out from tree stems are often called shelf fungus, and you can imagine how a forest gnome might rest something on top of one. The fungus's relationship with the tree started long ago when a small wound from a borer beetle or a fallen branch gave an airborne spore a place to land and grow. The spore fed off the living wood cells, replacing their contents with its own threadlike strands. Where the fungus had finished feeding, the wood felt wet and looked whitish. As the fungus continued to grow, cracks in the bark were sometimes filled with its white cottony mass. Eventually the fungus got so strong it was able to form its spore-making structure—the part we call the shelf fungus. A small white bulge poked out from the bark and got larger by the day. The top took on a shiny dark reddish color and the underneath became covered with tiny holes where spores were formed and released. Now a human walking by could tell that the tree was infected with *Ganoderma*—a fungal disease that could eventually kill the tree. If the human also happened to be a healer, he might call this fungus reishi and collect some, since it has been shown to be effective as a wound healer and a cancer tumor reducer.

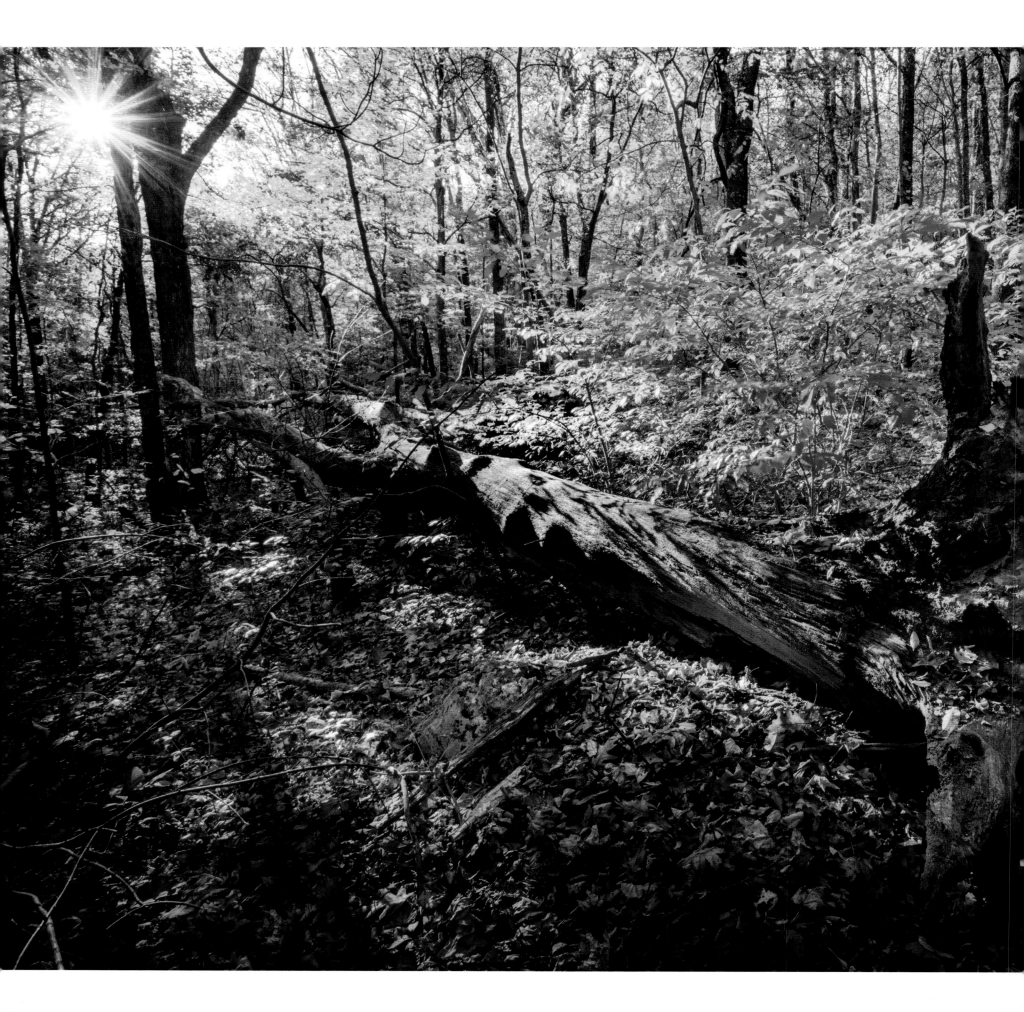

Dead trees with roots still attached add beauty and complexity to the forest ecosystem. ◄

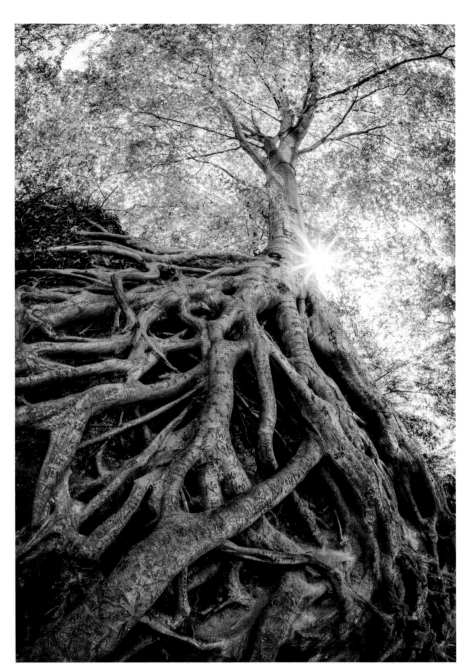

A beech tree sends roots down a boulder face. Large roots such as these are not taking in water and nutrients; they primarily provide structural support and get the thin feeding roots into a beneficial location. ◄

But let us suppose that our tree is deep in the forest where no humans ever pass by. In this case, the hemlock varnish shelf fungus is still useful to another organism. A large orange-and-black beetle with the sweet name of pleasing fungus beetle is very pleased to see this fungus. She will land on it, eat it, and lay her eggs on it. When the eggs hatch into wormlike larvae, they will feed on it, too. Within just a few weeks they will pupate and become adult beetles—and continue to feed on the fungus as long as it remains in good condition.

Some shelf fungi inhabit and then kill a tree; others grow on a tree only after it's already dead. The dead tree might still be standing. Chances are if you walk past a tree covered in many small, thin shelf fungi, when you look to the top of that tree you'll see that it's dead. Sometimes a single species of fungus has colonized a tree and all the "shelves" look the same. In other places, a variety of fungus species can be found growing together, and it's not uncommon to see lichens or moss growing among them.

When the shelf fungi first emerge from the wood, they are delicate and brightly colored. Some have concentric rings that remind one of a fanned-out bird's tail, and these go by the name turkey tail. When the fungi have released their spores and grown old and dry, they become convenient platforms for green algae to grow on. The fungal organisms that have never photosynthesized become the stage for that process. Layer upon layer.

Other fungal species resemble an animal hoof more than a shelf, and they're called conks. Although many of the soil-growing mushrooms are ephemeral—lasting only a few days—the fruiting body of the tinder conk may live for decades, adding a new spore-producing layer on the bottom every year.

If you were to peel back the bark from any one of these colonized trees, you would observe white fungal mycelia. The strands growing throughout the dead tree appear delicate and weak, yet they contain chemical enzymes powerful enough to dissolve wood fibers. The decomposition they perform is very important to the forest ecosystem. Soon these trees will be lying on the ground, becoming soil.

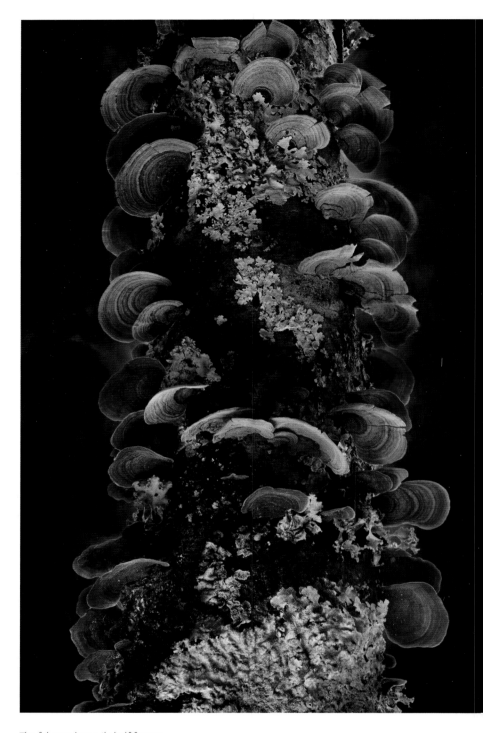

The false turkey tail shelf fungus is a pathogen of hardwood trees. It has been shown to be an effective antibacterial for treating staph infections. ▲

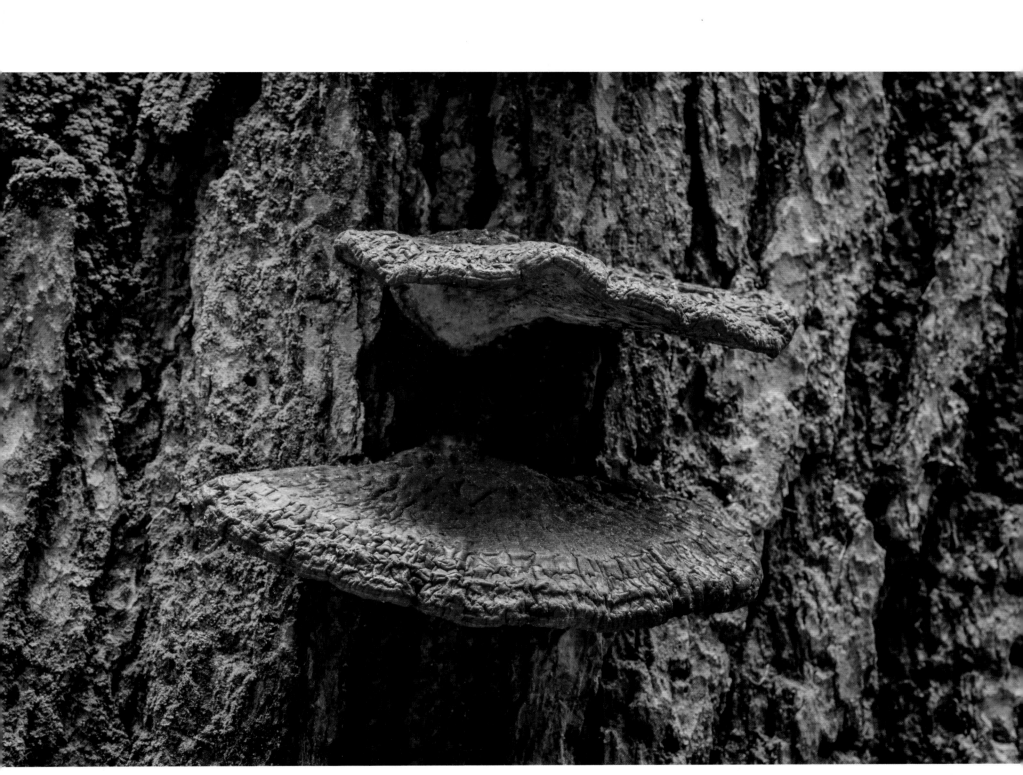

Varnish shelf fungus is a species that grows only on hemlock trees. Connected to this fungus is a vast web of mycelia inside the wood. ▲

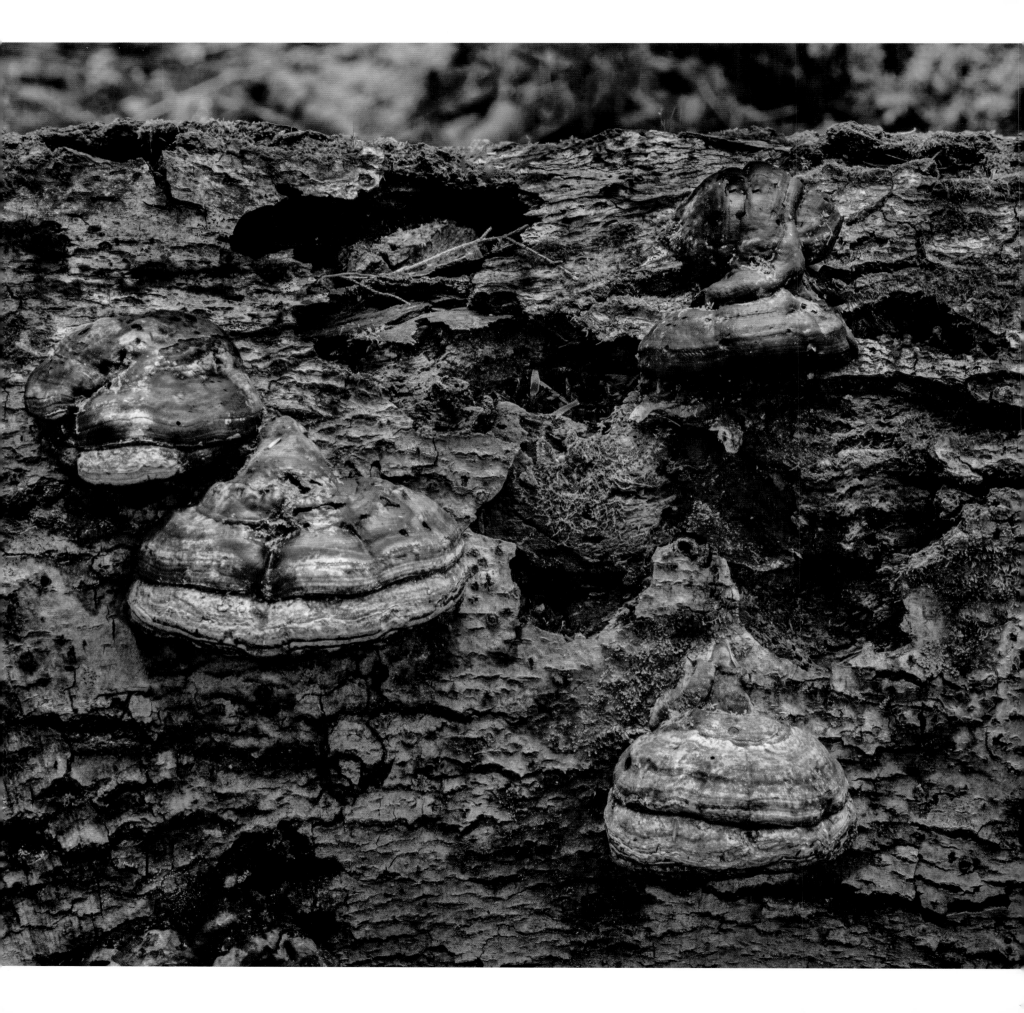

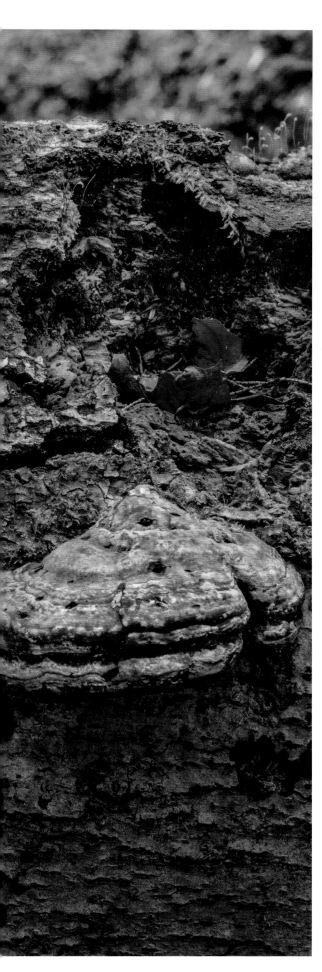

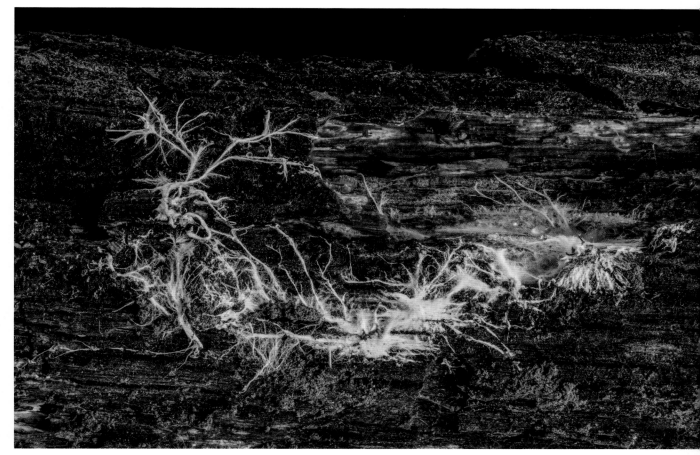

This type of fungus conk grows all over the globe and has been used by humans since prehistoric times. One of its main uses was for starting fires; hence it became known as tinder conk. ◄

Behind every mushroom is a vast network of mycelia collecting water and nutrients. Some kinds feed only on living matter, and other kinds feed on dead organisms, extracting the left-behind energy and nutrients. ▲

Other types of fungi do not grow directly out of tree trunks; instead they spring up from the base of trees or from the soil. It may not be readily apparent that these mushrooms have anything to do with a tree, but chances are very good that they're connected to tree roots or some other food source through their mycelial networks. One easy-to-identify fungus that's sometimes associated with tree roots is the coral fungus. Instead of shelves or conks, this fungus forms narrow fingers covered with spores.

One type of fungus that can grow only on living plants is cedar-apple rust. In fact, it needs two kinds of living plants to complete its life cycle. It first infects a juniper or cedar tree and produces a brown gall that looks nothing like a fungus to most people. When that gall is mature, in its second year, strange-looking orange horns emerge from it practically overnight. If you were to examine these orange structures under a microscope, you would see the spores that will be carried on the wind to apple trees. There the fungus lives in spots on the leaves and produces a different type of spore that will eventually blow back to the cedar tree and keep the cycle going.

Hundreds of fungi species inhabit a typical forest, and the fruiting bodies come and go unpredictably; as a result, very few humans can name more than ten different kinds. If you're interested in naming the mushroom you're looking at, you'll have to consider the color and texture of the cap, whether it has gills or pores, whether the gills are attached to the stalk or separate from it, and the color of the spores. Another feature used for identification is the remains of the tissue that covered the gills before the cap pushed from the ground and expanded. This ring of tissue is present in some of the more poisonous species.

Fungi play every role imaginable in the forest, from helper to harmer, and range in size from microscopic to an organism covering underground acres and sending up plate-size fruiting bodies. We still have much to learn about the fungal kingdom. We have much to learn about forests, too. Keep looking.

Not all fungi grow out of the soil or out of a trunk. The unusual cedar-apple rust fungus grows on the leaves and twigs of red cedar trees. During spring rains, orange gelatinous horns emerge from the brown ball-shaped fungus gall to release their spores. The spores can only grow on a plant in the apple family; in turn the apple plant will produce spores that can only grow on the red cedar. ▲

Some types of coral fungus form beneficial relationships with tree roots, although the mushrooms may appear to be growing right from the forest floor. ▶

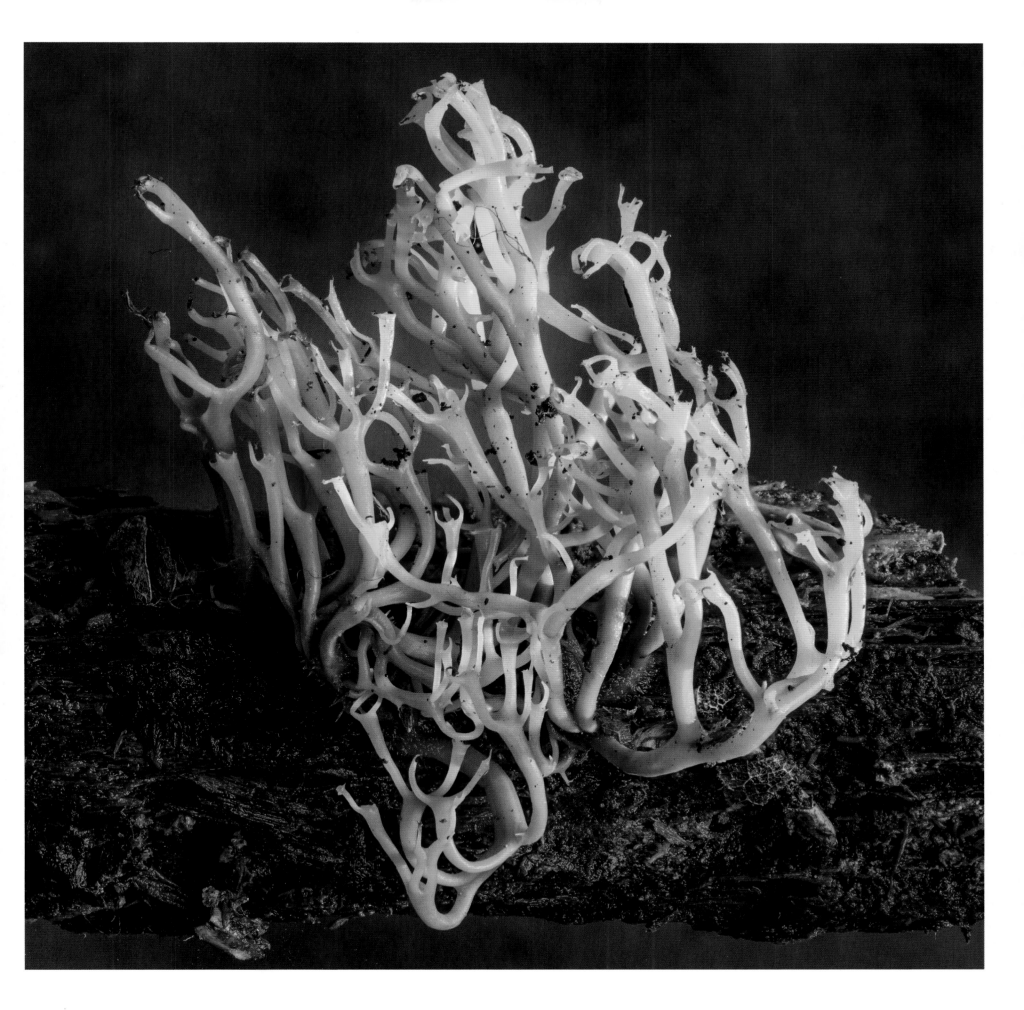

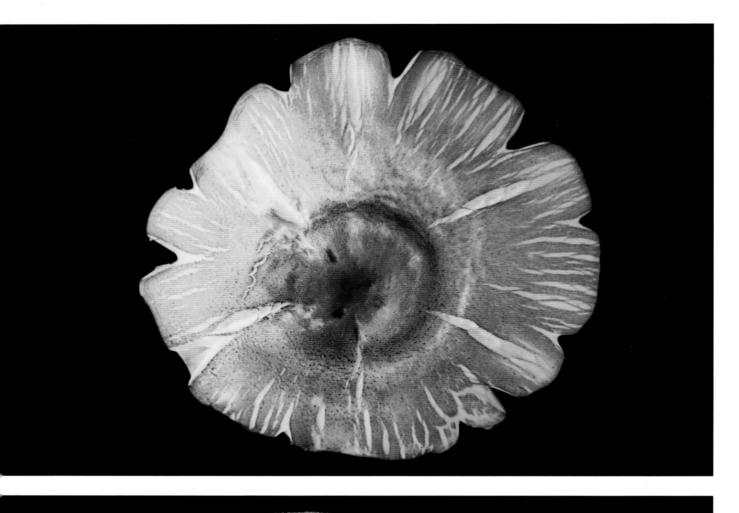

Once the network of mycelia is strong enough to produce a mushroom, it can do so very quickly. A cap such as this can spring up overnight. This one grew so quickly it has stretch marks. ◄

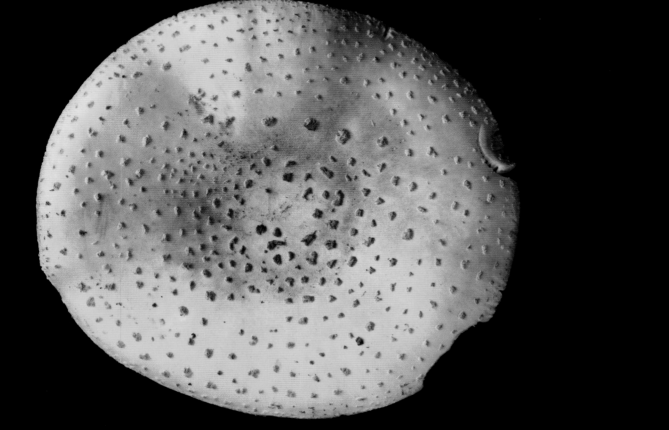

Some mushrooms emerge from a structure that resembles a delicate white underground egg. As the mushroom pushes through the enclosure, bits of it may stick to the cap, resulting in the warts we see here. The presence of warts can be a key to identification. Many of the poisonous mushrooms have warts. ◄

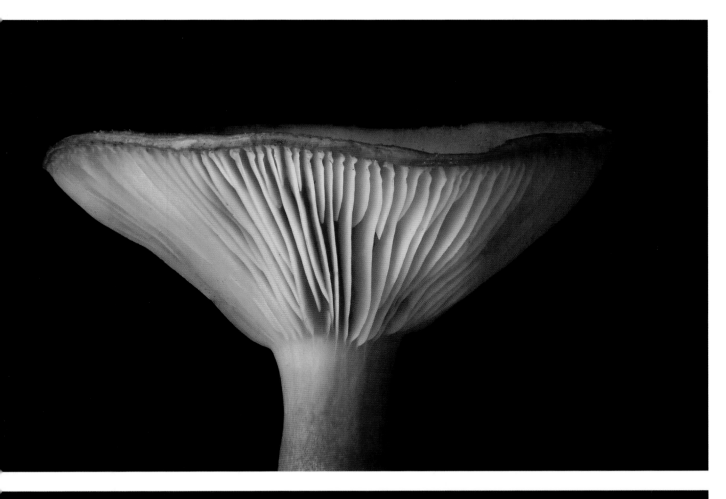

Another key to identifying mushrooms is the way the gills are attached to the stalk. ◄

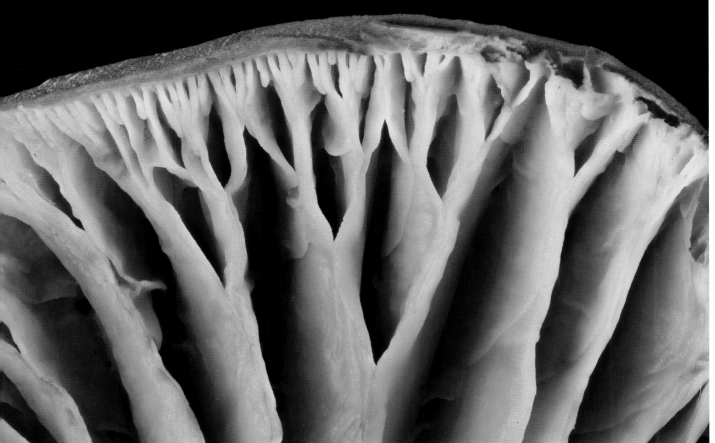

The shape and structure of a mushroom's spore-bearing surfaces can also help with identification. Here we see the forked false gills typical of the edible chanterelle mushroom. ◄

205

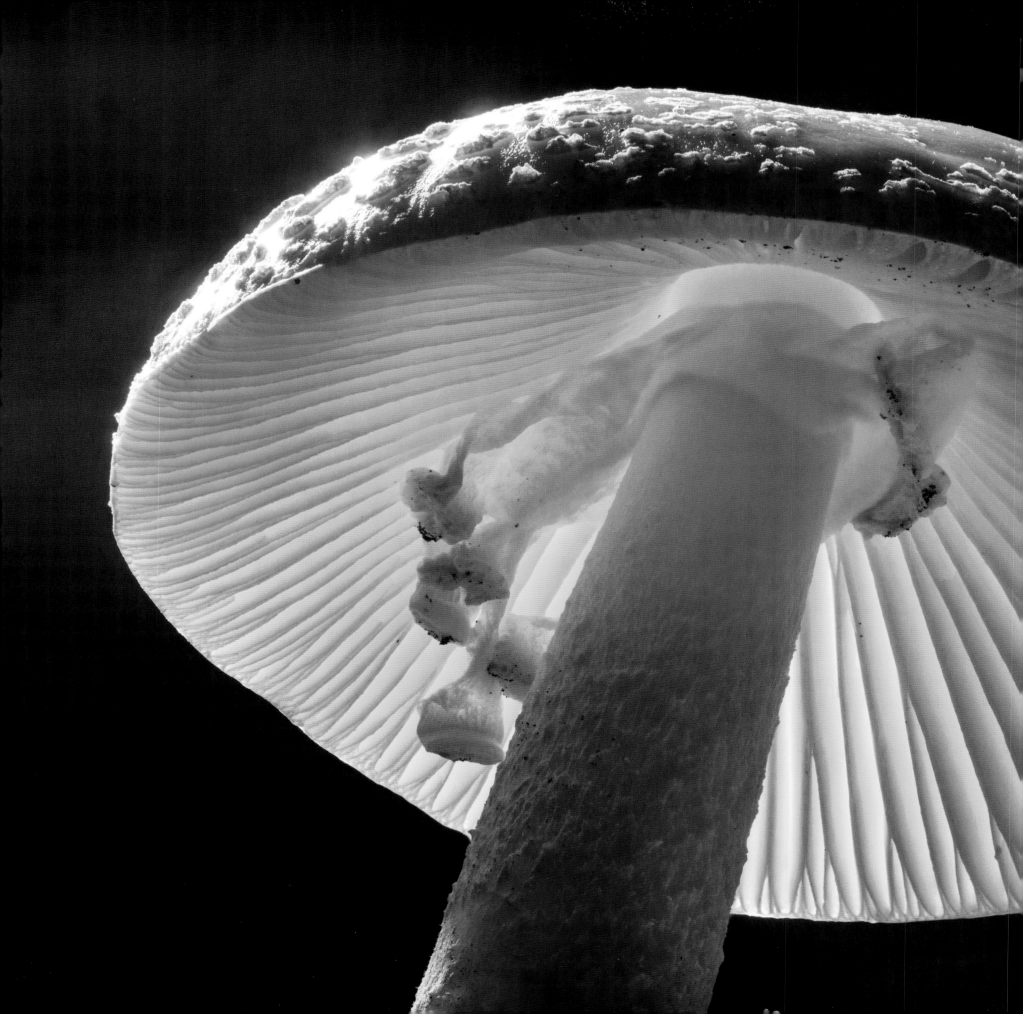

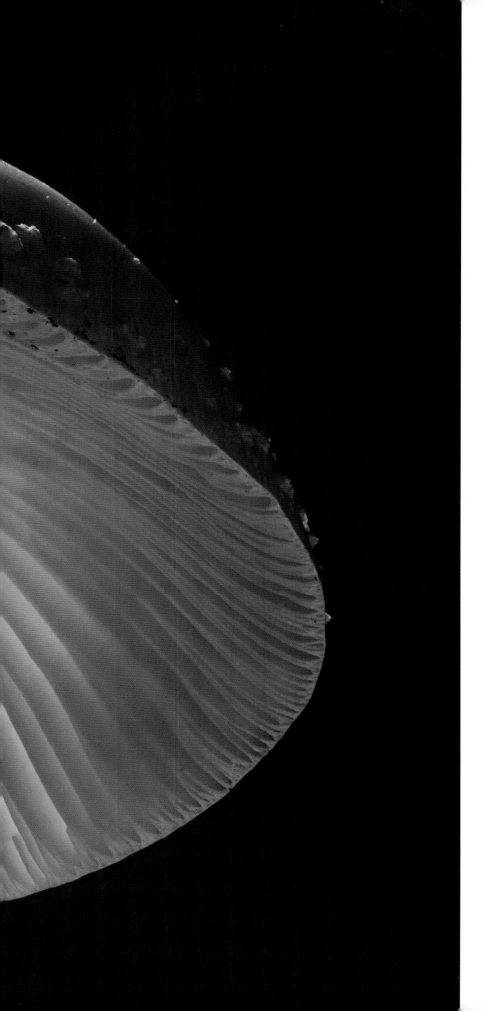

The poisonous "destroying angel" mushroom can be identified by the presence of a ring of tissue left over from when the immature gills were still covered. Also note the warts on the cap.

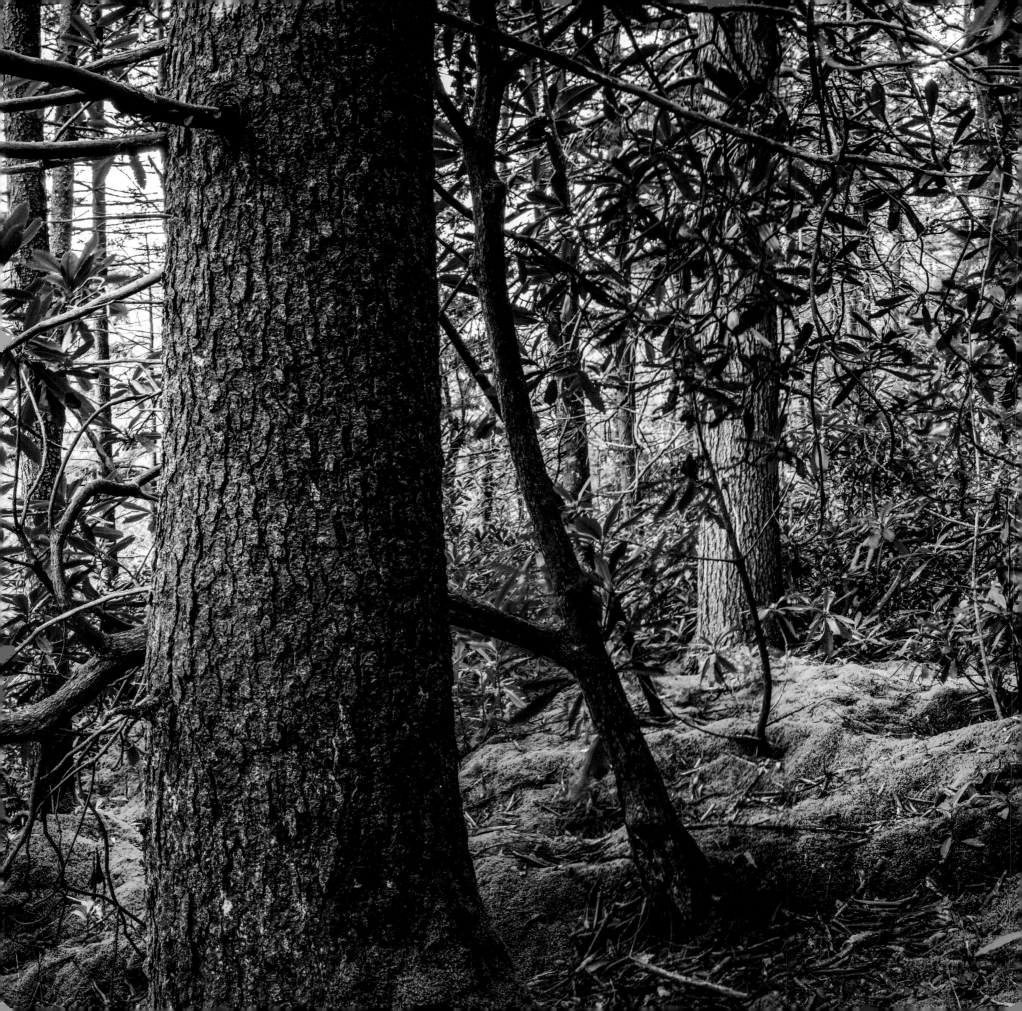

The Only-Green

Moss and Fern

SOME FOREST PLANTS WILL never make colorful flowers—they are only green. Moss, clubmoss, and fern inhabited this planet before there was such a thing as a flower. And some of these species have persisted until the present era, so we can still appreciate their early-evolved adaptations and their unique beauty. When we enter the forest, our eyes feast upon the brilliant glowing green of moss as eagerly as they do upon the colors of wildflowers. These tiny plants, too, are soaking in the rare sunshine that reaches a forest floor only certain times of the day or year.

Something about moss draws more than just our eyes. It draws our hands, too. We want to touch moss. We want to stroke it. And we're not disappointed when we do. The moss itself is marvelously soft, but when it has spore capsules our strokes are rewarded with an unusual springing motion. Once is not enough. We must do it again. And by doing so we become the animals who are spreading tiny spores.

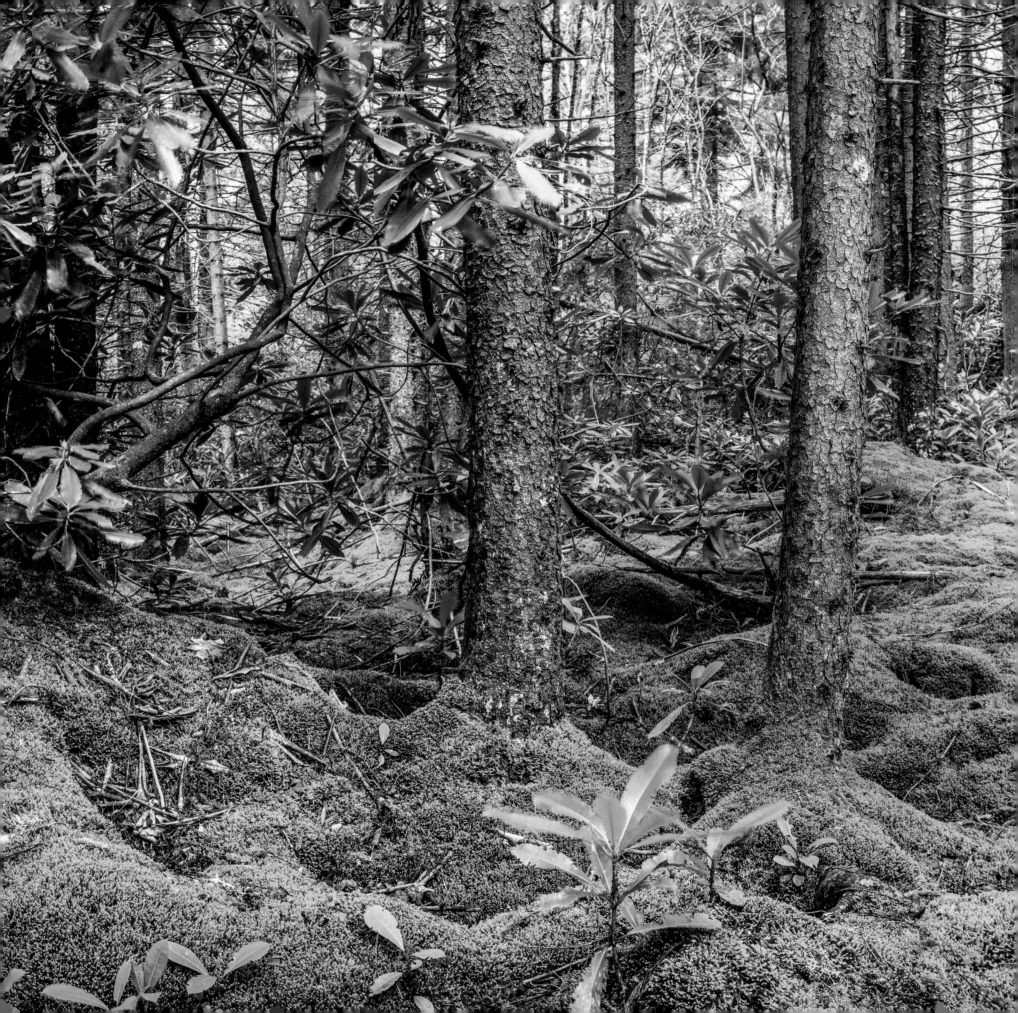

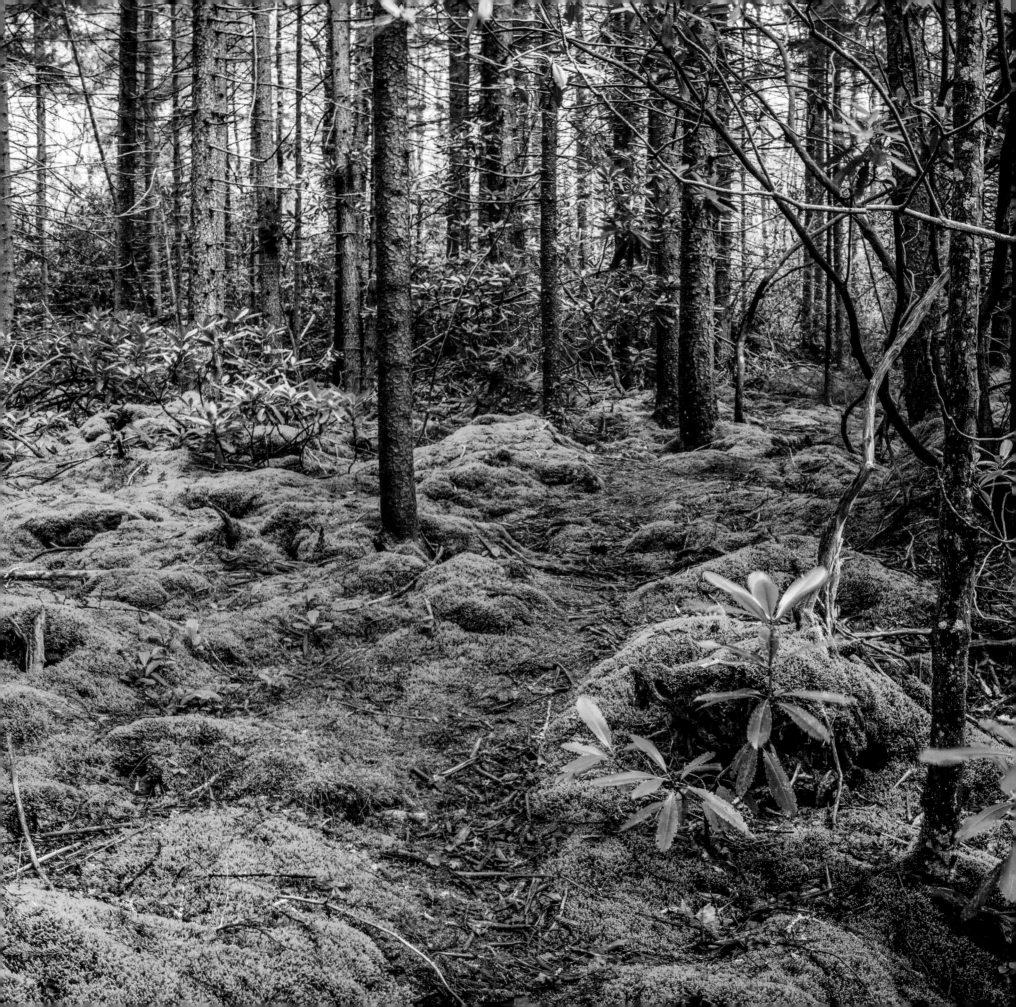

These stalked spore capsules are not just an extension of the green moss. The capsules are their own genetically distinct organism, simply being supported by the parent plant below. (This may sound familiar to those with grown children at home.)

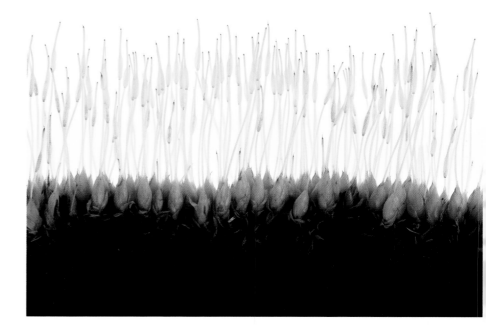

Moss was one of the earliest plants on Earth. It was here when dinosaurs roamed. It was here when there were no trees, back when sunshine was abundant at ground level. But now moss has learned to live with the trees. Trees keep the soil moist and cool, so moss can now live in more places than it did before. It has found ways to get the sunlight it needs. One way is to soak it up in the spring before the trees get it all. Another way is to get closer to the sunshine by growing on a tree trunk. The moss doesn't hurt the live tree at all. On a dead tree, the moss holds moisture and protects the fungal filaments that are helping to decompose the wood. This, in turn, helps the beetles that inhabit softened wood, which in turn helps all the forest creatures that eat beetles—from salamanders to skunks.

Rocks, too, are good places for moss to grow up and away from the smothering autumn leaves. Moss has an advantage here over wildflowers and other small plants because moss doesn't need soil; it has no roots, just small appendages that help it cling to a surface. Roots and vessels and seeds all came later in evolution. Moss has none of those things and does just fine without them.

The next step in the march of evolution was the type of plant we sometimes call clubmoss. These plants, like the mosses, reproduce by spores instead of seeds; but they have vessels that can transport water, so they can get taller than mosses—tall enough to poke out from among the fallen leaves. The young, and young at heart, among us sometimes mistake these little plants for baby trees, but you could wait for decades and they would never get any taller. At one time in Earth's history clubmoss species did get as tall as trees, but those species died out when the climate got colder. Their remains became the fossils in the fossil fuels we're still burning to keep warm.

This side view of moss plants shows the green, parental, generation and the yellow spore capsules that are a second generation supported by the parents. ▲

(PREVIOUS PAGES) Is it possible that moss has evolved to attract touch? When the forest offers a place to lie, it's often a mossy bed.

Moss plants are the ideal
habitat for many microscopic
creatures such as water bears
and nematodes. ▲

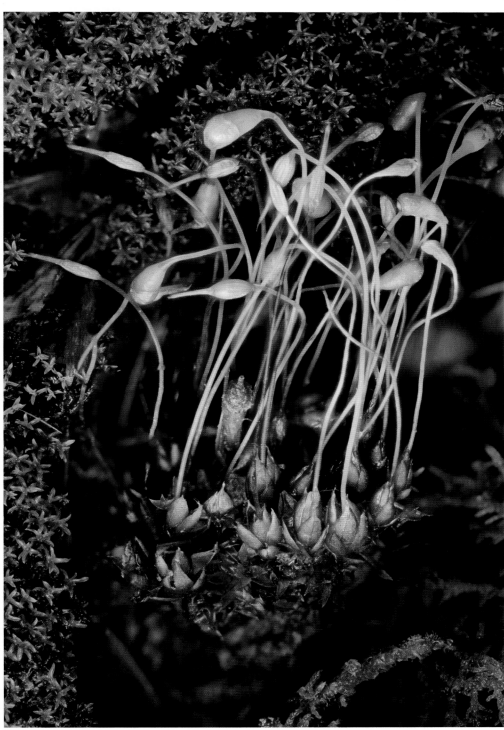

Both standing live trees and fallen dead trees are good places for moss to escape the downed autumn leaves that would bury it and block the light. ◄

Spore capsules come in many shapes and colors. ▲

215

Moss can grow on rocks and capture the moisture it needs from the air.

Clubmoss was the first plant to have water-conducting vessels. As a result, it was once the tallest plant on Earth. ◄

The many species of clubmoss have different common names. This one might be called running cedar or crowsfoot by some. ▼

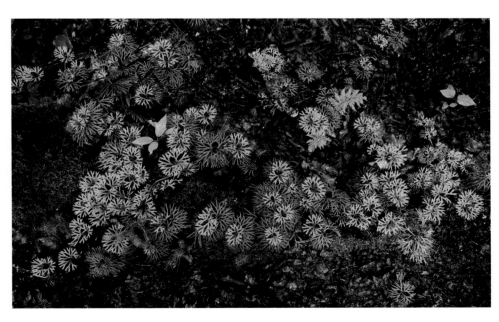

Ferns came next, all those many millions of years ago. They spread by spores, too. Ferns love forests for the same reasons moss and clubmoss do—dampness. Seeds can land in a dry spot and stay there for years waiting for rain to release them, but spores are much more delicate.

Moss and clubmoss and fern are green all over because they have no reason to attract pollinating insects. They can take care of their sexual reproduction needs without an intermediary. Just give these primitive plants a little dampness, and the male cells can swim their way to the eggs.

Many, many different species of ferns—more than ten thousand—exist, and almost all of them emerge in the same distinctive manner, like a rope unwinding from a coil. On each frond the bottom leaflet unfurls first, and then the next and the next and the next, all the way to the top tip. The energy produced by the photosynthesizing bottom leaflets helps to power this expansion. This coil looks so much like the scroll used to decorate the top of a violin neck that it has come to be called a fiddlehead. The more scientific term, *circinate vernation*, is barely used (*circinate* meaning coiled, and *vernation* meaning leaf expansion).

While moss and clubmoss spores are barely noticeable, most of us remember seeing fern spores. They typically appear in clusters on the back of the frond, and the shape and pattern of these clusters help us identify the fern species. In some species, clusters don't uniformly dot the backs of green fronds but instead are entirely absent from some areas and entirely cover others. These arrangements, too, help us identify which species we're looking at.

Some fern species, like the royal fern, have remained exactly the same for the past 180 million years. Today very few animals eat ferns, but at one time ferns had a voracious predator, one of the largest animals ever to walk the planet. The dinosaur *Diplodocus* would rip out ferns by huge mouthfuls. But ferns have outlived the dinosaurs, and now we see them mostly left alone by large animals. Apparently deer find them distasteful. These are the glory days for many fern species, like hayscented fern, which now carpets many deer-impacted forests.

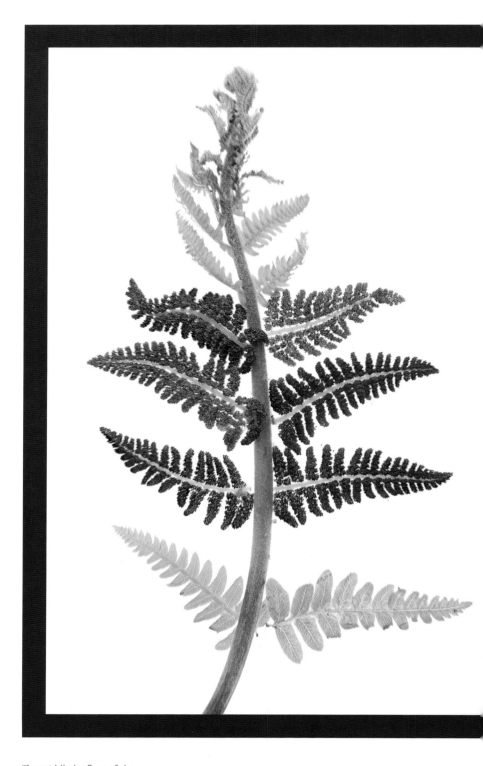

The middle leaflets of the interrupted fern are entirely covered by spore capsules. A close-up of these capsules shows them popping open to release tiny green spores. ▲

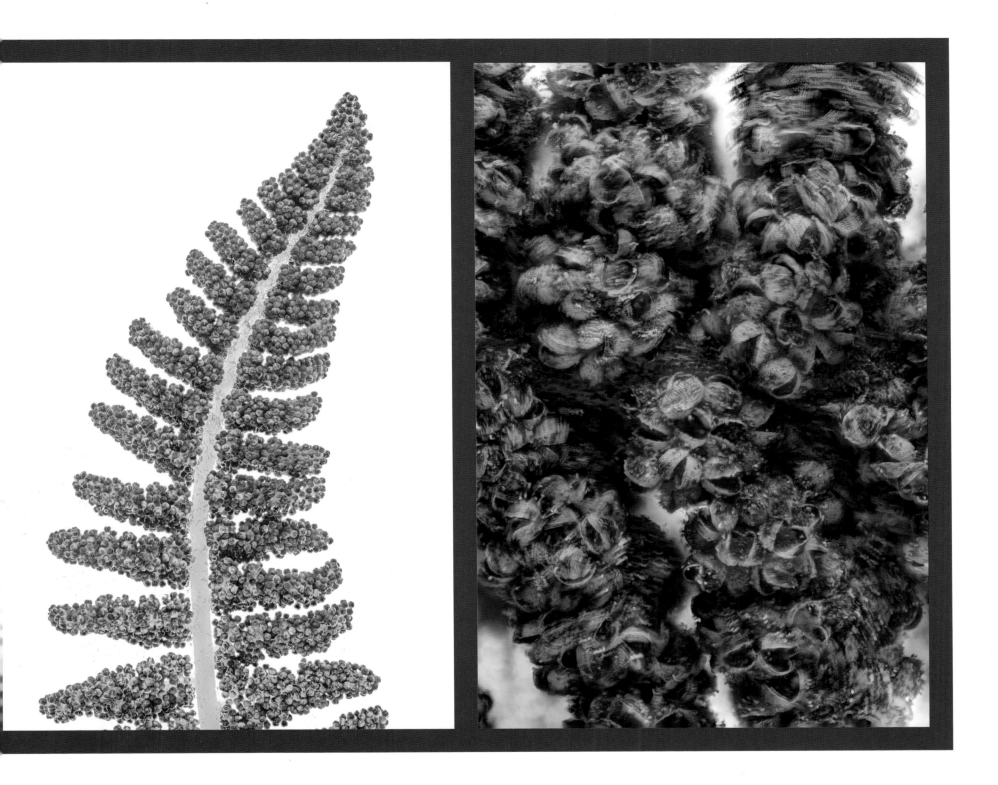

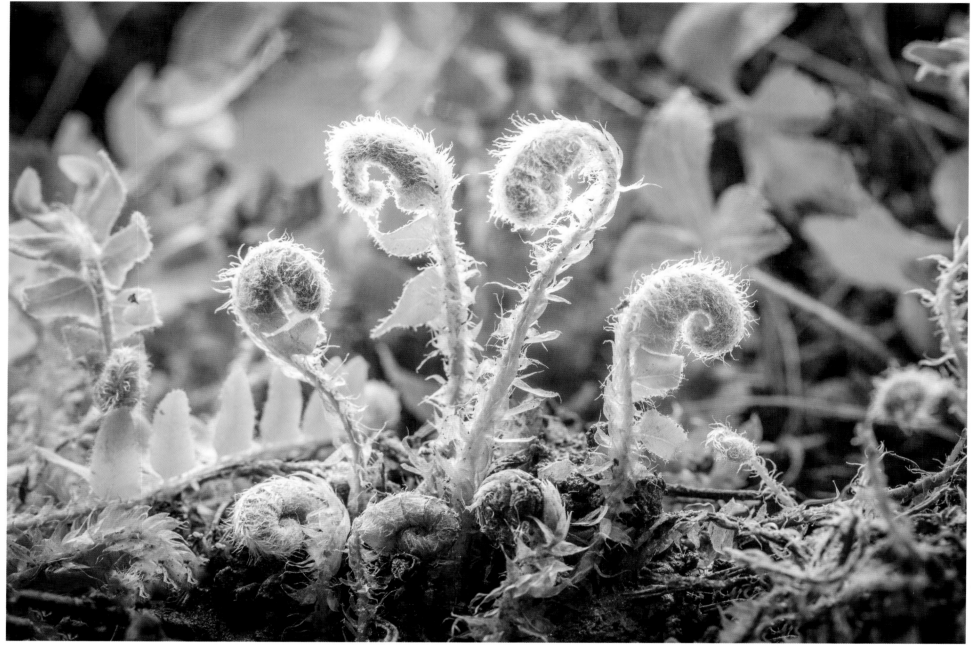

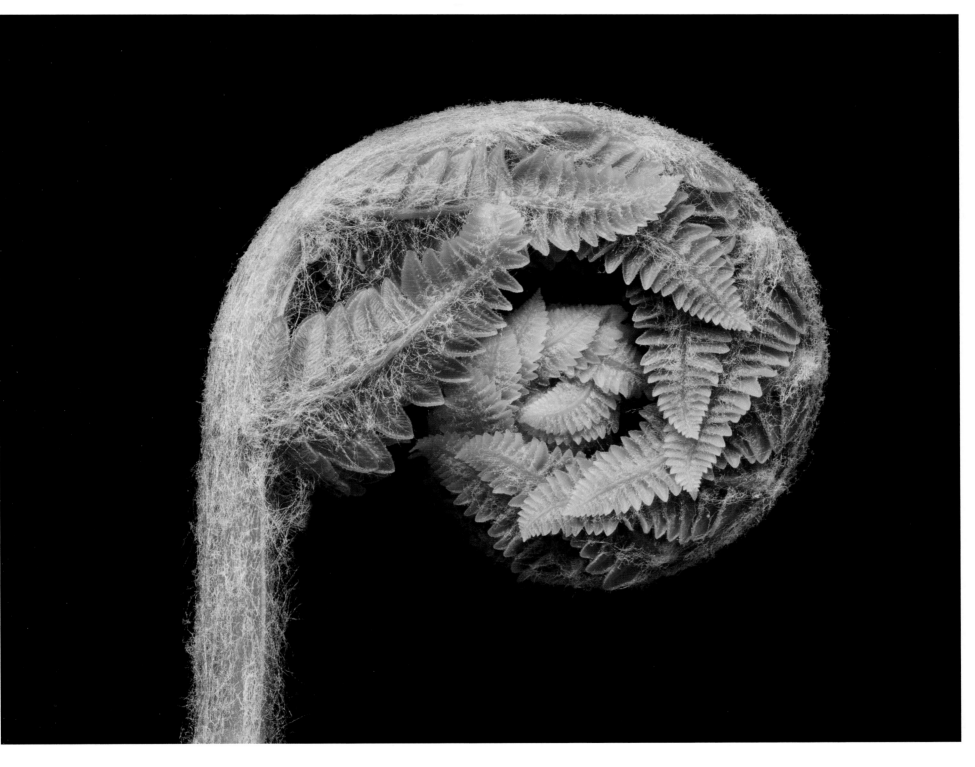

(TOP) Many fern colonies spread by underground rhizomes. The hairs on a caterpillar can deter predators and insulate from temperature extremes, and the hairs on a fern may do the same. ◄

(BOTTOM ROW) More than ten thousand different fern species live on this planet, and each has its own favored habitat. ◄

Ferns fronds uncoil from a distinctive fiddlehead as they enlarge. ▲

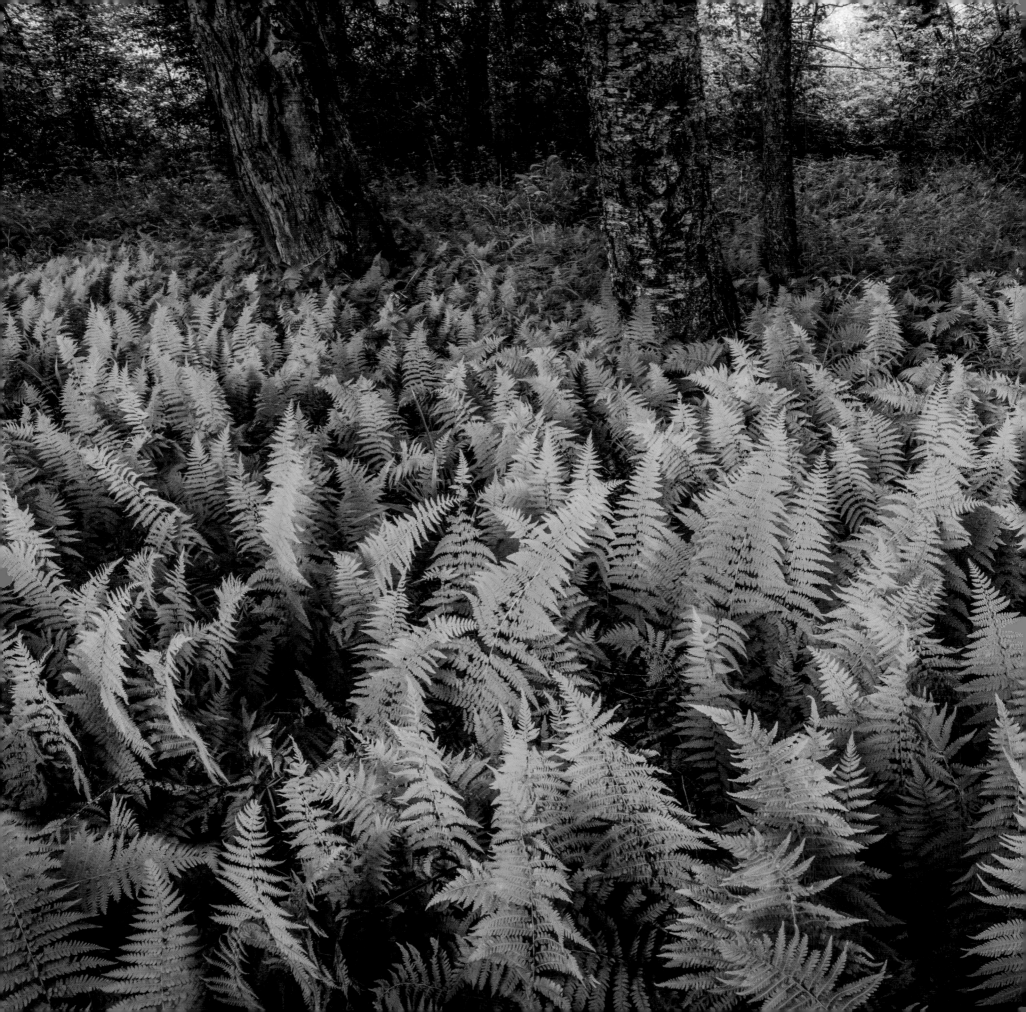

Of all the green ground-level vegetation in the forest, fern is among the least favorite foods of deer. So the trilliums get eaten, the shrubs get eaten, the tree seedlings get eaten, but the ferns remain.

225

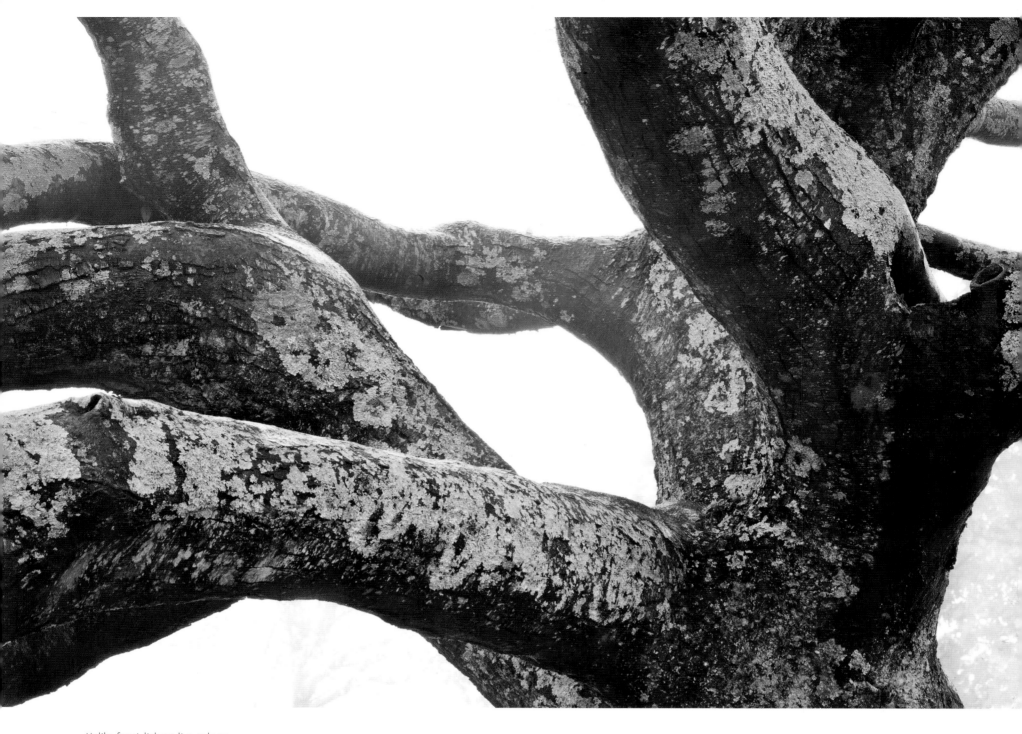

Unlike fungi, lichens live only on the surface of trees and do not decompose the wood. ▲

Lichens are another interesting member of the forest. They're a unique combination of fungi and algae. This combination allows them to live anywhere they can find a little sunshine. The algal partner photosynthesizes and makes sugar that it shares with the fungal partner, and the fungal partner provides protection, moisture, and micronutrients. Together they form a miniature ecosystem.

Naming these tiny, unique ecosystems has become quite a challenge. They're typically named after the fungal partner, but one type of fungus may pair with different kinds of algae or cyanobacteria, resulting in different-looking organisms that go by the same name. The naming of lichens will likely change in future years.

Just as the various shapes and colors of fungi are keys to identification, so it is with the lichens. Some may be spiky, almost like miniature shrubs growing from the ground, while others are pressed flat to rocks. Some have black hairs that look like eyelashes, while others have tiny red dots or hornlike appendages. Although they're grouped here with the only-green because they don't make flowers, lichens also exist that are more yellow and orange than green. A magnifying glass is handy for appreciating lichens.

Any surface can provide habitat for lichens. Rocks and trees are likely sites. If you see lichens growing on a tree, it's not a sign that the tree is in poor health. Unlike the fungi that may have threadlike mycelia infiltrating and decomposing the wood, the lichens live only on the surface, and trees are merely their scaffold. Like the roots that form unique and beautiful patterns, lichens add another layer of beauty and mystery to the forest.

(TOP) Most lichens are somewhat flat, but the so-called reindeer lichens are shrubby. These organisms prefer well-drained sites in sparse coniferous forests; there they may live for a hundred years. ▲

(BOTTOM) Like moss, many lichen species grow best on rocks. Rocks provide a surface few other plants can use, and as a result there is little competition for space. ▲

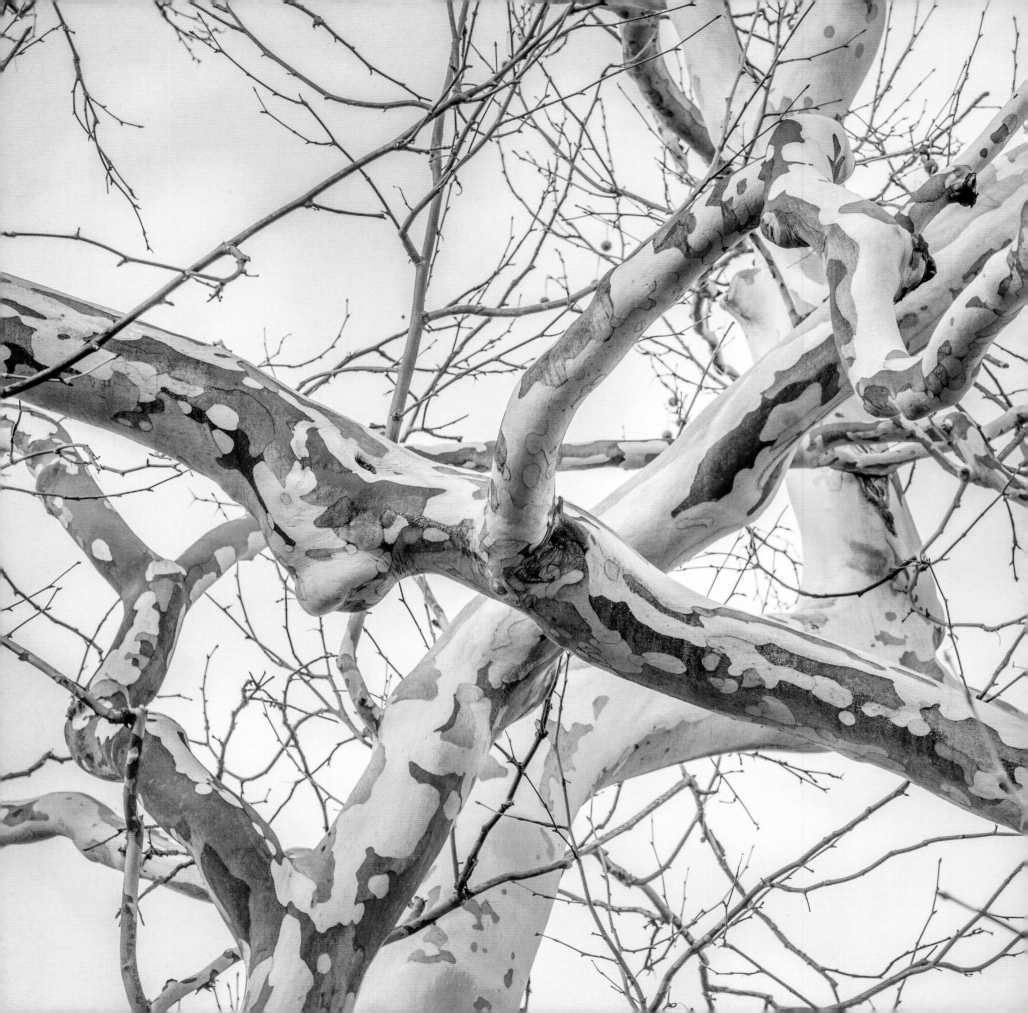

The Spirit of the Forest

SO MANY THINGS TO see in the forest! So many strands in the web of life. So many questions about how it all fits together. It's stunning to realize how little we know.

Maria Mitchell, the first female astronomer in the United States (1818–1889), said, "We especially need imagination in science. It is not all mathematics, nor all logic, but is somewhat beauty and poetry." This same thinking can be extended to our forests, for the forest is not only something to be understood, it is also something to be felt. The forest offers beauty and poetry to those who are open to it, perhaps waiting in silence for it to appear. It feels like a shift of the heart, like falling in love. The forest is worthy of being loved, and of being mourned when it is gone. It is more than trees and timber dollars and habitat. It is a spirit-filled place. Have you felt it?

The poetry of sycamore boughs

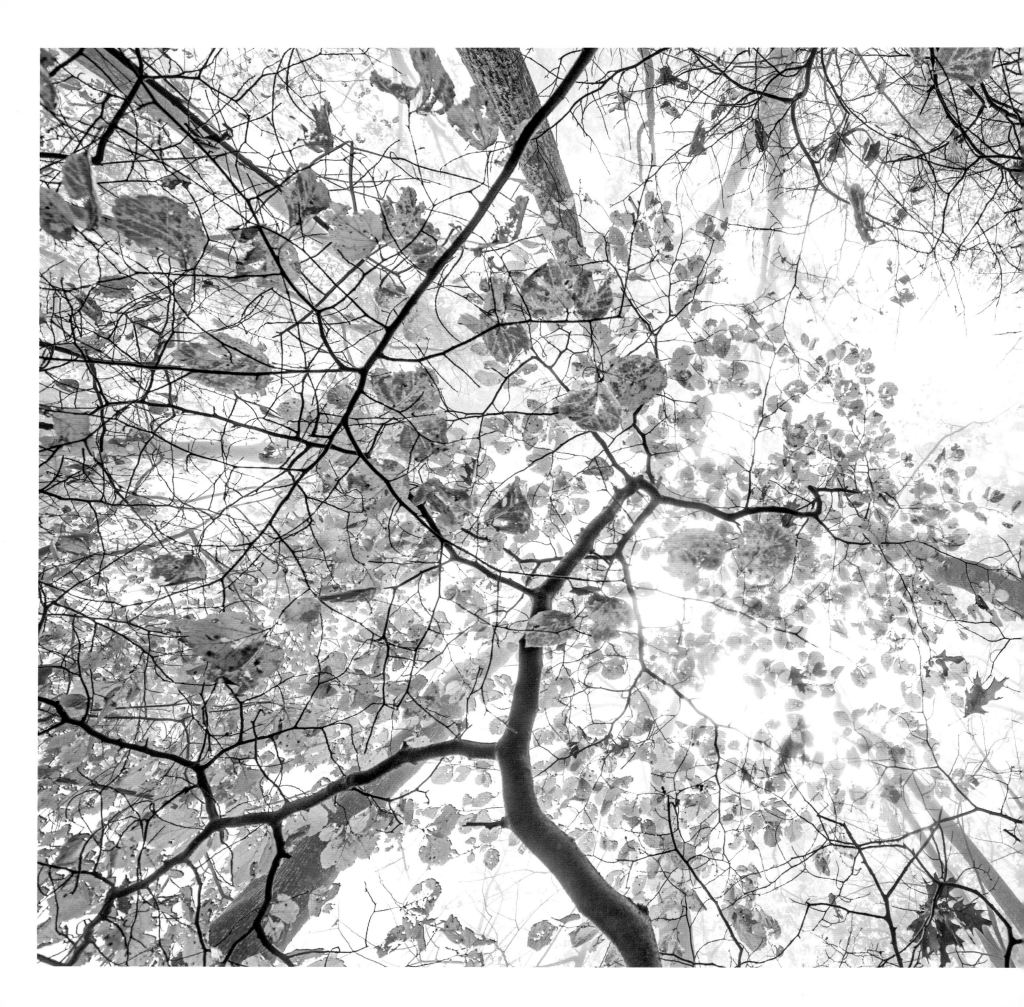

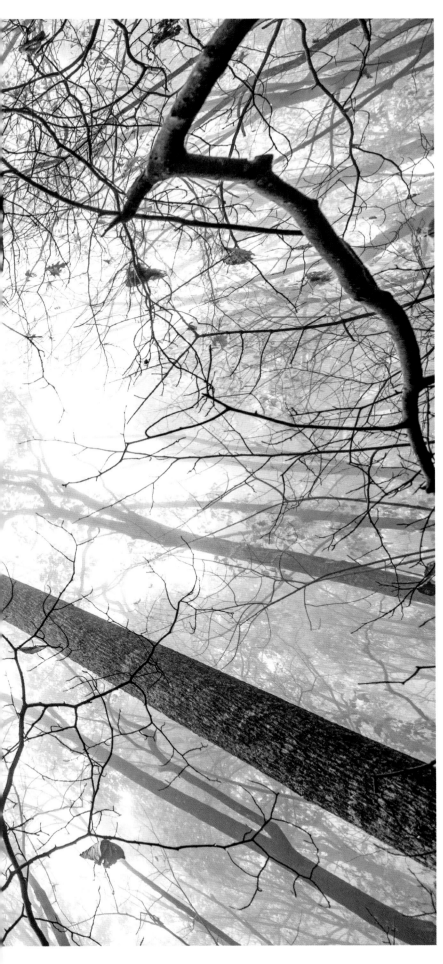

The light from above

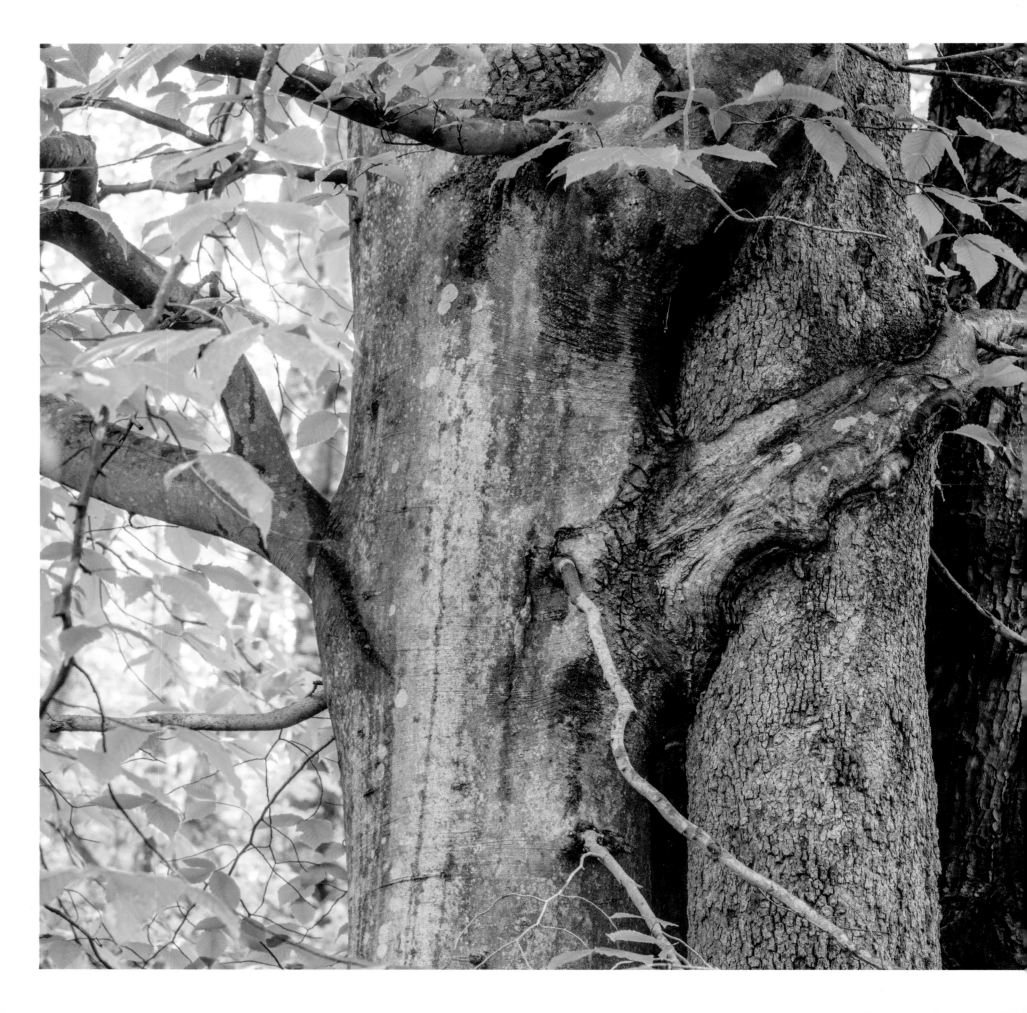

The slow embrace of limbs

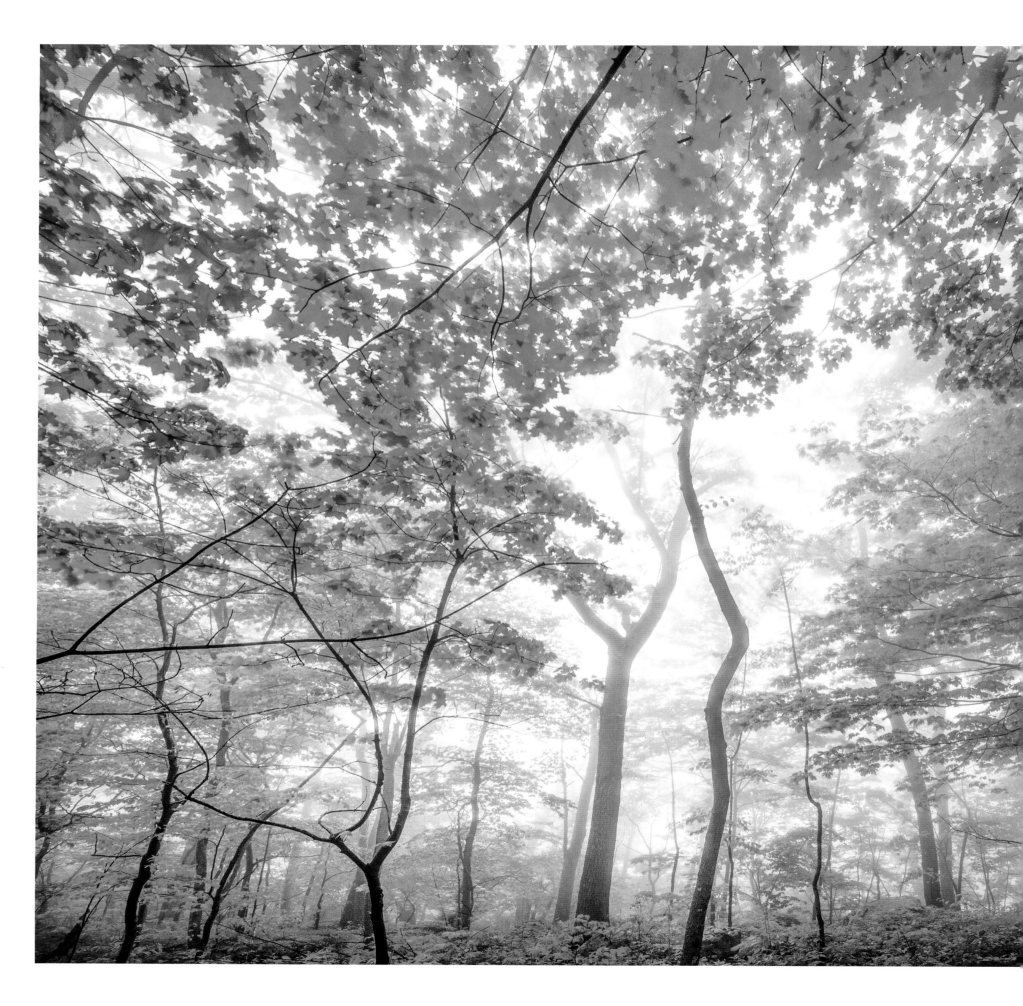

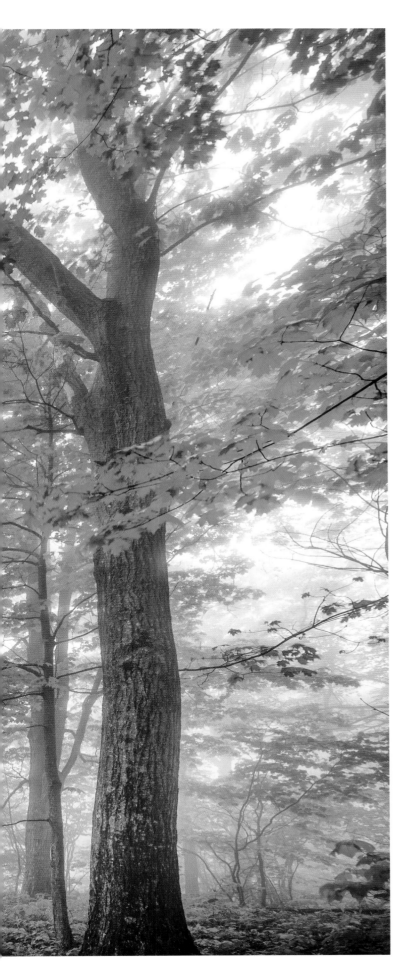

The green of spring

235

Reflections of light

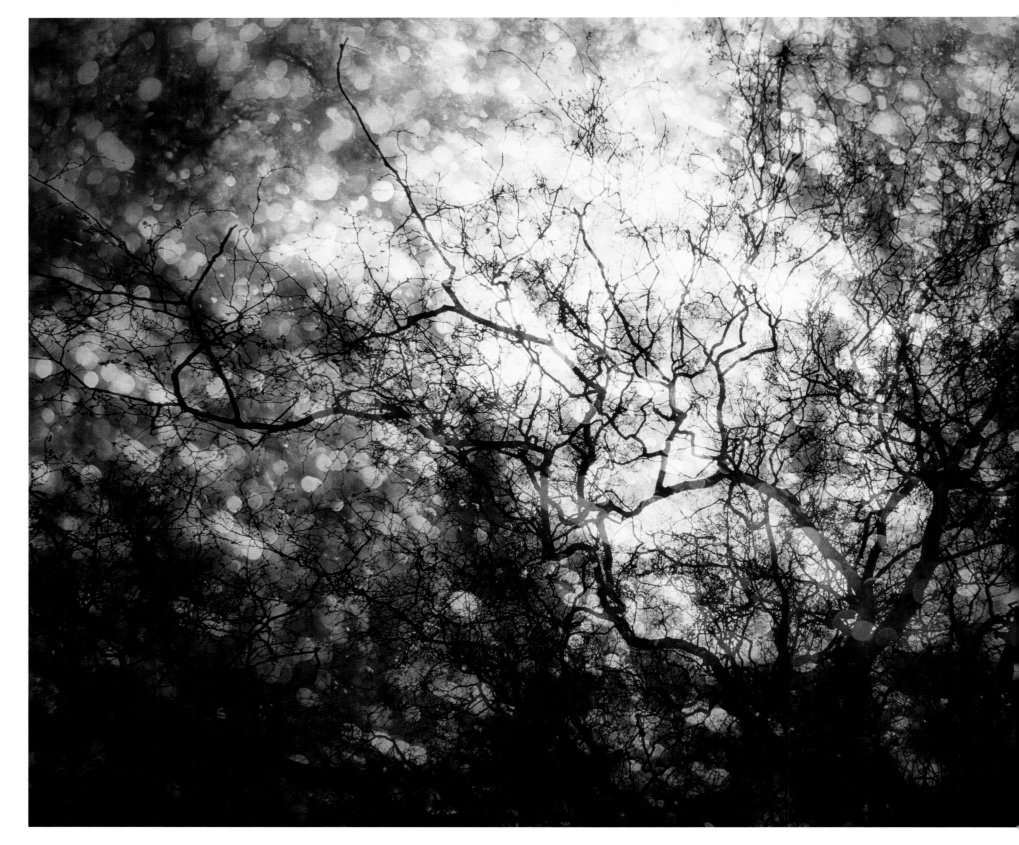

The magic of night ▲

(TOP) The feathers of an owl (BOTTOM) The skin of a toad

239

The sparkle of ice

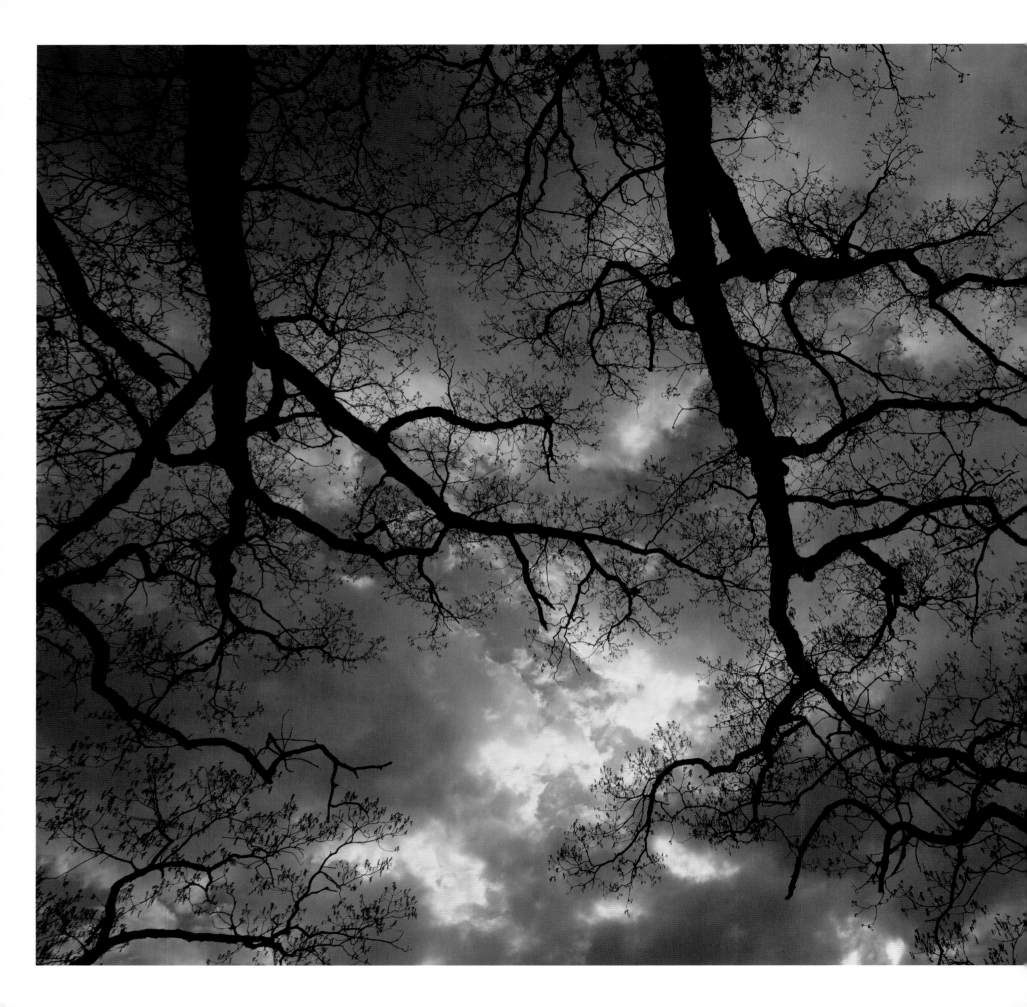

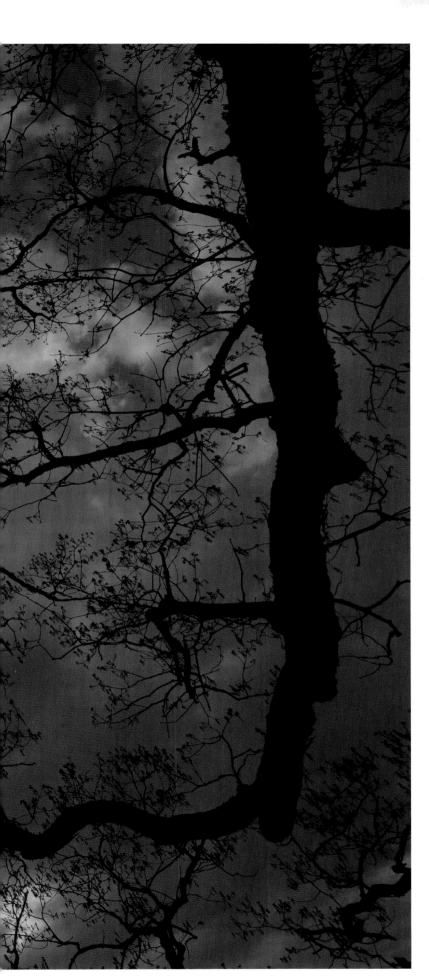

An uncommon sight

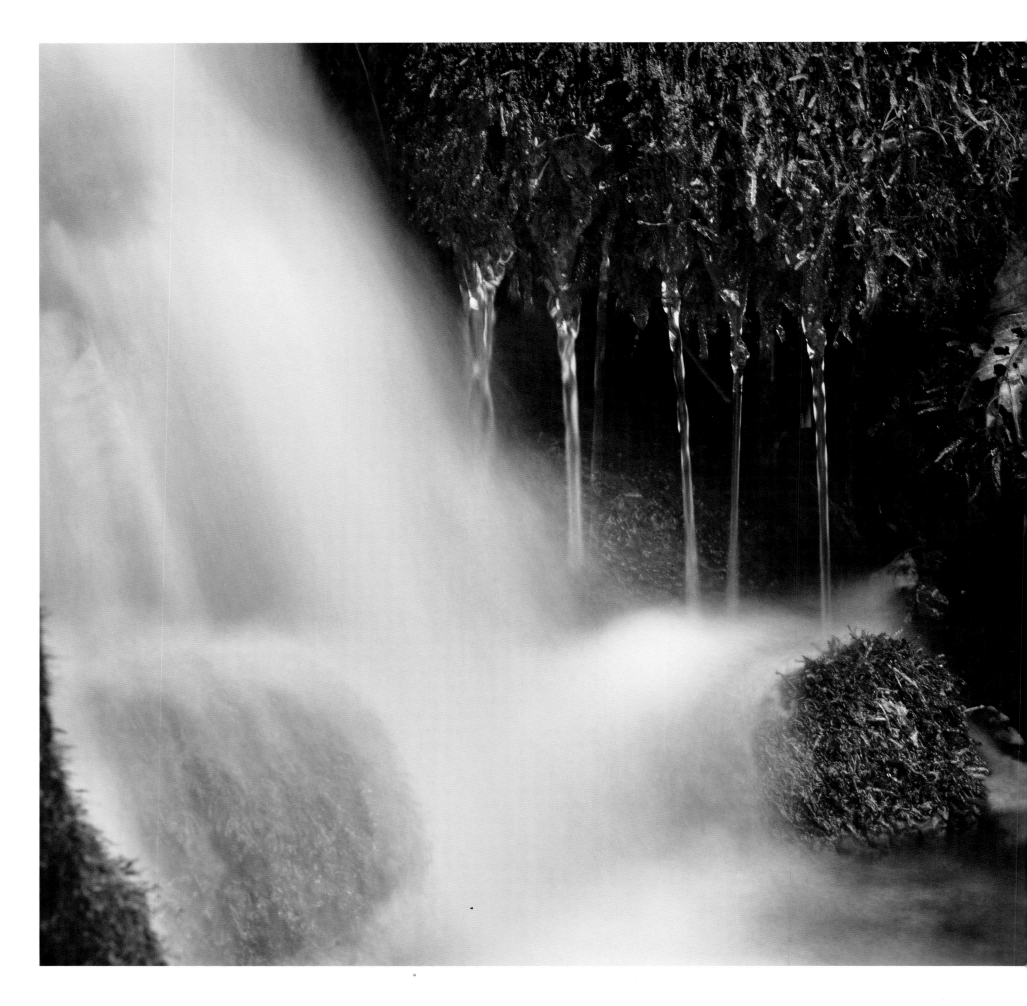

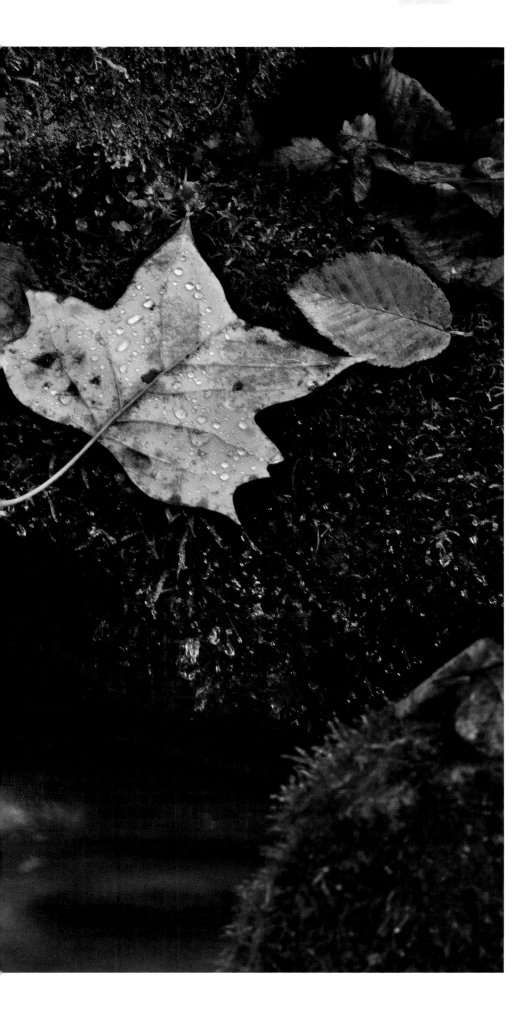

Sounds that soothe

The fading of day

The sensing of spirit

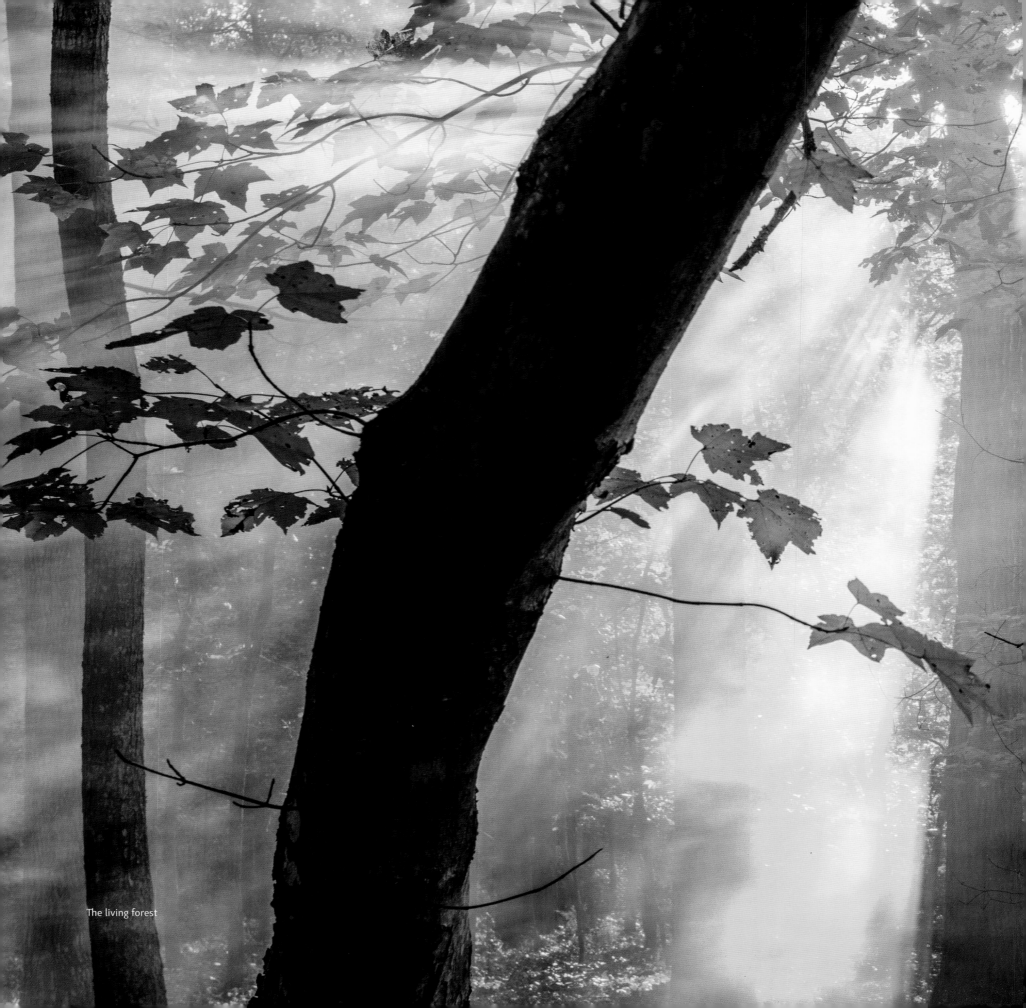

The living forest

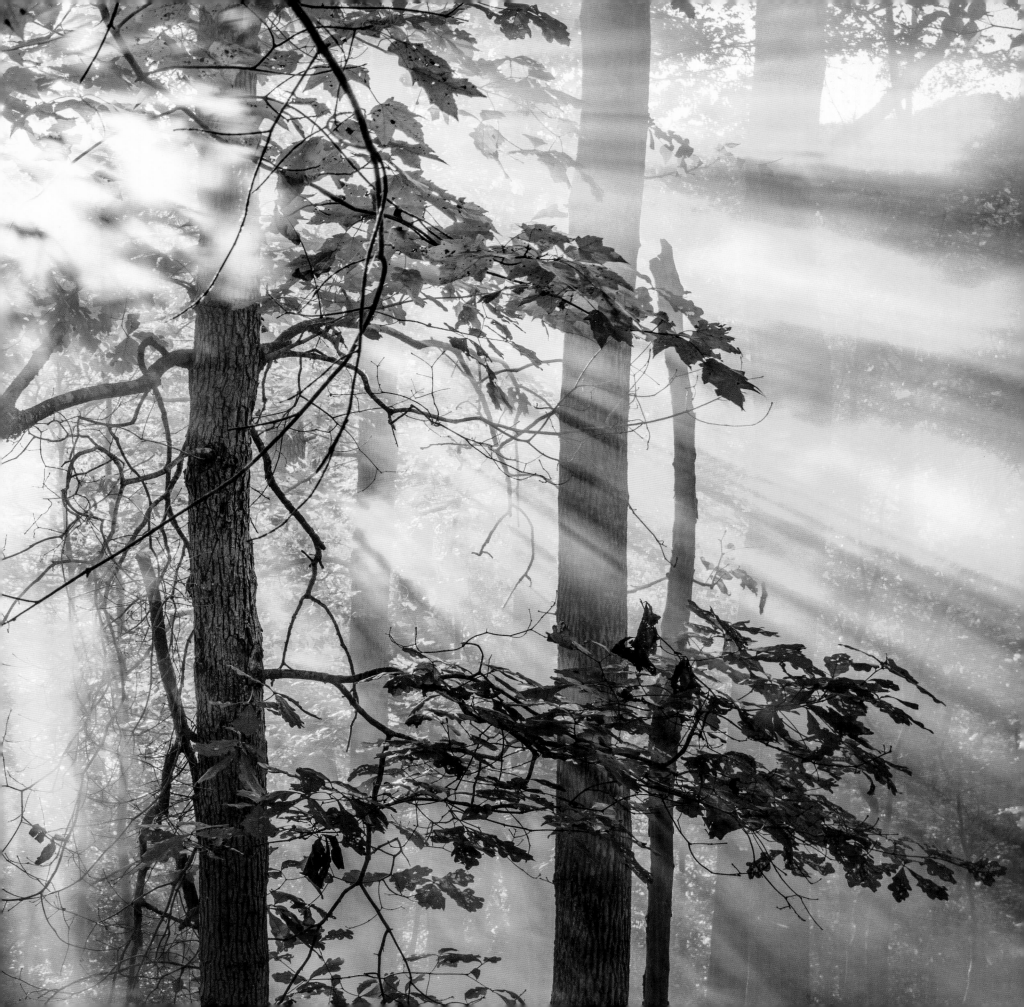

Bibliography

Abbott, H. 1974. Some characteristics of fruitfulness and seed germination in red maple. *Tree Planters' Notes* 25 (2): 25–27.

Arnold, S. 1976. Sexual behavior, interference and sexual defense in salamanders *Ambystoma maculata, Ambystoma tigrinum* and *Plethodon jordani. Zeitschrift für Tierpsychologie* 42: 247–300.

Arosa, M., J. Ramos, L. Quintanilla, and D. Brown. 2010. First report of fern (*Culcita macrocarpa*) spore consumption by a small mammal (*Apodemus sylvaticus*). *Mammalian Biology* 75: 115–121.

Atterberry-Jones, M., and B. Peer. 2010. Cooperative breeding by red-headed woodpeckers. *The Wilson Journal of Ornithology* 122 (1): 160–162.

Blake, W. 1950. Auguries of innocence. *Poets of the English Language*. New York: Viking Press.

Boch, S., M. Berlinger, D. Prati, and M. Fischer. 2016. Is fern endozoochory widespread among fern-eating herbivores? *Plant Ecology* 217: 13–20.

Bünning, E., and I. Moser. 1969. Interference of moonlight with the photoperiodic measurement of time by plants, and their adaptive reaction. *Proceedings of the National Academy of Sciences of the United States of America* 62 (4): 1018–1022.

Congdon, J., A. Dunham, and R. Sels. 1994. Demographics of common snapping turtles (*Chelydra serpentina*): implications for conservation and management of long-lived organisms. *American Zoologist* 34 (3): 397–408.

Croshaw, A., and D. Scott. 2005. Experimental evidence that nest attendance benefits female marbled salamanders (*Ambystoma opacum*) by reducing egg mortality. *The American Midland Naturalist* 154 (2): 398–411.

Dammeyer, T., and N. Frankenberg-Dinkel. 2008. Function and distribution of bilin biosynthesis enzymes in photosynthetic organisms. *Photochemical and Photobiological Sciences* 7: 1121–1131.

Davenport, J., and D. Chalcraft. 2012. Evaluating the effects of trophic complexity on a keystone predator by disassembling a partial intraguild predation food web. *Journal of Animal Ecology* 81: 242–250.

Davic, R., and H. Welsh. 2004. On the ecological roles of salamanders. *Annual Review of Ecology, Evolution and Systematics* 35: 405–434.

Duffey, S., M. Blum, H. Fales, S. Evans, R. Roncadori, D. Tiemann, and Y. Nakagawa. 1977. Benzoyl cyanide and mandelonitrile benzoate in the defensive secretions of millipedes. *Journal of Chemical Ecology* 3 (1): 101–113.

Dukas, H., and B. Hoffman, eds. 1981. *Albert Einstein, the Human Side: New Glimpses from His Archives*, Einstein reply to a letter in 1954 or 1955, p. 39. Princeton, New Jersey: Princeton University Press.

Epps, M., S. Allison, L. Wolfe, and M. McPeek. 2015. Reproduction in flame azalea (*Rhododendron calendulaceum, Ericaceae*): a rare case of insect wing pollination. *The American Naturalist* 186 (2): 294–301.

Fedriani, J., T. Fuller, R. Sauvajot, and E. York. 2000. Competition and intraguild predation among three sympatric carnivores. *Oecologia* 125 (2): 258–270.

Franks, P., and D. Beerling. 2009. Maximum leaf conductance driven by CO_2 effects on stomatal size and density over geologic time. *Proceedings of the National Academy of Sciences of the United States of America* 106 (25): 10343–10347.

Gamble, L., K. McGarigal, and B. Compton. 2007. Fidelity and dispersal in the pond-breeding amphibian, *Ambystomaopacum*: implications for patio-temporal population dynamics and conservation. *Biological Conservation* 139: 247–257.

Gerber, N., and H. Lechevalier. 1965. Geosmin, an earthy-smelling substance isolated from actinomycetes. *Applied Microbiology* 13 (6): 935–938.

Haribal, M., and P. Feeny. 1998. Oviposition stimulant for the zebra swallowtail butterfly, *Eurytides marcellus*, from the foliage of pawpaw, *Asimina triloba*. *Chemoecology* 8 (3): 99–110.

Hassall, M., and S. Rushton. 1982. The role of coprophagy in the feeding strategies of terrestrial isopods. *Oecologia* 53 (3): 374–381.

Hassinger, D., and J. Anderson. 1970. The effect of lunar eclipse on nocturnal stratification of larval *Ambystoma opacum*. *Cope* 1970 (1): 178–179.

Heyers, D., M. Manns, H. Luksch, O. Güntürkün, and H. Mouritsen. 2007. A visual pathway links brain structures active during magnetic compass orientation in migratory birds. *PLOS ONE* 2 (9): e937.

Hölldobler, B., and E. O. Wilson. 1990. *The Ants*. New York: Belknap Press.

Hunter, L., M. Pilkington, V. Andrews, S. Thomas, R. Molina, and N. Paiva. 2006. Analysis of nutritional components in edible parts of eastern redbud (*Cercis canadensis L.*). *Proceedings of the Southwest Regional Meeting of the American Chemical Society* (October 19–22, 2006).

Jackson, M., D. Scott, and R. Estes. 1989. Determinants of nest success in the marbled salamander (*Ambystoma opacum*). *Canadian Journal of Zoology* 67: 2277–2281.

Jones, K., and T. Tupper. 2015. Fowler's toad (*Anaxyrus fowleri*) occupancy in the southern mid-Atlantic, USA. *Amphibian and Reptile Conservation* 9 (1) [General Section]: 24–33.

Karban, R. 2015. *Plant Sensing and Communication (Interspecific Interactions)*. Chicago: University of Chicago Press.

Kerney, R., E. Kim, R. Hangarter, A. Heiss, C. Bishop, and B. Hall. 2011. Intracellular invasion of green algae in a salamander host. *Proceedings of the National Academy of Sciences of the United States of America* 108 (16): 6497–6502.

Kilmer, J. 1913. Trees. *Poetry Magazine*, August.

King, J., R. Warren, and M. Bradford. 2013. Social insects dominate eastern US temperate hardwood forest macroinvertebrate communities in warmer regions. *PLOS ONE* 8 (10): e75843.

Koprowski, J. 1993. Alternative reproductive tactics in male eastern gray squirrels: making the best of a bad job. *Behavioral Ecology* 1993: 165–171.

———. 1996. Natal philopatry, communal nesting, and kinship in fox squirrels and gray squirrels. *Journal of Mammalogy* 77 (4): 1006–1016.

Lopez, O., K. Farris-Lopez, R. Montgomery, and T. Givnish. 2008. Leaf phenology in relation to canopy closure in southern Appalachian trees. *American Journal of Botany* 95 (11): 1395–1407.

Lyford, W. 1943. The palatability of freshly fallen forest tree leaves to millipedes. *Ecology* 24 (2): 252–261.

Maginniss, L., S. Ekelund, and G. Ultsch. 2004. Blood oxygen transport in common map turtles during simulated hibernation. *Ecological and Evolutionary Approaches* 77 (2): 232–241.

Martin, J., S. Madigosky, Z. Gu, D. Zhou, J. Wu, and J. McLaughlin. 1999. Chemical defense in the zebra swallowtail butterfly, *Eurytides marcellus*, involving annonaceous acetogenins. *Journal of Natural Products* 62: 2–4.

Maynard, D., T. Crowther, J. King, R. Warren, and M. Bradford. 2015. Temperate forest termites: ecology, biogeography, and ecosystem impacts. *Ecological Entomology* 40: 199–210.

McRae, T., and S. Green. 2014. Joint tail and vocal alarm signals of gray squirrels (*Sciurus carolinensis*). *Behaviour* 151: 1433–1452.

Merwin, W. S. 2010. Poets and readers together: W. S. Merwin addresses librarians at Poets House, Thursday, October 21, 2010. https://www.youtube.com/watch?v=5OANUzvOp1I.

Monk, C., D. McGinty, F. Day. 1985. The ecological importance of *Kalmia latifolia* and *Rhododendron maximum* in the deciduous forest of the southern Appalachians. *Bulletin of the Torrey Botanical Club* 112 (2): 187–193.

Narendra, A., S. Reid, and J. Hemm. 2010. The twilight zone: ambient light levels trigger activity in primitive ants. *Proceedings of the Royal Society B (Biological Sciences)* 277: 1531–1538.

Nislow, K., and W. Lowe. 2003. Influences of logging history and stream pH on brook trout abundance in first-order streams in New Hampshire. *Transactions of the American Fisheries Society* 132: 166–171.

Pardo, M., S. Pardo, and W. Shields. 2014. Eastern gray squirrels (*Sciurus carolinensis*) communicate with the positions of their tails in an agonistic context. *The American Midland Naturalist* 172 (2): 359–365.

Perry, T. 1989. Tree roots: facts and fallacies. *Arnoldia* 49 (4): 3-21.

Pittillo, J., and B. Collins. 2010. Flowering phenology: trends over 32 years in a common garden. *Southeastern Naturalist* 9 (4): 837–846.

Rose, F. 1999. Indicators of ancient woodland: the use of vascular plants in evaluating ancient woods for nature conservation. *British Wildlife* 10: 241–251.

Safina, C. 2015. *Beyond Words: What Animals Think and Feel.* New York: Henry Holt and Company.

Seton, E. 1920. Migrations of the graysquirrel (*Sciurus carolinensis*). *Journal of Mammalogy* 1 (2): 53–58.

Shlaer, R. 1972. An eagle's eye: quality of the retinal image. *Science* 176 (4037): 920-922.

Statham, M., B. Sacks, K. Aubry, J. Perrine, and S. Wisely. 2012. The origin of recently established red fox populations in the United States: translocations or natural range expansions? *Journal of Mammalogy* 93 (1): 52–65.

Steele, M., M. Bugdal, A. Yuan, A. Bartlow, J. Buzalewski, N. Lichti, and R. Swihart. 2011. Cache placement, pilfering, and a recovery advantage in a seed-dispersing rodent: could predation of scatter hoarders contribute to seedling establishment? *Acta Oecologica* 37 (6): 554–560.

Stein, B., L. Kutner, J. Adams, R. Stebbins, and N. Cohen. 1995. *Precious Heritage: The Status of Biodiversity in the United States, A Natural History of Amphibians.* Princeton, NJ: Princeton University Press.

Stranko, S., R. Hildebrand, R. Morgan, M. Staley, A. Becker, A. Roseberry, and E. Perry. 2008. Brook trout declines with land cover and temperature changes in Maryland. *North American Journal of Fisheries Management* 28:1223–1232.

Suzuki, S. 1970. *Zen Mind, Beginner's Mind*, p. 65. Boulder, CO: Shambhala Publications.

Whishaw, I., J. Sarna, and S. Pellis. 1998. Evidence for rodent-common and species-typical limb and digit use in eating, derived from a comparative analysis of ten rodent species. *Behavioural Brain Research* 96: 79–91.

Zhang, T., S. Maruhnich, and K. Folta. 2011. Green light induces shade avoidance symptoms. *Plant Physiology* 157: 1528–1536.

Acknowledgments

FROM R. L.

I start with great appreciation for Joan Maloof and her passion for the forest. She is a great teacher and has transformed what I know about the forest. I am forever changed when I am in a forest and now see many things that previously were hiding in plain sight.

Joan sent me a suggested list of possible photographs. Further along she sent specific and unique items to find. For me this project then turned into a compelling treasure hunt. I live in the middle of 384 million acres of forest, so I needed help. The most help finding these treasures (like a "kissing tree," where two different trees melt into each other) was from master naturalist Emily Luebke, who took on the list as a challenge and found and guided me to many of the forest treasures.

Master naturalist John Holden guided and carried equipment for me on a salamander and frog trip to Maples Flats, Virginia, and its famous limestone vernal pools. He was assisted by the amazing salamander finders Eva and Norah Floyd. Thanks also to salamander expert Katy Cain.

Help with other animals came from Carla Murray, Buz Bireline, and Anaka Nazareth of the Robbins Nature Center at Maymont in Richmond, Virginia. Help with birds came from Rita McMahon and her Wild Bird Fund in New York City. Some animals were photographed in captivity. Other help came from birders Thomas Jones, Albert Connette, and Walter Catlett.

I would also like to thank Mark Gardner for help with the old-growth forest at the William Cullen Bryant Homestead in Massachusetts; Barbara Corcoran and Jessica Arcate Schuler with the Thain Family old-growth forest at the New York Botanical Gardens; and Adam Downing, who guided me through the old-growth forest at Montpelier, Virginia. Other assistance came from Julie Shuren of the Shenandoah National Park Trust; and Will Neuman, who guided trips into the Blude Ridge. Computer and equipment assistance came from Jon Golden.

Thanks to photographer Nick Nichols for guiding me up the mountain in search of wild forest orchids. The descent was in a torrential mountain thunderstorm. The forest does what it wants. I also appreciate my friend and fellow photographer Scott Barrow, who makes photographs only in first light and last light, for getting me up at zero dark hundred to make photographs in first light for this book. Thank you to my brother, Boxley, and his wife, Jane, for transporting us to the most exquisite specimen of beech roots in the world.

I fondly honor Kathy and Troost Parker along with Bill and Carolyn Achenbach, who took on this project and guided and assisted me on journeys through the moss-covered forest floor in the Cheat Mountain rain forest and other old-growth forests of West Virginia.

I have great appreciation for my publisher, Timber Press, and for Tom Fischer, editor-in-chief; Patrick Barber, creative director; and Adrianna Sutton, book designer, for their support and the transformation of this project into a great book.

I am grateful for the photography support of the Southern Environmental Law Center and its work preserving roadless forests in the George Washington National Forest in Virginia, saving old-growth forests from timbering in the Pisgah National Forest in North Carolina, and saving the unique forest of Sandy Island, South Carolina, from destruction.

And finally, and most treasured, I have enormous love and appreciation for my wife, Bobbi, who loves to walk in the forest and would accompany me on most of my adventures. She would often walk in large circles around me as I made photographs or as I waited for the light.

FROM J. M.

My deepest thanks to Robert Llewellyn for inviting me to put words to his wonderful images. It has been a delightful journey from beginning to end.

Index